VOGUE

INCORPORATING VANITY F

ADVANC
RETAI
TRA
EDITIO

see section facing p e 1

FIFTY
BATHING
SUITS

BEACH FASHIONS • BEAUTY • SUMMER TRAVEL • JUNE 1, 1940 • PRICE 35 CENTS

IN VOGUE

NORBERTO ANGELETTI
ALBERTO OLIVA

IN VOGUE

THE ILLUSTRATED HISTORY OF THE
WORLD'S MOST FAMOUS FASHION MAGAZINE

RIZZOLI
NEW YORK

PART I

VOGUE AND THE CULTURE OF FASHION

CONTENTS

PART II

THE NEW WOMAN IN *VOGUE*: FASHION PHOTOGRAPHY AND EDITORIAL STYLE

PART III

THE MAGAZINE OF THE NEW CENTURY

INTRODUCTION

This book is, by any measure, long overdue. Though *Vogue* is now in its twelfth decade, no book has yet recounted its history or detailed its editorial, visual, and artistic contributions to culture in general and to fashion journalism in particular. The few titles published about *Vogue* are picture books or are focused on one of the magazine's key personalities, usually a photographer or fashion editor. They are written in a biographical or anecdotal vein, with *Vogue* little more than a backdrop or a point of reference. No book has paid homage, as this book does, to the editors, photographers, writers, and designers who built *Vogue* in the past and continue to build it today—the women and men, invisible to the readers but highly visible to the industry, behind each cover and behind every page.

In these and other ways, *In Vogue* is out of the ordinary.

We were fortunate to be granted, from the outset, not only unprecedented and unlimited access to the behind-the-scenes workings of *Vogue* but encouragement to write freely about what we saw and lived and felt, with a guarantee of absolute editorial control.

As researchers, analysts, writers, and teachers of magazine history, we had never faced such a challenge: to discover the secrets of success of the world's foremost fashion magazine, to dissect what it has done to attract and hold the attention of millions of women for more than a century.

The task has been both fascinating and complex. To explore the magazine's editorial attributes over the years, we also had to explore the world that *Vogue* reflected and, often, shaped—the evolution not only of fashion but of women themselves, how they choose and wear clothes, interpret beauty, assume a changing role in society. We had to delve into archives, vintage clothing collections, biographies, back issues of magazines, art books, and thousands upon thousands of

unforgettable photographs. And we had to interview editors, publishers, designers, photographers, and fashion historians.

The more we dug, the more it was clear that we were writing about a unique publication, with an influence that reached far beyond fashion journalism into the realms of art, photography, and popular culture.

In the course of our research we saw how *Vogue*, cultivating its image in the early years of the twentieth century as an avant-garde publication, turned its covers into a showcase for emerging artistic movements from cubism to art deco, associating itself firmly with the latest trends in painting and illustration. A parade of extraordinary talent, whether specialists in illustration like Georges Lepape, Eduardo Benito, and Carl Erickson or artists with a broader range like Christian Bérard and Salvador Dalí, used the cover of *Vogue* on the newsstand as a sort of outdoor gallery, subtly creating a potent mix of fashion, feminine beauty, art, style, glamour, and journalism. These images remain a treasure to advertising agencies, collectors, and the general public. *Vogue*'s covers, reproduced as posters, still succeed in bringing to life the spirit of that outstanding era.

The magazine, which had started out in the nineteenth century as a social

gazette, a mirror of the culture and the tastes of a rarefied social class, was transformed early in the twentieth century by its new owner Condé Nast into an active participant in society, generating new ways of looking at reality.

In its search for better ways to transmit fashion with clarity, grace, and glamour, *Vogue* became the publication that contributed most to the development of photography in general and of artistic photography in particular. Its pages displayed the works of exceptional masters of the camera, who in their individual styles documented the aesthetic evolution of feminine beauty for nearly a century. *Vogue* can fairly claim to be the creator of fashion photography.

The first step in this rich history was taken by Condé Nast in 1913 when he hired Baron Adolphe de Meyer, whose romantic, seductive images and soft backgrounds unleashed a revolution in the world of imagery. Then in 1916 Nast created a photo laboratory, a rarity in the magazine world at the time, and set up a studio for the use of his staff photographers and for the training of their apprentices. By 1930 *Vogue* had three such studios, in New York, London, and Paris.

In the wake of Baron de Meyer, other camera artists left their imprint on the magazine, a roster that includes

Edward Steichen, Cecil Beaton, Horst P. Horst, Irving Penn, Richard Avedon, Arthur Elgort, Helmut Newton, and Herb Ritts, who are themselves chapters in the world history of photography. Today's names are just as luminous: Annie Leibovitz, Steven Meisel, Steven Klein, Mario Testino, Patrick Demarchelier. All of them have contributed to the cutting-edge visual style that has long characterized *Vogue*, a style presided over for more than fifty years by the legendary Alexander Liberman, the titan of twentieth-century magazine design.

The story of *Vogue* unfolds in three parts. The first covers the birth of the magazine and the era of Condé Nast, showing how the founders and early editors established a niche and a market for their publication and imparted to Vogue a distinctive style. The second part relates how, through successive editorships with differing philosophies and differing views of fashion, the magazine evolved along with the modern woman. In this section, as the story of *Vogue* is entwined with the history of culture, our focus is sometimes on fashion, sometimes on customs and mores, and always with an eye to editorial style and photography. The last part examines the workings of the magazine in the new century. Here, for the enlightenment of future generations of journalists, editors, advertising and marketing people, design artists, and photographers, we set forth the makings of the current magazine, the inner mysteries of its editorial and visual content, from fashion shoots to the selection of the face on the cover—all of it told from the inside.

In Vogue is as captivating as it is long overdue.

PART 1

VOGUE AND THE CULTURE OF FASHION

VOGUE'S FIRST ISSUE AND THE ARRIVAL OF CONDÉ NAST

On December 17, 1892, a weekly gazette called *Vogue* was born. Its creator was Arthur Baldwin Turnure, an impeccably credentialed member of New York society and a friend to the city's most distinguished and privileged families. The publication had the stated aim of representing the interests and lifestyle of this class, which during the last decade of the nineteenth century felt invaded by parvenus who, with little lineage but plenty of money, attempted to join in its aristocratic activities. In the inaugural issue's introductory letter, Turnure described *Vogue* as a magazine that would reflect "the ceremonial side of life." This, he said, "has in the highest degree an aristocracy founded in reason and developed in natural order. Its particular phases, its amusements, its follies, its fitful changes, supply endless opportunities for running comment and occasional rebuke. The ceremonial side of life attracts the sage as well as the debutante, men of affairs as well as the belle. It may be a dinner or it may be a ball, but whatever the function the magnetic welding force is the social idea."

The first issue included fashion articles for women and men, reviews of recently published books, drama,

music, and art, and a large number of articles on etiquette and on how to behave at social gatherings. The magazine was divided into departments. Among the readers' favorites were "Seen in the Shops," "*Vogue* Designs for the Seamstress," "Smart Fashions for Limited Incomes," "The Paris [or London] Letter," "Society Snapshots," "On Her Dressing Table," "The Well-Dressed Man," "Play House Gossip," "For the Hostess," and "Answers to Correspondence." The publication had a major advantage over the competition: with its social connections and exclusive access to some of the most prominent families—the Vanderbilts, the Astors, the Stuyvesants, the Whitneys, the Van Rensselaers—*Vogue* was able to show the interiors of their homes, their parties, and the gowns they brought back from Europe. In essence, *Vogue* was born with a silver spoon in its mouth. It was published by, for, and about the New York aristocracy, a class that was growing by leaps and bounds.

The second birth of the publication came seventeen years later in 1909, when Condé Montrose Nast, a young lawyer and publicist from St. Louis with ten years of experience at *Collier's*

Weekly, bought *Vogue*. Nast had actually begun negotiating the purchase in 1905, but the unexpected death of Turnure in 1906 delayed the deal for three years. *Vogue*'s editor at the time was Turnure's sister-in-law Marie Harrison, who had been running it since 1901 along with a young assistant named Edna Woolman Chase. The business had stayed afloat, despite being neglected on more than one occasion. Circulation had increased to 14,000 copies per week, and annual revenue had risen to $100,000. The magazine continued to be read by the richest and most prominent members of New York society, and Condé Nast intended to take maximum advantage of such a readership to eventually turn *Vogue* into the most fabulous magazine of style and fashion culture anywhere, ever. It would also be the launching pad for one of the most important publishing houses in the world. In the course of its development, it would have a profound influence on the artistic and journalistic world, on design, photography, cover illustration, and editorial content. More than merely a symbol of glamour and frivolity, *Vogue* became a publishing icon with a lasting impact on journalism and on culture in general. *Vogue* made and makes history.

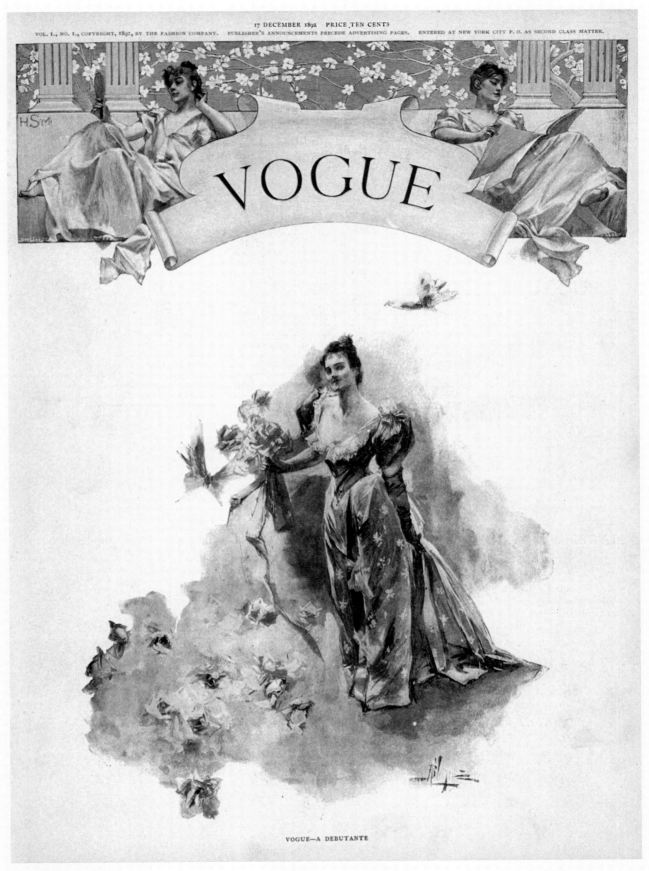

17 DECEMBER 1892 PRICE TEN CENTS
VOL. I., NO. I., COPYRIGHT, 1892, BY THE FASHION COMPANY. PUBLISHER'S ANNOUNCEMENTS PRECEDE ADVERTISING PAGES. ENTERED AT NEW YORK CITY P. O. AS SECOND CLASS MATTER.

VOGUE

VOGUE—A DEBUTANTE

FIRST ISSUE

On the cover of the premiere issue, above an illustration by A. B. Wenzel, the title appeared in a scroll with two elegantly gowned women reclining upon it. This design, by Harry McVickar, would crown the publication's covers inter-mittently until 1906.

SOCIETY AT THE TURN OF THE CENTURY

Fashion journalism, or at least the first magazine to address the subject, was born in France in 1763 with *Le Mercure Galant.* In the United States, the first periodical for women, *Lady's Magazine,* dates back to 1792, but it is *Godey's Lady's Book,* published between 1830 and 1898, that is considered to have laid the editorial groundwork for the genre. According to Amy Janello and Brennon Jones in their 1991 book *The American Magazine,* "When Sarah Josepha Hale became the editor of *Godey's Lady's Book* in 1837, she set the mission for women's magazines: to inform, assist and advise, and to keep women in touch with each other in a society that believed with Thomas Jefferson that 'the tender breasts of ladies were not formed for political convulsion.'"

By 1880 the sector had grown considerably in the United States, with eighteen women's and fashion magazines appearing regularly on the newsstands. And this was no coincidence: as the blossoming capitalist economy produced more and more affluent families, a large number of women found themselves with plenty of leisure time and plenty of money to spend. They had two ways to show how well their husbands were doing and to climb the social ladder—their homes and their wardrobes. Being in style and having a smart outfit for each occasion was recognized as one of the most effective ways to stand out in society. Magazines dedicated to the topic became, for the richest women, a vital source of information from Paris—the undisputed wellspring of fashion—with particulars of the latest trends in color, cut, fabric, trim, and accessories. For the less wealthy, the magazines' service of incorporating actual outlines for sewing in each issue became an indispensable aid to looking chic and having the latest styles for the season. These patterns experienced a boom for decades after the invention in 1846 of the sewing machine, which later facilitated the creation of clothing at home as well as the establishment of countless workshops dedicated to wholesale manufacturing.

The women's clothing industry grew steadily. In 1900, it was estimated, there were nearly 2,000 workshops dedicated to sewing blouses and dresses, of which some 600 were in New York. A new type of woman was also born, the female consumer, who became the target of everyone—manufacturers, businesses, department stores. In *A History of Popular Women's Magazines in the United*

COLOR COVER
The first color cover was published in April 1901. Its green frame emphasized the hat and the red neckpiece on the model, drawn by Allan C. Gilbert. As the following pages show, social gatherings and outdoor activities were recurrent cover themes.

VOGUE

A GILBERT HEAD

SECOND OF THE SERIES—SEE TEXT

VOGUE

HAMILTON KING 1902

States, 1872–1995, the researcher
Mary Ellen Zuckerman points out:
"A spate of new women's magazines
appeared in the 1870s, 1880s and
1890s. Changes in market demand,
print technology, transportation sys-
tems, and financing worked to place
magazines in the hands of ever-greater
numbers of readers. As Americans
gained more leisure time and became
more literate, they turned to magazines
for education and relaxation." From
another perspective, thanks to fast dis-
tribution operations and special mail
privileges, these publications could
assure advertisers that their products
would get national exposure. This
development immediately began to
yield its fruits to magazine publishers,
who in 1900 brought in 95 million dol-
lars in advertising revenue, a figure that
climbed five years later to 145 million.

It was in that context and in that
expanding market that Turnure's *Vogue*
was born and grew. The small illus-
trated gazette called *Vogue* appeared
in 1892—and the year of its launch-
ing was not accidental. In that same
year, as newly powerful and wealthy
families were struggling to achieve
recognition and carve out a place in
New York society, an event sent ripples
through the most illustrious names in
the city: the winter ball given by the
wife of millionaire William Backhouse
Astor Jr. for "the Four Hundred." The
epithet derived, it was thought, from
the maximum capacity of the ballroom
in the Astor mansion on Fifth Avenue.
But that number also represented a
sort of limit to the number of individu-
als that the traditional aristocracy
would be willing to accept into its
nucleus. Being invited to Mrs. Astor's
ball, then, became a vital issue, par-
ticularly for the new rich who wanted
to be admitted into the New York
elite. To deflect the pressure, Mrs.
Astor designated as arbiter Mr. Ward
McAllister, the very man who in
1888 had coined the term "the Four
Hundred." McAllister, well known for
his supreme elegance, based his
decisions strictly on that—elegance
and decorum and proven social
graces, in addition to money—as he
created the fateful list of invitees.

C. M. RELYEA 1893

ARTIST UNKNOWN 1893

PARKER NEWTON 1893

F. FOURNEY 1893

MAX F. KLEPPER 1893

HARRY McVICKAR 1893

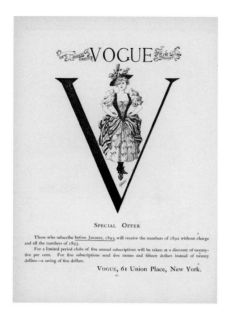

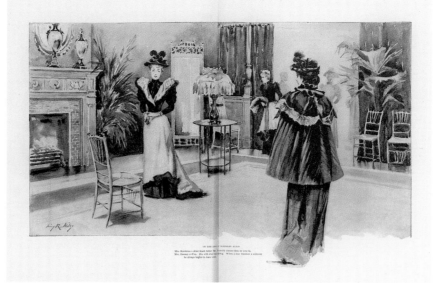

SPREAD IN *VOGUE*'S FIRST ISSUE
The drawing shows not only the women's apparel but details of the luxurious interior. Fashion and social status went hand in hand and were always linked in the pages of *Vogue* during this era.

Vogue was born to be the mirror of the Four Hundred, to recount their habits, their leisure activities, their social gatherings, the places they frequented, and the clothing they wore. The target was the Four Hundred, and everyone who wanted to look like them, act like them, and enter their exclusive circle. The first staff of writers was headed by publisher Arthur Turnure, art director Harry McVickar, and editor in chief Josephine Redding. Turnure and McVickar were members of such exclusive social clubs as the Grolier, the Union, and the Calumet, and they met for dinner at Delmonico and, after its opening in 1893, at the Waldorf. Their editors-at-large also hobnobbed with the upper class and expressed the interests and concerns of the aristocracy in their columns. One of the most widely read, polemic, and controversial was Walter Robison, who commented harshly on the behavior of some Americans. In one column, referring to the bad image that some wealthy travelers give Americans overseas, he wrote, "A very odd thing about this class of Americans, and in fact, about nearly all our country people, except those who have been in the habit of going abroad for years, or who have lived over there, is that, no matter what their morality may be

at home, the moment they arrive in Paris they imagine that they must mingle with the very worst and most disreputable assemblages and visit the most extraordinary places. In other words, they want to do 'the sights . . .' In spite of this mob abroad, and with such representatives, there are some who still deny there exists in America both the upper- and the lower-middle class."

Vogue set the rules for social conduct and was avidly read by those who considered themselves part of New York's elite as well as by those who strove to join it. In 1895, on the third anniversary of the magazine, Turnure wrote, "Two leading ideas control [*Vogue*'s] career. One, the constant recollection that improvement and development go hand in hand; the other, that its readers are gentlemen and gentlewomen and that to the requirements of this class its energies and resources shall conform." But *Vogue* also became essential entertainment for readers of both sexes—back then, the magazine aimed to interest both women and men equally—as it reported on all the social happenings of the week. From the doings at the country clubs, where golf and bridge were all the rage, to the parties

held at mansions and on yachts, readers followed every move to find out who was there and what they wore. Fashion filled a large portion of the magazine's pages, with at least three regular departments, "Seen in the shops," "*Vogue* Designs for the Seamstress," and "The Paris [or London] Letter." And its advice—"For street wear a morning coat suit of plain smoke or dark gray is rather smart" or "Not to have an all-black or black and white Chantilly gown this season is to declare oneself out of the mode"—was followed religiously.

In its internal structure, the magazine reflected a gender-based division of labor. Turnure, McVickar, and some male friends handled articles related to sports and social affairs at clubs and residences. Redding was responsible for the dress patterns, fashion-related topics, and a section called "Concerning Animals," her true passion. She retired from the magazine in 1900 and was succeeded in 1901 by Marie Harrison, Turnure's sister-in-law. When Josephine Redding left *Vogue*, she had endowed the magazine with a record-setting section—her "Concerning Animals" would last until the 1940s—and, most important of all, with its name.

EARLY COLOR
Color covers such as this unsigned example from 1903 alternated with black and white until 1909.

THE CHRISTENING OF *VOGUE*

The list of names was long, but none of them seemed quite right until the editor in chief Josephine Redding showed up at an affair where she was expected to announce the name of the new publication, bearing a *Century Dictionary* in her hands with the word *vogue* underlined. The definition said:

vogue (vōg). . . . The mode or fashion prevalent at any particular time; popular reception, repute, or estimation; common currency: now generally used in the phrase *in vogue*: as, a particular style of dress was then *in vogue*; a writer who was *in vogue* fifty years ago; such opinions are now *in vogue*.

Turnure and McVickar were immediately convinced. It was just the name they needed to identify their social gazette. None of them could imagine, in 1892, that they were creating a brand that would become famous all over the world.

ALLAN C. GILBERT 1901

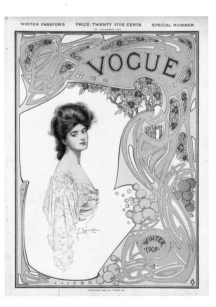

C. F. FREEMAN 1904

ARTHUR TURNURE
A member of New York society, Turnure was the founder of the weekly journal called *Vogue*.

CONDÉ NAST

Condé Montrose Nast was born in New York on March 26, 1873, raised in St. Louis, and educated at Georgetown University in Washington, D.C. It was at Georgetown that he met Robert J. Collier, son of the publishing entrepreneur who owned the magazine *Collier's Weekly*. The two young men developed a great friendship, which would play a fundamental part in Nast's evolution as a publisher.

After graduating in 1895, Nast returned to St. Louis to study law. In addition to getting his law degree and passing the Missouri bar exam, he also got his first experience in the publishing industry. In 1897 his family's small printing firm was about to go bankrupt. The young Condé tried to solicit orders for the print shop by calling on business friends and acquaintances, but they turned him down, saying they were too busy preparing for the city's annual fair. Instead of discouraging Condé, this gave him an idea: Why not capitalize on the much-anticipated summer event? He quickly prepared a list of all the exhibitors and proposed to them the creation of fliers and adver-

tisements for the products they planned to exhibit and sell at the fair. His marketing strategy worked perfectly: not only did it save the printing firm in the short term, but it allowed him to establish a solid and permanent commercial relationship with his clients, ensuring the future of the family business.

This episode was Nast's introduction to the publishing trade. As it happened, at the end of that summer, when the fair had ended, he received a visit from his friend Robert Collier, who had become owner of *Collier's* magazine upon his father's death. After hearing about Nast's experience, and with the intention of turning the sagging publication around, Collier offered him the position of advertising manager. Nast accepted and returned to the city of his birth, New York.

The two young men immediately transformed the weekly, Collier on the editorial side and Nast in advertising. Condé imposed a new style, unheard of in that era, that yielded large returns to him and the magazine.

GIBSON STYLE
Condé Nast (photo) loved the style of Charles Dana Gibson, who had succeeded in creating a new ideal of feminine beauty. *Vogue* covers reflected the phenomenon even before Nast took over the magazine.

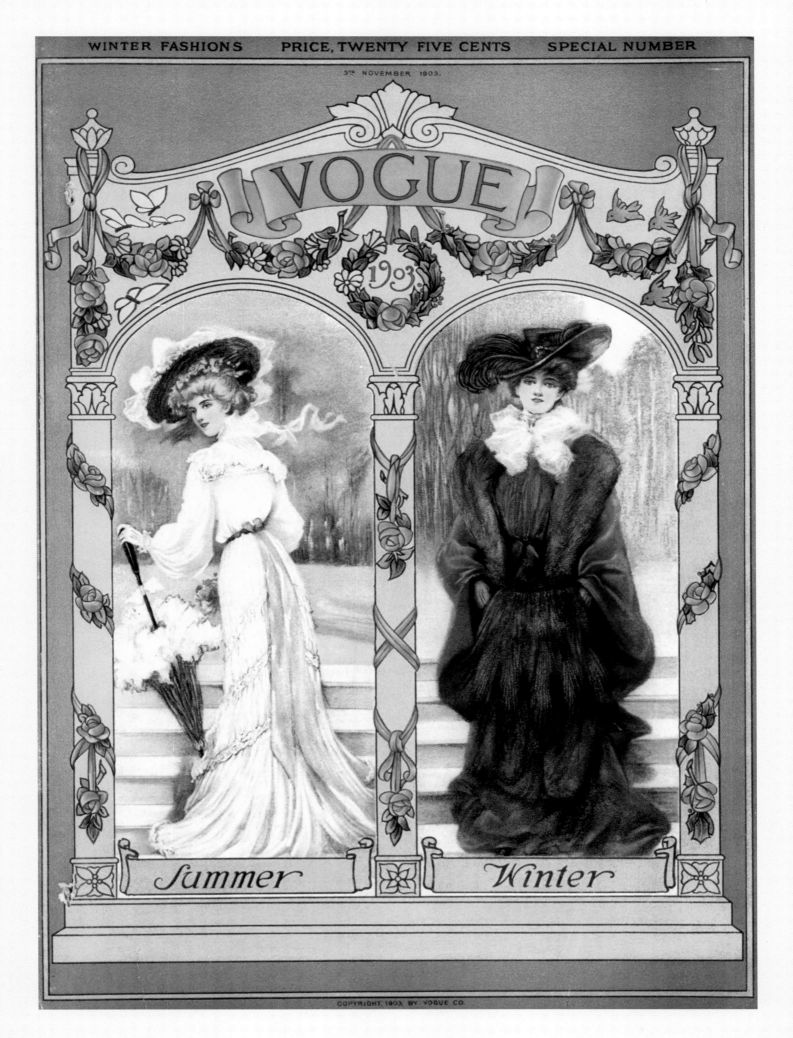

He addressed advertisers with an attention-grabbing offer: "I am the Advertising Manager of *Collier's*, but I don't expect you to give me any business. Most manufacturers don't believe in weeklies; and it has only taken three months' canvassing to prove to my perfect satisfaction that the few who do won't use *Collier's*. However, I accept this situation, I don't want to argue with you. I merely want your residential address: We want to send *Collier's* to you regularly. Certain things are going to happen; things that you have neither the time nor inclination to inquire into. . . ."

Condé was at *Collier's Weekly* for ten years. When he began in 1897, the magazine had a weekly circulation of 19,000 copies and publishing revenue of $5,600; a decade later circulation averaged 560,000 and advertising brought in more than a million dollars a year. In 1897 his starting salary was $12 a week; in 1907 Nast was earning $40,000 a year, quite a fortune for that era.

His achievements were not confined to the business side. Although he was always seen more as a publisher than as an editor, several initiatives can be attributed to Condé Nast. He was among the pioneers of color printing and of the two-page spread. Most important, Nast is considered the creator of the special issue. In 1904, at his instigation, *Collier's* published an extra edition dedicated to the work of the illustrator Charles Dana Gibson, whose famous Gibson Girl (for which

ETHEL WRIGHT 1903

ETHEL WRIGHT 1902

he used his wife as model) had appeared on the cover of numerous women's magazines, especially *Ladies' Home Journal*. The special issue featured twenty of the illustrator's drawings, one to a spread, and was a complete success.

While still working at *Collier's*—after 1905 as business manager—Nast found time to develop his own projects. In 1904 he became vice president of a firm that manufactured and distributed patterns for the home dressmaker. This Home Pattern Company turned into a great business. Because a woman with a sewing machine could make fashionable clothing at home, patterns were in steady demand. Home Pattern published its patterns in various catalogs for sewing supplies that were distributed for free in department stores and clothing retailers. Nast's business was to bring in as much advertising as he could to the publication. When he left *Collier's* in 1907, he dedicated himself full-time to this business, and in just one year he increased his firm's advertising revenue to an annual $400,000.

With his own capital reserves and his experience in publishing and circulation, plus the knowledge he had acquired of women and the world of fashion, Condé Montrose Nast decided in 1905 to take the plunge and buy a magazine. And he selected none other than *Vogue*.

Artist unknown 1902

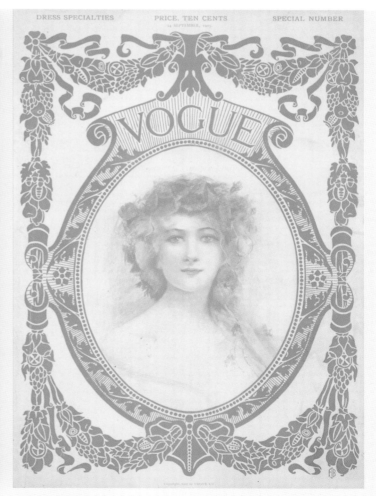

Artist unknown 1903

When Condé Nast took over *Vogue*, he had already established his place on New York's social ladder with his marriage to Clarisse Coudert on August 19, 1902, at St. Patrick's Cathedral. The bride, introduced to Nast by Robert Collier at a parade in New Jersey, belonged to one of the families of the exclusive Four Hundred—the group to whom *Vogue* dedicated such a large portion of its pages.

Nast's name first appeared on *Vogue*'s masthead in the issue of June 24, 1909. However, his presence wasn't felt until the first months of the following year when he made a number of drastic changes: the magazine started coming out every two weeks instead of weekly, the price rose from 10 to 15 cents while the subscription rate stayed at $4, more color was added to the covers, more pages were allocated to advertisements, and more articles featured society and fashion. In subject matter, it became a women's publication—a decided departure from its origins as a social gazette.

The page count, just thirty when *Vogue* was a weekly, rose in 1910 to an average of a hundred per issue. Several new departments provided special services to the female audience. One of the first manifestations of this service philosophy appeared in the June 1 issue, a department called "Sale and Exchange" in which readers could make transactions among themselves. "Wish to sell my black Russian lynx shawl collar, and

VOLUME XXXIII NO. 25 PRICE TEN CENTS WHOLE NUMBER 86?

VOGUE

MIDSUMMER NUMBER 24 JUNE 1909

Copyright. 1909. by The Vogue Company Reg. in the U. S. Patent Office

NAST'S ARRIVAL
The June 24, 1909, issue of *Vogue* was the first to include Condé Nast in the magazine's masthead as publisher.

large muff, for $25. Cost $55. Not worn, as black does not become me," said one. Another offered: "Pair very handsome Sheffield plated candelabra. Have just been replated by Tiffany. $75." This style of exchange—adopted from English women's publications that dedicated several pages to such items—was very well received by *Vogue* readers, who found both utility and entertainment in the section.

In Caroline Seebohm's *The Man Who Was Vogue*, one of the most complete investigations into the life and times of Condé Nast, a phrase is quoted that clearly describes the publisher's intentions for the magazine. "*Vogue*," proclaimed Condé Nast, "is the technical adviser—the consulting specialist—to the woman of fashion in the matter of her clothes and of her personal adornment." In addition to giving fashion guidance, Seebohm recounts, *Vogue* felt obligated to give its readers every last scrap of information about what other women with similar interests wore and did. For *Vogue* it was very important to report everything that happened in London, as the English were considered to be the most elegant and to have the best taste, especially if they had noble titles. The Paris fashion scene was of course covered exhaustively, with illustrations by French artists (who sent their work by the fastest ships) showing every detail of the designs, while the text gave advice and information on the various styles. The magazine also filled several pages with the clothing worn by the wealthy

women who frequented Newport and Southampton, Tuxedo Park and Palm Beach, Aiken and other American resorts.

Every issue was full of society news. For example, the first issue of August 1910 dedicated an article titled "Society by the Sea" to ladies who summered at the shore, with Newport, Bar Harbor, and Southampton the preferred locations; another piece revealed all the details of the Acheson-Carter wedding ("The second of this season's fashionable Anglo-American marriages"), and another addressed "Where Europe's Varied Society Seeks the Sea." A spring issue in 1911 devoted several pages to Helen Vivien Gould's wedding to John Graham Beresford, fifth baron Decies, noting that the bridal gown had a train five yards long and gushing, "Never in the history of nuptial events in New York have we had so many of the old British nobility represented at one fell swoop."

Unlike most other successful magazines of the time, *Vogue* did not publish any fiction. This was in line with Nast's plan to limit the magazine's circulation. He judged that fiction would indiscriminately attract a more mainstream audience, which wouldn't accord with his sales strategy. "By the beginning of 1911," says Seebohm, "the new Nast *Vogue* had taken shape, and this was the prototype—a richly embellished frieze of society, fashion, social conscience, and frivolity, picked out in gold by the confident and stylish hand of its new publisher."

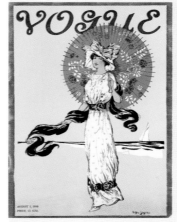

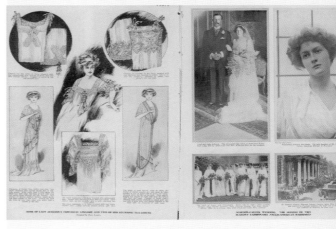

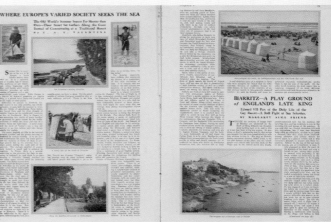

SOCIETY NEWS
Vogue also reported on society weddings, bride's wardrobes, and exclusive travel destinations. The covers and spreads shown above are from 1910 and 1911.

THE WOMEN'S MARKET

"By the end of the nineteenth century, several journals had emerged as leaders, titles that would go on to top circulation charts in the first half of the twentieth century. Known as 'The Big Six,' these magazines led in circulation, attracted large advertising dollars, and were treasured in the homes of thousands of loyal readers, causing journalist Charles Hansen Towne to term them 'old homes in a city of perpetual change,' referring both to the time of their founding and the intimate role they played in readers' lives. These journals, familiar to so many women, were *Delineator*, *McCall's*, *Ladies' Home Journal*, *Woman's Home Companion*, *Good Housekeeping*, and *Pictorial Review*."

Thus has Mary Ellen Zuckerman identified *Vogue*'s main competitors. *Harper's Bazar*, purchased by the Hearst group in 1913, would later join these leaders and become a tough competitor in the sector that Nast called "class publications." Here in 1910, the year that Nast was remaking *Vogue*, is a snapshot of the magazines that dominated the market:

Delineator was the first of the Big Six women's magazines. Established in 1873, it began as an advertising catalog featuring the dress patterns of Ebenezer Butterick. A few years later, in addition to patterns, the magazine began to include articles—on travel, floral arrangement, beauty, the home—and especially literary fiction. In 1910, at the price of 15 cents an issue, its circulation reached 750,000 copies monthly.

McCall's also debuted in 1873 as a catalog, distributing patterns by the Scottish tailor James McCall. Its patterns differed from the rest in providing no sewing measurements, which forced each woman to adapt the pattern to her own silhouette. Over the course of the years, *McCall's* evolved into a fashion, fiction, general interest, and home service magazine. During the twentieth century it became one of the largest-circulation women's magazines in the country. At its peak, for example, it sold an average of 4,650,000 copies a month.

Woman's Home Companion first appeared in 1874 as *The Home*, a title that changed several times (*Home Companion*, *Ladies' Home Companion*) until settling on the definitive name in 1896, the same year that the magazine became a monthly. Its editorial formula fundamentally emphasized sewing—it too published patterns—more articles on housekeeping, and recipes. Its circulation in 1910 hovered around 700,000 copies.

Good Housekeeping was launched in 1885 with the subtitle "A Family Journal Conducted in the Interest of the Higher Life of the Household." Its contents included fiction, poetry, responses to readers, and service articles offering advice on the home, cooking, decoration, sewing, and fashion. It was the only women's magazine in a small format. In 1910 it created a unique service, the Good Housekeeping Testing Institute, which put new home products to the test and then published the results. Widely regarded as authoritative, the Good Housekeeping Seal of Approval added luster to the products it endorsed, and to the magazine itself.

Ladies' Home Journal started as a supplement to *Tribune and Farmer* in 1883. Its name was born by chance. The founder, Cyrus Curtis, told the printer that the publication was a type of newspaper for women (a "ladies' journal"), and the printer added a small house in the middle of the title to indicate its contents and then the word "home." Its initial formula: speaking to readers in a woman-to-woman tone with such popular columns as "Talking With the Girls" and "From Heart to Heart," and running serialized stories by famous writers such as Mark Twain, Rudyard Kipling, and Mrs. Humphry Ward. In 1900 its circulation stood at 800,000, in 1903 it topped a million, in 1910 it was 1,305,000, and in 1919 sales reached two million copies. The *Journal* was a record-breaking magazine.

Pictorial Review, produced by the dress-pattern supplier Fashion Company, joined the magazine world in 1899. In addition to patterns, its pages also featured serials by authors including Edith Wharton and Joseph Conrad, theater and literature reviews, and articles on fashion, beauty, home decor, and entertainment. Every month it published on its cover an attractive illustration that could be framed. It was considered the magazine with the broadest appeal of all, and it had a large impact on middle-class women.

Harper's Bazar did not belong to the Big Six, but it competed fiercely with *Vogue*. It was created by Fletcher Harper in 1867 after a trip to Germany, where he became excited about Berlin's *Der Bazar*. Bearing the slogan "A Center for Fashion, Enjoyment and Instruction" and a $4 annual subscription price, *Harper's Bazar* offered patterns, stories by English authors in installments, and articles on domestic matters—embroidery, interior decoration, gardening. But its main attraction was fashion. It published styles from the Berlin *Bazar* that were adapted in New York to American tastes. In 1913 William Randolph Hearst purchased *Harper's Bazar* for his International Magazine Company, seeing it as a key piece in the publishing empire he had started to build.

"THE QUINTESSENCE OF VIOLETS"

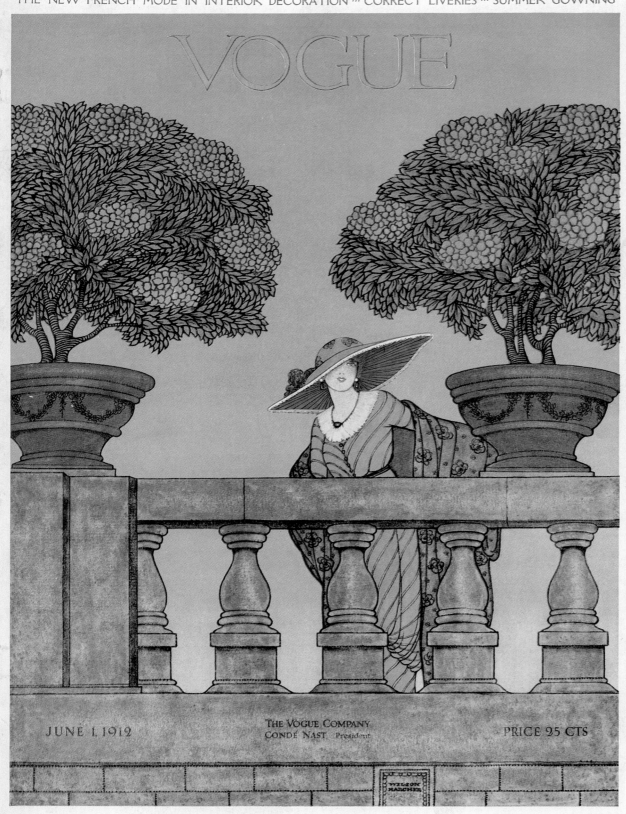

THE NEW FRENCH MODE IN INTERIOR DECORATION ··· CORRECT LIVERIES ··· SUMMER GOWNING

VOGUE

JUNE 1, 1912

THE VOGUE COMPANY
CONDÉ NAST President

PRICE 25 CTS

WILSON KARCHER 1912

Vogue was up against the Big Six magazines, which had circulations in the hundreds of thousands. It was 1910. Condé Nast's magazine had a circulation of only 30,000 copies a month–but it brought in much more revenue than any of the other publications. During the first six months of that year, *Vogue* had 44 percent more advertising pages than its closest competitor, *Ladies' Home Journal*, 78 percent more than *Woman's Home Companion*, and 138 percent more than *Delineator*. And this despite *Vogue*'s rates being the highest in the market. Advertisers who took a full page paid $10 for every thousand readers, an extremely steep price at a time when high-circulation magazines such as *McCall's* were charging $2 or $3 per thousand readers.

What was the formula? What did *Vogue* do to achieve so much advertising success with such a low circulation?

In June of 1913 Condé Nast wrote an article for *Merchants' and Manufacturers' Journal* of Baltimore, titled "Class Publications." Today that article is viewed not only as an analysis of the phenomenal success of *Vogue* but as the "bible" that established the concept of specialized publications, and as the springboard for the development of a large portion of the American publishing industry. Given its importance, let us quote some of the most significant paragraphs:

. . . [A] "class" publication is nothing more nor less than a publication that looks for its circulation *only* to those having in common a certain characteristic marked enough to group them into a class. That common characteristic may be almost anything: religion; a particular line of business; community of residence; common pursuit; or some common interest. When I say a class publication "looks" to one of these classes for its circulation, I state it very

mildly; as a matter of fact, the publisher, the editor, the advertising manager and the circulation man must conspire not only to get all their readers from the one particular class to which the magazine is dedicated, *but rigorously to exclude all others*.

Class publications don't happen by accident. Every publisher must make up his mind whether he shall edit a publication for the whole heterogeneous reading population, or deliberately aim to attract some special segment of it. To edit for a greater audience, however mixed, and do it in such a way as to retain everybody's interest is, of course, quite possible; but it can be done only by utilizing those things broad enough to appeal to human nature itself. All men *are* created equal certainly so far as the fundamental elements are concerned; for example, a rattling good story will interest anyone and everybody–the learned, the unschooled, the rich, the poor, the dilettante and the vulgarian. But right there is the crux of the whole "class" question so far as the advertiser is concerned. From the editorial contents of a great general publication, no matter how worthy, you cannot in the least judge the state of mind of its readers on any given subject. The manufacturer offering his goods to an audience gathered together by editorial contents of such broad human appeal has not the slightest means of knowing what proportion of them, if any, will be interested in the type and quality of article he is offering.

In a single crowded city block you might easily collect, say, an automobile dealer, a stamp collector, an expert fisherman, a kindergarten teacher, an art student, a chicken fancier, a baseball fan, a clergyman, a soubrette and suffragette. Suppose, then, you were asked as an experiment, to edit a publication that would appeal to this heterogeneous group! Your life would be one incessant hunt for stories, pictures, humor, verse, of the simplest, broadest and

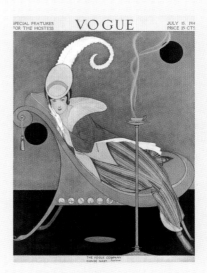

GEORGE PLANK 1914

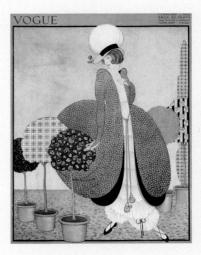

GEORGE PLANK 1914

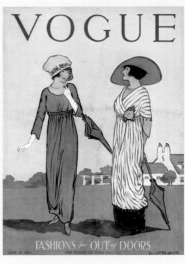

HELEN DRYDEN 1914

E. M. A. STEINMETZ 1916

GEORGE PLANK 1916

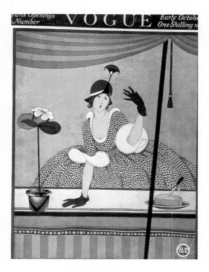

GEORGE PLANK 1916

most general appeal—and, even then, one or two of your ten readers would probably cancel because they were not *particularly* interested.

. . . Take the little group we mention; the stamp dealer has an excellent possibility of a client in the one stamp collector, but what chance has he with the soubrette, the fisherman, the art student? And every publisher, I say, has to face this dilemma; he must make up his mind to either go after stamp collectors, fisherman and all, or to select the stamp collector, the fisherman or the art student and go after this class alone. Even after his mind is made up, it still takes farsightedness and *the utmost fixity of purpose* to prevent any really good class publication from growing into a general magazine and thereby diluting its circulation enough to defeat its own ends.

Time and time again the question of putting fiction in *Vogue* has been brought up; those who advocated it urged with a good show of reason that the addition of stories and verse would make it easy to maintain a much larger circulation. That it would increase the *quantity* of our circulation we granted; but we were fearful of its effect on the *class* value. That those who became readers of *Vogue* because of its news of the so-called *smart* world would be equally interested in the fashions and in all the rest of *Vogue*'s contents, we were fairly certain; but that all those who might be attracted to *Vogue* through fiction would be seriously interested in the rest of its contents or in its advertisements, we had every reason to doubt. So, rather than risk it, *Vogue* still does without fiction. This is what I mean by the "fixity of purpose" necessary, if a magazine is to remain a pure class publication in the better sense. I hold that *a community of active interest in what the publica-*

tion presents editorially is the only safe criterion of class paper circulation.

In the Waldorf-Astoria stands a flower booth, so small that its keeper has scarcely room to move about. Yet, he pays $10,000 a year rent. Two blocks away, where fifty times as many people pass, he could hire a store five times as large at half the rent. Why is this tiny stand more valuable to him than the bigger store only two blocks away? Simply because the Waldorf itself introduces the florist to a select group of purchasers. Everybody there who looks at the flowers can afford to buy, and a large proportion do buy generously; while thousands of people who never think of buying an orchid are hurrying down the street two blocks away.

Just one more example and I am done: To extract the perfume from delicate and fugitive flowers, such as the jasmine and the violet, the French manufacturers use "cold enfleurage," wherein the flowers are placed upon the purest of cold lard applied on the surface of glass plates held in wooden frames. This perfumed lard is afterwards separated from the exhausted flowers by pressure and long filtration. In this expensive and painstaking way is obtained the real "quintessence."

A single pound of quintessence of violets sells for $1363; a pound of fresh violets is worth, perhaps, sixty-three cents. General circulation is like a pound of violet petals. Somewhere among these petals is what you seek, but along with it are the stems, the pistils, the fibre—for your purpose, waste. In class paper circulation, all these waste products have, at infinite labor and expense, been eliminated for you. There remains only the *quintessence* of what you seek.

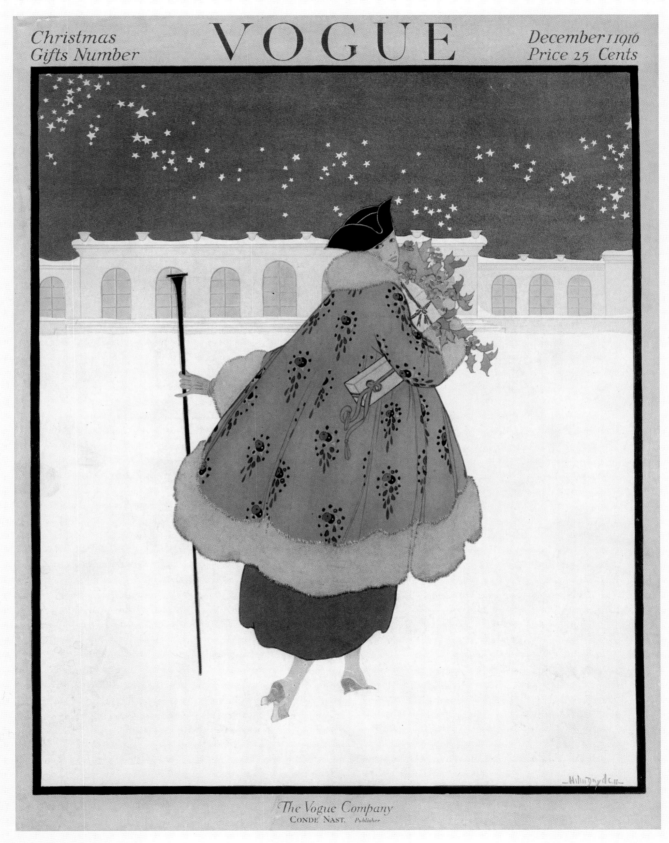

HELEN DRYDEN 1916

EDNA WOOLMAN CHASE

TOP EDITOR
Edna Woolman Chase was at the helm for thirty-seven years. During her tenure, the longest in the magazine's history, the fashion writing became very detailed and thorough. Chase was the third of the seven women who have run *Vogue* since 1892.

PATTERN ISSUE
In 1914 the magazine started to publish patterns regularly. From then on, the patterns were headlined on the cover as a hook to increase sales. The type used for the announcement was as large as the logo of the magazine, as seen on this cover by Helen Dryden.

The challenge of running the magazine always fell to women. And they were few. Josephine Redding (1892–1900) was the first, replaced by Marie Harrison (1901–14). Edna Woolman Chase held the position for the longest time (1914–51). She was succeeded by Jessica Daves (1952–62) and then Diana Vreeland (1963–71), followed by Grace Mirabella (1971–88) and Anna Wintour, the editor in chief who brought *Vogue* into the new millennium. In total, just seven women in more than a century.

The first to head the magazine in the Nast era, Marie Harrison, stayed with the new owner for five years. Harrison, the sister of founder Arthur Turnure's widow, had remained on the staff along with Edna Woolman Chase as part of the transfer contract. But after Mrs. Turnure filed a lawsuit against Condé Nast, claiming a larger percentage of the premium stock than she ended up with, the company let Harrison go, contending she had sided with her sister.

Now it was the turn of Edna Woolman Chase, who in 1895 at eighteen years of age had started in the magazine's circulation department. Chase assumed the editorship in February 1914 and guided *Vogue* until 1951. The years bracketed by the World Wars were for *Vogue* a time of splendor, growth, international expansion, the hiring of noteworthy staff members, and, most of all, a time when the editorial philosophy that would make the magazine world-famous planted its roots deep in the ground. Chase, who did not belong to the aristocracy or to the world of frivolity, took her job and the subject matter very seriously. She was an exceptionally organized person and very demanding of her employees, to the point of decreeing that every woman who worked for the

magazine must wear black silk stockings, white gloves, and a hat, and could not come to the office in open-toed shoes. She was also famous for her sermons and advice. "You have a very fine pen, my child, but we must do something about your clothes," she said once to a young writer who had just started. She believed that to work at *Vogue*, one must be and look *Vogue*. "We at *Vogue*," she said on another occasion to an editor who had tried to commit suicide by leaping onto the train tracks, "don't throw ourselves under subway trains, my dear. If we must, we take sleeping pills."

When it came to editorial work, Chase was equally exacting. As Caroline Seebohm relates, "The fashion writing had to be as thorough as possible—you described everything, including what the reader could not see. If a dress and jacket were shown, the dress sleeves and waist had to be explained; if only the front view of a dress was shown, then the buttons down the back had to be described."

Chase's pronouncements on fashion and its trends, Seebohm maintains, were rigorous and merciless. One editorial declared: "The cloche is preeminently a hat for the youthful face—a hat for the woman who can afford to have her hair hidden, her eyes played down, her mouth and chin and the structure of her head emphasized at the expense of everything else." On the French trend to shorter skirts, she wrote: "*Vogue*—surely as sophisticated, as modern, as shock proof as one can well be without sacrificing good taste—has come to a place where it actually holds up its hands in horror. And the place, to come directly to the point, is the knee of the woman today. . . . *Vogue* does not insist that skirts should be long, since long skirts are not the mode. But *Vogue* does

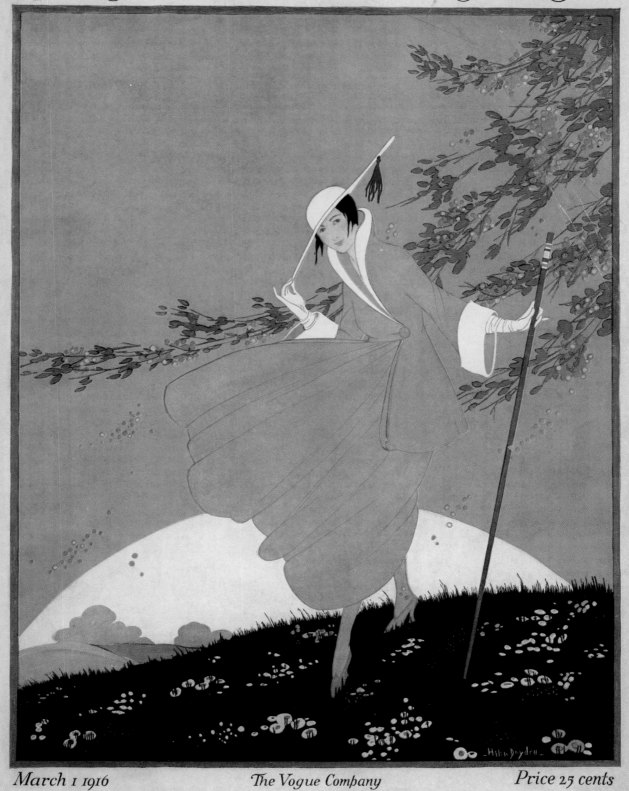

March 1 1916 The Vogue Company Price 25 cents

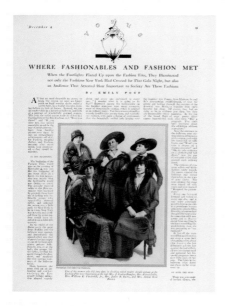

FASHION FETE

The issue of December 1, 1914, covered the collections organized by *Vogue*, devoting eleven pages to the fashions that were modeled at the Ritz-Carlton and three to the elegant attendees present at the charity event.

THE MODELS

Chase's charity fashion show (opposite) took place over three days, and the models were regular employees of the designers, who trained the girls to walk on the runway. The promotion of local designers was a great boost to American couture.

insist that, before buying a [new French] frock, one should look oneself squarely in the legs and temper the length of one's costume to the shape one sees."

In the first decade of the twentieth century, as now, two currents coexisted in the fashion world: mass-produced clothing and haute couture. The realm of haute couture was defined by a set of rules that had come to be widely accepted: The styles must be presented as a collection and exhibited at an exclusive gathering of potential buyers, the designers must be men, and their ateliers must be in Paris. In New York most of the shops dedicated to dressing ladies of society imported clothing, and designers such as the Frenchman Paul Poiret were equally famous on both sides of the ocean. In short, French haute couture was everywhere—and in America's fashion magazines its creations were featured almost exclusively.

Soon, however, world events threatened to leave the magazine without its core material. When World War I broke out, French couture went into a state of crisis, as many designers and dressmakers joined the army or the Red Cross, and their workshops started making bandages and uniforms. For the first time, the possibility that French couture might not continue to produce became very real. *Vogue* was on red alert, and its new editor in chief, facing an "editorial emergency," had to develop a strategy to protect the magazine from a French shutdown. Her idea: bring together the most prominent ladies of New York society and the best American designers and, under the magazine's aegis, hold a fashion show to benefit women and children afflicted by the war. *Vogue*, Chase thought, would introduce society to new designers and styles not commonly seen in its pages

and thus guard against a dearth of French material. Chase's plan went against the current: Never in the United States had there been such an event for charitable purposes, as fashion shows were generally understood to have a commercial end, to sell clothing. "You'll never get really smart women interested in this," Condé Nast told her. "They wouldn't dream of it; it has too much to do with trade." Still, he endorsed Chase's proposal as long as she could find prominent ladies to sponsor the event.

It was an arduous task to convince all the parties and to select designers whose style matched *Vogue*'s, but in the issue of November 1, 1914, the magazine announced the fashion event, which would take place over the course of three days at the Ritz-Carlton Hotel. The attendees would pay a $3 entrance fee for each day. The designers selected to show their work were Bendel, Gunther, Tappé, Maison Jacquelin, and Bergdorf Goodman. The modeling profession didn't yet exist in the United States, and thus girls were picked from the dressmakers' shops and trained in walking down the runway.

The event was featured in the December 1 issue, with eleven pages devoted to the models and another three to photographs of the attendees. The article, guest-written by Emily Post, declared, "It was an extraordinary achievement—all of it; for Fashion, meaning clothes, and Fashion, meaning the smart world, were represented, as they should be, together."

As it happened, French couture kept producing throughout the war and the dire shortage of copy never materialized. But Edna Woolman Chase had become the creator of the charity fashion show.

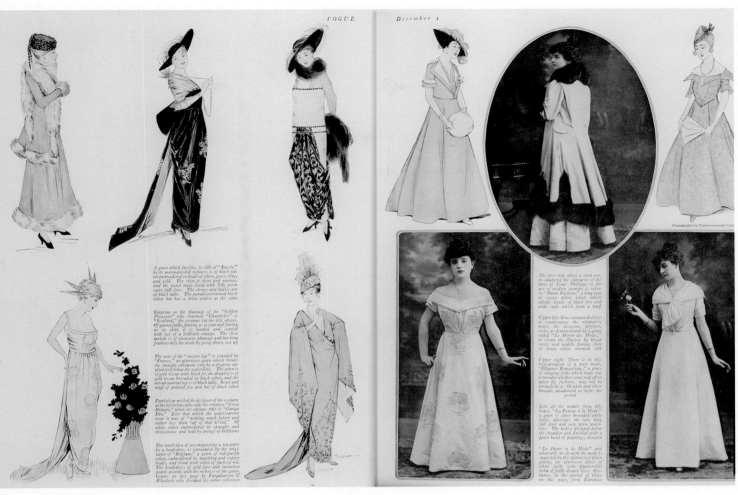

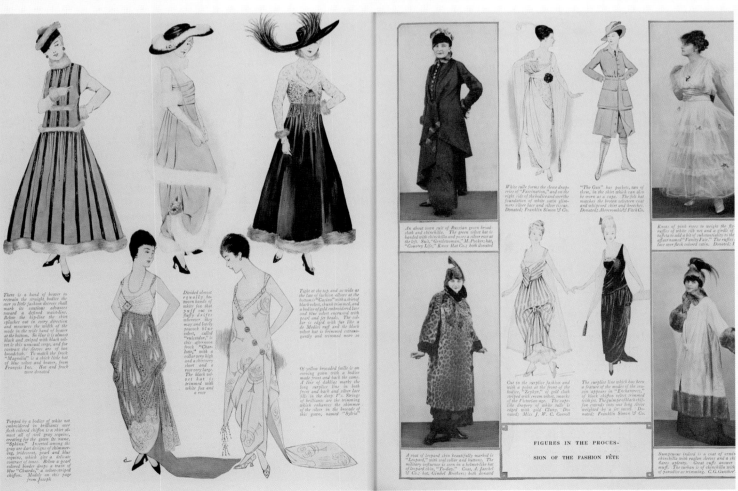

25

BRITISH PREMIERE ISSUE
The curtain rose on British *Vogue*, with a George Plank cover, on September 15, 1916. The war had accelerated publication of a separate overseas edition.

In the March 1911 issue, *Vogue* ran an announcement that marked the beginning of great years of growth and new annexations: Condé Nast had purchased shares in the magazine *House & Garden*, a title that the publishing company still owns. Nast acquired *House & Garden* in its entirety in 1915 and transformed it into one of the most recognized interior design and decor magazines. But the shopping spree did not end there. In 1913 the company added the fashion magazine *Dress* to the lineup and acquired the title *Vanity Fair*, which had graced a small social and political publication between 1880 and 1890. *Dress & Vanity Fair* made its debut that year, but by March of 1914 the title was trimmed to just *Vanity Fair* when the legendary Frank Crowninshield became its editor in chief.

For all the domestic expansion, one of Condé Nast's most important achievements of the decade was at the international level, when in September 1916 the British version of *Vogue* was launched. *Vogue* was the first magazine in the world to have a foreign edition produced and edited locally. Until then, no newspaper or magazine had a foreign presence beyond the export of a small part of its press run.

The "British operation" that culminated in publication of a British *Vogue*—nicknamed *Brogue* within the company—began in 1912 with the decision to distribute the American edition in London. Sales, slow at first, were improved by an advertising campaign to approximately 4,000 copies in 1914, and by 1916 topped 15,000. As the war went on, however, shipping became risky, and a choice had to be made: stop selling *Vogue* in England, or directly create a local edition. The challenge was accepted, and on September 15, for the price of a shilling, the first issue went on sale.

Brogue, with its ups and downs, was a success. Condé Nast's second international attempt, a Spanish-language edition published between 1918 and 1923, did not fare so well. The selection of Havana as the editorial headquarters turned out to be an error, as articles were translated into a Cuban Spanish with regional particularities that were understood by the islanders but by very few other Hispanics of the style, class, and quality that the magazine targeted.

The third attempt, the French version of *Vogue*—known internally as *Frogue* or *Frog*—hit the newsstands on June 15, 1920. This edition was planned practically from the beginning of the international expansion. For *Vogue*, a magazine that focused on style and fashion, that favored designers who were French or lived in Paris, and that employed several illustrators (see the next chapter) who had graduated

from the city's School of Fine Arts, a French edition was inevitable. Despite occasional financial setbacks, French *Vogue* allowed the company to establish a foothold in the country—Les Éditions Condé Nast would become famous as a publisher of high-quality titles—and to develop contacts with professionals who would be instrumental in the magazine's evolution through the creation of its own photography studios.

The last foreign venture during this period lasted little more than a year: German *Vogue* came out in April 1928 and disappeared before the end of 1929. It was spearheaded by Francis L. Wurzburg, a company vice president of German descent, who had Condé Nast's support despite Edna Woolman Chase's dissenting opinion. The editor in chief, who had questioned Nast's international ambitions more than once, adamantly opposed this new edition because, she argued, Germans lacked good taste and an edition in that language would surely fail. Wurzburg countered, "Even in Germany, Edna, some smart women *must* exist," but in the end Edna's prediction was borne out.

Still, with its successes, failures, and financial storms, the fact is that by 1930 two overseas editions were solidly established as a testimony to the international adventure that had started in 1916.

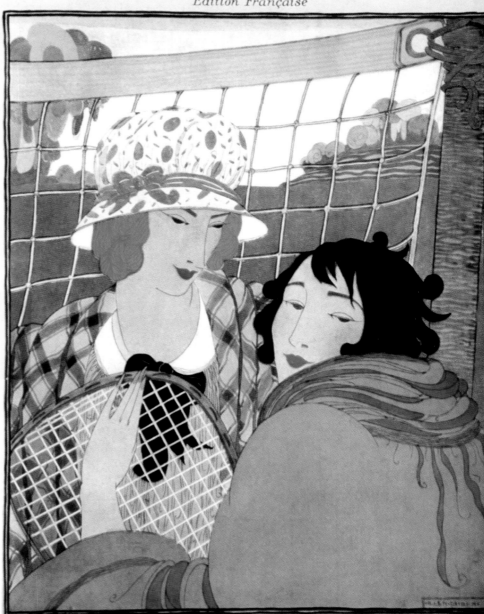

FRENCH PREMIERE ISSUE
French *Vogue* debuted on June 15, 1920, with a Helen Dryden cover featuring two rather mismatched badminton players.

THE ILLUSTRATED COVER

During the first era of *Vogue*, when it was still a gazette for members of society, the covers did not have a defined personality. Sometimes a quality photograph was used, or an art nouveau illustration or print, with a small headline—words such as "Invitation" or "Alone" or "Row in your boat." When Nast arrived, everything changed. Well aware of the cover's impact on newsstand sales, he planned to create a style that would give the magazine an identity, one that would differentiate it from *Harper's Bazar*, its top competitor in the fashion category.

In 1913 William Randolph Hearst bought *Harper's Bazar* (still without the double "a"; that came in 1929) and immediately challenged *Vogue*. In fact, when Hearst's revamped *Bazar* made its debut, it did so with the slogan "The first magazine published for women of the upper class; the others are published at them."

Scholars of the editorial world agree that the competition between the two magazines engendered a series of artistic innovations in page design, cover illustration, and the use of photography, and generally raised the level of graphic journalism. The competition developed on every level. By 1915 the two publications were vying to arrive first at a circulation of 100,000, and both were seeking the best French illustrators for their covers. *Bazar* hired the famous illustrator Erté (Romain de Tirtoff), who had also been courted by *Vogue*, and in 1916 *Harper's* was the first American magazine to feature a Chanel dress. *Vogue* fought its rival vigorously on all fronts. An editorial strategy was created that aimed at strengthening the identity and name recognition of the magazine. This strategy centered on its most important page, the cover, and developed in three directions:

First, *Vogue* sought to proclaim itself as the arbiter elegantiae. To position itself as emblematic of elegance, *Vogue* on numerous occasions used illustrations of peacocks on its covers. Nast began developing this element in 1909, shortly after taking the helm.

SYMBOL OF ELEGANCE
This illustration by St. John was published in 1909. By linking *Vogue* with the peacock, the magazine aimed to be regarded as the ideal of elegance.

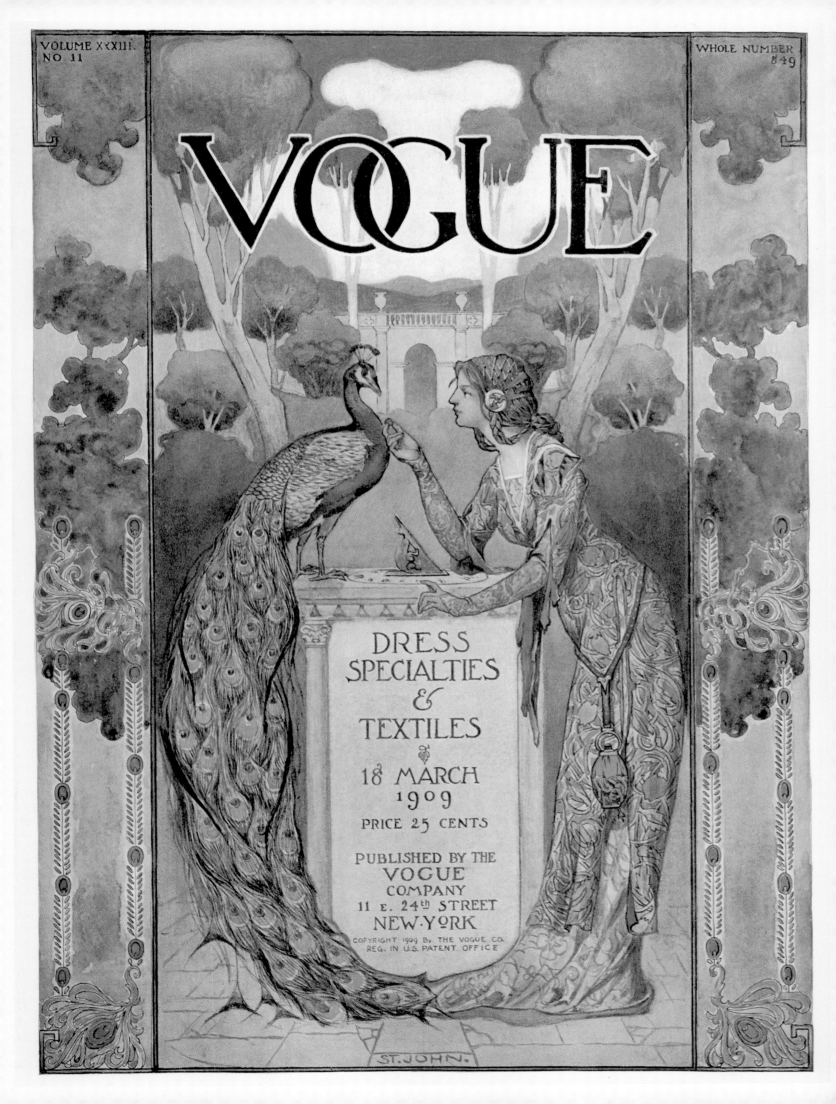

VOLUME XXXIII.
NO 11

WHOLE NUMBER
849

VOGUE

DRESS
SPECIALTIES
&
TEXTILES

18 MARCH
1909
PRICE 25 CENTS

PUBLISHED BY THE
VOGUE
COMPANY
11 E. 24th STREET
NEW·YORK

ST. JOHN.

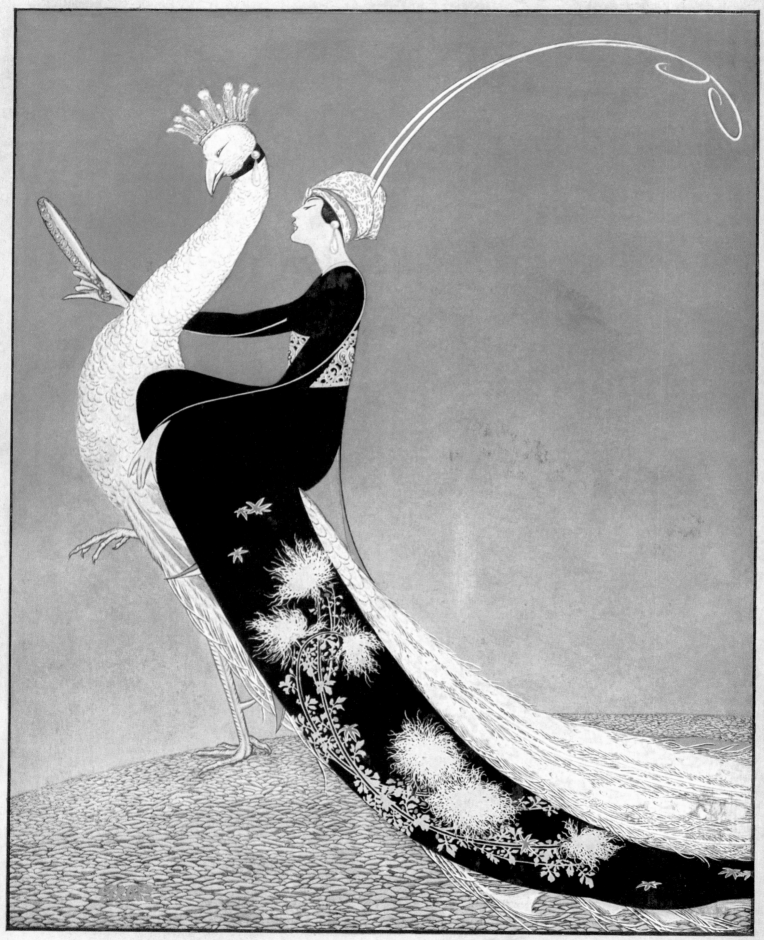

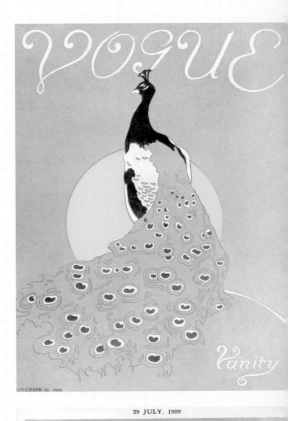

He believed strongly in the effectiveness of the peacock in linking *Vogue* with elegance—so strongly that a particularly fine peacock cover created by George Wolfe Plank in 1911, showing a girl in a fanciful gown sitting on the back of one of these birds, was used a second time, in 1918. No cover before or since was ever accorded this distinction.

Next, if *Vogue* was to be the undisputed leader in fashion journalism, Nast knew, the magazine's name had to be inextricably identified with the news it imparted. One method of promoting this identification was to repeat its "V" symbol constantly in its cover illustrations. Another was to depict the woman in the cover illustration not only wearing the latest designer creations but reading a copy of *Vogue*. The magazine thus sold itself as the very embodiment of fashion.

Third, *Vogue* needed to position itself as the locus of avant-garde art. Paris was the center of fashion and of everything related to fashion culture,

and *Vogue* covered it all. The great French designer Paul Poiret, who had become friends with Condé Nast, told Nast about the exceptional talent of the illustrators who graduated from the École Nationale des Beaux-Arts and who were part of new artistic movements, principally cubism and art deco. An enthusiastic Nast hired several of them—Georges Lepape and Eduardo García Benito were the most famous—and they had a decisive influence on *Vogue*'s most artistically venturesome period. The magazine's covers not only proclaimed *Vogue*'s status as the arbiter of elegance and the herald of the latest in fashion, but they transmitted the news through illustrations done in the latest artistic modes. The new movements in art coincided with the change in the woman's silhouette from a corseted body with enhanced curves to a looser and more natural figure. With its covers *Vogue* promoted each new artistic tendency that was—in Nast's words—"inherently good" and had "the intangible quality of chic that characterizes all the material in the magazine."

PEACOCKS
The two covers above, from 1909, are by unknown artists. The large one by George Plank (opposite) was published twice, in 1911 and 1918. The woman's costume projects elegance and fantasy, positioning the magazine as what we call today an aspirational product.

TRADEMARK COVERS

With the decision in 1910 to publish the magazine twice monthly, *Vogue*'s covers were given particular attention. Rather than being merely decorative, each cover was expected to deliver a statement on the latest in women's fashion. Nast meant to stamp his magazine's distinctive identity on the public mind, and the cover was his best instrument. Accordingly, he laid down strict criteria. *Vogue* covers had to be in color; use only drawings, not photographs; use a limited roster of artists, so readers would identify them with the magazine; bear the artists' signatures; systematically incorporate the word "Vogue" in the design; and transmit elegance, refinement, and social position. In October of 1909, for the first time, the issue's table of contents credited the illustrator: Gayle Porter Hoskins, who had drawn a woman dressed as a shepherdess standing on the symbol "V." The magazine commissioned artists of the stature of George Plank, creator of the twice-used peacock cover. In every aspect of the artwork, Nast sought covers that emphasized *Vogue*'s style and identity. Here are a representative handful.

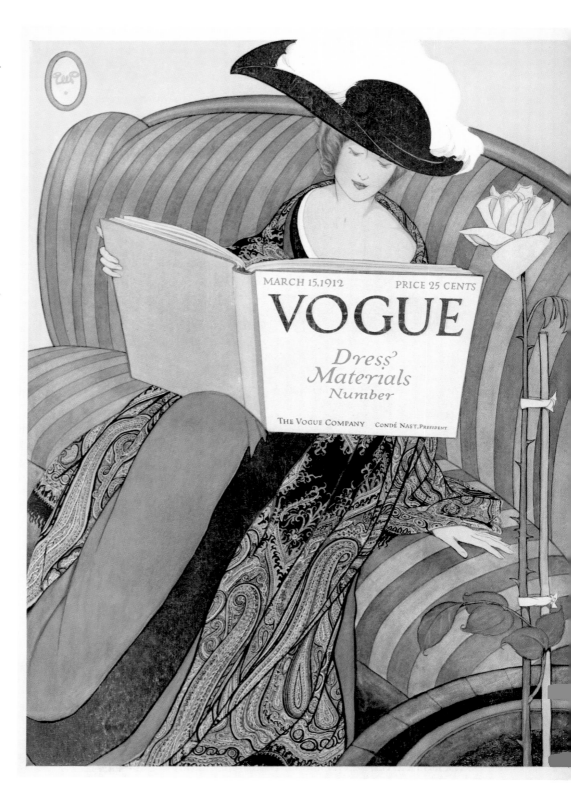

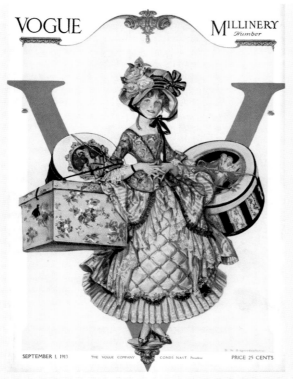

LOGO AND STATUS

George Plank created the cover for March 15, 1912, which shows an elegantly dressed woman reading *Vogue* (opposite). The purpose was to present the magazine as an exclusive and sophisticated vehicle of entertainment. At other times the "V" symbol was used as a frame for the model, so as to link the *Vogue* name with the fashions. This approach was used by several illustrators, including Frank Leyendecker (upper left and lower right), an artist who initialed his work "J. G." (upper right), and Gayle Porter Hoskins, with his shepherdess (lower left) evoking the style of a bygone day.

THE ILLUSTRATION ERA

The early twentieth century was called the Illustration Era of covers. It lasted until the mid-1930s, when it was succeeded by the Photography Era and subsequently by the Journalism Marketing Era.

According to experts on covers—among them Patricia Frantz Kery, author of one of the best books on the subject, *Great Magazine Covers of the World*—in the Illustration Era, magazines featured two types of artists. There were the "serious" painters, many of them famous. And there were the professional illustrators who specialized in drawing for magazines.

The serious artists included such luminaries as Henri Matisse, Pablo Picasso, Joan Miró, Marc Chagall, Fernand Léger, Salvador Dalí, Henri de Toulouse-Lautrec, Gustav Klimt, and Georgia O'Keeffe. It is generally believed that they accepted commissions for magazine cover illustrations for three reasons: because it was a just cause; because the magazine was sufficiently attractive and aesthetic; and/or because through covers they could build a following for themselves and for the artistic movement to which they belonged. In fact, Dalí did use

covers to spread surrealism; Picasso, Léger, and Braque did the same for cubism, and Gustav Klimt for Vienna Secession. From a publisher's point of view, of course, having such pieces on the cover guaranteed sales, because many people bought the issues as collectors' items.

The professional illustrators were likewise well known: Théophile Alexandre Steinlen, Alphonse Mucha, Charles Dana Gibson, Howard Chandler Christy, James Montgomery Flagg, N. C. Wyeth, Norman Rockwell, J. C. Leyendecker, and other standouts. Some of these illustrators were so closely identified with the publications that ran their work that, in the public perception, their names were virtually incorporated into the magazine's title. For example, *Good Housekeeping* was said to be Coles Phillips's magazine, *Vanity Fair* was Miguel Covarrubias's, and the *Saturday Evening Post* was the preserve of Norman Rockwell.

Rockwell, called the Child Illustrator, was a special case. He began drawing magazine covers at about age fifteen and worked at the old *Life* (the literary version that was later sold to Henry

Luce), at the *Literary Digest*, *Ladies' Home Journal*, and *Country Gentleman* before starting at the *Post*. He was there for forty-seven years and drew 324 covers. "He was the king of illustration," says Milton Glazer, one of today's leading American magazine designers. "He didn't create drawings, he told stories. Rockwell appealed to basic human emotions with a simple look." He retired in 1963 and is recognized as one of the most popular artists of the twentieth century.

Regardless of whom the illustrator was, the artwork always took up the entire cover. It stood alone and generally ran without headlines and sometimes even without the date. People read the magazines and bought them because the cover expressed a mood, or illustrated a special event or season. The Illustration Era was what some experts later called the Golden Age of Magazine Covers. "The American magazine cover was a museum of the street," said Steven Heller and Louise Fili in the introduction to their 1996 book *Cover Story: The Art of American Magazine Covers 1900–1950*. "They looked like outdoor galleries."

ILLUSTRATED ART
Christy, Flagg, and Phillips were among the most celebrated cover artists for magazines. The famous Uncle Sam image by James Montgomery Flagg, actually a self-portrait, was printed on more than four million posters during World War I.

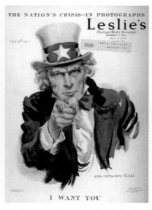

HOWARD CHANDLER CHRISTY 1923

JAMES MONTGOMERY FLAGG 1917

COLES PHILLIPS 1910

NORMAN ROCKWELL 1962

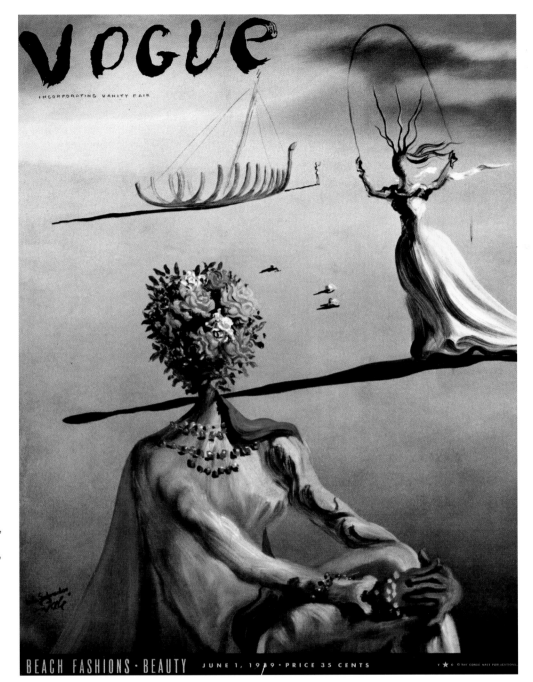

FINE ART ON THE COVERS

During what is known as the Illustration Era of covers, from the late nineteenth century to the mid-twentieth, many fine artists painted magazine covers such as the one above by Dalí. Although this was considered a lower form of art for "serious" artists, it was a reliable source of income and a good way to make themselves known.

HENRI DE TOULOUSE-LAUTREC 1895

GUSTAV KLIMT 1900

ALPHONSE MUCHA 1909

GEORGE BRANDT 1921

NARRATIVE COVERS

Up to 1915, a period dominated in its entirety by American artists, *Vogue* cover illustrations depicted the dernier cri in glamorous gowns, stylish skirts and shirtwaists, and chic hats. In this first period, information prevailed over art. Starting in 1916 and influenced by professionals from Paris's École Nationale des Beaux-Arts, fashion ceded primacy to art. Contemporary art on the cover showed readers that the publication was au courant with trends in every category, be it art or style. Beginning in the early 1930s, the illustrations offered more specific reporting on fashion, as service reclaimed its position of importance on magazine covers.

Among the most prominent American illustrators of the first period were George Plank, Helen Dryden, E. M. A. Steinmetz, Frank X. Leyendecker, Irma Campbell, Stuart Davis, F. Earl Christy, H. Heyer, and Vivian Valdaire. These were—just as Nast intended—the exclusive group that gave character and personality to the most important element of each issue. They accomplished this in the classic style of British illustration, gracing *Vogue*'s covers with drawings and paintings that were characteristically decorative. The women they immortalized were soft, elegant, and refined, with mysterious eyes and alluring smiles. But the attractive staging of the illustrations accomplished one exclusive function: to report on fashion.

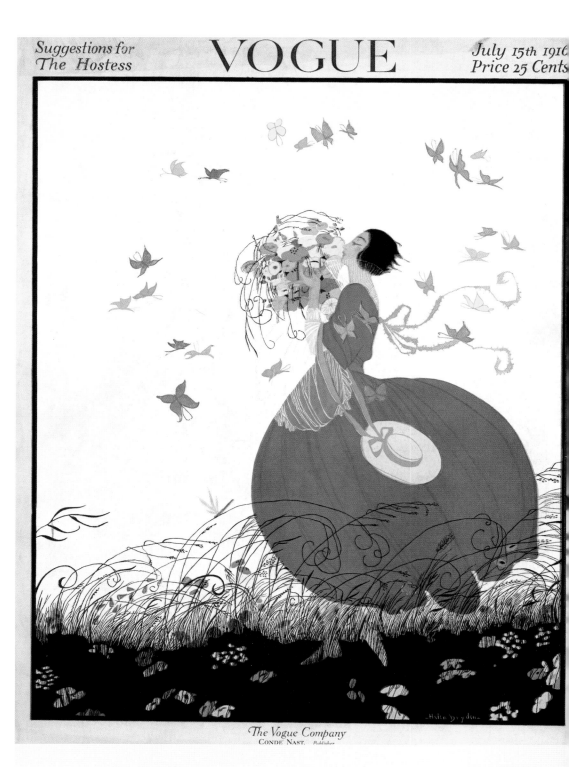

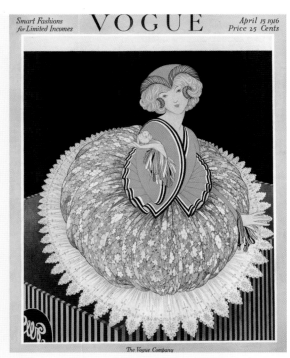

Smart Fashions *for Limited Incomes* VOGUE April 15 1916 Price 25 Cents

The Vogue Company

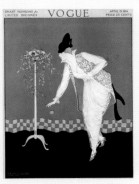

FIRST PERIOD

By 1911 illustrated covers had firmly taken hold, and a number of artists began to stand out, such as Helen Dryden, who in a 1916 cover (left) represented summer fashion in her distinctive style; George Plank, who dressed a woman as an Easter egg (top); Frank Leyendecker (above, right); and E. M. A. Steinmetz (above, left).

And so *Vogue* became a witness to new trends. Although its covers did not have headlines, the illustrations conveyed the news, which might be anything that was happening in style and culture. If there were women in hats on the cover, it was to announce new styles in millinery. If the drawing showed women with deep décolletage or markedly shorter skirts, it was because these necklines or hemlines were being seen in Europe. And if a woman on the cover was peering through a shop window, it meant that the issue was about shopping and the latest fabrics and accessories. *Vogue* sold itself as a useful publication that was up-to-the-minute on everything and indispensable for the woman who wanted to be in style. And it did so from the start, from its cover.

Of the illustrators mentioned, two stood out, both for the quality of their work and for the closeness of their association with *Vogue*. These were George Plank, who remained with *Vogue* the longest (1911–27), and Helen Dryden (1912–23). The others— Campbell, Leyendecker, Steinmetz, and the rest—produced stylish and decorative works that were very beautiful and formal, but they were published only sporadically and did not have the same distinction or influence. Plank and Dryden truly left their mark.

The two were quite different in approach. Helen Dryden was essentially representational. While Plank too drew romantic images of charming women, a Dryden cover offered the reader concrete clues to what was new on the fashion scene. Plank, in contrast, gave full rein to his artistic sensibility, creating covers that transmitted fashion's ideals and dreams and nostalgia more than the actual styles. His girls were wrapped in ruffles and bows and extravagantly full skirts, clad in the most sophisticated and eccentric articles of clothing, posing in their private world of exotic riches or on a shooting star streaking past the Milky Way. Plank's work personified the fashion fantasy. More than showing what to wear, his stylized figures suggested where, when, and how to wear it. During 1912 Plank created six covers, more than any other illustrator, and he was one of the first to put on the cover of *Vogue* the looser dresses that freed the constricted female silhouette.

Both, with their individual styles and techniques, gave the magazine the personality that Condé Nast and Edna Woolman Chase wanted. That was the first stage. Starting in 1916 with the debut of the British edition, the magazine would get a new face.

DRYDEN AND PLANK: AMERICAN STYLE

Helen Dryden was at *Vogue* until 1923, and George Plank stayed on until 1927. These two were the American illustrators most noted for the work they presented on the cover of the magazine. In 1919, for example, of the year's two dozen covers, Plank and Dryden along with the French illustrator Lepape—whom we shall soon meet—created all but three. During the 1920s and 1930s, Plank drew thirty-three covers, while Dryden did twenty-four. Their particular styles—Dryden's more naturalistic, Plank's more dreamlike and fanciful—represent an entire period of *Vogue*. Here are some representative images of their art.

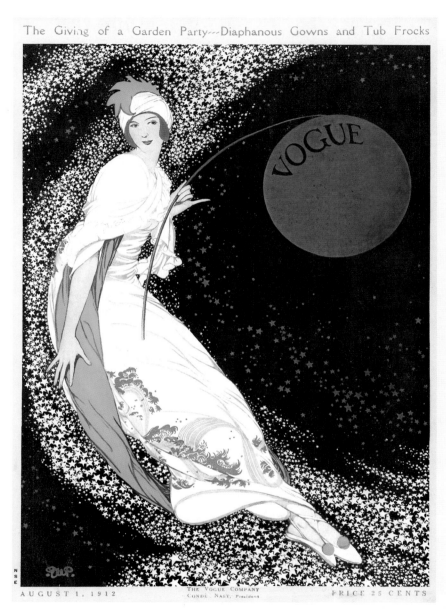

DREAMS AND FANTASIES
Plank almost always illustrated haute couture as fantasy. He used the Milky Way as the background for a striking cover in 1912 (top), and a starry sky again in 1921 (bottom center). Other Plank covers from 1920 present figures in opulent interiors wearing exotic clothing and hairstyles. His illustrations reflected an endlessly alluring world of luxury.

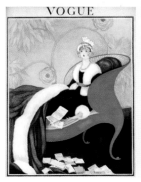
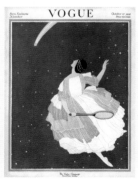
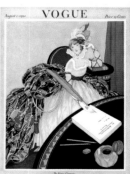

All of Helen Dryden's illustrations are highly decorative and cheerful. A recurring theme in her work is the well-read woman of fashion, who is seen reading in her garden, or under the trees, or in an elegant seasonal setting. The fashion news is always present, as in the large picture, which features a chic hairstyle with straight bangs and neck-length curls.

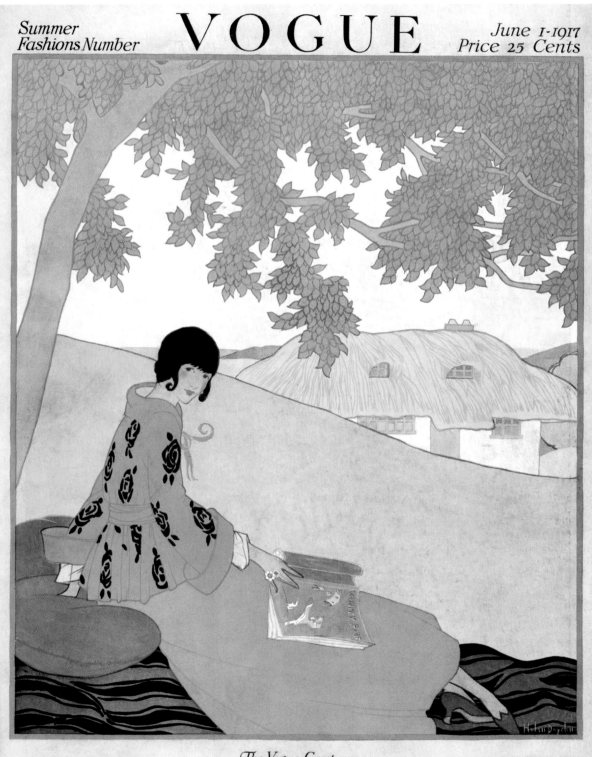

Summer Fashions Number — VOGUE — June 1·1917 Price 25 Cents

The Vogue Company
CONDÉ NAST, *Publisher*

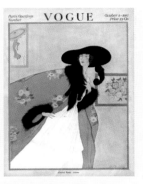

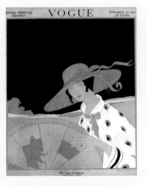

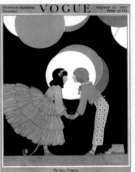

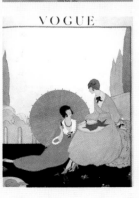

FASHION NEWS

In these illustrations, the reportorial direction that *Vogue*'s covers took during the early 1910s is readily discernible. The artists were able to convey through images alone, without headlines, the latest intelligence from the fashion front. In some cases this specialized subject matter—the news of higher hemlines and lower necklines, of the types of hats to be worn on various occasions, and of the treasures to be found in various shops—intersected with the broader concerns of current events, most notably the Great War.

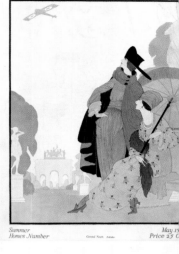

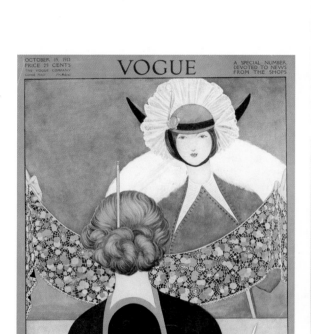

WARTIME
War-related illustrations were done by Helen Dryden and Alice Little. In one 1918 cover (top) Dryden portrayed two Parisiennes watching a warplane overhead, with the Arc de Triomphe in the background. Both Dryden and Little offered scenes of ladies waving from their windows (above and opposite, respectively) as unseen Allied troops parade below.

SHOPPING
Two covers by George Plank illustrated special editions devoted to shopping. One of them depicts an enthralled window-shopper (above), the other a saleswoman about to trim a print length of fabric for a customer (top).

VOGUE

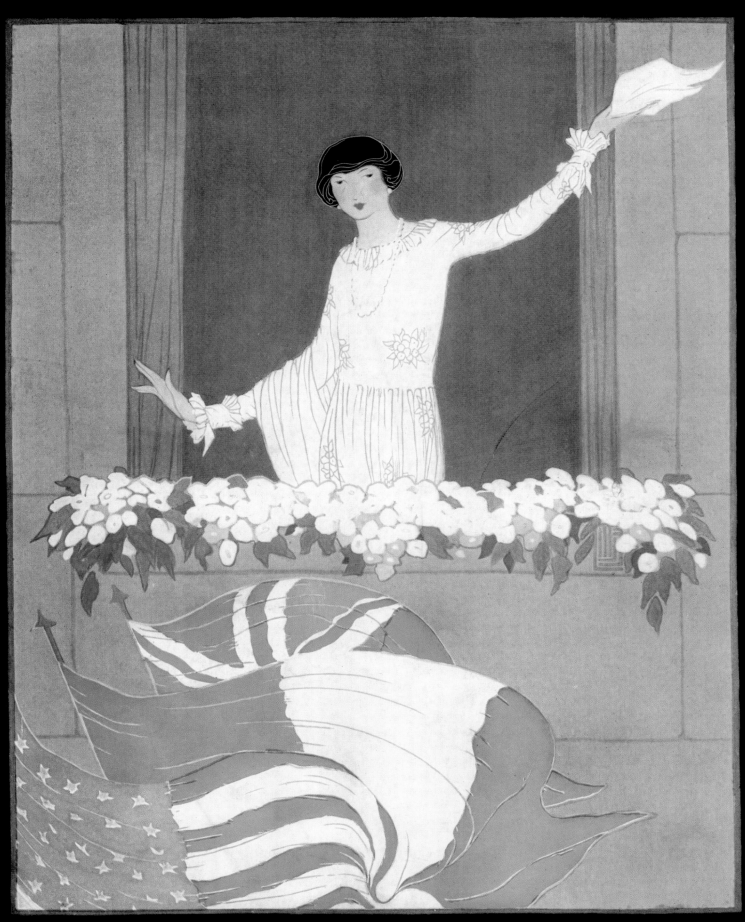

In the Country
Number

CONDÉ NAST Publisher

June 15 1918

Price 25 cts

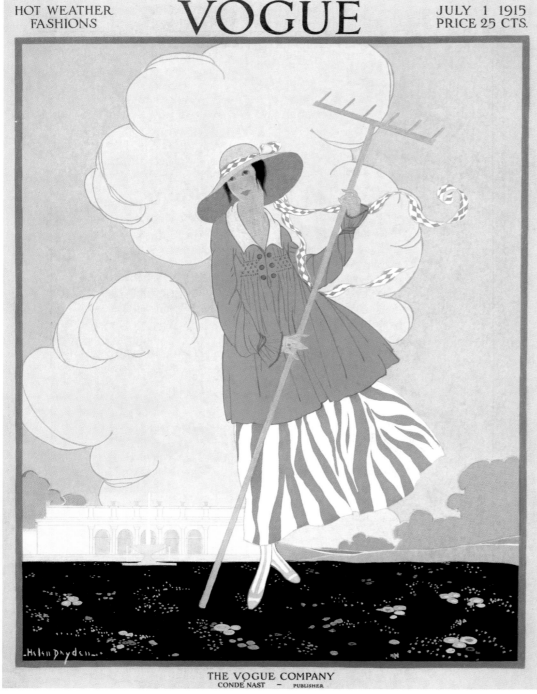

HOT WEATHER FASHIONS

VOGUE

JULY 1 1915 PRICE 25 CTS.

THE VOGUE COMPANY
CONDE NAST — PUBLISHER

SKIRTS

Four fashion covers exemplify the informational approach of the magazine. While all four point to the advent of shorter skirts, *Vogue* uses the illustrations to advise readers to wear them only for informal activities. The covers were the work of four different artists: Helen Dryden (left), Pierre Brissaud (bottom, middle), Rita Senger (bottom, left), and E. M. A. Steinmetz (bottom, right).

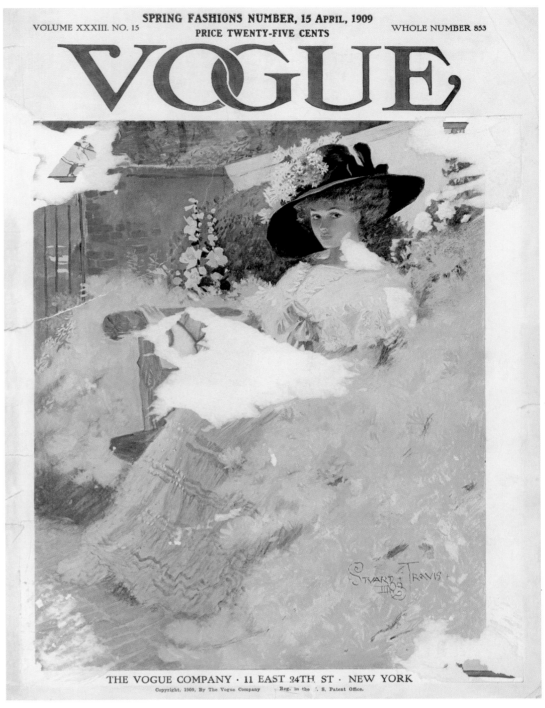

VOLUME XXXIII. NO. 15 SPRING FASHIONS NUMBER, 15 APRIL, 1909 WHOLE NUMBER 853
PRICE TWENTY-FIVE CENTS

VOGUE

THE VOGUE COMPANY · 11 EAST 24TH ST · NEW YORK

Copyright, 1909, By The Vogue Company · Reg. in the U. S. Patent Office.

HATS

In these three covers devoted to hats, the magazine implicitly tells readers, through the use of background and landscape, what style of hat should be worn on various occasions. The large cover at top, illustrated by Stuart Travis, is an informal picnic hat. The one at lower left, drawn by Vivian Valdaire, is for riding, while the one on the right-hand cover, by H. Heyer, looks perfect for tea at the Ritz.

THE FRENCH CHANGE EVERYTHING, EVEN THE SILHOUETTE

While the elegance and style of French clothing had long been recognized, the French officially launched the international scene of haute couture in 1900, at the Universal Exposition of Paris. There, in the Pavillon de l'Élégance, two of the most important designers, Jacques Doucet and Charles Frederick Worth, captured the public fancy with their striking and splendid dresses. Worth, who was considered one of the fathers of French haute couture although he was, improbably, British, held two distinctions: He was the first dressmaker to sign his clothing as if it were a work of art, and he was the first to organize a presentation of his annual collection with live models—what is today the classic runway show—to propel sales.

From that time on, the dominion of the French in the fashion world was indisputable. Their innovations were accepted as mandates. One of the designers who had the most influence on haute couture in the first decades—and therefore also on the illustrations of such publications as *Vogue*—was Paul Poiret, a disciple of Doucet. It was Poiret who dared to challenge the tradition dating back nearly a century that dictated the constriction of women's waists, definitively ending

the rigid corseting that young women had tolerated for decades. His creations decisively influenced the feminine silhouette—and they made the woman herself more sensual and free. Poiret not only designed dresses, he also promoted them through catalogs in which cutting-edge illustrators, heretofore unknown, showed his clothing being worn by figures in motion. The implication was that his creations released his clients from the rigidity of the old corsets into a new life of freedom.

The world of haute couture was thrilled by the magnificence of Diaghilev's Ballets Russes, which visited Paris in 1909. Their colorful costumes, their freedom of movement, and the exoticism of the dancers' wardrobes clearly influenced the new shorter skirt styles, exposed shoulders and arms, and the V neckline. The ballerinas, chorus girls, actresses, and other women of the entertainment world—Isadora Duncan is the best example—became unavoidable points of reference for fashion designers.

This burgeoning freedom in haute couture, and in society in general, had its counterpart in the art of illustration, as new artists appeared with new techniques and a fresh view of

LEPAPE
On Lepape's first *Vogue* cover, in October 1916 (opposite), the flared coat shows the influence of the Ballets Russes on fashion at the time. The three covers above reveal another facet of Lepape's artistic style.

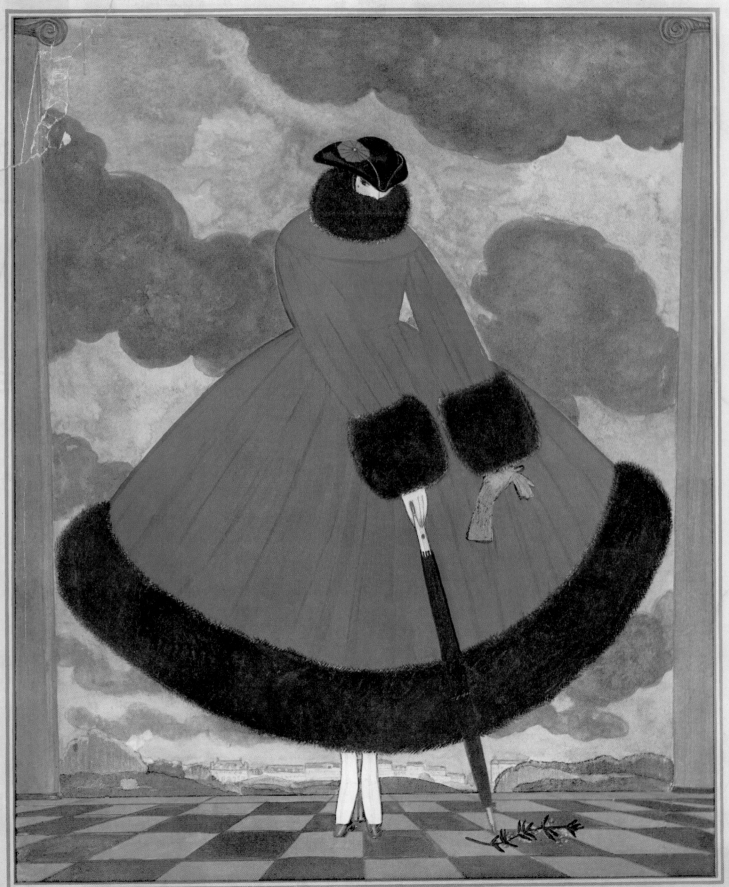

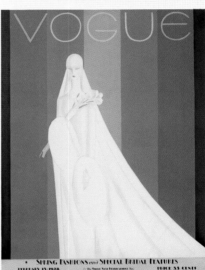

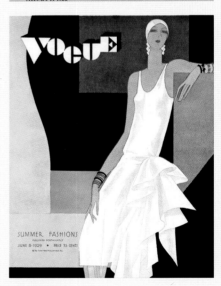

fashion. These artists were heavily influenced by expressionism, fauvism, and cubism, movements led by figures of the stature of Kandinsky, Matisse, and Picasso. The first novice illustrator who worked for Poiret was Paul Iribe, who through a painstaking technique highlighted the dressed figures in a modern and simple way. Iribe was the creator of the catalog *Les Robes de Paul Poiret*. In 1911 Poiret commissioned another graduate of the École Nationale des Beaux-Arts, Georges Lepape, to produce his second fashion album, *Les Choses de Paul Poiret*. Lepape's illustrations—models in loose-fitting dresses and turbans, placed in theatrical poses against impressionistic backgrounds—shook the editorial world of high-end magazines. Lucien Vogel brought Lepape to work for *La Gazette du Bon Ton* and later introduced him to Condé Nast. Nast, having already lost Erté to Hearst, didn't hesitate a moment in hiring him. On July 15, 1916, *Vogue* ran an article introducing Lepape to its readers, and three months later he made his debut with a stunning cover. Against a turbulent sky, a woman stands on a checkerboard floor in a full-skirted red winter coat with dark fur at the cuffs, collar, and hem. This was the first manifesta-

tion of the direct French influence on *Vogue*'s cover art, a style that the magazine would retain throughout the 1920s.

Lepape was joined five years later by the Spaniard Eduardo García Benito, another product of the École Nationale des Beaux-Arts and a faithful exponent of cubism on the covers of *Vogue*. Benito published his first work in November of 1921: an elegant couple, standing tall and stylized like all his figures, dressed in ultra-formal evening dress. Between them, Benito and Lepape dominated the covers of *Vogue* beginning in 1916, and not only in the American edition but in the English and French versions as well, because it was common for the same illustration to be used for multiple editions. Lepape painted 114 covers for the magazine, surpassed only by Benito with 144 plus a redesign that Nast assigned him in 1928.

Their success faded in the early 1930s when sales began to drop and the magazine saw a need for covers that were more service-oriented and less artistic. But the names of Lepape and Benito were already permanently identified with one of the most artistically dazzling periods of *Vogue*.

BENITO
Benito's debut in *Vogue* took place in November 1921 with the image (opposite) of an aristocratic couple dressed for a formal evening affair. It was the perfect example of modern art on *Vogue* covers.

VOGUE

Smart Fashions
for Limited Incomes

November 15·1921
Price Thirty five Cents

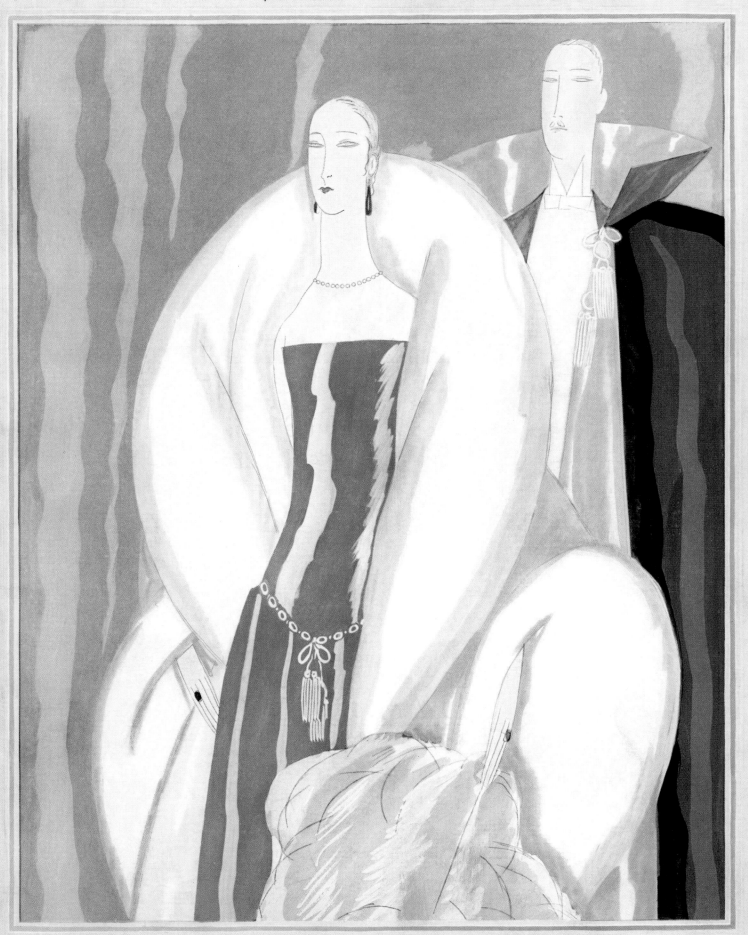

The Vogue Company
CONDÉ NAST *Publisher*

LEPAPE AND FRENCH STYLE

Between 1916 and 1939 Georges Lepape created a total of 114 covers for *Vogue*. He was the preeminent illustrator of the 1920s at *Vogue*, publishing seventy cover illustrations during the decade. His work was marked by a consistently high artistic level and constant innovation in the use of graphic resources and cutting-edge techniques. One of the most inventive illustrators, Lepape was the first to experiment with close-ups of faces on the cover, women of exaggerated elegance, short silhouettes or rounded ones, figures in motion protecting themselves from the rain or wind, and others more stylized, alone or with children. Whether luxurious or simple, his work always stood out.

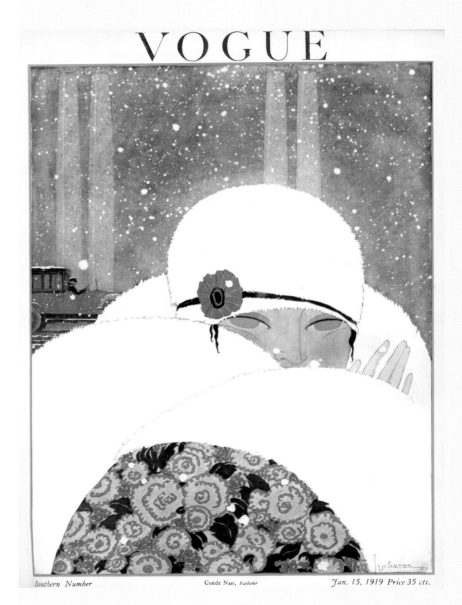

Southern Number Condé Nast, *Publisher* *Jan. 15, 1919 Price 35 cts.*

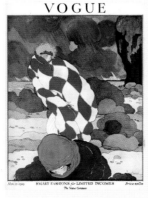

THE IDEAL WOMAN
Lepape's ideal feminine silhouette was tall and lithe. Here, in the large picture opposite, we see how he worked the *Vogue* name into the illustration with a piece of clothing currently in fashion, in this case a scarf blown by the wind.

Paris Openings

APRIL FIRST · 1928

© The Condé Nast Publications Inc.

PRICE · 35 CENTS

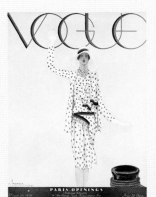

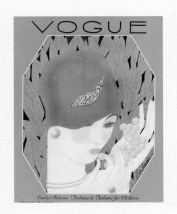

BENITO AND ART DECO

Although the Spaniard Eduardo García Benito debuted in *Vogue* in 1921 and had a pronounced influence all during the twenties, his domination of the magazine's cover did not begin until 1926. Before then he had created only seven significant covers, but he produced double that number within the year. His style, which blended soft lines with geometric shapes in an arresting way, marked an entire phase of *Vogue*, and with 144 works Benito was the illustrator who contributed the most covers in the history of the magazine. His elongated figures and modernistic heads and faces combined with architectural forms are today paradigmatic of *Vogue*'s Illustration Era.

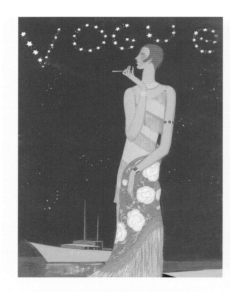

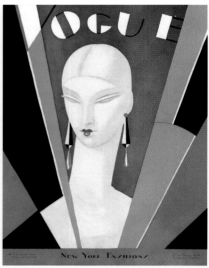

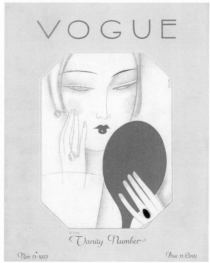

BENITO'S FIRST ERA
All of these covers, with their attenuated figures, are typical of Benito's first era. In the example just above, we can appreciate the facial features—thin and elongated cheeks and eyes, lips like rosebuds—which will appear many times in the 1920s.

GEOMETRICAL BENITO
In 1926 Benito entered a new phase, using geometric lines that, according to him, came from the machinery that influenced modern architecture. And he found in *Vogue*'s "V" a perfect foil, drawing it as a rainbow (opposite).

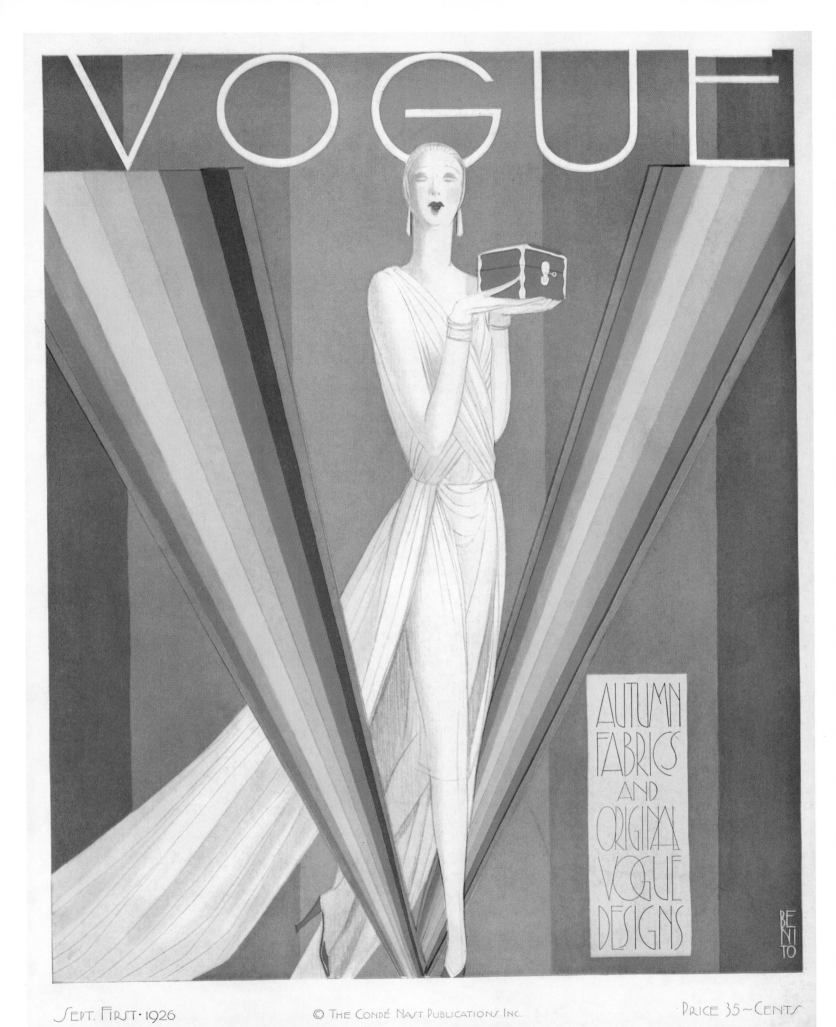

VOGUE

AUTUMN FABRICS AND ORIGINAL VOGUE DESIGNS

BENITO

SEPT. FIRST · 1926 © THE CONDÉ NAST PUBLICATIONS INC. PRICE 35 ~ CENTS

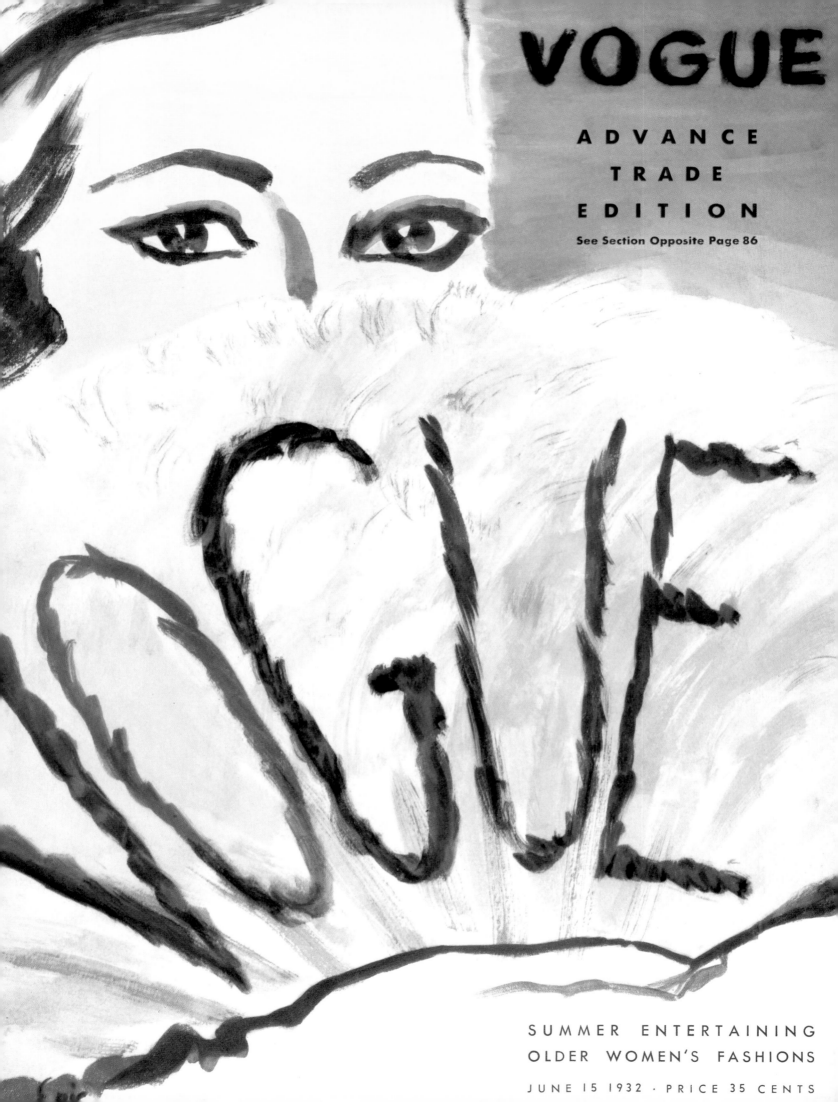

VOGUE

ADVANCE TRADE EDITION

See Section Opposite Page 86

SUMMER ENTERTAINING
OLDER WOMEN'S FASHIONS
JUNE 15 1932 · PRICE 35 CENTS

The domination of *Vogue* covers by Parisian artists started to decline in the early 1930s. Although the artistic value of their work was acknowledged, not everyone at the magazine agreed with the message that their figures transmitted about fashion and its reporting. One of the main critics was the editor Edna Woolman Chase herself, who complained that illustrations by Benito and Lepape never showed where a seam or zipper or pleat was. Such illustrations, she argued, were nothing more than the surrealistic cerebrations of the artists, which served only them and not the readers. "I have never been able to get up much sympathy for fashion artists," she explained, "who shrink from clearly depicting the clothes they are sent to draw. If the great masters of old didn't think it

beneath them faithfully to render the silks and velvets, the ruffs and buttons and plumes of their sitters, I don't see why it should be so irksome to modern-day fashion artists to let a subscriber see what the dress she may be interested in buying is really like."

Nast, like Chase, always demanded that *Vogue* be painstaking and precise in its fashion coverage. But Nast, the main proponent of the Parisian school on the covers, maintained that art and fashion could coexist perfectly in a magazine—especially if the cover art that beckoned the reader from the newsstand expressed "the intangible quality of chic" found in the articles inside the magazine. However the internal debate may have played out, it is certain that beginning in 1930 the magazine's covers became

less rarefied. The overly elongated figures in exotic and fanciful garb gave way to more realistic female forms in more realistically rendered fashions. *Vogue*'s return to a more informative phase was evidently influenced by the growth of photography, which with smaller cameras and faster film was becoming the most indispensable reportorial tool of the time. "Any new style of fashion illustration," Nast said in a memo to his closest colleagues, "that can claim to be a potential successor of the present style must, in order to conform with this fundamental decision, be a faithful and legible report of fashions, expressed in a manner which is pleasant, convincing, striking (if possible), contemporary, and above all, elegant. But mere novelty, or art value, or surprising 'modernism' of such a style will

PHOTOGRAPHIC STYLE
Beginning in 1930, the covers and the treatment of the illustrations became less fanciful. Carl Erickson (known as "Eric") set the style for the decade. His drawings anticipated by several decades what other magazines would eventually do. Eric did it in 1932.

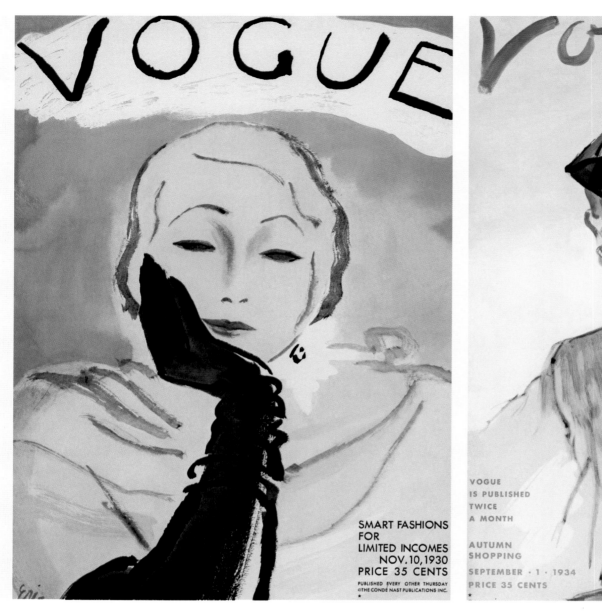

VOGUE SMART FASHIONS FOR LIMITED INCOMES NOV. 10, 1930 PRICE 35 CENTS PUBLISHED EVERY OTHER THURSDAY ©THE CONDÉ NAST PUBLICATIONS INC.

VOGUE IS PUBLISHED TWICE A MONTH

AUTUMN SHOPPING

SEPTEMBER · 1 · 1934 PRICE 35 CENTS

ERIC TIMES THREE
Carl Erickson made his debut at *Vogue* in November 1930 with the cover shown above left. All his pictures documented a detail of fashion, a season, or an event. He would place and draw the name *Vogue* according to his own taste.

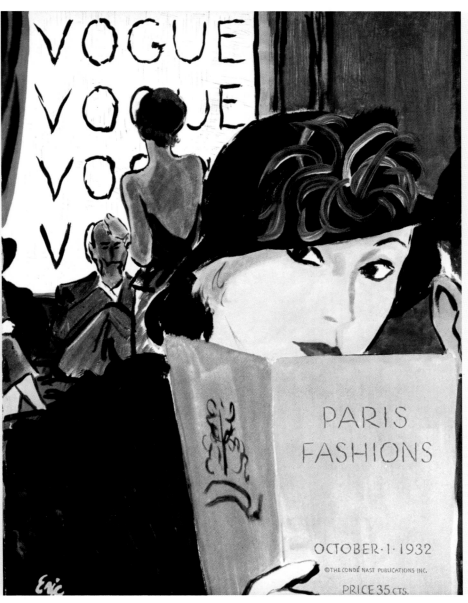

never, in my opinion, make it acceptable to our readers if it lacks in any of the fundamental qualities required by the mission, the service, which is the foundation-stone upon which the *Vogue* formula is built."

Vogue's covers accordingly reflected a more "photographic" tendency, with more detailed, specific works. Among the illustrators who were best suited to this artistic-but-realistic style were Harriet Messerole, Douglas Pollard, William Bolin, Jean Pagès, and Christian Bérard. However, the prime example of this period was an American of Swedish origin, Carl Erickson, who signed himself "Eric" and who, according to Nast, combined a certain realism in the details with an ability to evoke the spirit of elegance. With his first cover for *Vogue* in 1930, Eric marked an illustration

style that would characterize all of the thirties: a close-up of a woman's face with heavily lined eyes and a fashion element—in this case a black glove on the hand supporting the chin—that stood out from the rest. Throughout the decade this elegant figure appeared on *Vogue* covers, looking at herself in the mirror as she adjusted her hat or put on lipstick, contemplating readers with an enigmatic expression from behind a program or a fan or a stand-up collar, picking flowers, clasping a string of pearls around her neck, or simply striding forward.

Some view Eric as the interim artist between the Illustration Era and the Photography Era of the magazine's covers, and even Benito in his last phase adopted Eric's realistic and reportorial style. William Packer, in his magnificent book *The Art of Vogue*

Covers, 1909–1940, chronicles the transition and laments the loss: "By the end of the thirties the *Vogue* cover had changed utterly and forever. It was still decorative and arresting after its new, conventional fashion, but the old deliberation and attention had gone, replaced by something more cursory, temporary and consciously ephemeral. More and more, the cover was now, as it had not been for some thirty years, a temporary expedient, serving the magazine effectively but only immediately, and soon fading from the mind. And all the while the photographs were making their inexorable advance, as the consummate professionalism of the great photographers, Steichen, Beaton, Hoyningen-Huené, Frissell and Horst, put forward the almost too persuasive commercial argument. That, of course, is another story."

FASHION PHOTOGRAPHY

"A fashion photograph is not a photograph of a dress; it is a photograph of a woman."

This insightful definition presented by Alexander Liberman, art director and later editorial director at Condé Nast, introduces the 1992 book *On the Edge: Images from 100 Years of Vogue*. Liberman incisively encapsulates what a woman expects to see in a fashion photograph: a mirror of herself, of her fantasies, of how she wants to be seen by others, of what clothes she can wear and how she can wear them. To attain this ideal, however, is challenging, and over the years both the fine points of fashion and the modes of representing them have undergone constant change.

The fashion photograph developed in parallel with the twentieth century. It originated in Paris, like haute couture itself, and the models were usually the wives of the designers or of the distinguished and wealthy gentlemen who paid for the clothes. The first professional mannequin—a term taken from the wooden dolls on which, in the capitals of Europe in the seventeenth and eighteenth centuries, Paris fashions were exhibited—seems to have been the wife of the designer Worth. And the first photographs to appear in *Vogue*, many of them unidentified, were pictures of society ladies in large hats and sumptuous gowns, taken at their homes or yacht clubs or country clubs during the tea parties or sporting events or exclusive gatherings they attended. When Condé Nast took over the magazine, he immediately determined to change the graceless and unexciting images, plain backgrounds, and flat portraits that constituted *Vogue*'s photographic style. His first instruction concerned

ART AND FASHION
In this picture, published by *Vogue* on July 1, 1919, the French photographer Adolphe de Meyer's luminous style, which magnified feminine glamour, can be appreciated to the fullest. The model was Ann Andrews, dressed by Jonas.

the models: To make the images livelier, he recommended that the modeling be done by actresses, capable of more practiced poses, and by society ladies of outstanding beauty. He also had the pictures themselves taken by photographic studios such as the Campbell Studios, which used mirrored backgrounds, ornamental frames, and other decorative elements to enhance the pictures.

But the great milestone that was forever to change fashion photography was the first publication in *Vogue* of a picture taken by Baron Adolphe de Meyer. The date was January 15, 1913, and the subject was Gertrude Vanderbilt Whitney, the daughter of Cornelius Vanderbilt, one of the millionaires who had backed the creation of *Vogue* in 1892. The arresting portrait showed her wearing a white dress with a dark design, confronting the camera with hand on hip and a haughty look. The photo, taken by de Meyer with lenses that diffused the image and gave it a distant look, altered social and fashion photography totally and forever. The following year, de Meyer was hired by Condé Nast to work exclusively for his magazines. Thus began what was to be a historic saga of fashion photography. De Meyer, a Frenchman, would be followed by other professionals from other parts of the world who were also to make names for themselves—Edward Steichen, born in Luxembourg, who joined the magazine in 1923; George Hoyningen-Huené, a Russian, who started at French *Vogue* the same

year; in 1928 the Britisher Cecil Beaton; in the early 1930s the German Horst P. Horst and the American Toni Frissell; in 1938 the Frenchman André Durst.

Each of these masters of the camera contributed to setting the photographic course of the magazine under the direction of Condé Nast. Although their techniques and tastes differed, each was able in his distinctive way to capture, interpret, and transmit the feminine taste in fashion as it evolved from month to month and year to year. In her *Vogue Book of Fashion Photography, 1919–1979*, Polly Devlin put it well:

> The most important thing we get from fashion photography is a unique, valuable and extraordinarily detailed view of women, which reveals itself, after anything more than a cursory study, to be multifaceted. We see very clearly how women looked; not just how they dressed, but how they desired to look, and were expected to look, and how they were looked at. We can discern how they behaved, and how they were expected to behave. We can see what was found shocking, and how repetition of that shock lessened its impact. We can see what roles women played and how these roles have changed, trace how long it took for one stereotype to take over from another, and finally perceive the reality of the women behind their images, even in the most fantastic of guises or in the most unreal settings.

A MILESTONE
De Meyer's picture of Gertrude Vanderbilt Whitney was published in the issue of January 15, 1913, and is considered to mark the fusion of social and fashion photography.

BARON ADOLPHE DE MEYER

"Soon it became a certificate of elegance for a Newport aristocrat or a Broadway star to have her portrait, signed by de Meyer, in *Vogue*," wrote his biographer Philippe Jullian. "The Baron gave them all the aura of elegance bestowed by English chic, Slavic charm and Parisian dressmakers."

Adolphe de Meyer was born in Paris in 1868. His fame as a photographer began in London with portraits of personalities such as Sarah Bernhardt and Oscar Wilde, and continued in Paris where he created spectacular images of Nijinsky and the Ballets Russes. When he married model Olga Caracciolo, his best man was Albert Edward, Prince of Wales, later to be King Edward VII. At the time it was rumored that the prince was his father—in reality he was the bride's father—and that the title of baron was granted to him so that he and his wife would be entitled to attend the coronation of the future monarch. De Meyer's initial contact with New York photography circles came in 1903 when, during his first visit to the United States, he was photographed by Gertrude Kasebier. A year earlier this specialist in portraits had joined with a group of professionals to create the Photo-Secession, a movement dedicated to establishing photography as a recognized art form. The leader of this group was the American photographer Alfred Stieglitz, who later would marry the painter Georgia O'Keefe. Another outstanding member was the young artist and photographer Edward Steichen, who would contribute signally to the evolution of *Vogue*'s image. The group exhibited their works at 291, Stieglitz's gallery on Fifth Avenue, where de Meyer was invited to exhibit in 1912. It was there that he was discovered by Edna Woolman Chase, who introduced him to Nast. De Meyer was, like the members of the Photo-Secession, an ardent advocate of artistic photography, and the pictures he exhibited greatly impressed the editors. His pictorialist style, a perfect balance between commercial chic and the aura of pure art that *Vogue* sought, was exactly in step with Nast's vision of changing the way fashion was portrayed to the female reader, and accomplishing it in a novel way. De Meyer's working connection with *Vogue* was formalized only in 1914, when World War I broke out and he fled to the United States. He signed an exclusive contract with Nast for a sum considered astronomical for a photographer at that time: 100 dollars a week. Immediately de Meyer's backdrops, his lighting technique, and the way he presented both women and their clothes changed the character of the magazine. Polly Devlin has given one of the most accurate assessments of de Meyer's work and its significance:

De Meyer transformed fashion photography from being a sideline for photographers into being a full-time *artistic* occupation and a fashionable way of life. There was a feeling of social intimacy between him and the

SEPTEMBER 1, 1920
Model: Helen Lee Worthing

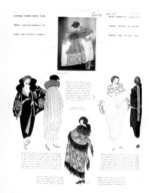

APRIL 15, 1921
Model: Ann Andrews

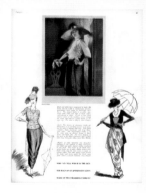

JULY 1, 1919
Model: Ann Andrews

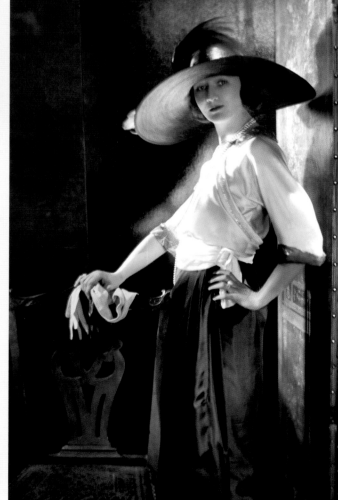

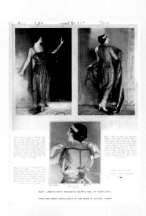

women he photographed. No matter how haughtily they stare out from the pages, no matter how self-regardingly they gaze into the proffered looking glasses, no matter how disdainfully they stare down the camera, beauties like Miss Ann Andrews, or Mrs. Harry Payne Whitney, are relating directly to the photographer. They are accessible and at home, even if that home sometimes seems to be in the middle of a silvery cloud. De Meyer was not primarily interested in fashion photography—after all, the fashion industry as such did not exist in New York since all haute couture came from Paris, and many of the clothes photographed belonged to the wearers themselves. Nor was he intent on psychological revelations about his sitters, or even on getting a good likeness. He wanted to create an ideal of feminine beauty, of softness, luxury and high romance. He created a glamorous and elaborate world, gleaming with reflected light, a world of lush textures and silvery fabrics. His sittings took place in his own studio—and his women were objects of admiration, mysteriously feminine and luminous.

De Meyer's pictures dominated the pages of *Vogue* and *Vanity Fair* for eight years. In 1922, seduced by the offer of a magnificent salary and the promise of being able to live and work in Paris, he went to work for William Randolph Hearst's *Harper's Bazar*. But de Meyer had already left his imprint on photography in general and the pages of *Vogue* in particular. Floating veils, luminous salons replete with luxuries, and women dressed like goddesses had brought art and romanticism to the world of fashion.

STEICHEN'S STRAIGHT PHOTOGRAPHY

"The year 1923 was memorable for us because it brought into the organization three men who were to be associated with *Vogue* for many years. The trio was John McMullin, Main Bocher, and Edward Steichen."

With these words Edna Woolman Chase, who was not known for overly generous praise, stressed in her memoir *Always in Vogue* the significance of the hiring of Condé Nast's new chief photographer, whose portraits and fashion photos immediately made de Meyer's work seem antiquated. Steichen was already well known as a master photographer, a member of the group headed by Alfred Stieglitz, who had worked indefatigably from the early years of the century to establish photography as a legitimate art form. It was Steichen who contributed to the Condé Nast magazines the concept of "straight photography" free of the soft focus, chiaroscuro, and other devices used by de Meyer to make his photographs look like paintings. The decided realism of Steichen's style allowed not only for marvelously detailed views of the clothes being modeled but also for a new view of the models themselves, as real women, seated with their legs crossed, or standing in doorways, or leaning against pillars, all the while looking at the camera with assurance and confidence. Nast once said to Steichen: "Every woman de Meyer photographs looks like a model. You make every model look like a woman."

Edward Steichen was born in Luxembourg in 1879 and grew up in Milwaukee, Wisconsin, in the heartland of the United States. In 1900 he was in contact with the Photo-Secession movement in New York. Between 1906 and 1914 he lived in Paris, where he took up painting and photography. During World War I he was commander of the photographic section of the Air Service of the American Expeditionary Forces for the United States Army in France. In 1923 he returned to New York to devote himself entirely to photography. Frank Crowninshield, who was running *Vanity Fair*, was looking for a photographer who specialized in portraits of notable figures. He introduced Steichen to Nast and offered him the possibility of working for *Vogue* as well, as a fashion photographer. "He said they would not use my name with the fashion photographs, if I preferred," Steichen recalled in his autobiography, *A Life in Photography*. "My response was that I had already made fashion photographs in 1911, for the magazine *Art et Décoration*. . . . I also said that, if I made a photograph, I would stand by it with my name; otherwise I wouldn't make it." Nast was pleased with this answer, and

MAY 1, 1927
Marion Morehouse, Steichen's favorite model, was photographed in a dress by Chéruit at the New York apartment of Condé Nast. This is a first-rate example of how to portray not only fashion but the woman who wears it.

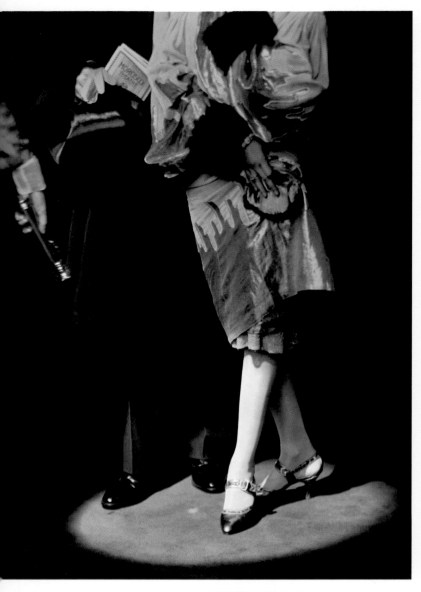

DECEMBER 15, 1926
Spotlight on Sandals

NOVEMBER 1, 1925
Model: Actress Katharine
Cornell

before long Steichen was photographer in chief of his publications.

The way Steichen illuminated his pictures became legendary, for he combined natural and artificial light. On one occasion, to confer greater realism on a scene, he brought a white horse into his studio, where several of his models were dressed in white against a background of the same

color. Chase recalled in her book: "For the first time in the assistant's experience this new man was taking advantage of the studio's enormous window, whereas all the other photographers curtained it off as though daylight were some virus that might penetrate the pores, causing God knows what ill-effects in the matter of over- and underexposure. . . . Steichen has always felt it was fatal to com-

mence a fashion sitting by asking the model to 'strike a few artistic poses.' 'Good fashion models,' he said, 'have the qualities inherent in a good actress, and the photographer is wise if he makes use of this ability by giving it a chance to work. But he should bear in mind that models are usually types . . . and should not expect them to do the impossible and be all types at once.'"

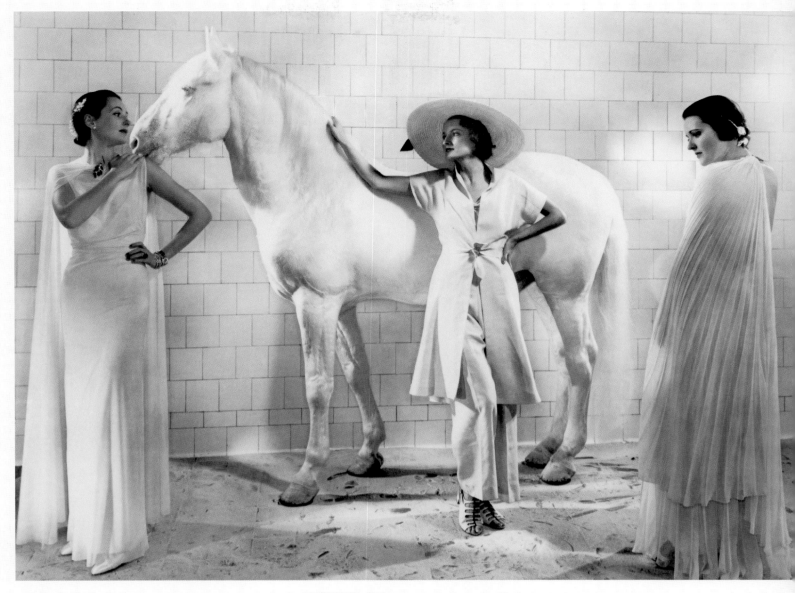

JANUARY 1, 1936
Steichen took this picture, titled "White," in the studio in New York.

Steichen's favorite was Marion Morehouse, one of the first professional fashion models. She appeared in several of his best photos, and more than once their joint work as photographer and model was used as a case study at specialized schools. Years later, during a course given at *Vogue* itself, the art director Alexander Liberman showed the young photographers a picture

Steichen had taken of Morehouse in 1927–a picture of a sophisticated young woman whose smile exuded self-confidence and whose hands rested on her hips as she showed off a dazzling dress by the design firm Chéruit. "That was the key to modern fashion photography," Liberman told his students. "The fashion showed very clearly, but the picture offered something far more important:

an image of a woman at her most attractive moment."

When Steichen left Condé Nast in 1937, his realistic style had launched an era in fashion photography. And during his time at the magazine he had achieved yet another milestone: In 1932 he contributed the first color photograph published as the cover of *Vogue* (see page 104).

HOYNINGEN-HUENE, MASTER OF THE SCENIC PHOTOGRAPH

George Hoyningen-Huené had an obsession: to convey everything he possibly could about fashion, including its ability to generate emotion through gesture and setting. And all of this he meant to transmit through photography.

Hoyningen-Huené was also a baron. His father, from St. Petersburg, had been in charge of the tsar's stables, and his mother was an American from Michigan, the daughter of a high-ranking diplomat assigned to the imperial court. The family fled Russia when the revolution broke out, and George settled in Paris. The French capital was in a permanent state of artistic effervescence, animated by the dadaist, cubist, surrealist, expressionist, and futurist schools. The young Russian studied drawing with the cubist painter André Lhote and secured employment as an illustrator

with the French edition of *Vogue* in 1925. However, he soon realized that his true passion was photography, and he applied to it all the knowledge he had acquired in the artistic and theatrical circles he moved in. Rather than merely making a pictorial record of the clothing worn by his models, he would integrate the posed model into an evocative scene through atmosphere, lighting, and background.

Hoyningen-Huené created in his studios the illusion that behind his models there existed a beach with sun and sand. He introduced onto the set automobiles, chairs, plants, sunshades—whatever might suggest real life and real fashions being shot outdoors. One of his most famous pictures, published in July 1930, shows a couple in bathing suits who seem to be on a diving board looking out over the sea. It was in fact taken on the

SEPTEMBER 15, 1933
The model (Mademoiselle Koopman) and the dress (by Augusta Bernard) appear against a backdrop designed to highlight the figure in the characteristic manner of Hoyningen-Huené.

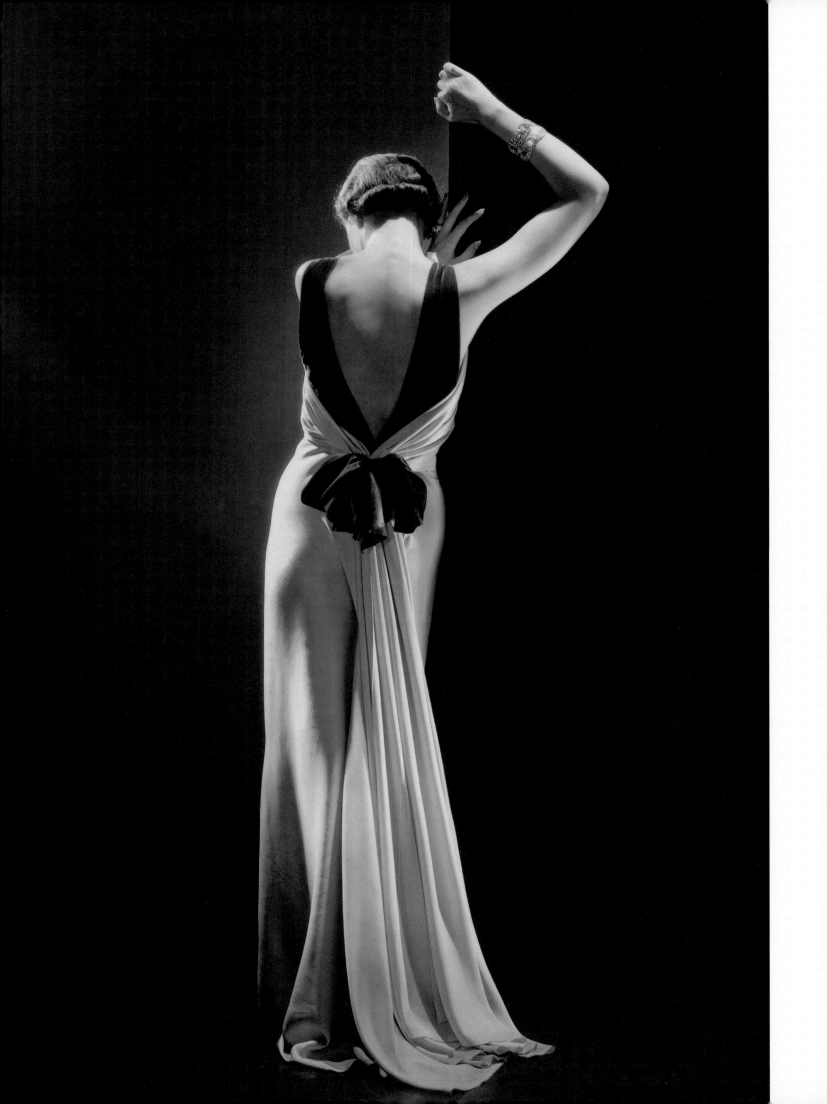

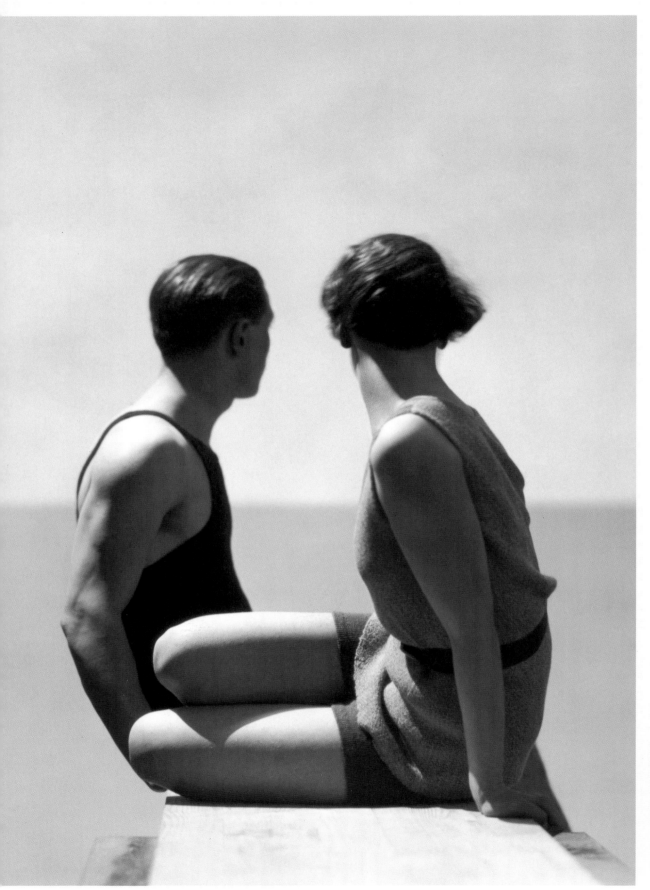

JULY 5, 1930
This photo of a pair of bathers, one of Hoyningen-Huené's most popular pictures, was taken at the Paris studios and was first published in small size.

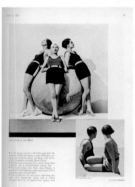

roof of *Vogue*'s photo studio on the Champs-Elysées in Paris. The models were seated on boxes, and the low wall surrounding the roof, rendered slightly out of focus, simulated the sea and the horizon.

The atmosphere and the scenery of his photographs were his major contribution. Aside from displaying clothing, his pictures captured the look of an entire era, when the Chanel suit had definitively established itself and the upper-class woman, freer than ever before, had begun to drive her own automobile and to appear in sports clothes. Aside from his creativity and his style, the Russian baron was renowned for his bursts of bad temper and his unfriendly demeanor. *Vogue* fashion editor Bettina Ballard recalled in her memoir, *In My Fashion*, that "he would walk into a sitting late, take one withering look at the models standing nervously in the dresses he was to photograph, turn to the editor in charge and say, 'Is this what you expect me to photograph?', snap the camera a few times, and walk away. Everyone was terrified of him."

It was thus not out of character when in 1934, while lunching with *Vogue* art director Mehemed Fehmy Agha, who had traveled to Paris expressly to negotiate a new contract with him, Hoyningen-Huené erupted in fury at something Agha said, violently upended the table, and declared he would resign from *Vogue*. Edna Woolman Chase herself was unable to change his mind. Hoyningen-Huené left to join *Harper's Bazaar*. It is a curious fact that his assistant, who had served as a model in his celebrated picture of the couple wearing bathing suits, would years later become one of his successors. His name was Horst P. Horst.

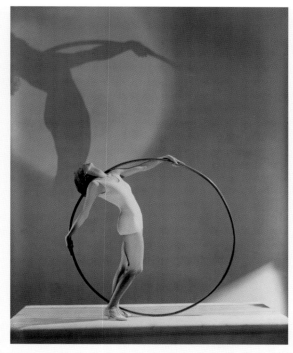

JULY 15, 1930
The fashion shoot at right featured swimsuits, and the model with the hoop was Emor Carise.

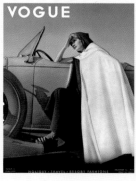

DECEMBER 15, 1934
This photo was created in black and white, then processed in the lab to be published as a color cover. The model was Miriam Hopkins, dressed by Travis Banton.

BEATON'S ROMANTICISM

At the same time that Steichen was making his mark with straight photography and Hoyningen-Huené with scenic pictures, another photographer was bringing his particular style to the pages of *Vogue*. His name was Cecil Beaton. The defining characteristic of his work and his contribution to fashion photography was the romanticism of the backgrounds and the use of exotic supporting materials, such as folded gauze, screens, and a profusion of flowers. With their theatrical and surreal mise-en-scènes, Beaton's pictures were considered a return to the style of Baron de Meyer.

Cecil Beaton first appeared in the British edition of *Vogue* in 1926, when he was only twenty-two years old. Born in London and educated at Harrow and Cambridge, he was not only interested in photography, he was passionate about painting. When he joined the magazine, it was as a writer and illustrator, and he published articles and sketches of society personalities such as Lady Diana Cooper. Beaton's connection with American *Vogue* came two years later, after Edna Woolman Chase became fascinated with his photos of Edith Sitwell, taken to illustrate an article he had written for British *Vogue* about poets and writers at Cambridge. As he would later recall in *The Glass of Fashion*, Beaton arrived in New York in the winter of 1928 with his tall, thin tripod, his small Kodak camera—which he would use until Condé Nast insisted that he change it—and a supply of the fabrics that he so often

used as backgrounds: silvered tulle and gauze, dotted swiss, and lengths of burnet.

Aside from the baroque lighting and backgrounds that typified Beaton's work, his years at *Vogue* were marked by two memorable episodes—one scintillating and the other sobering. The first involved royalty and the romantic tale that held the world in thrall: the wedding of American divorcée Wallis Warfield Simpson and the Duke of Windsor, who had abdicated the throne of England to wed "the woman I love."

Beaton, a friend of Mrs. Simpson, was able to photograph her in 1937 at the Château de Candé in France, where she was waiting for her divorce to become final. The resulting six-page picture story appeared in *Vogue*'s issue of June 1, 1937, which immediately sold out. And better was to come. The photos of Wallis in white pants by Schiaparelli so impressed their wearer that in June of that year she called on Beaton to be the official photographer at her wedding. *Vogue* thus had a world exclusive on an event that came to symbolize a society now discarding its old rigid rules. Wallis was seen by women as an icon of modernity who had defied and defeated the codes of royalty and as an inspiration to an entire generation. And *Vogue* alone, thanks to Beaton, was there to record the event and to show the new Duchess of Windsor in the wedding gown and wardrobe designed for her by Mainbocher.

BEATON AND HIS ART
In the larger photo, published on May 15, 1935, the model was Mary Taylor and the dress by Chanel; below, the Marquise de Casa Maury on March 16, 1929. In both photos the background brims with fabrics, flowers, and accessories with which Beaton sought to impart a romantic touch.

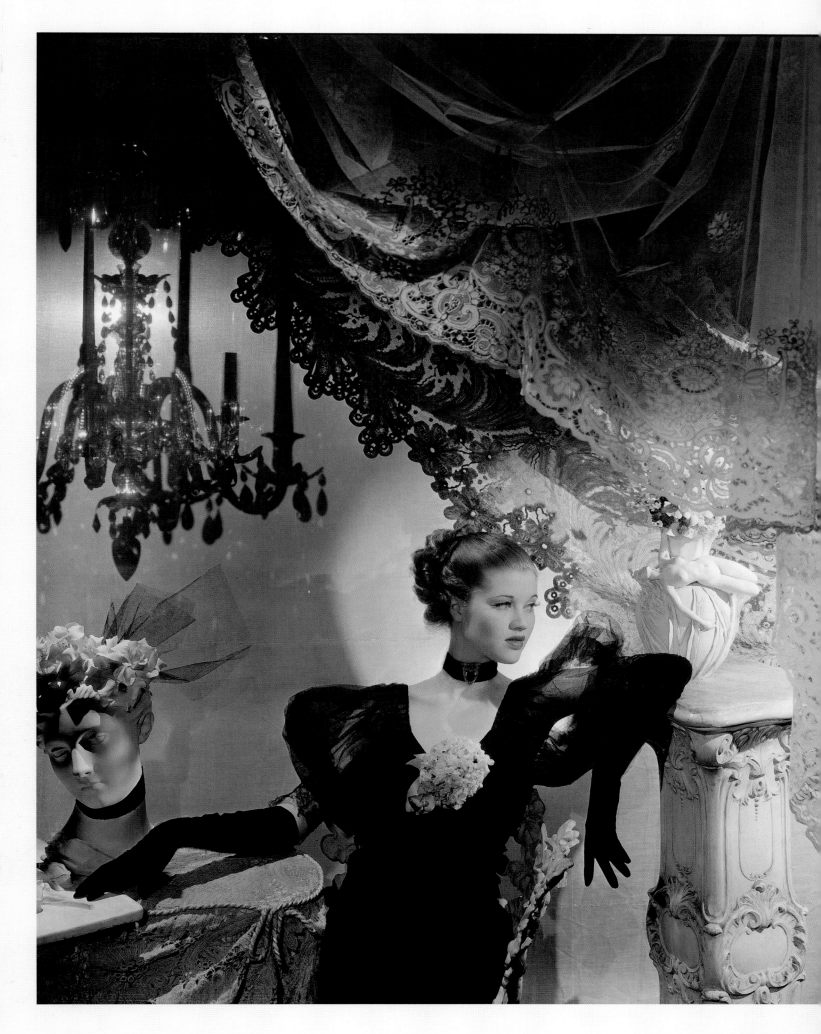

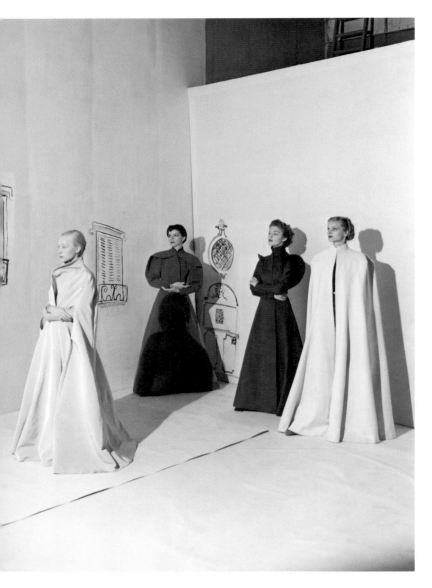
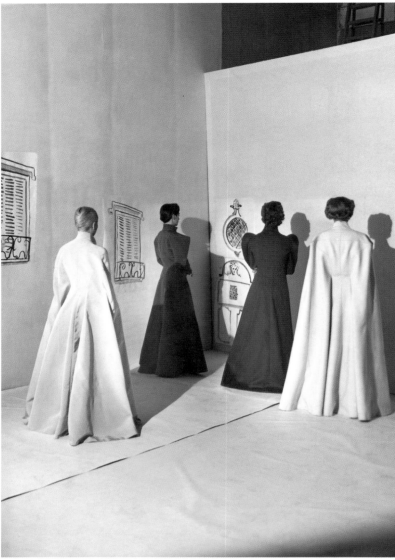

FRONT AND REARVIEW SHOTS
Beaton, at his most innovative, shot this two-page spread for the issue of November 1, 1936, as a creative way of showing Charles James's coats from the front and the back.

The second episode occurred the following year and was not at all felicitous. As it had done on other occasions, the magazine asked Beaton to illustrate an article written by Frank Crowninshield, the former editor of *Vanity Fair*, which had merged in 1938 with *Vogue*. It was Beaton's habit to incorporate in his drawings certain writings, such as store signs, newspaper headlines, slogans from posters, or paragraphs from publications. In this case, two of the written inscriptions included the word "kikes," one of them being "M. R. Andrew ball at El Morocco brought out all the damn kikes in town." It was never determined whether Beaton was merely careless or used the offensive phrase on purpose. On January 24, 1938, Walter Winchell called attention to it in his syndicated column in the *New York Daily Mirror*. A public outcry ensued, as a result of which Beaton resigned "by mutual agreement" with Condé Nast and returned to London. He was absent from the pages of *Vogue* for three years, until Condé Nast lifted his ostracism in 1941. Another Beaton-*Vogue* relationship began, which was to last several years.

Devlin writes: "Beaton's work has always had relevance to its times. More than any other photographer, he saw the relevance of the visual images of Surrealism to that other art of dreams which is fashion photography. He was deeply influenced by painters he admired, by contemporary movements and trends: when he fell under

THE DUCHESS OF WINDSOR
Beaton had the privilege of photographing the Duchess's wedding, while remaining faithful to his unconventional pictorial style. Here he highlights not only the dress by Mainbocher but also the fine French furniture to create a more romantic atmosphere.

Pavel Tchelitchev's spell, his photographs took on a neo-romantic look. Many of his photographs are based on the conventions of painting, partly due to his natural inclination towards that medium, partly to his love for stage design. His studio backdrops often looked like theater sets, as though he were photographing staged productions of clothes rather than fashion. . . . He was a master of the conceit, mixing real and artificial flowers, piling on all kinds of props and decorations. For decades, the pages of *Vogue* are filled with his fashion photographs, his portraits, his drawings, his writings, and through his pen as well as through his camera we get an inquisitive, unblinkered unique view of women."

MORE ROMANTICISM
The backcloth and the model dressed by Reboux combine to evoke a romantic mood. This picture was published in the issue of August 15, 1933.

THE SPLENDOR OF SHAPES
In one of the most representative images of Horst's elaborate style, the geometric background follows the shape of the hat worn by model Lisa Fonssagrives. The photo was published in the August 1, 1938, issue.

DECOR
This image, published on
March 15, 1938, exemplifies
the decorative resources,
the architectural touch of
columns, and the lighting
effects employed by Horst.

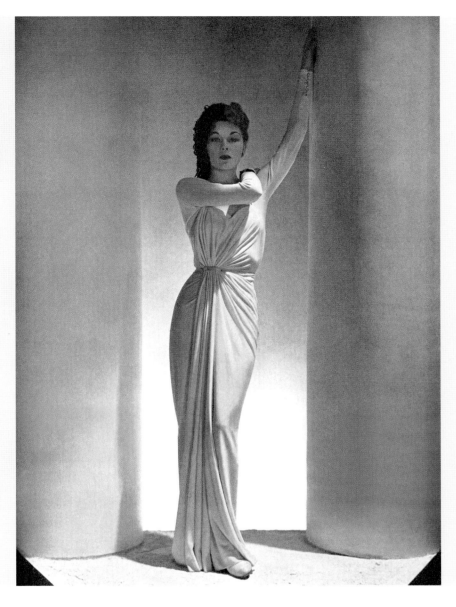

His real name was Horsty Bohrmann, and his debut in the photo studios of French *Vogue* was as a set handyman and as the muscular bathermodel in Hoyningen-Huené's famous picture. Horst P. Horst—the artistic name he adopted—had been born in Germany and arrived in Paris at the end of the 1920s to study architecture under Le Corbusier. A friend and protégé of Hoyningen-Huené, he started working as his assistant. In 1930 Agha, during one of his visits to Paris, encouraged Horst to devote himself to photography. Such were the beginnings of another professional who, through *Vogue*, was to leave his imprint on the history of fashion and photography. The signature characteristics of his work were a striking use of the color black, dramatic lighting, and the harmonious

integration of geometric and architectural forms in his backgrounds.

During the 1930s Horst worked almost entirely in the Paris studios. At one point he was hired by New York *Vogue*, but he severed that connection after only a few months following a disagreement with Nast, who made some unwelcome suggestions regarding certain of the photographs Horst had taken for the magazine. Back in Paris, he again began to distinguish himself in 1934, after Hoyningen-Huené's resignation. At ease in the company of *le Tout-Paris*—among his closest friends were the painter and stage designer Christian Bérard, the film director Luchino Visconti, and Coco Chanel—he incorporated into his work all the artistic and architectural knowledge

he had picked up during his passage through Le Corbusier's school. Obsessive about organization, he planned each photograph meticulously so that the end product would faithfully reflect his initial concept. He paid great attention to the decor and often made use of elaborate background setups, sometimes designing them himself and sometimes entrusting to professional designers the creation of the settings in which he would pose his models. In his book *Photographs of a Decade* Horst recalled: "My first pictures were loaded with background. I was continually dismantling palaces, hauling in small forests and entire hothouses meant to enhance but really crushing the little woman in their midst. Finally I realized the incongruous effect and began a series of strong black compositions

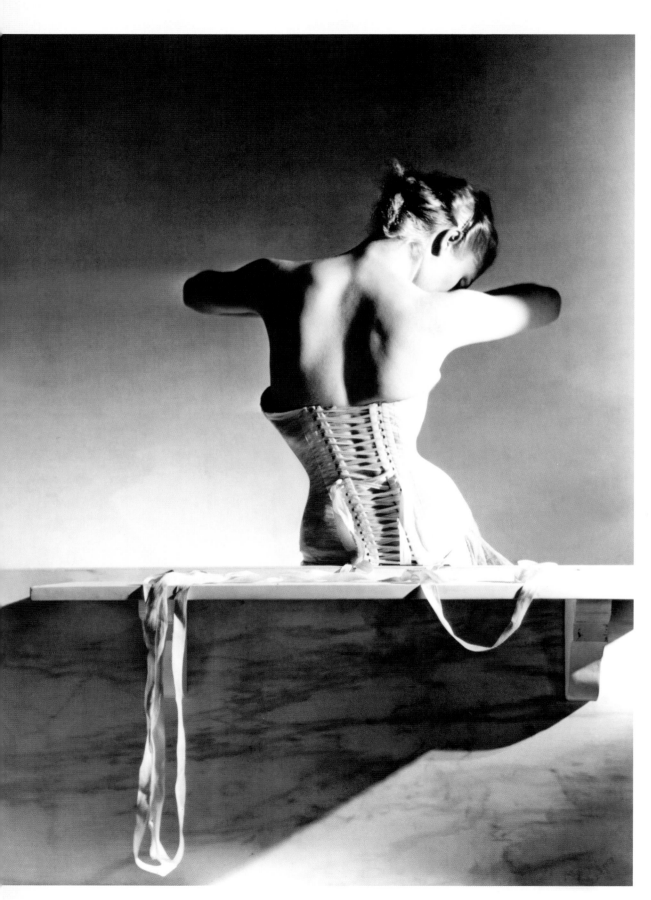

CORSET
Perhaps Horst's most popular fashion photograph, this was the last one he made in Paris before fleeing the war. Published on September 15, 1939, it is a beautiful handling of light and shadow.

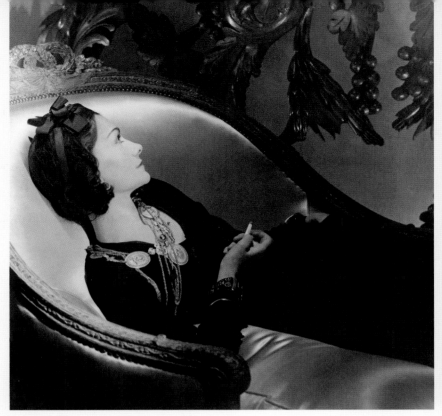

COCO CHANEL
The best-known picture of Chanel, and the one she liked the most, was taken by Horst in the *Vogue* studios in 1937 and was published on several occasions, including the February 15, 1954, issue.

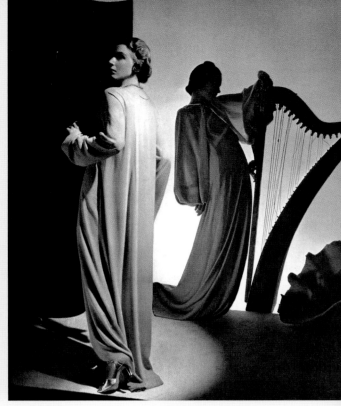

SHADOWS AND GEOMETRY
With mirrors and linear shadows Horst achieved an excellent image of the dress in this picture published in the April 15, 1937, issue.

that made a big inky splash on the magazine page blotting out everything else."

Among his studio photographs, Horst took two pictures that became, in time, icons of his work. The first is of Coco Chanel in a little black dress, reclining on a sofa at the *Vogue* studios in 1937. The portrait shows the couturiere in pensive profile, dreamy and very seductive. This was Chanel's favorite photograph of herself, and certainly one of the most widely circulated. The other landmark photograph of this period shows the bare back of a model sensually draped in an unlaced corset. The picture became known the world over for its clever use of light and shadow. Until then, fashion

photographers had avoided using shadows and black for fear that the final image would be dull and unclear. The corset photo was published in *Vogue* in September 1939 and was the last of Horst's Parisian works. The impending war and the renewal of an offer to work in New York prompted a definitive move to the United States, where his magazine photos would continue to be outstanding for another two decades.

During Horst's Parisian period, two other remarkable photographers also contributed to *Vogue*: Man Ray and André Durst. Man Ray was already an established avant-garde painter and cinematographer when he launched his career as a fashion photographer.

He did this chiefly for financial reasons. Man Ray once said, "I paint what I cannot photograph and I photograph what I don't want to paint."

Durst also added touches of surrealism to his photographs. Most of his work was done for French *Vogue*, and after Horst's departure he became the chief of the Paris studio. He contributed a style that fashion editor Bettina Ballard described as follows: "He took Dali-like photographs of elegant women standing in a desert with such surrealist props as a rope twirling around one of them that zoomed off into space. . . . He was the first photographer to translate a surrealist feeling to fashion photography."

FRISSELL TAKES VOGUE OUTDOORS

It is worth noting that the photographers who at this time influenced fashion photography and the style of the magazine all had previous connections to traditional art. Baron de Meyer sought to make his pictures look like paintings, Steichen had been a painter before embracing photography, Hoyningen-Huené studied drawing, Horst studied architecture, and Beaton was a writer and illustrator. And all of them poured the knowledge gleaned from their initial vocations and studies into their handling of the camera, contributing significantly to the development of fashion photography. However, perhaps because their earlier artistic inclinations moved them to attempt pictures worthy of a salon exhibition, they invariably worked indoors, with lights and constructed backgrounds—all this despite the advent in the 1920s of the Leica camera and of fast 35-mm film, which now made outdoor work in natural light feasible.

The break with the past on the pages of *Vogue,* its journey out of the studio, came at the end of the 1920s when Toni Frissell set the new standard. Frissell, an attractive member of the New York elite with much energy and many valuable contacts, joined the magazine as a headline writer. But she was not long in that position, at which she was found wanting. In order to save her job she became a photographer at social events of interest to the magazine, events to which she had access in her own right. Simultaneously, she started to work in the studios as an assistant to Cecil Beaton, from whom she learned much about photographic techniques. Frissell liked to experiment with unusual angles and focuses—for example, pictures taken from floor level. As photo techniques evolved, she tried to take pictures out of doors and captured open-air images of women in movement on the slopes of hills, on beaches, riding bicycles or horses.

It was not easy for Frissell to stamp her style on the pages of *Vogue.* However, certain external factors moved Nast, Chase, and Agha to publish her outdoor pictures frequently. First, the Hungarian photographer Martin Munkacsi had joined the magazine's perennial rival *Harper's Bazaar.* Munkacsi was the author of exuberant and flashy outdoor fashion photos. While the *Vogue* photographers continued to build ingenious indoor sets for their fashion shoots, Munkacsi with his high-speed Leica was taking pictures of women out of doors and in motion. When his pictures first appeared in *Harper's Bazaar*, Nast dismissed them as "simple snapshots," and Chase commented derisively, "Country girls jumping fences."

SUN
This two-page spread from May 15, 1942, is a fine example of Frissell's specialty, outdoor pictures of models in sports clothes.

RAIN
Frissell's unusual photograph taken in Indianapolis in a winter rain was published in the February 1, 1938, issue. The model was C. Ruckelshaus.

REALISM
One of the aims of Frissell's photography was to show real women in real situations and settings. In this picture, published on April 15, 1939, the model wears sportswear by Peck & Peck.

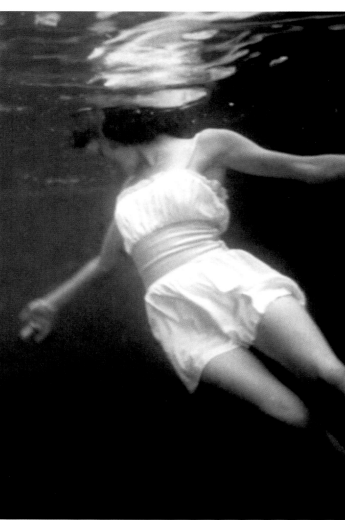

UNDER WATER
Frissell's shot of Joan Dixon, dressed by Brigance, was taken through glass at Marineland's Oceanarium in Florida and was published on January 1, 1939.

Nast and his team started to change their outlook when *Life* appeared in 1936, revolutionizing the magazine market with its action photos and with the creation of the photo essay, a brand-new way of telling a story in pictures. Nast and Henry Robinson Luce, the founder of *Time*, *Fortune*, and *Life*, were in close contact and constantly exchanged opinions about journalism and photography. More than once they debated the merits of commercial artistic photography versus photo-reportage. Luce, who had married Clare Boothe Brokaw, an ex-editor at Nast's *Vanity Fair*, was of the opinion that people should be photographed in their natural settings and activities, so that magazine readers could identify with them. This viewpoint influenced Nast considerably, and at the end of the 1930s fashion articles with outdoor photographs by Frissell, and action snapshots taken alfresco, became the new photographic style of the magazine. This style also altered the image of women in general, who ceased to be static monuments enclosed in decorated interiors and became active and healthy participants in sports activities. Years later, Frissell was described in *On the Edge: Images from 100 Years of Vogue*:

Frissell specialized in sports clothes shot out of doors. "With her social connections, her passion for skiing that took her to Switzerland every winter, and her willingness to travel any place at any time," Bettina Ballard recalls, "she was a valuable combination editor-photographer for the magazine." Frissell's models (sometimes friends) leaned against cars with their dogs and posed robustly on their bicycles or at the beach, beaming with American healthiness, the wind blowing in their hair. Frissell was an early practitioner of the art of the fashion photograph that simulates "real life." "Little by little you see the great revolution that happened in photography," Alexander Liberman explains, looking through her photographs. "It was action, movement, and what a small camera made possible. Little by little we're getting to snapshots. The magnificent snapshot."

BEACH
Another picture taken at
Marineland in Florida,
this one was published
on December 1, 1939.
Frissell, who had plenty
of social contacts, used
her friends as models
more than once.

RAWLINGS'S REALISM

The introduction of American photographer John Rawlings to *Vogue*'s visual team in 1936 was certainly one of Condé Nast's best strategic moves. At a time when opulence, pretentiousness, and theatrical lighting were prevalent in fashion photography—fueled by the European school led by the British Beaton, the German Horst, and the Russian Hoyningen-Huené—Nast and *Vogue*'s editor in chief Edna Woolman Chase decided they needed a change of direction and placed their bets on a talented but unknown twenty-four-year-old Midwesterner.

In two memos sent by Chase, one to her staff in 1937 and another to the photographers in 1938, she demanded more information and less art in *Vogue* pictures: "Several of the photographs for September fifteenth are nothing but black smudges," she wrote in the second. "Concentrate completely on showing the *dress, light it for this purpose* and if that can't be done with art then art be damned. *Show the dress.* This is an order straight from the boss's mouth and will you please have it typed and hung in the studio."

The change of direction would take a few years, but the man to lead it, John Rawlings, would become one of the most prolific and important photographers of the twentieth century, with more than two hundred *Vogue* and *Glamour* covers to his credit.

His beginnings were unremarkable. Born in Ohio in 1912, John Rawlings attended the local Wesleyan University, and upon graduation in the early 1930s he relocated to New York, where he became a freelance store window dresser. After buying a Leica to photograph his work and show it to potential clients, Rawlings discovered that he enjoyed taking pictures and eventually started to photograph some of the aristocratic clients themselves, alone or with their dogs. A few of those shots found their way to the desk of Nast, who decided to offer Rawlings a job at the *Vogue* studios as prop builder, studio hand, and apprentice to the legendary masters Beaton and Horst. The young Midwesterner was so dedicated and worked with such unbridled enthusiasm that four months later he not only was promoted to first assistant to the masters but also got his first photo published in the September 15 issue of *Vogue*. Impressed by his precocious talent and visual style, Nast and Chase rewarded him in 1937 with a job at the British *Vogue* studio in London, where he would train and work until the early 1940s.

Although his early work for British *Vogue* showed the strong influence of Hoyningen-Huené and Horst, Rawlings would slowly depart from their style. "Rawlings was certainly the first major Condé Nast photographer to demonstrate a truly American eye. . . . John Rawlings' photography has a practical, no nonsense feeling. . . . he focused his lens on the vibrant world surrounding him," writes Charles Dare Scheips Jr., former director of the Condé

APPLIED SCIENCE – NYLON COAT

AUGUST 15, 1942
Author of more than 200 covers for *Vogue* and *Glamour*, Rawlings showed fashion in a direct, informational way that combined beauty with clarity.

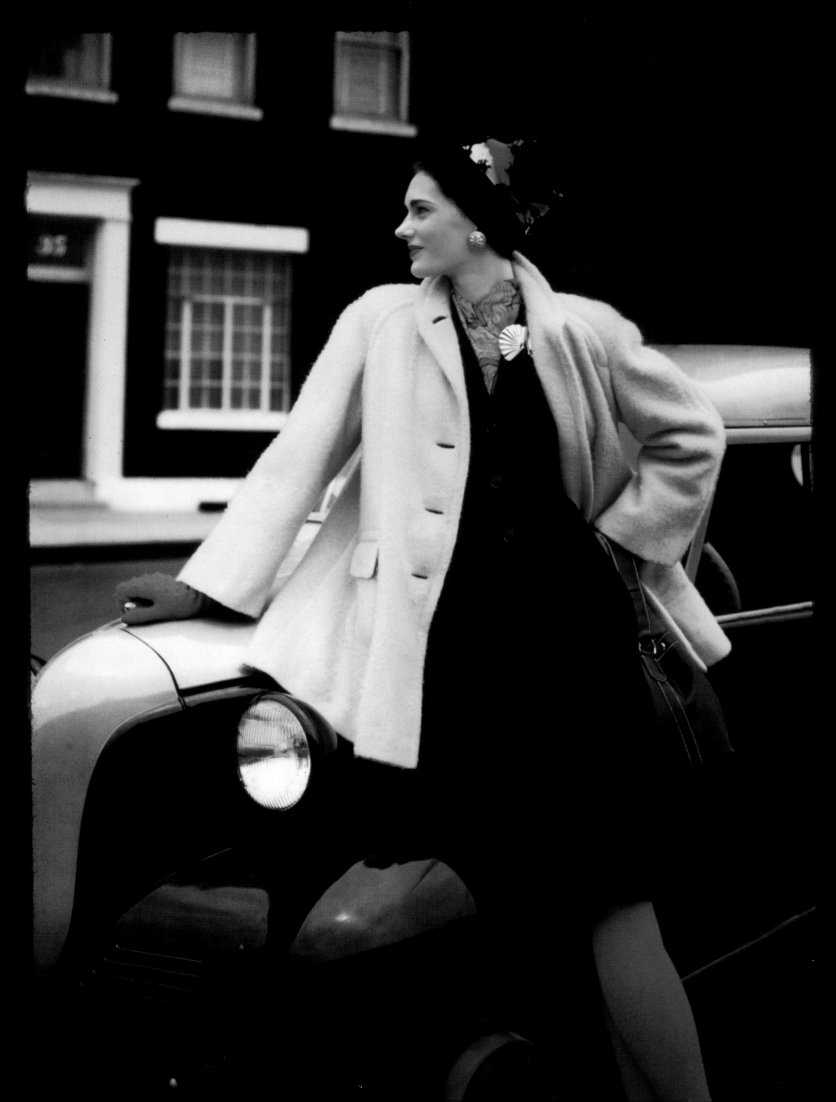

Nast Archives, in his introduction to Kohle Yohannan's book *John Rawlings: 30 Years in Vogue*. "Rawlings brought a realistic visual style, presenting fashion as a force rather than a decoration."

During his training in England, Rawlings had the opportunity to explore new photographic and lighting techniques without censorship from his masters. He went back to daylight, taking more descriptive and informative shots, incorporating the environment in the shoot, starting to experiment with mirrors, and combining natural and artificial lighting. "Enjoying an amount of autonomy he would never have been granted had he remained an assistant in New York, Rawlings produced such impressive work during his first months in London that, in a break from standing tradition, many of his British editorial pages found their way (with increasing regularity) in the international circulation of both French and American *Vogue*," writes Yohannan. Rawlings's London training proved to be excellent preparation when he was called back to New York, which in the early 1940s was becoming the center of world culture. His return to Manhattan coincided with a cultural shift in which commercial photography was quickly catching up with art. Rawlings seized the moment to break with the artificial status-based formula of fashion photography inspired by Horst and to achieve a fresher, more American and lifestyle-driven look. "Once back on native soil as the American rising star," says Yohannan, "Rawlings began almost instinctively to realign himself with the markedly less-labored glamour of the American ideal of beauty, what Christian Dior had offhandedly termed 'Le look sportif.'"

The personal and independent path that Rawlings had created for himself led him to clash with the photographers of the time, who he said underestimated sunlight, did not crop enough, and always got themselves in the picture. Above all he criticized the ones who took themselves too seriously; without naming names, Cecil Beaton was surely on the list because, among his other eccentricities, he worked in the studio in his beret and cape, to proclaim his artistic and aristocratic standing. Like many of his colleagues, Rawlings had a list of favorite models. In the late 1930s and the early 1940s these included Dana Jenney, Helen Bennett, and Betty McLauchlen. Meg Mundy, whom he discovered by chance in a waiting room at the CBS studios, proved to be an all-time favorite, and he helped her greatly when she jumped from singer-model to Broadway actress.

A few months later Rawlings would start a new creative stage at *Vogue* when he became the first photographer to systematically associate fashion with Hollywood celebrities.

JANUARY 1, 1944
In London, Rawlings experimented with new techniques including the use of mirrors in his shots.

FUR BERET...NEW HEADWAY

NOVEMBER 1, 1942
With his informative style, Rawlings was an acknowledged groundbreaker in fashion photography. For experts, he was the first American to show fashion in this way.

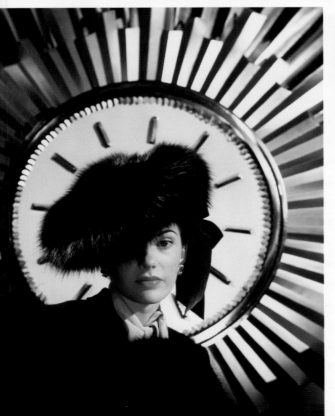

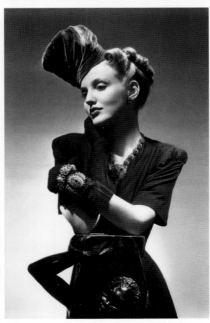

PHOTOGRAPHY UNDER NAST'S MAGNIFYING GLASS

He was the impulse behind the great changes in fashion photography and at the same its greatest critic, the originator of severe commentaries, the man who drove his photographers to distraction with his observations and his pronouncements. Not one of them escaped constant subjection to the lectures and advice and the sharp recommendations of Condé Nast—not Horst or Beaton, Steichen or Hoyningen-Huené. Some of them resented his meddling. The first time Horst left *Vogue* was after a meeting in Nast's office, where Nast had hung Horst's photos on the wall for the purpose of analyzing their defects. Others considered Nast's approach valuable. Beaton said he would never work for *Harper's Bazaar* because he would not have the critical input he so appreciated from Nast. The publisher's conduct can be explained: Nast felt his photographers shared a proclivity for artistic license and creative excess with his illustrators, who disregarded the imperative in a fashion magazine to portray not just beautiful women in beautiful clothing but every detail of how that clothing was

constructed and worn, should the reader want to copy it.

Nast's criticisms extended to the cover photographs as well.

With regard to a Horst cover photograph of September 15, 1940: "The basis of the beauty of this unusually graceful and charming dress was the manner in which the sash was draped. The scheme of draping was a new idea and the main feature of the dress." For Nast the image did not achieve its informative purpose. "The right arm was so placed that it covered the waist, thereby obscuring the fall of the sash. In addition, a table had been placed in front of the figure, which not only obscured the fall of the sash along the length of the legs, but distorted the one bit of the sash that was left to view."

Of pictures by John Rawlings published in the issue of December 15, 1941: "The accessories consist of monstrous statues, the consoles of wooden scrolls, placed in the foreground, completely killing the dresses.

They not only distract attention, but imprison the model and in some parts are so aggressive that they merge with the model, thus creating general confusion."

To photographers who indulged in overly ornate backgrounds: ". . . a room with beautiful furniture and charming decoration, and architectural detail, a landscape, a building—any background picturing luxurious surroundings can add to the impression of the beauty of the dress. But the use of such backgrounds requires judgment and taste in their selection, a painter's sense of composition, and above all, a realization that the prime object of the photograph is to report the dress accurately and to bring out its distinctive characteristics or its utility. I am beginning to think we shall be obliged to appoint a censor whose sole duty at all sittings will be to accomplish simplicity by eliminating backgrounds and accessories of every nature—furniture, ornaments, decoration and architectural details—that are distracting and unnecessary."

CRITIQUE
Horst's cover of September 15, 1940, displeased Nast because the model's arm and the table obscured the innovative feature of the dress, its loosely tied sash.

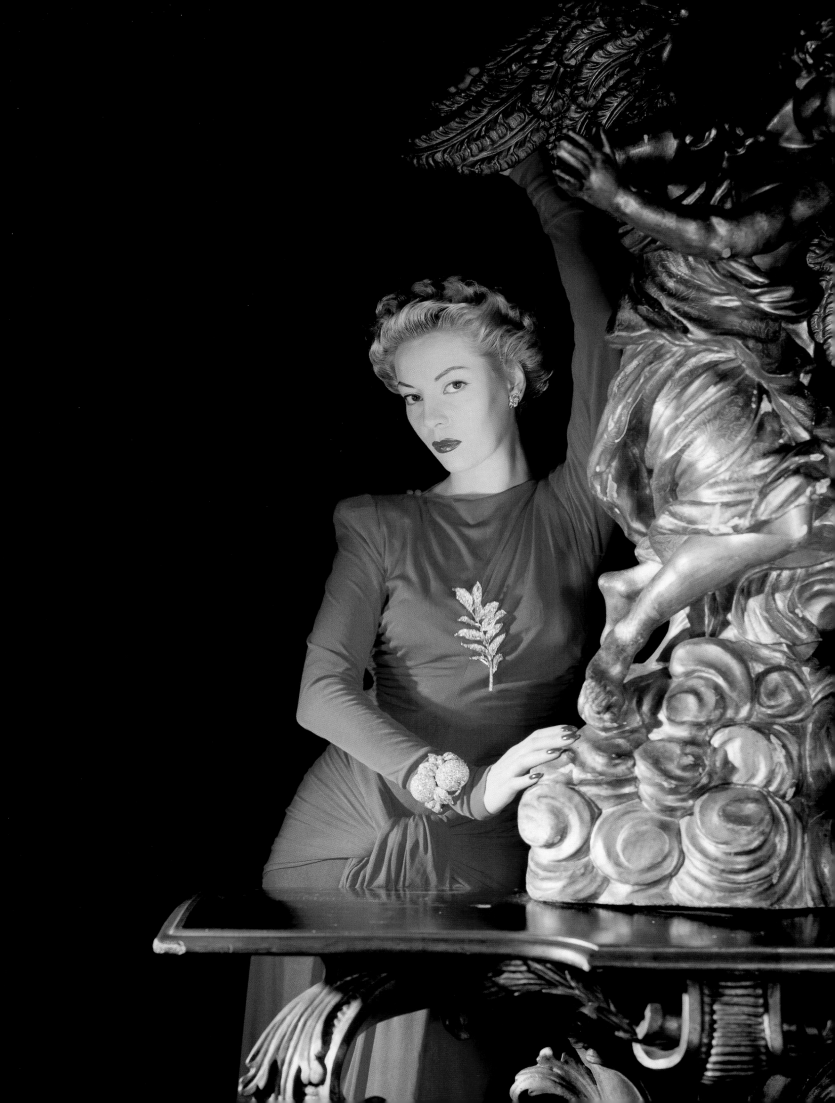

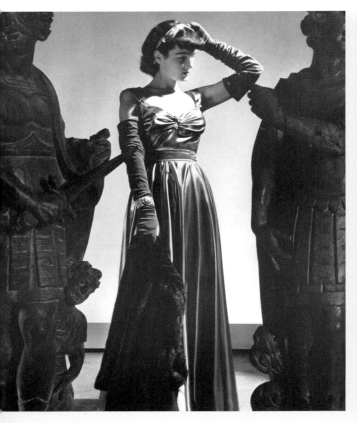

CRITIQUE
In Rawlings's picture published on December 15, 1941, Nast felt that the statues were ugly and distracting and spoiled the presentation of the dress.

Here is a studio photograph:
Do you prefer this kind?
Please write and tell us

THERE are two kinds of fashion photographs—studio photographs and outdoor snapshots. The studio photograph, like the one taken by Horst, above, is a work of photographic art completely under the photographer's control. He can use any lighting, background, and composition he chooses. He can pose the models and arrange the clothes to express his conception of beauty and elegance. He is, in fact, an inventor—conceiving an idea and executing it.

Do you prefer this sort of photograph? We're taking a poll; to make your choice easier, we have photographed the same dresses for each example of photographic style. Please write to us, and cast your vote. Address: Art Director, Vogue, Graybar Building, N. Y.

With the advent of outdoor pictures of fashion subjects, Nast's resolve to find out what was acceptable to the female readership led him to carry out an experiment never before attempted. In order to ascertain public opinion in the matter of indoor or outdoor photography, in the June 15, 1942, issue of *Vogue* he published two pictures side by side, on opposing pages. To the left, a picture taken by Horst in a studio showed two models wearing evening gowns and leaning on a love seat; to the right, a photo by Toni Frissell showed the same models wearing the same gowns, but on a sun-drenched beach. The magazine invited the readers to report their preference. The result was not what Nast expected: 75 percent chose the indoor photo. So the editor, to support his own predilection for outdoor photography, made appeal to the statistics drawn up by his advisor Lucien Vogel, which were perhaps the most accurate ever. Vogel stated: "Since the models were in evening dresses, the average reader finds the studio photographs more natural, both on account of their setting and

I FRISSELL

TEST
These pictures taken by
Horst in the studio and
by Frissell outdoors were
published side by side.
Readers were invited to vote
for their favorite.

The outdoor snapshot, like the one taken by Toni Frissell,
·ove, is entirely diffcrent from studio photographs. Nature pro-
·les sunshine for lighting, wind for dramatic effects. The outdoor
·otographer is a discoverer, on the lookout for something lovely
· happen—and when he sees it, he snaps his camera. The result, an
·rested fragment of life and spontaneous motion.

Do you prefer this sort of photograph? We're waiting to hear
·ich type appeals to you. In any case, you'll find the dresses appeal-
·g. The first, starched white rayon chiffon with blue Celanese rayon.
·9.95. Bonwit Teller; I. Magnin; Marshall Field. Second, black
·gandie with white bands; about $23. From Russeks; L. S. Ayres

Here is an outdoor snapshot:
Do you prefer this kind?
Please write and tell us

the lighting. On the contrary, the pho-
tographs taken outdoors seem artifi-
cial. The average reader is quite rightly
disturbed by the incongruity between
the evening dresses and the settings,
lighting effects and poses in the out-
door photographs." The experiment, in
short, showed that indoor and outdoor
fashion photography could coexist.

It was now the early 1940s. In the rel-
atively short span of thirty years Nast's
obsession with improving *Vogue*'s
graphics—with creating a new way of
showing fashion, with achieving per-

fection in the pages of his magazine—
had changed photography itself. The
styles put forward by de Meyer,
Steichen, Beaton, Hoyningen-Huené,
Horst, Frissell, and other notables
made photographic history and at the
same time changed the way women
and their place in society were looked
upon. Nowadays the *Vogue* pho-
tographs from those years constitute
a testimony of the times, of customs,
of artistic currents. As Horst once
aptly said, "We never felt we were
just taking a photograph. We were
making a record of our time."

1910–1940: CHANGES IN FASHION AND THE END OF AN ERA

During the three decades that Condé Nast ran *Vogue*, new styles appeared, new fashions, new modes of social behavior, new pastimes and customs, all of which progressively changed the ways people lived.

When *Vogue* first appeared, fashion was thought to be important only to European aristocrats and a handful of Americans, especially the Four Hundred for whom the magazine was ostensibly published. Later it became a fundamental factor in the lives of women of all social classes. The early *Vogue* magazine showed through its illustrations a tall and slim ideal of feminine beauty. During the first decade of the twentieth century, fashion largely retained the ornate style of the Belle Époque, with its ostrich-feathered hats and fans as symbols of social status. The prince of fashion was designer Paul Poiret, who would do away with corsets and petticoats. In came the brassiere and the hobble skirt, and the fit of dresses was generally loosened.

During the first ten years of Nast's management of the magazine, fashion was powerfully influenced by the

magnificence of the Russian ballets and by the exotic clothing of the female dancers. Poiret, whose ascendency endured until after World War I, decreed that the ultimate in elegance was the combination of plumes with turbans and stone beads with spectacular, harem-style apparel such as baggy trousers and fur-lined tunics. Skirts were being shortened, shoulders and arms were bared, and the rigid choker collar gave way to the open neckline. In April 1911 *Vogue* for the first time started mentioning trousers (which were then worn under skirts) together with such adjectives as "daring" and "sensational" but also "modest" and "flirtatious."

This decade saw the appearance of two towering figures in the world of fashion, Gabrielle "Coco" Chanel and Madeleine Vionnet. In 1913, rejecting the overblown Oriental style, Chanel introduced her first creations in jersey knit. She was the first designer to recognize the clothing needs of women interested in sports activities. Vionnet about this time formulated her theory that "it is the dress that must adapt to the female body." She created a simple fashion based on simple

1936 STYLE
With simple but elegant aesthetics, Chanel designs charmed women and caused a revolution in fashion. This photograph is from a production published in April 1936.

Stelchen

MODEL IMPORTED BY BERGDORF GOODMAN

*Rose moire—an important fabric in an important colour—
combines with flesh coloured moire in a Vionnet picture dress
with a full skirt with an uneven hem-line and a bow effect in
front; shoes from I. Miller; jewels from Black, Starr and Frost*

FORERUNNERS
Vionnet fitted the clothes to
the body and created the
"bias cut." At left, one of her
first creations using the tech-
nique, published in 1926.
Ten years earlier, in February
1916, Chanel and her dresses
and coats (opposite) had
made their first appearance
in the pages of *Vogue*.

straight lines inspired by contemporary
art movements, which were attracting
wide popular attention and which were
reflected on the covers of *Vogue* by
Lepape and Benito. In 1926 Vionnet
introduced the bias cut, a technique
that allowed the fabric to conform to
and enhance the female figure.

In the 1920s, following the horror of
the war, the world wanted to have a
good time. The cult of youth and
hedonism was born with its dances,
travels, outings, automobile races,
sports, and body consciousness. The
trend was toward slim, flat, boyish
figures. As fashion literature was only
then taking its first steps, it was hard
for readers to identify the designers.
So in 1923 *Vogue* decided to offer a
prize to readers who could recognize
the creations of twelve famous
designers, among them Jean Patou,
Paul Poiret, Jeanne Lanvin, Jacques

Doucet, and Charles Worth. The
magazine published one picture of
each item of apparel and gave some
clues to the identity of its creator.
The prize was a discount on pur-
chases of clothing. This was one of
the very few occasions when *Vogue*
referred to money in any way, as it
never published the prices of the
clothing it wrote about.

In the postwar era designers did not
limit themselves to the creation of
clothes but began to turn their atten-
tion to perfumes. A *Vogue* article titled
"The Perfume of Couture" pointed out
that Worth, Callot Soeurs, Lucien
Lelong, and Poiret favored intriguing
names for their fragrances, whereas
Coco Chanel (whose Chanel No. 5
would become a classic like her little
black dress) and Edward Molyneux
had chosen to number their creations.
Jean Patou created three fragrances,

one for blondes, one for brunettes,
and one for redheads.

By this time many women held jobs
that had been vacated by men during
the war years, and more were flowing
into the labor market. This, and the
influence exercised by art deco with
its long and nonvoluptuous figures,
led to the appearance of the *garçonne*
(tomboy) style, which called for short
hair and sleek clothes that stream-
lined the shape of the body.

Coco Chanel now came into her own.
She created the "poor chic" style,
opening for women a world of comfort
inspired by male attire and champi-
oning a simple aesthetic. The Chanel
look was truly a revolution both in
fashion and in society. Until then, a
woman needed money to have class;
for Chanel, class depended not on
money but on style.

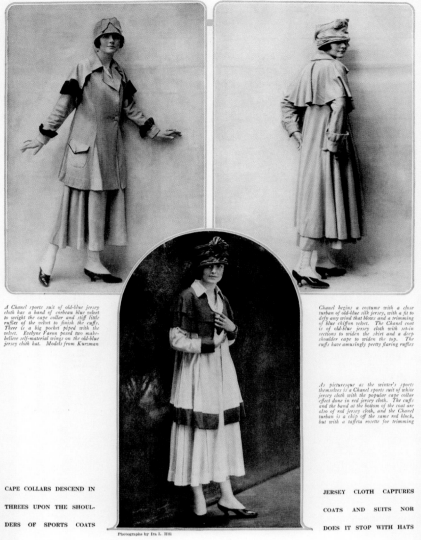

A Chanel sports suit of old-blue jersey cloth has a band of corbeau blue velvet to weight the cape collar and stiff little ruffles of the velvet to finish the cuffs. There is a big pocket piped with the velvet. Evelyne Varon posed two mother-believe self-material wings on the old-blue jersey cloth hat. Models from Kurzman.

Chanel begins a costume with a close turban of old-blue silk jersey, with a fit to defy any wind that blows and a trimming of blue chiffon velvet. The Chanel coat is of old-blue jersey cloth with set-in sections to widen the skirt and a deep shoulder cape to widen the top. The cuffs have amusingly pretty flaring ruffles

As picturesque as the winter's sports themselves is a Chanel sports suit of white jersey cloth with the popular cape collar effect done in red jersey cloth. The cuffs and the band at the bottom of the coat are also of red jersey cloth, and the Chanel turban is a chip off the same red block, but with a taffeta rosette for trimming

CAPE COLLARS DESCEND IN THREES UPON THE SHOULDERS OF SPORTS COATS

JERSEY CLOTH CAPTURES COATS AND SUITS NOR DOES IT STOP WITH HATS

Photographs by Ira L. Hill

Chanel was responsible for yet another revolution in the fashion world of her day: She was the first to identify elegance with youth. Until Chanel arrived, elegant women wanted to look mature. After she came on the scene, elegant women wanted to look youthful. And everywhere, elegant women wanted to wear Chanel. In 1927 the designer opened a second salon, in London.

The true measure of Chanel's influence on fashion was expressed by historian and curator Harold Koda in the catalog for the 2005 retrospective of her work at the Costume Institute of the Metropolitan Museum of Art in New York:

> From the beginning Chanel's designs reflected the aspirations of women and their changing lives. Her work was an elegantly conceptualized modernism . . . that transcended class barriers and revolutionized the ideals of dress. Her new women drove cars, wore pants and ran companies (as she herself did). After World War I women began to lead freer, less circumscribed lives, and her fashions, masterfully cut and easy moving, enabled them to do so. Coco Chanel made fashion functional when she introduced her simple but elegant designs into a milieu of ornate, suffocatingly complex clothing. While other designers pursued themes of escapist fantasy—of other worlds and other times—Chanel fixed her vision on the excitement and vitality of the emphatically contemporary.

Vogue echoed all the changes that were taking place and from its pages supported the cause of liberated women in the modern world. It even encouraged second marriages (which were still not viewed favorably by society) through fashion spreads such as "An ideal gown for a second wedding day." Nast biographer Caroline Seebohm declared that the key to his success was his acumen in picking the right moment and the right type of woman reader to address in his magazine. "Like the other great magazine publisher of the twentieth century, Henry Luce, Nast, although a brilliant businessman, was driven by a vision. But whereas Luce's vision was political and patriotic, Nast's was purely aesthetic. . . . At an exhilarating moment in history, Nast invented the superfluous in America. He showed Americans how to spend their money on the embellishment of life, and carried his standards of taste to England and France in a triumphant reversal of form. He cultivated a social world that may have been glossy and frivolous at heart, but whose members were encouraged to appreciate some

of the most dazzling forms of aesthetic excellence, and to improve their own lives through the pages of his magazines."

In the 1930s, despite the economic hardship following the stock market collapse of 1929, female fashion was characterized by a return to evening wear, long silken dresses tight at the waist and bare at the back. The chic detail in day wear was provided by the hat, worn slightly tipped over the forehead. With the exaggeration of shapes and outlines, women's shoulders were padded in what was dubbed "the coat-hanger look."

Dancing dominated the social scene. This was the swing era, the era of the big band, of the lindy, the fox trot, and the rumba. Fred Astaire and Ginger Rogers danced across the screen and into the hearts of moviegoers. New fashion trends were born in Hollywood and propagated by stars and starlets. The clothes and hairdos of Greta Garbo, Marlene Dietrich, and Gloria Swanson in their films were reported by *Vogue* and identified as trends. Coco Chanel signed an exclusive contract with United Artists to design the wardrobes of its actresses. Other styles were brought from Paris by the avant-garde designer Elsa Schiaparelli, whose vision was to link women with art. Drawing her inspiration from the intellectual and artistic atmosphere that surrounded her, she made lavish use of costume jewelry and beads, introduced the practice of dyeing furs, and created surrealist sleeves.

In 1932 *Vogue* suffered a serious loss from its ranks with the resignation of Carmel Snow, right-hand assistant to Edna Woolman Chase, whom Condé Nast had groomed to be the next editor in chief of the magazine. Snow, who had joined *Vogue* in 1921, left to go over to *Harper's Bazaar*, a publication of Nast's archrival William Randolph Hearst, taking with her all

her contacts and experience. At *Vogue* she had worked with Steichen to develop fashion photography. After her promotion to editor in 1926, it was she who chose all the clothes pictured in the magazine, and when Mehemed Fehmy Agha became art director, she learned the value of visual impact in the design of a publication. During her tenure she imposed on *Vogue* fashions a new, more practical style, with the clothes subordinated to their wearer, and she conveyed the message that the styles and colors should express the personality of the woman herself. Carmel Snow was not the only person to defect from one army to the other—among those who followed in her footsteps was the photographer Hoyningen-Huené in 1935—but her case was the most open manifestation of an editorial war that was to last several more years, into the period when the respective generals, Nast and Hearst, were no longer leading their own troops.

Also in this decade, new materials appeared that allowed the creation of body-hugging bathing suits that did not lose their shape in the water. *Vogue* showed one on its first color-photograph cover in 1932, and in 1935 included for the first time in its pages a picture of a two-piece bathing suit.

During the first decade under Nast, the words most used by *Vogue* had been "good taste," "education," and "distinction." Later, in the 1920s and early in the 1930s, everything became "chic" or "elegant." In 1937 the expression "sex appeal" made its first appearance, just two years before the party came to an end and Hitler unleashed World War II. From then on and for the next six years, world history would be drastically changed. *Vogue*'s history would also change going into the 1940s. A new history was being written.

HARLEQUINS
All the magic of Elsa Schiaparelli's style is evident in this luxurious 1938 production. Her clothes were inspired by avant-garde art, with surrealist sleeves and dyed fur. She favored the use of sequins and costume jewelry.

THE LOGO AND ILLUSTRATION

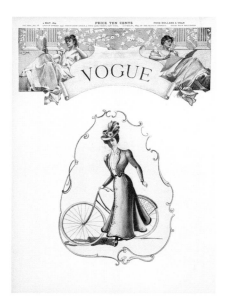

During the early years the *Vogue* logotype created by Harry McVickar, with two reclining women in the upper half, remained largely unchanged. It varied only occasionally, mainly when the cover was printed in color. In January 1907 the word "Vogue" was inserted as an entablature above columns. With the arrival of Condé Nast and his decision that the cover should always be in color, the *Vogue* logo became part of the illustration and changed often, a luxury that would be almost impossible to afford today. Condé altered the logo of his publication as often as he cared to, and even left its form and location up to the imagination and creativity of the illustrators. The word "Vogue" would sometimes appear obliquely, or resting against a margin, or written in stars or in simulated marble letters or in flowers surrounded by small clouds or in filigree. The object was to identify *Vogue* with the most elegant and modern pictorial style, and to make the women readers feel that, rather than a magazine, they had in their hands an object of art. Here are some of the logos and their variants during the Illustration Era.

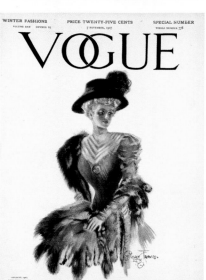

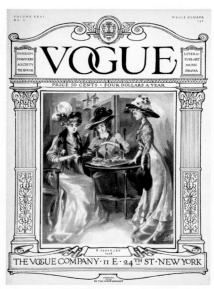

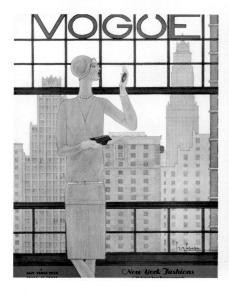

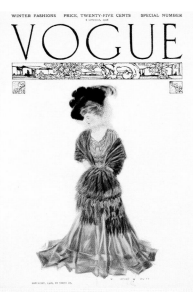

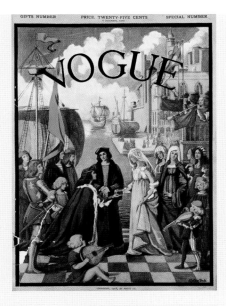

FIRST STAGE

The logo created by McVickar did not change between 1892 and the beginning of the twentieth century. It varied only when the cover was published in color. Then the logo became part of the illustration, and it was the illustrator who determined its shape, location, and color.

SECOND STAGE

In 1907 efforts were made to modernize and unify the typography used for the magazine's title. The logo was enhanced by the linking of the letters O and G in the word "VOGUE."

THIRD STAGE

In 1909, with the arrival of Condé Nast, the illustration became the most important part of the cover, and the logo was integrated into it. This approach was used until the 1940s, when a more uniform typography came into use, rather like the one employed today.

FROM COVER TO INSIDE DESIGN

The constant concern of *Vogue*'s editors for the visual appeal of the covers extended to the inside of the magazine. Nast always contended that a publication that aspired to offer the very best in art and elegance had first to set an example with its own pages: The quality had to be superb, from the presentation of the articles to the paper on which they were printed. It would not please Mrs. Stuyvesant Fish or Mr. Vanderbilt, he thought, to have their photographs appear in a magazine printed on low-grade stock, or in an article designed without aesthetic discernment. Caroline Seebohm gives this example of Condé Nast's obsession with design:

The *Vogue* formula, to which Nast returned over and over during his career, depended on service—the imparting of fashion information to his readers as efficiently and clearly as possible. He believed, therefore, that legibility was the fundamental principle behind every editorial decision. "Legibility," he told his staff, "is the first essential of good editing—it demands clear writing, the logical organization of written or illustrated material, photographs or drawings that clearly fulfill their mission, informative titles and subtitles properly displayed. The necessity for legibility applies uniformly to all the various kinds of editorial material. The editor who makes his periodical readable and satisfactory must achieve legibility on a dozen different fronts. Sloppy editing that defeats legibility on any one of these fronts puts the reader to extra work to discover what, in text or picture, the publication is getting at. The editor succeeds in achieving legibility only when he protects the reader from even momentary doubt as to the meaning of whatever kind of editorial material he is offering his reader." To this end, throughout his career, Nast would meticulously measure the position of titles and artwork on the magazine's page. If a line, caption or illustration was off by a fraction of an inch, according to his blueprint, the page would have to be reset. However inventive the art director wished to be, Nast's ruler would be the final arbiter. Naturally enough, these regulations drove the art department into a frenzy.

During his time as head of the magazine, which extended to the early 1940s, Nast had two art directors, Hayworth Campbell and Mehemed Fehmy Agha. He also had two outstanding advisors, the illustrator Eduardo Benito and the artist-turned-photographer Edward Steichen. Each contributed in his own field to improve the design and image of *Vogue* to keep the magazine fresh looking. Campbell, who had worked as an illustrator of articles that appeared in the inside pages, was responsible for the layout of the magazine between 1909 and 1925. It was he who gave *Vogue* its characteristic style during these years: very orderly pages with much white space,

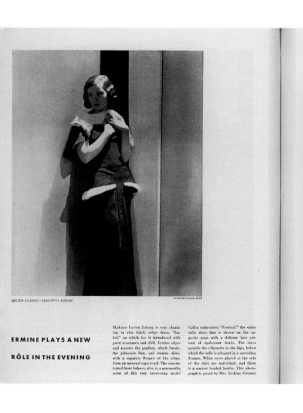

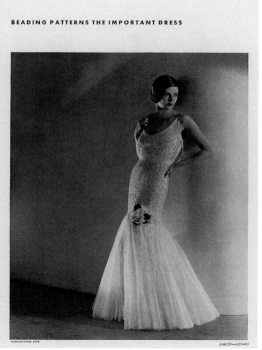

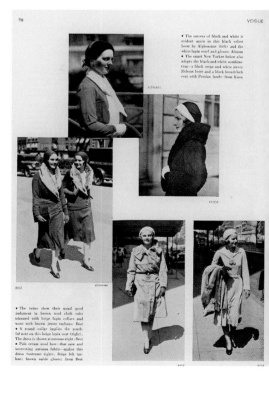

NEW DESIGN

Beginning in 1930, the new art director Mehemed Fehmy Agha changed the face of the magazine. Based on an earlier sketch by illustrator Eduardo Benito, Agha altered the typography, removed the frames around pictures, and gave the pages a much more modern air. He increased the visual impact of the photos and even placed them in sequence to tell fashion stories. This was the first major redesign of *Vogue*.

small titles, traditional type (Bodoni and Cheltenham), decorative illustrations, text in dense blocks, and thick frames around the photographs. In short, *Vogue* looked very much like a photograph album sprinkled with columns of text.

This visual identity, adequate for the second decade of the century, needed to be modernized to match the aesthetic spirit of the times that *Vogue* captured on its covers. The worlds of illustration, painting, and design were being revolutionized by the modern style that first appeared in Paris in 1925 at the Exposition Internationale des Arts Décoratifs et Industriels Modernes. Nast asked Benito, whose elegant art deco models and cubist figures had transformed *Vogue*'s covers, to produce a new look for the magazine. Before Benito left *Vogue* in 1927, he introduced the Gothic or sans-serif typeface developed by the Bauhaus, the German school that was distancing itself from traditional forms in all

aspects of art, architecture, and design. This typeface was perfectly suited to the modernist aura Nast wanted for his magazine. Benito explained his philosophy: "Let us realize that . . . for the first time, thanks to machinery, we are living in effective collaboration with the pure geometric forms. Le Corbusier writes on architecture, but his reasons are applicable to all forms of art. Modern aesthetics can be explained in one word: machinery. Machinery is geometry in action. . . . The setting up of a magazine page is a form of architecture, it must be simple, pure, clear, legible like a modern architect's plan, and as we do a modern magazine we must do it like modern architecture."

The new look and the arguments impressed Nast, who offered Benito the post of *Vogue* art director. Benito declined. "I don't want to have to go to the office every day," he said. Fortunately, Mehemed Fehmy Agha soon appeared on the scene. In the

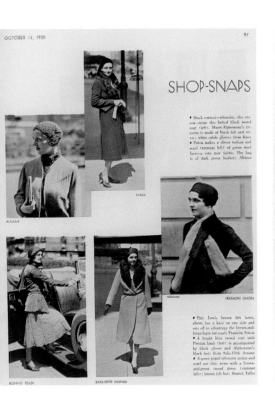

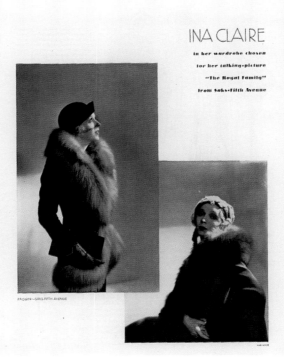

SPRING IS SERVED

COLOR ARRIVES

In 1931 Condé Nast hired two experts in color photography, Anton Bruehl and Fernand Bourges, who developed for the company a high-quality color separation process. This technical advance enabled *Vogue*, on April 15, 1932, to publish its first color photograph, of a springtime table setting (left). Three months later a color photograph first appeared on the cover, and September brought the first double-page color spread (right), which showed seventeen different types of fabric with a woman's hands resting on them.

years that followed, he would put into practice the philosophies of Benito and definitively change the appearance of the magazine.

Mehemed Fehmy Agha's first experience at *Vogue* was with the German edition, published between April 1928 and late 1929. Dr. Agha (he liked to be called "Doctor" as he had a graduate degree in political science) brought to *Vogue* not only an acute artistic sensibility but also an impressive command of languages. Born in the Russian Ukraine to Turkish parents, he spoke German, French, English, Russian, and Turkish. Nast met him in Berlin and, greatly impressed by his work, immediately proposed that Agha direct the entire art department of the American publications. In 1929

Agha began transformating the layout and the presentation of photographs in the pages of *Vogue*, *Vanity Fair*, and *House and Garden*. Taking the advice of Benito, he did not permit the use of italics and continued the use of the sans-serif typeface, enlarging the headlines.

Agha, who in time would become Nast's right-hand man, was consulted about everything and soon became the central figure of the firm's editorial dynamics, making important contributions to the modernization of the magazine throughout the 1930s. Before he appeared on the scene, illustrations frequently were presented in frames and sometimes the captions and the images had little to do with each other. Furthermore, every page had

identical margins. Agha did away with the frames and occasionally even with the margins; he enlarged the photographs and sometimes filled entire pages with them, presenting them side by side, to illustrate an article on fashion. He set titles in larger-than-usual type to tie pages together and create spreads. He carefully related layout to content in order to transmit a sense of unity. Until Agha joined the firm, the writers had been able to add to pages already closed; after Agha joined, the editorial department and the art director worked in close collaboration. It was Agha who, through his personal approach to his work, changed forever the role of the art director. He ceased to be a mere supporting figure and became a major force within the magazine. As art director he was able to exert enormous influence on the work and the career of a photographer or an illustrator. With his professional eye he could improve deficient photos, reducing their size or enlarge those of mediocre quality and make them memorable merely by the way they were grouped and positioned on the page.

During the Agha years *Vogue* published the first color photograph in its history, became the first magazine to print images across double pages, and was the first to come out with a color photo cover. For an entire decade Agha was responsible for *Vogue*'s new, modern look, which presaged the next editorial stage, the Photography Era.

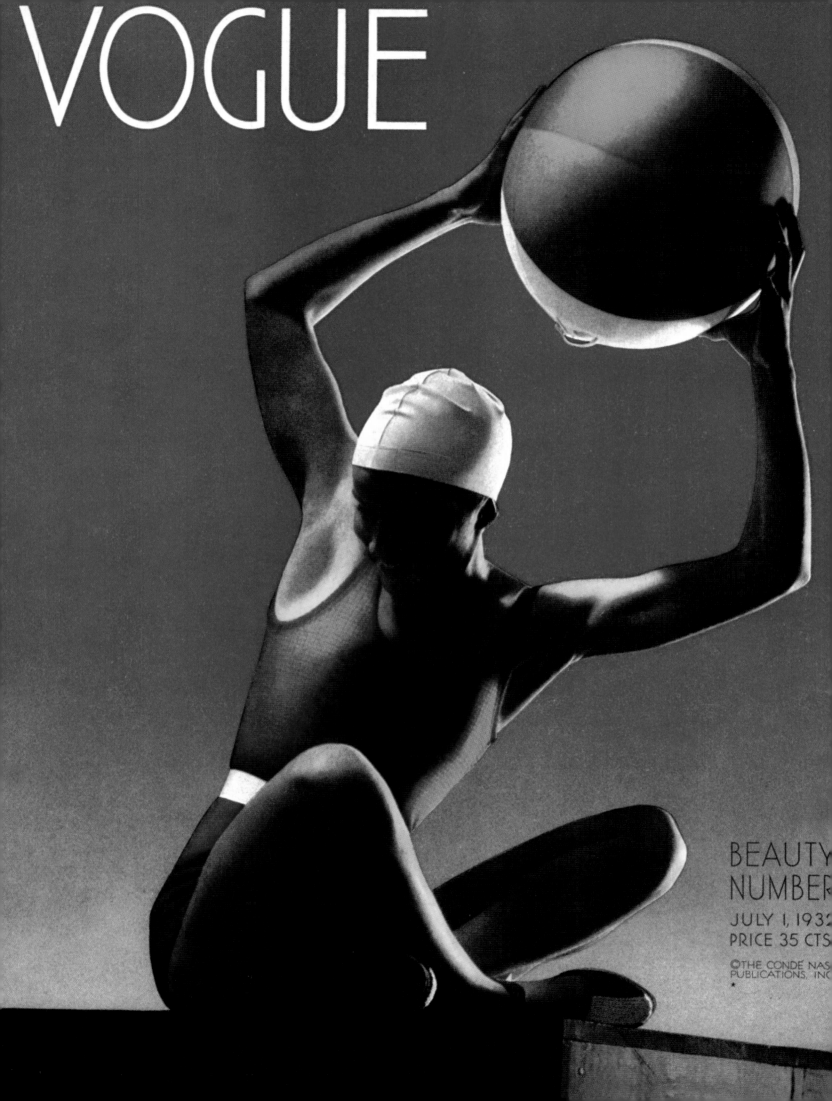

VOGUE

BEAUTY
NUMBER

JULY 1, 1932
PRICE 35 CTS

©THE CONDÉ NAST
PUBLICATIONS, INC

A NEW ERA: COLOR PHOTOGRAPHY AND THE COVER

FIRST IN COLOR
Edward Steichen, then the magazine's head photographer, took this picture for the July 1, 1932, cover. The tanned figure with the beach ball became the symbol of the new type of athletic, active, healthy woman.

The impact of the cover for July 1, 1932, a color photograph by Steichen of a girl in a bathing suit, was decisive for the future of *Vogue*. As the Photography Era progressively replaced the Illustration Era, *Vogue*'s experiences with color photographs for covers assumed particular relevance in that very few magazines then had such covers. Either the magazines did not have the technical know-how, their images lacked quality, or photo covers were simply too costly to produce. It is worth pointing out that *Time* magazine started using color on its covers only in 1926, a year before it instituted its famous red border; the use of color photographs, however, on its cover had to wait several decades. *National Geographic*—one of the first publications to experiment with color photography on its inside pages, in 1916—waited until 1959 to bring out a cover in four colors. And *Life*, the premier photo magazine launched in 1936, kept to black-and-white covers for several years. Leading the way in 1932 with its Steichen photo, *Vogue* was a true pioneer in the use of color photography on magazine covers.

The Nast years at *Vogue* had already seen three different stages in cover illustration, as chapter 2 has shown.

The consistent use of color dated to 1909, with American artists illustrating the fashions of the Belle Époque in styles ranging from great realistic detail to a high degree of fantasy. Starting in 1916 the magazine imported illustrators trained at Paris's École Nationale des Beaux-Arts, who depicted fashion from their avant-garde artistic standpoints. Then in the 1930s the style of illustration again began to favor explicit detail. With the dawn of the Photography Era in 1932, the documentary tendency in covers was reinforced, and color photography ended up totally dominating the field by the end of the decade.

This gradual change in the covers was guided by the perceptions of the editor, who was seeking the most effective way to attract contemporary readers. Early in the 1930s, photography, which had already established its presence inside the magazine, seemed the best way to communicate its contents. Alexander Liberman recalled, from his period as art director, that "the reason was that the artist had to commit himself to reproducing a dress; a photographer was simply taking a picture of a beautiful woman. You can't ask Matisse to copy a dress pattern. Yet a photographer clicks the shutter and it's done."

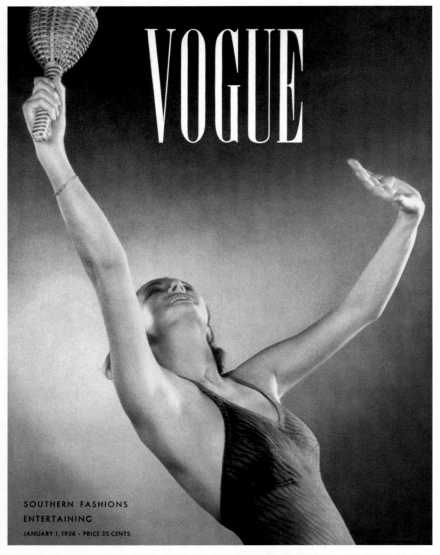

VOGUE

SOUTHERN FASHIONS
ENTERTAINING

JANUARY 1, 1936 · PRICE 35 CENTS

Nast, always an obsessive student of everything concerning the aesthetics of the magazine, constantly analyzed and compared the covers that were created by artists with those done by photographers. Memos on his views were distributed to the editors. In these Nast would note the circulation of the issue, the sales and returns, and whether the cover was an artist's illustration or a photograph. He would grade each cover for quality and attractiveness according to criteria of his own and write a brief comment on the issue's sales. For example, "January 1, 1934. Photographer Bruehl. Grade B. This issue sold well. The cover has no poster value, the model is boring and is unintelligent. Print run 47,447. Sales 36,187. Returns 24%." Or " March 15, 1935. Illustrator Benito. I grade it B because I think it is brilliant, has clear colors and has a different look. It sold rather badly taking into consideration the season. Print run 64,427. Sales 49,620. Returns 30%." The Nast reports, plus the research data contributed by his circulation department during the 1930s, showed that the new color photographs by Steichen, Hoyningen-Huené, Horst, Bruehl, and Beaton directly contributed to sales. In 1938 eight covers employed photography, and in 1939 the number rose to twelve, or half of the year's covers.

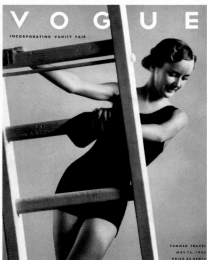

SUMMER

For the first time ever, women began to expose their bodies to the sun in a quest for slim, tanned figures. Their bathing suits were new types made of latex and piqué, such as these photographed by Steichen (top), Horst (model applying lipstick and Angelica Welldon on ladder), and Bruehl (model with luxurious headdress).

WINTER

During the 1930s furs were very much in fashion. Blue fox and silver fox, which were bulky and commanded attention, were popular. Horst (top and far right), Steichen (large cover at right), and Bruehl (top, middle) specialized in photographing them for the magazine's covers.

Vogue

AUGUST·15·1933

VOGUE

SUMMER HOLIDAYS

VOGUE incorporating VANITY FAIR

PARIS OPENINGS I
SPRING SHOPPING
MARCH 1, 1936
PRICE 35 CENTS

Vogue INCORPORATING VANITY FAIR

BETWEEN-SEASONS FASHIONS · JANUARY 15, 1938 · PRICE 35 CENTS

HATS

The fashion of the decade was largely based on the use of accessories such as gloves and jewelry, but the touch of distinction was imparted by hats, which were frequently presented on covers as symbols of glamour and elegance. The larger photograph was taken by Hoyningen-Huené, who used contour lighting to guide the viewer's eye toward the feathered felt hat by Reboux. In another example by Huené (top, right) the hat cleary steals the show, while Bruehl exudes sophistication in his covers (right, middle and bottom).

Aside from sales considerations, for Nast the photo covers achieved a basic *Vogue* objective: They presented the readers with a faithful preview of the subject matter, or, as Nast put it, "Should serve as an eloquent barker in behalf of the show that goes on within the pages of the magazine." And they accomplished something more, which Valerie Lloyd pinpoints in her 1986 book *The Art of "Vogue" Photographic Covers*:

The earlier graphic covers usually had more to do with the artist's imagination than with any current fashion. Photography was to change all that. Although it could record fantastic assemblages constructed by the photographer in his studio, the documentary nature of photography, inherent in its mechanical process, set a limit to the credibility of such ventures. The differences were clear: from now on women photographed for the covers were particular women and the clothes they wore specific garments created by designers who could be credited. It was thus that photography contributed directly to the development of *Vogue* and all other magazines into the highly organized market products they are today. Credits meant advertising and advertising meant revenue, and gradually over the years, when many glossy magazines have foundered, *Vogue*, like others, has become increasingly reliant on marketing policies.

NOVELTIES

Multihued capes, hats, and dresses were used to create an image of newness on the covers. The larger photo was taken by Toni Frissell, who caught viewers' attention with the incongruity of a woman wearing a long gown at the beach. At left is a graceful composition by Beaton, while just below are two stunning Horst covers.

A VOGUE MILESTONE:
CELEBRITIES PRESENT FASHION

IN THE GARDENS
OF THE
CHÂTEAU DE CANDÉ

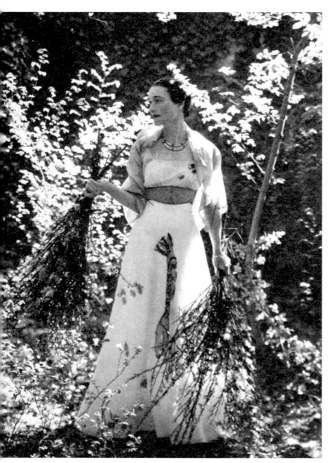

SIMPSON AS MODEL
In 1937 Wallis Simpson, photographed by Cecil Beaton, appeared in the pages of *Vogue* wearing clothes by Schiaparelli and Mainbocher. The photo shoot took up six pages.

In the mid-1930s, unlike today, there were no magazines devoted to celebrities. *Vogue* pioneered the news coverage of royalty. Several issues between 1934 and 1937 published material about the British royal family and even featured them on the cover. *Vogue* focused on such grand occasions as the wedding of the Duke of Kent and Princess Marina of Greece, the silver jubilee of King George V and Queen Mary, the coronation of King George VI and Queen Elizabeth, and the wedding of the Duke of Windsor and Wallis Simpson. There even was an issue about Edwardian England, comparing Edward VII with the briefly reigning Edward VIII, whom the magazine considered the most elegant monarch of the day. Always there was an emphasis on the clothes worn by countesses, duchesses, and princesses.

Two circumstances moved *Vogue* energetically toward this subject matter: the existence of a British edition of *Vogue*, and the fact that photographer Cecil Beaton was on the exclusive guest list of these celebrations. He was the official photographer of the engagement and the June 1937 wedding of the Duke of Windsor and Mrs. Simpson. As we have seen, Beaton even carried out a fashion shoot using Simpson as his model, wearing dresses by Mainbocher and a white Schiaparelli pantsuit. It caused a sensation that Wallis Simpson herself, considered the prime example of style and elegance and good taste, would actually model for a magazine. And of course the fact that she, a commoner and twice-divorced American woman,

had caused the abdication of a British monarch only added to the excitement and interest. When Condé Nast saw the marvelous job Beaton had done, he had no doubts: Against the advice of British *Vogue*—whose editors thought the entire matter to be in very poor taste—he devoted six full pages to Beaton's photographs.

Following this 1937 triumph, for the rest of the decade and through the 1940s, celebrities presenting fashion in the pages of *Vogue* became much more frequent. Kohle Yohannan, in his book *John Rawlings: 30 Years at Vogue,* credits photographer Rawlings with submitting the idea to Condé Nast. According to Yohannan,

> As a result of his suggestion in 1942 that Hollywood personalities and society figures would prove more visible and effective vehicles of editorial fashion than models, *Vogue* increased its focus on New York's glittering café society and the stars of the silver screen. In a truly prophetic three-page inter-office memo (which not only documents Rawlings' idea but also offers insight into the young photographer's social and business savvy), Rawlings specifically pointed out that Condé Nast could trade on its magazine's international circulation in exchange for unpaid cameos by glamorous personalities. The implications and resulting phenomenon of this seemingly simple communication are nothing short of mind-boggling. Who knew that after a relatively brief time on the job, an unknown Midwestern display artist would so profoundly affect the

cultural underpinnings of what was unarguably the most powerful and influential fashion magazine of its era? Beyond this, and proof of Rawlings' and *Vogue*'s long-term impact, nearly fifty years later one can scarcely even conceive of fashion beyond the realm of its respective film and media stars—all forms of media and advertising having been virtually subsumed by the celebrity-saturated fashion industry, now fueled almost entirely by star power. From the point of view of cultural history, Rawlings' role in effecting this change is without question one of the most highly impacting achievements of his career and is more resoundingly influential and formative than any contribution to twentieth-century pop culture made by any photographer since. . . . To the credit of Edna Woolman Chase and Condé Nast, John Rawlings' insightful suggestion was met with unanimous praise, and it quickly paid off to an extent that no one could ever have predicted.

After Wallis Simpson, other well-known figures followed, including Vivien Leigh, Marlene Dietrich, Veronica Lake, and Loretta Young. *Vogue* led the trend toward celebrities long before the last years of the century, when celebrities would crowd the covers and inside pages of all magazines.

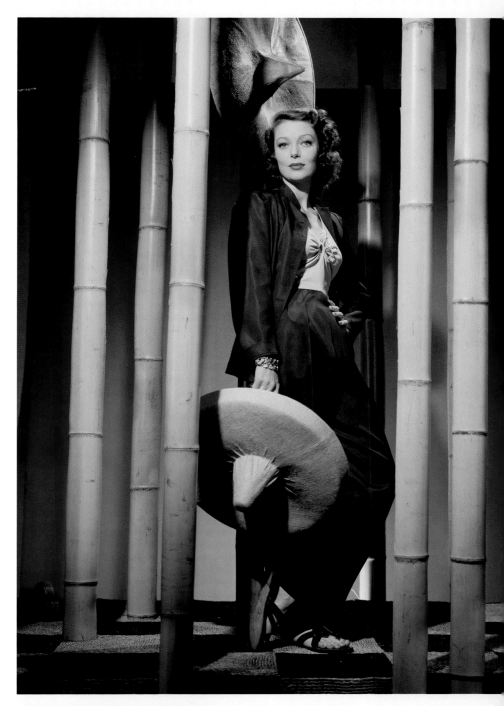

MOVIES AND FASHION
Screen stars such as Loretta Young (above) or Gene Tierney (left) posed to model clothing fashions for *Vogue*. The photographer John Rawlings was an advocate of the idea.

FROM ECONOMIC CRASH
TO THE LAST DAYS OF NAST

Dear Edna,

Fact No. 1: I am a very rich man. Fact No. 2: Your devotion, industry, and very amazing intelligence have been a very great factor in accomplishing Fact No. 1. Fact No. 3: Having achieved great wealth at a time of great age I find some difficulty in spending my money. Fact No. 4: I have found one expenditure that will give me supreme pleasure and that will compensate for my bald head and my trials and tribulations in accomplishing this wealth. Fact No. 5: I have set aside $100,000 which I want you to use for embroidery on the house you are about to build on Long Island.

Gratefully and affectionately, Condé

Idle rich

In this 1928 letter to Edna Woolman Chase, his most faithful and closest collaborator at *Vogue*, Condé Nast summed up the moment of economic splendor his magazine and his finances were enjoying. In the 1920s the magazine had made money prodigiously, as profits jumped from $241,410 in 1923 to more than $1.4 million in 1928. *Vogue*'s circulation, just 14,000 copies in 1909, stood at 138,000 in 1928; *Vanity Fair*, which in 1913 started with a circulation of 12,800 copies, had climbed to 84,600; *House and Garden* almost doubled its circulation between 1920 and 1928, growing from 67,000 to 131,000; and *Vogue Patterns* did not lag behind, with a 1928 profit of $150,000 as opposed to $11,600 in 1920. The corporation Condé Nast Press, considered a model of quality in the printing industry, showed a profit in 1929, only eight years after it was set up, of $388,000 after deductions for depreciation of machinery and equipment. Enthusiastic about these results, Nast began to invest all his profits in shares of stock. This was a grave mistake, and very soon the enormous economic structure he had built over the years collapsed. The crash of the New York stock market in 1929 wiped out his money, put his firm on the verge of bankruptcy, and threatened him with the loss of all his magazines.

Economic salvation came to Nast from England, by way of the British newspaper tycoon Lord Camrose, president of Allied Newspapers and Amalgamated Press Ltd. Camrose bought Nast's shares in the company and injected large sums of cash into the maintenance and development of the magazines. He gave Nast a participation in the firm and allowed him to continue managing the magazines as he saw fit. Aside from being interested in the business for its own sake, Camrose owed Nast a debt of gratitude. In 1924 Nast had helped both economically and professionally the woman who would become Camrose's wife, Edwina Pru, a former model and actress whom he had employed as a staffer at *Vogue*.

Nast was thus able to avert a definitive financial downfall, but the attendant stress and depression affected his health. Spurred by pride, he refused to listen to his doctors, who recommended increased rest. Instead he doubled his working hours and even worked through weekends. His efforts, however, were unsuccessful in saving the *American Golfer*, which closed in December 1935, and *Vanity Fair*, which ceased to appear at the same time and fused with *Vogue*. All this affected not only Nast's health but also his personal life. In 1928 he

FASHION IN THE U.S.
In February 1938 *Vogue* published an entire issue of fashion photos all of which had been taken against American backgrounds. The idea came from Edna Woolman Chase, who hoped to "promote the beauty and the dimensions of this country." The issue was a great success and was repeated every year for decades.

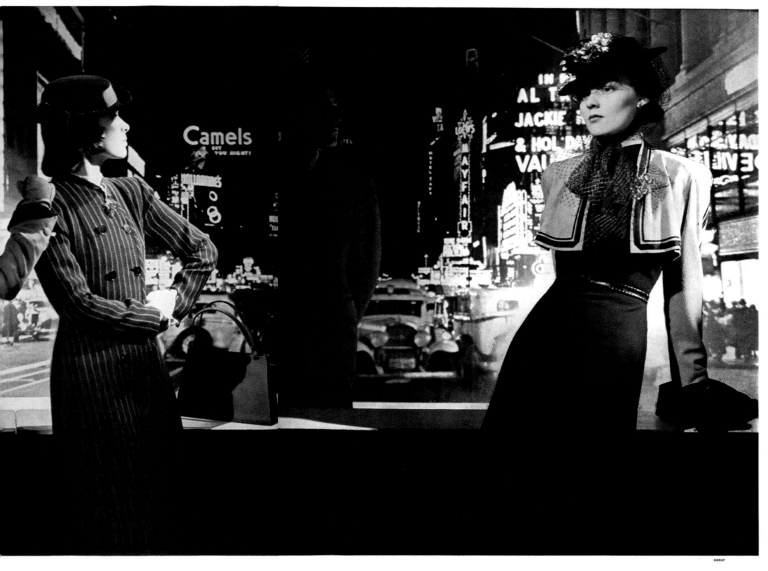

They pay high for clothes. They spend time on them. They lunch in groups, then on to shopping, bridge, or the hairdresser. They know every restaurant, night-club, and show in town. They wear outfits like the black wool one above with its grey bolero, from Jay-Thorpe. Or the two opposite: a blue wool bolero, black dress, and straw Breton from Milgrim. The other, a striped blue suit and a sailor from Saks-Fifth Avenue, New York and Chicago. They pay well over $100 for any of these costumes and consider it well spent

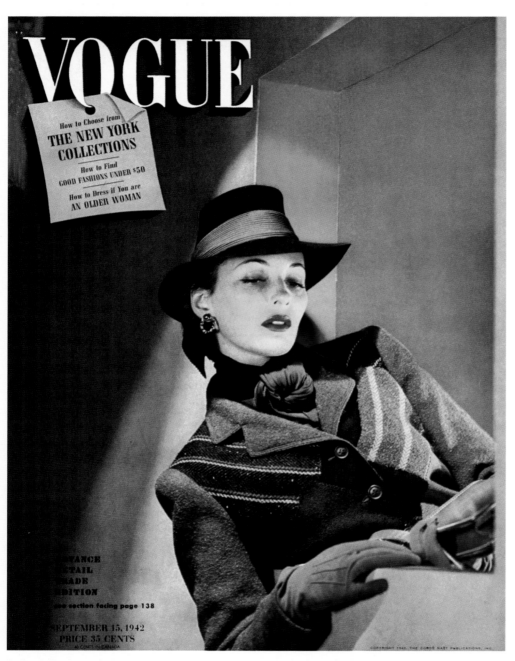

VOGUE

How to Choose from
THE NEW YORK COLLECTIONS

How to Find
GOOD FASHIONS UNDER $50

How to Dress if You are
AN OLDER WOMAN

...VANCE
...ETAIL
...RADE
...DITION

...e section facing page 138

...EPTEMBER 15, 1942
PRICE 35 CENTS
40 CENTS IN CANADA

COPYRIGHT 1942, THE CONDÉ NAST PUBLICATIONS, INC.

LAST COVER
Condé Nast died four days
after the publication of this
issue. He had firmly estab-
lished color photography and
headlines on the covers.

had married for a second time—Leslie
Foster, a woman thirty-four years his
junior—and the couple had a daughter
before they separated a few years
later. Although after the closures and
readjustments the corporation man-
aged to improve its balance sheet,
and Nast even recovered part of his
fortune, the 1929 crash scarred him
forever physically and spiritually.

Although the cumulative stress had
seriously affected his heart, Nast per-
sisted in working obsessively to recu-
perate his lost wealth and maintain the
prestige of his magazines. In 1936
the financial picture started to improve,
but his health and his state of mind
deteriorated and his character
changed completely. The formerly ami-
able and kind, well-mannered man
became sullen, irritable, and gloomy.
His criticisms found their way into
long memos that targeted everybody:
writers, editors, photographers, art
directors, business managers, gossip
columnists, and others. The memos
became more frequent and longer.
One of them, addressed to the entire
staff, started with "In looking through
the recent issues of *Vogue,* I believe
I ought to call your attention to certain
mistakes which are too often
repeated"—and then ran to sixty-
seven pages.

Nast's closest collaborators were the
first to perceive the changes in his
character and behavior. Edna Woolman
Chase recalled: "He ignored the opin-
ions even of men like Lew Wurzburg,
his vice-president, and MacDonald
DeWitt, his legal advisor. His own
judgment, indeed, became a kind of
obsession with him. Everyone else's
was poor." His friend Iva Sergei
Patcévitch said: "He was in a terrible
state of mind in the last months
before he died. He did nothing but
dictate memos. He was attempting to

write an appraisal of every member of the staff before he died." In 1941 he began suffering from very high blood pressure. Because he refused to pause, rest, or take days off from work, an oxygen tank had to be provided for him at the office. His secretary Mary Campbell, who was also a physical education teacher, was the person who looked after him. She and Patcévitch were the only members of the firm who were aware of his ailment. Every time there was a crisis—and the arguments with his collaborators were becoming ever more frequent—Campbell, with utmost discretion, would administer oxygen to him from a tank kept in her boss's private bathroom.

In December 1941, the same month the United States became enmeshed in the war, Nast was hospitalized. He had suffered a severe heart attack. At the office it was said that he had pneumonia and an ear infection. He recovered and returned to work as if nothing had happened. In September 1942 he suffered a second heart attack, and this one he would not survive. Condé Nast died on Saturday, September 19, at his apartment on Park Avenue. He was sixty-nine years old and had been head of *Vogue* for thirty-three of them. The press paid abundant tribute to him in its obituaries. Of these, the one that perhaps best summed up his contributions to the journalistic world and the influence *Vogue* had on American women was published by *Time* in its issue of September 28, 1942. Here are some extracts from that obituary:

> In an exquisite 30-room penthouse on Park Avenue death came last week to Condé Nast. He was 68; an amiable host; as publisher of Vogue, House & Garden, et al., a superlative technician of the publishing world. For a generation he was the man from whom millions of American women got most of their ideas, directly or indirectly, about the desirable American standard of living.

The apartment in which he died was the perfect complement to his publishing business and an index to the variety of his taste. There he entertained the same people for whom he published *Vogue*. There to his elaborate dinners, dances, cocktail parties, came socialites, Hollywoodites, Broadwayites, statesmen, royalty. The star of a Broadway opening was as thrilled by an after-theater party at Condé Nast's as she was by the first-night applause. The apartment which he himself planned to the last detail was so arranged he could entertain 100 cocktail guests on the roof, a dinner party of 50, another couple of hundred in the ballroom, all at the same time. Amidst 18th-Century French paintings, Chinese screens and a slightly rococo splendor, Condé Nast presided, bald and genial, peering sphinxlike through pince-nez glasses, the arbiter of his world.

But to Nast, society was only the work of evenings. The daylight was for publishing, and this was hard work. In the area he created, and in which he was lord, Nast became as expert as an assayer. His primary task as publisher was to choose editors who best knew how to choose—out of the flooding hundreds of fashion ideas, from ruffles to shoes to dinner-table glassware—the fashions which had that indefinable "smartness" which he could sense, almost by smell. Then he—and they—went to work on the presentation—to "bait the editorial pages," as he once unblushingly said, "in such a way as to lift out of all the millions of Americans just the 100,000 cultivated people who can buy these quality goods."

Vogue ran far ahead of this chill and modest ambition. Throughout the '20s and '30s, in its pages Nast decided what made fashion-sense in the welter of Parisian, New York and Hollywood ideas, about everything from decor to dogs. The best-dressed women in all U.S. towns were Vogue subscribers; stores fought to be listed as outlets for goods advertised in Vogue, and thus the Nast judgments set patterns far beyond Vogue's own circulation of a few hundred thousand. To his own women-readers Nast brought the excitement of modern art, from Seurat to Modigliani and to Covarrubias, the breath-taking photography of Steichen, Beaton, Lohse, Baron Hoyningen-Huené; and the vivid drama of fashion-drawings by Carl Ericsson, Sigrid Grafstrom, Count René Bouët-Willaumez and many others, which in turn influenced all U.S. advertising art. Vogue became a feminine bible of taste. Even its cheesecake was cool and cultured: cheesecake prettily iced. Technician Nast became a millionaire.

. . . Nast built a 30-acre printing plant at Greenwich, Conn. In the boom he also went into the stock-market. And just when he was ready to retire, he went broke. His last decade showed his qualities of honest pride and courage. Working seven days a week, he restored his personal and corporate fortunes, piloted Vogue through the '30s without making a single concession in its standards of smartness or excellence.

Always a keen student of the news, Condé Nast the man was strongly anti-Nazi and interventionist before Pearl Harbor. When the U.S. went to war, Nast the publisher took the lead in showing how patriotism can be smart and smartness patriotic. None could do it with so sure a touch.

MODELS:
THE FACES
OF FASHION

For decades, fashion photography attempted to portray the archetypal woman. The tastes and demands of each era pointed to an ideal in feminine beauty: Sometimes young women were narrow waisted, at other times less so. Their hair was long or short, blonde or brunette or auburn. Their bodies were sometimes ultraslender, sometimes clothed to enhance the roundness of their breasts. Those different ways of showing female beauty found a marvelous vehicle in women's magazines—and in the models themselves. It was they who over the years made known the face of fashion, its novelties and its attractions. They became the prime sine qua non of an industry that relied on style, elegance, glamour, and the women's fantasy of seeing themselves and being seen as attractive.

The first live mannequins were the wives of the designers, who wore their husbands' creations to show them to clients. Next came society ladies who were photographed in their own dresses, and then actresses who posed in studios and conferred a certain professional air on the metier. But it was in the 1920s that professional modeling began to take hold in the United States. This was a time when photographers were undertaking increasingly sophisticated fashion productions, employing young unknowns with beautiful faces and perfect bodies who wore impeccably the creations of the fashion designers.

TWELVE BEAUTIES
In 1947 *Vogue* asked Irving Penn to do a group portrait of the most photographed models of the decade. They were dressed by the American designers Claire McCardell, Hattie Carnegie, Traina-Norell, Nettie Rosenstein, and Charles James. From left to right, the models are Meg Mundy, Marilyn Ambrose, Helen Bennett, Dana Jenney, Betty McLauchlen (on stepladder), Lisa Fonssagrives, Lily Carlson, Dorian Leigh (reclining), Andrea Johnson, Elizabeth Gibbons, Muriel Maxwell (on stepladder), and Kay Hernan.

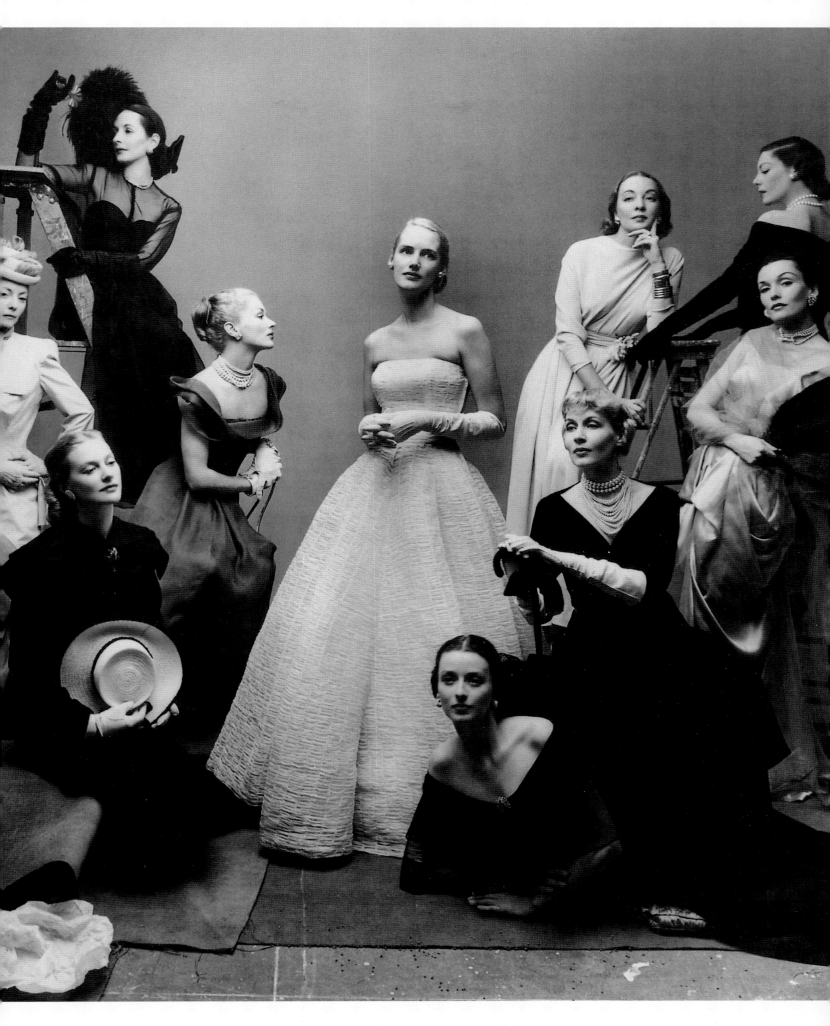

ANN ANDREWS

MIRIAM HOPKINS

MARY TAYLOR

In France some designers had begun to use specific models on an exclusive basis, so that these beautiful women would be associated only with their fashion houses. The models were identified by their given names alone, to differentiate them from the house name, which usually was the surname of the (male or female) designer. In 1924 an event called the First Audition of American Models was held in New York, organized by the French designer Jean Patou and sponsored by *Vogue*. Its purpose was to find local models who could show French fashion designs. The advertisement stated that applicants should be "elegant, slim, with good feet and ankles." This was a fundamental requirement in an era when the hemline was approaching the knee. They should also be "of refined manners." More than 500 young women auditioned. The selection was held at the Ritz Hotel, with a jury consisting of Elsie de Wolfe, Edward Steichen, Edna Woolman Chase, Jean Patou, and Condé Nast choosing five winners. It was the kick-off moment for a profession in which physical looks were a passport to success. The models would become the very faces of fashion itself on the covers of magazines, and symbols of beauty. This was the road to fame for women such as Marion Morehouse, Ann Andrews, Tilly Losch, Dorothy Smoller, Anita Chace, Mary Heberdeen, Miriam Hopkins, Lud, Mary Taylor, and Edwina Pru.

MARION MOREHOUSE

The list never stopped growing, and both the profession and its practitioners became news in and of themselves. In 1947 *Vogue* commissioned a photograph unique in the world of modeling. It was titled "Twelve Beauties" and was taken by Irving Penn. *Vogue* said that it was the first time the most-photographed beauties of the decade were brought together in a single portrait. The models were Meg Mundy, Helen Bennett, Betty McLaughlen, Lisa Fonssagrives, Dana Jenney, Marilyn Ambrose, Lily Carlson, Elizabeth Gibbons, Muriel Maxwell, Kay Hernan, Andrea Johnson, and Dorian Leigh. The models Jean Patchett and Lisa Taylor joined the list of the most famous in the 1950s, a decade in which modeling schools and agencies proliferated, and the profession became economically attractive and the ultimate dream of a new generation of young women.

MURIEL MAXWELL

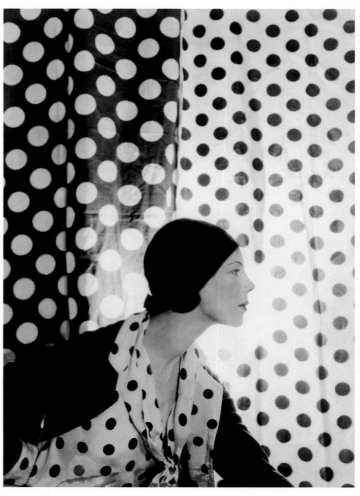

TILLY LOSCH

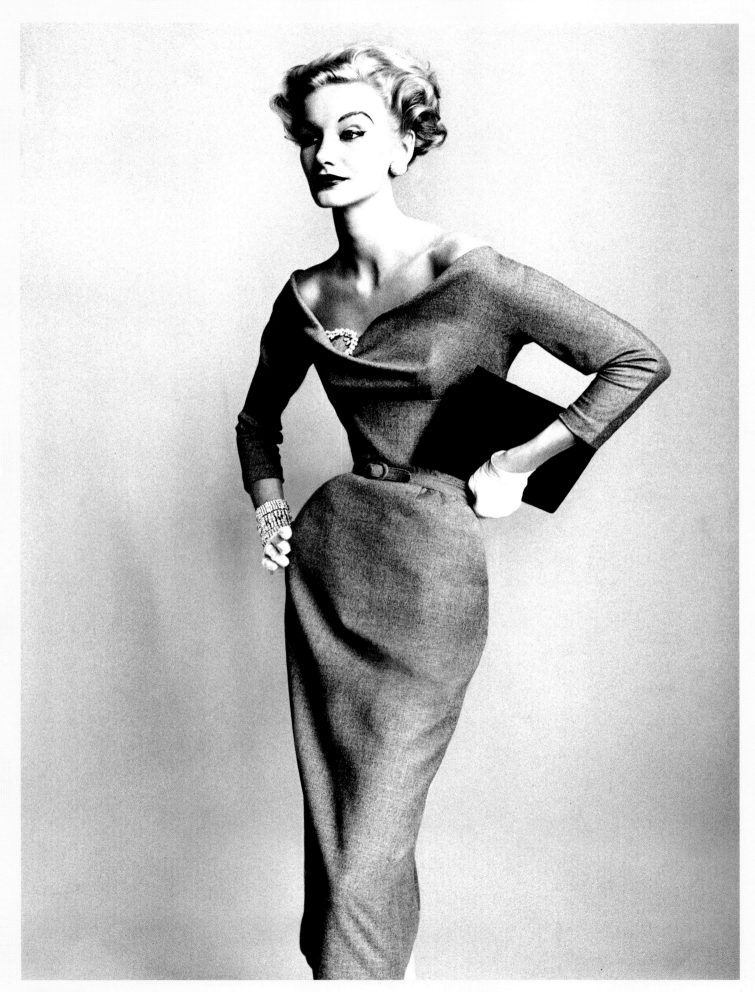

SUNNY HARTNETT

VOGUE IN FASHION AND CULTURE

Kohle Yohannan

Looking back at *Vogue*'s first fifty years, art historian and author of *Claire McCardell: Redefining Modernism* (1998), and *John Rawlings: 30 Years in Vogue* (2001), Kohle Yohannan examined how the magazine championed beauty, luxury, talent, and fashion to appeal to both the moneyed and the aspiring classes.

ANNIVERSARY
The cover of November 15, 1943, was devoted to the fiftieth anniversary of the magazine. For half a century *Vogue* had, through its editorial focus, reflected the changes in society and women and contributed to the development of the culture of fashion.

What are the cultural contributions in general that the most influential and important women's magazines made to the perception and the development of women from the beginning of the 1900s to 1940?

The first four decades of the twentieth century bore witness to unparalleled and often tumultuous changes in the political, social, and cultural lives of American women. A key herald to these seismic social shifts, and often a protagonist force, was the proliferation of magazines, journals, periodicals, and newsletters targeted specifically at American women of the middle to leisure classes. Here was a time when women's lives were changing faster than their clothing and hairstyles—an era buttressed by two world wars, Prohibition, the change of voting status for American women, and the Great Depression. Understandably, magazines of the era were hard pressed to identify and remain appealing to merely one type of woman, and most approached their female readership in broad stroke. Consequently—and perhaps not seeing the forest for the trees—the majority of women's magazines were filled mainly with helpful household hints, practical style tips, hostess honing skills, heroine tales of hardship and sacrifice, and voyeuristic reportage on the current belles de jour. A surprise to no one, pictures of the glitteringly glamorous, daringly freethinking flapper were understandably more relevant and immediately newsworthy than the complex and perhaps not-yet-visible social conditions

that not only made the existence of the flapper possible but necessary to the development of women's rights.

In journalism, as in life, hindsight is a luxury.

Despite this seeming lack of self-awareness—perhaps even because of it—periodicals at every level of society were unwittingly raising the collective awareness of a newly emerging politically and commercially empowered female population that would soon prove to be the largest consumer of media and lifestyle products on earth. By the late teens and early twenties, broken free of their corsets, now driving, then voting, then (gasp!) drinking, and ultimately speaking their minds while staring modernity square in the face, the once-veiled post-Victorian woman was becoming recognized as an immutable force to be reckoned with. During the first four decades of the twentieth century, transmitting the female roar soon to be heard round the world, was the written word, the image, the newly emerging and unwitting conscriptor of common female cause and shared interests in the woman's magazine. Sentinels of change, dream sheets—or call them what you will—magazines in the early twentieth century helped American women self-identify, prepare, and mobilize in their move toward full emancipation in the coming decades.

What particular contributions do you think Vogue made in the same period?

From the outset, *Vogue* shrewdly presented itself as the leader of the pack and the last word in issues of taste and decorum—a very carefully poised and jealously guarded, if potentially risky positioning—as the voice of social significance and arbiter of all things worthy of the attention of a refined and privileged few. This was a very ambitious program for *Vogue*'s publisher Condé Nast, the son of an impoverished preacher from the Midwest, and editor in chief Edna Woolman Chase, granddaughter of Quakers in New Jersey. In keeping with his lifelong fascination with the goings-on of America's newly emerging social aristocracy and the international swells who sought pleasure (or exile) on American shores, Condé Nast's newly acquired and refocused *Vogue* turned a lens on the rarefied, elegant extremes of luxe and lifestyle as it was lived on the red carpets, in the ballrooms and box seats of what soon came to be known as café society. Banking on the self-aware vanity of the "beautiful people" to make themselves available for viewing by their admiring peers and jealous hordes alike, Nast's prescient social insight more than paid off and inadvertently exposed the unforeseen irony that while poor people and rich people lived very different lives, they did, however, share one common interest—both were devotedly fascinated by how the rich lived.

Despite their humble beginnings, Nast and Chase's meticulously groomed editorial pages landed *Vogue* on the doorsteps and coffee tables of exactly the target audience Nast had hoped for: the rich, the very rich, and the super rich.

Then, the penetration of the magazine in society was motivated by the fact that Vogue showed in its pages the interests, habits, and vanities of a class that everybody wanted to know and imitate?

Ironically, and perhaps even more relevant, the long-term success of *Vogue* came about largely by way of a trickle-down effect that has yet to be fully understood: Nast's decidedly exclusive status-driven fashion and lifestyle magazine had caught the attention of an uncharted audience that proved more numerous and more loyal than the frolicking heiresses and dashing robber barons scattered among the pages of *Vogue*: the aspiring rich. Of greater importance, and certainly more impacting, was the cultural cross-pollination that came about as a result of *Vogue*'s gradual inclusion of theater talents, musicians, artists, and celebrated beauties of the day. Nowhere but at Condé Nast's personal dinner parties in his Fifth Avenue penthouse could one find a showgirl and a countess at the same table with a jazz trumpeter and a billionaire shipping tycoon. By the late twenties and early thirties, influenced largely by Nast's own social life, *Vogue* had approvingly annexed the snowballing allure of the era's reigning stage and screen stars while simultaneously promoting a host of appealing, up-and-coming bright young things. In hindsight, these social mélanges seem logical: A movie star appearing as a *Vogue* model was not much of a stretch, and, to be sure, a fair number of models—Lucille Ball

and Lauren Bacall, for example—were lucky enough to find themselves catapulted, by way of *Vogue*'s prestige and exposure, in the opposite direction. But it must be remembered that in the 1920s the blurring of the social and racial lines at Nast's swanky shindigs was decidedly risky business. Once again, Condé Nast's intuition paid off. The universal currency known as Beauty, the undeniable aura of wealth, a title, blazing talent, or, indeed, any combination of extraordinary sparkle and the right stuff and even downright notoriety became the established price of admission to both Nast's ultraexclusive soirées and the immortalizing pages of *Vogue*.

That said, where *Vogue* truly reigned supreme in the teens, twenties, and early thirties was in its featured fashion spreads, shot at unquestioned expense by the best photographers available— and actively recruited from anywhere—on large-format cameras in Condé Nast's dream-factory studios assembled for his unbroken chain of resident geniuses ranging from de Meyer to Steichen, Hoyningen-Huené to Horst, Beaton to Rawlings to Penn, among others. Even to the untrained eye, *Vogue*'s fashion spreads were works of art in their own right. Both in terms of beauty and imagination, aided in great part by the technically superior developments of Nast's proprietary advances in four-color printing, the editorial pages of *Vogue* so far outdistanced the competition for nearly thirty years that it seemed Nast had indeed succeeded in his quest for *summum bonum* mastery of the magazine

publishing business par excellence. By virtue of its very content and physical manufacture, *Vogue* was the first magazine unswervingly dedicated to the very summit of fashionable lifestyle and high society living, as well as the most lushly illustrated, beautifully produced periodical available to the mass American market and, indeed, the world at large.

Going back to the editorial content, which were the social aspects on which the magazine focused, and why did its editorial focus command the attention of people of different classes and interests?

In many ways, *Vogue* was an almost voyeuristic glimpse into the privileged lives of those unaccustomed to being viewed by onlookers outside of their own social rank. Seen, then, as an authorized periodical biography of American blue bloods to be perused by both inner-circle peers and anyone who cared to read about their life behind the velvet ropes, what becomes all the more fascinating is that *Vogue*'s audience soon came to be comprised of more outsiders looking in than Nast had originally intended. In a marvelously complex twist on social voyeurism and the necessary balancing act of social exhibitionists to stage the parade, *Vogue* became perhaps the ultimate manifestation of the social show-and-tell, trading on the eager hunger for celebrity among the rich and well-connected, and the equally charged public interest in celebrities as a whole. Recognizing the ironic ultimate fate of Nast's intended subscription market for

Vogue is crucial to forming an accurate understanding of the magazine's seemingly accidental cross-market appeal. Consider that by the late 1930s a subscription to *Vogue* was as appealing to the international grande dames of society as it was to the twenty-dollar-a-week typist, both of whom would have aspired to look like any number of starlets pictured in its fashion or society pages, who, in their turn, were equally delighted to have been deemed worthy to have appeared in the pages of *Vogue*. Privileged access, license to dream, social validation, or gleanable hints to help you polish your game along the way—*Vogue* was at once inspired fantasy that educated by way of windows on the world of the elite. Therein lies *Vogue*'s inexplicably unique market-spearing leap ahead of its early competition and unprecedentedly authoritative status during the early twentieth century.

Vogue started as a witness of the aristocratic social scene and the fashion of that elite. Today, more than a hundred years after, it stands not only as a witness to fashion but rather as a leader of it. What's your take on this fact?

I don't believe that the end product of fashion is currently influenced by magazines to the degree that it was in the past. Since the 1960s, fully autonomous, self-expressive fashion has been unleashed in youth culture, running rampant in the streets, across concert stages, and on television, where for decades now the shrewdest of our designers reencounter it and bring it back to their ateliers for the

world to wear as haute couture. From the Carnaby Street mods to the San Francisco hippies to Vivienne Westwood's punks, these looks were not led by magazines, but rather they ended up in them after they had been picked up by the sharp editors and most dialed-in designers. Where *Vogue* has often outdistanced its competitors has been in each consecutive editor's uncanny ability to keep a finger on the pulse of pop culture and the arts, be it music-related (Galliano's rock-and-roll slut collections), politically implicit (Miyake's communist and Gaultier's Hasidic looks), or merely just the introduction of a new face or body type that somehow whispers the ideals of the moment (Vreeland's Midas touch as seen in her early use/discovery of Veruschka, Twiggy, and Penelope Tree).

As in the days of Edna Woolman Chase, today's *Vogue* has seamlessly changed to reflect the times. Much like the 1930s and 1940s, the early twenty-first century is witnessing a time of renewed interest in the stars and social aristocracy of the day, as witnessed by the recent years of Hollywood starlets gracing the cover of *Vogue* under the watchful eye of current editor in chief Anna Wintour. To be sure, this was a brilliant move. And, one suspects, a move that was deftly executed in light of a dirty little secret that has been alternately whispered and hushed among fashionistas for the past ten years: After more than five centuries of fashion having reigned unfettered, at one period bullying women into this shape and that corset, we live in an era where the dress can

finally and thankfully begin to be seen as slightly less important than the woman wearing it. As a result, the fashion industry has been wise and fortunate to weave an intersupportive relationship with film and music luminaries, bringing added media value to a readership grown accustomed to celebrity spokespeople attached to everything from their toothbrush to their tulle gowns. Consequently, the arrival of a red-carpet diva now carries with it the de facto expectation and promise of a footnote on the lucky couturier who was deemed worthy of wrapping the goddess for the evening. And usually free of charge.

What has changed?

Can one imagine the incomparable Madeleine Vionnet or the imperiously haughty Valentina handing over thousands of dollars of clothing to Jean Harlow in hopes of merely being credited for dressing her for the night? A hard image to conjure, to be sure. And one cannot help but opine that it seems more than a little unlikely that Coco Chanel—who once refused a proposal of marriage from the Duke of Westminster because, as she put it, there had been several Duchesses of Westminster but there was only one Chanel—would have been willing to share the marquee with Nicole Kidman in an attempt to sell dresses. Quite unlike the early days of haute couture, today, in an era of cutthroat marketing competition for media visibility, the fashion industries tango with carefully measured interdependence with the film and music world, striving for a sort of piggybacked opulence

and megastar grandeur on the advertising front, ostensibly creating a more powerful final product with exponentially more appeal than the advertised images of the past.

Ostensibly.

As we move closer and closer to a truly global society, magazines are wont to represent a more panoramic view of the world of fashionable living. Does this shift and sharing of power from the couturiers to the entertainers, models, and luminaries indicate a weakening of the influence of fashion? Or can we thankfully celebrate that people's entire lifestyle, and not merely their clothing, are once again of interest to the general reader and the fashion enthusiast alike? Perhaps the latter thought is mere Pollyanna optimism, but the very idea that fashion and the performing arts have once again united as they did in the heyday of Hollywood's silver screen is an exciting prospect, providing much page-turning fanfare and copy in the pages of *Vogue*. In many ways, *Vogue* has evolved into the very vehicle of excellence Condé Nast had anticipated, once more proving his hypothesis that people at every level of society still have one thing in common: They all want to know what the rich and the beautiful people are wearing, where they're wearing it, and how much it cost.

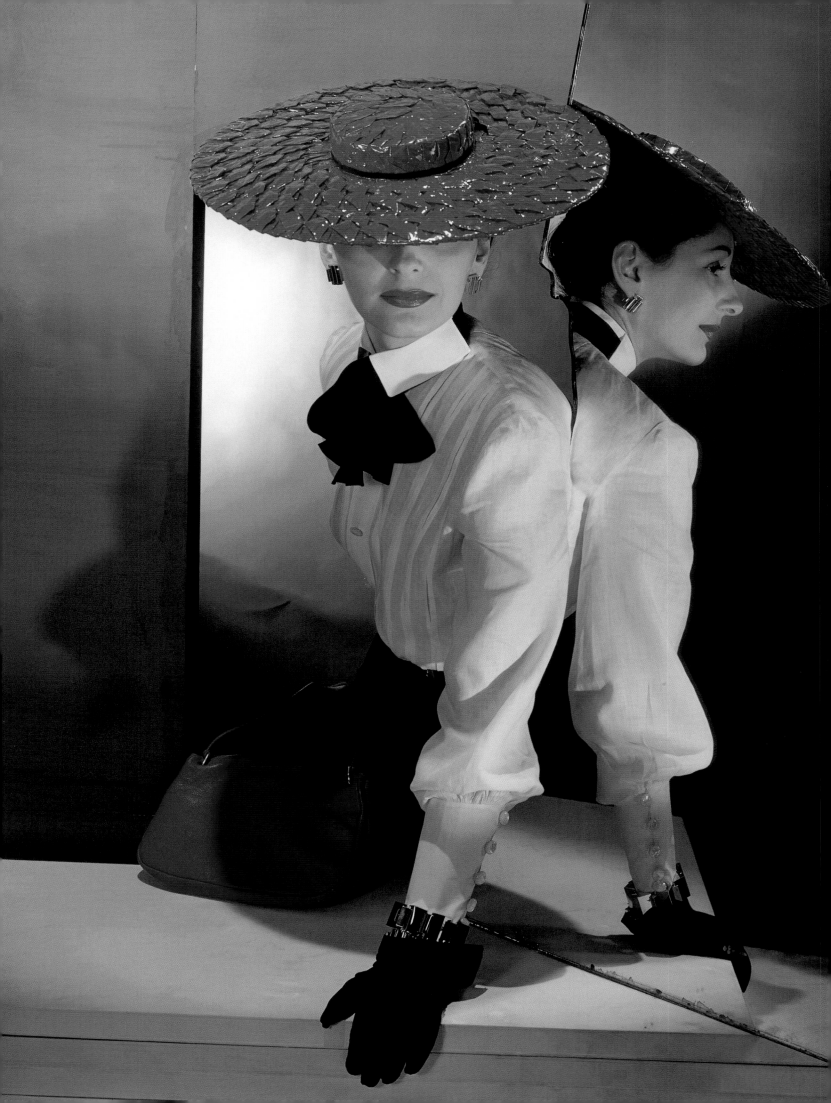

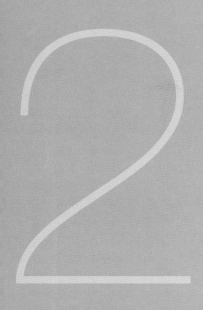

PART 2

THE NEW WOMAN IN *VOGUE*: FASHION, PHOTOGRAPHY, AND EDITORIAL STYLE

THE EVOLUTION OF STYLE

Dear Pat:

When Mary gives you this you will be the acting President of the Company. I would have told you my plans but I couldn't. Mary will convey my messages to you and Barrow. I am turning the management of the property over into your hands. I suggest you appoint Mary your personal assistant. Unofficially she has served me in that capacity for the past year and has demonstrated her value.
It is a hard and difficult road ahead. You have proven your loyalty, integrity and business ability. I am confident that you will ably continue the outstanding leadership of our periodicals and push them to even greater prestige and brilliance.
Good luck and my deep gratitude to you, dear Pat, for the many things you have done for me.

Affectionately yours,

Condé

With this brief note dated May 9, 1942, four months before his death, Nast settled his legacy. The beneficiary: Iva Sergei Voidato-Patcévitch, a forty-year-old Russian émigré who was business manager of all the company's operations. On the editorial side, at the last magazine created by

Nast, *Glamour*, in Hollywood in 1939, a new work stage had been launched, granting more autonomy and decision-making power to the editor in chief. Patcévitch, unlike Nast, practiced a leadership style that allowed considerable freedom on the editorial side while he focused on the business side, the numbers, and on publishing strategy.

At *Vogue*, Edna Woolman Chase continued as editor in chief until the end of 1951. She was followed by Jessica Daves, who had developed under her tutelage to become the editor of American *Vogue*, and who continued to shape the *Vogue* style for women aged thirty-something with a comfortable lifestyle. In the convulsed 1960s, Diana Vreeland took charge and changed everything: the locations, the way clothes were presented, the models; she introduced revolutionary clothing styles and designers, brought in new photographers, and sited fashion shoots in settings such as had never been seen before, rivaling the richest exuberance of the movie world. Vreeland's leadership style was supplanted by another, more realistic, more oriented toward the educated businesswoman who held down an important job, had a family, practiced sports, attended social events, and always had to look good. Those

were the Grace Mirabella years, from the early 1970s to the late 1980s. Then came Anna Wintour, the editor who transformed the presentation of fashion, who captured the young reader, and who retooled the magazine to prepare it for the new century.

Working with all of these editors, and especially closely with Daves, Vreeland, and Mirabella, was a gifted art director who was responsible for molding the magazine's face and image and, eventually, its editorial course. This was Alexander Liberman, a Russian painter, sculptor, and photographer who joined the firm in 1941 at age twenty-nine after leaving war-torn Europe to start a new life in New York. In 1943 Liberman was promoted to art director at *Vogue*, and in 1962 he was named editorial director of all the Condé Nast magazines, a position he held until the early 1990s. The following sections examine his contributions over the years, his editorial vision, the context of the times, and the changes in fashion and its reporting that made *Vogue* not just a witness, not just a mirror reflecting the aesthetic evolution of women, but an active participant in the culture of fashion.

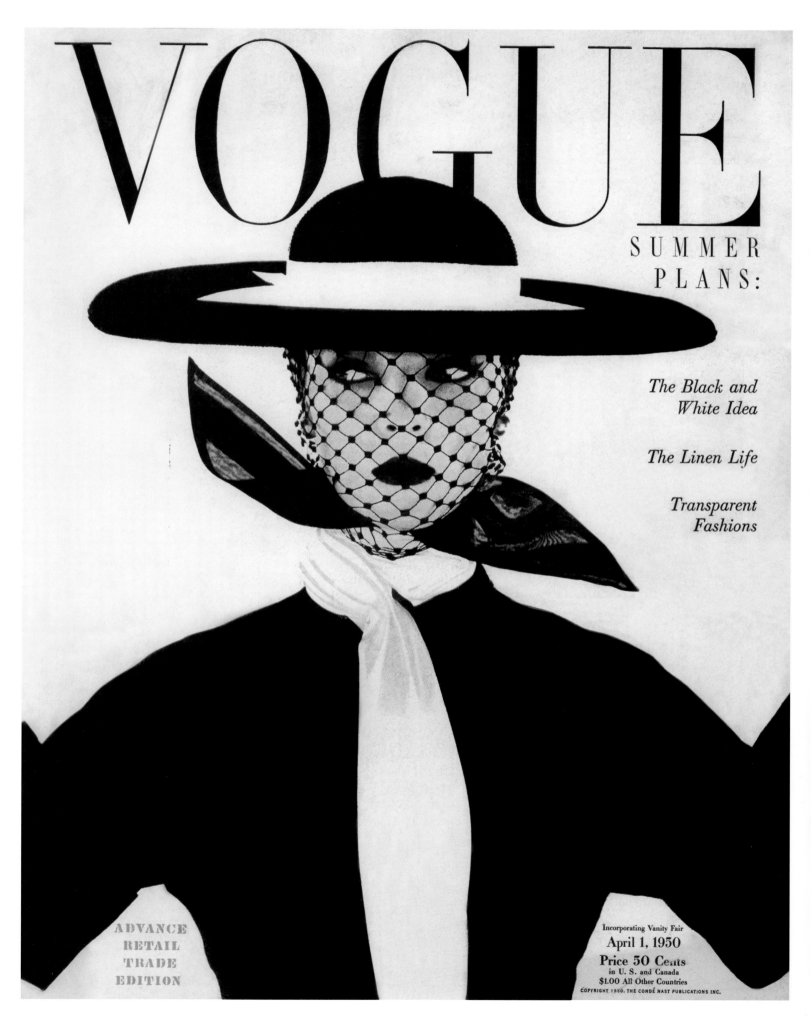

VOGUE

SUMMER
PLANS:

*The Black and
White Idea*

The Linen Life

*Transparent
Fashions*

ADVANCE
RETAIL
TRADE
EDITION

Incorporating Vanity Fair
April 1, 1950
Price 50 Cents
in U. S. and Canada
$1.00 All Other Countries
COPYRIGHT 1950, THE CONDÉ NAST PUBLICATIONS INC.

129

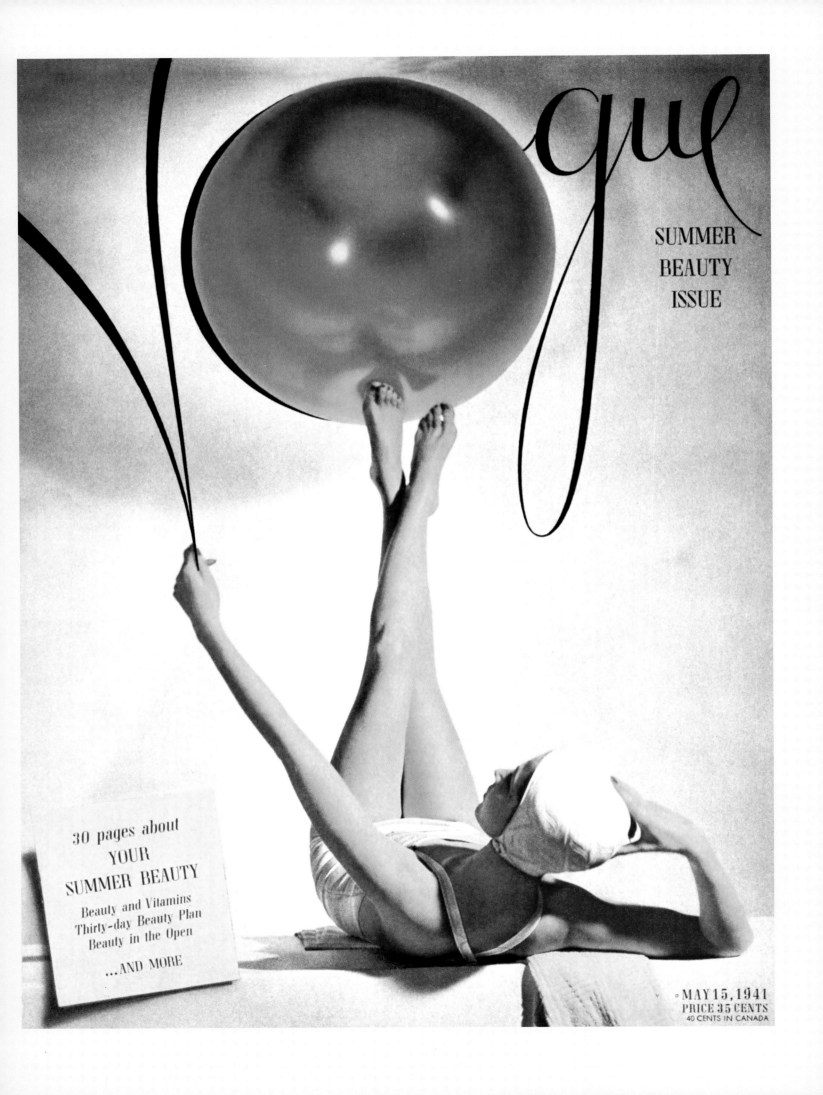

Vogue

SUMMER
BEAUTY
ISSUE

30 pages about
YOUR
SUMMER BEAUTY

Beauty and Vitamins
Thirty-day Beauty Plan
Beauty in the Open

...AND MORE

MAY 15, 1941
PRICE 35 CENTS
40 CENTS IN CANADA

THE LIBERMAN STYLE

Alex Liberman was the last important person to join the company before Condé Nast's death. His arrival at *Vogue* was attended by a certain amount of confusion. Liberman, former managing editor of the French photo magazine *Vu*, had been raised in St. Petersburg and Moscow and educated in London and Paris, where he took art lessons from the cubist painter André Lhote, studied architecture at the École Nationale des Beaux Arts, and worked with the poster artist Cassandre. As soon as he arrived in New York, Liberman got in touch with Lucien Vogel, the founder of *Vu*, who had also fled France. Vogel was now an adviser to Nast and was a close friend of Liberman's compatriot Iva Patcévitch, who would soon become president of the company.

Vogel and Patcévitch agreed that Liberman's credentials suited him to work at *Vogue*, especially because Nast was contemplating changes to the magazine's visual presentation. Patcévitch promised to talk to his boss. In the meantime Liberman had made an appointment with the art director, Mehemed Fehmy Agha, and presented himself at Agha's office at

Vogue. Agha, also born in Russia but of Turkish parents, was nicknamed the Terrible Turk by fellow workers because of his imposing presence and imposing girth, his monocled eye, and his sarcastic and disdainful treatment of the people he dealt with. He was, however, deeply respected for the professionalism with which he had modernized the visual style of the company's magazines. At his interview it was agreed that Liberman would have a chance to show his worth. The following Monday he was told to lay out a double-page spread that would carry illustrations by the fashion artist Jean Pagès. After devoting that week to the project, Liberman was called into Agha's office on Friday afternoon. Agha pointed out the failings he found in the layout and concluded laconically: "I'm sorry, you are not right for *Vogue*."

A dejected Liberman picked up the check for his work and returned to his hotel. Astonishingly, a few minutes later the telephone rang and he heard the voice of Mary Campbell informing him that her boss, Condé Nast, wanted to see him on Monday morning. In their book *Alex: The Life of Alexander*

Liberman, one of the best accounts of the man and his work, Dodie Kazanjian and Calvin Tomkins quote Liberman recalling the occasion of his first meeting with Condé Nast in his vast office:

You had to walk the length of this huge room, and there was Condé, at a banker's desk, wearing his little pince-nez. . . . it became clear very quickly that Nast did not know that Agha had already hired and fired me. We talked about various things—*Vu*, and French publishing, and Vogel— and I showed him a certificate I had brought along, for a prize I had won at the Universal Exposition in Paris in 1937. It was for a photo montage display on how magazines are created, and it had won a gold medal. There was this certificate with my name on it, although to tell the truth I don't really remember doing the montage. The minute Nast saw it, he said, "Well, a man like you must be on *Vogue*." And he pressed a buzzer, called Mary Campbell, and said, "Please send in Dr. Agha." Agha came in while I was sitting there. Nast said, "Dr. Agha, this is Mr. Liberman. I would like him to be in

BEFORE AND AFTER
The cover for May 15, 1941, revealed the creativity of the new designer Alexander Liberman, who imaginatively added lettering to a Horst photo (left), to convert the beach ball into the O of "Vogue."

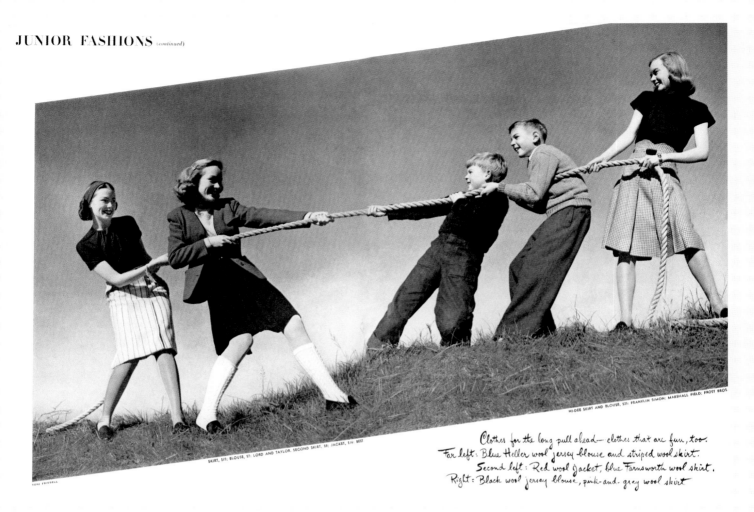

HI-DEE SKIRT AND BLOUSE, $25; FRANKLIN SIMON; MARSHALL FIELD; FROST BROS.

SKIRT, $15; BLOUSE, $7; LORD AND TAYLOR. SECOND SKIRT, $8; JACKET, $16; BEST

Clothes for the long pull ahead— clothes that are fun, too.
Far left: Blue Heller wool jersey blouse and striped wool skirt.
Second left: Red wool Jacket, blue Farnsworth wool skirt.
Right: Black wool jersey blouse, pink-and-grey wool skirt

TONI FRISSELL

62 63

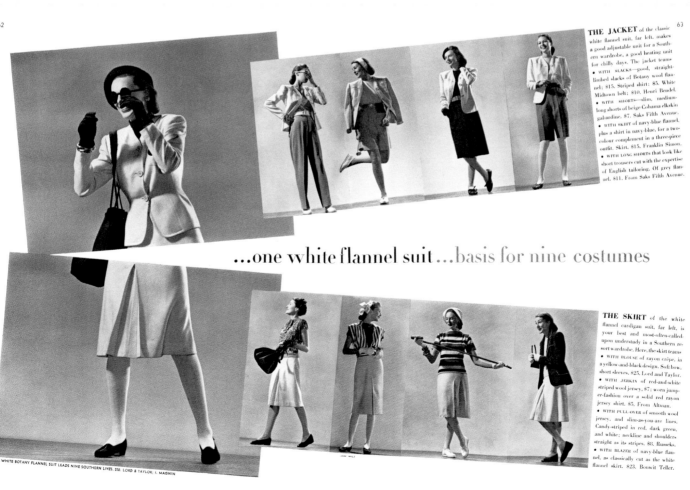

THE JACKET of the classic white flannel suit, far left, makes a good adjustable unit for a Southern wardrobe, a good heating unit for chilly days. The jacket teams—
• WITH SLACKS—good, straight-limbed slacks of Botany wool flannel; $15. Striped shirt; $5. White Midtown belt; $10. Henri Bendel.
• WITH SHORTS—slim, medium-long shorts of beige Cahama elkskin gabardine, $7. Saks Fifth Avenue.
• WITH SKIRT of navy-blue flannel, plus a shirt in navy-blue, for a two-colour complement in a three-piece outfit. Skirt, $15, Franklin Simon.
• WITH LONG SHORTS that look like short trousers cut with the expertise of English tailoring. Of grey flannel, $11. From Saks Fifth Avenue.

...one white flannel suit...basis for nine costumes

THIS WHITE BOTANY FLANNEL SUIT LEADS NINE SOUTHERN LIVES. $50. LORD & TAYLOR; I. MAGNIN

JOHN MILLI

THE SKIRT of the white flannel cardigan suit, far left, is your best and most-often-called-upon understudy in a Southern resort wardrobe. Here, the skirt teams
• WITH BLOUSE of rayon crêpe, in a yellow-and-black design. Soft bow, short sleeves, $25. Lord and Taylor.
• WITH JERKIN of red-and-white striped wool jersey, $7; worn jumper-fashion over a solid red rayon jersey shirt. $5. From Altman.
• WITH PULL-OVER of smooth wool jersey, and slim-as-you-are lines. Candy-striped in red, dark green, and white; neckline and shoulders straight as its stripes. $8. Russeks.
• WITH BLAZER of navy-blue flannel, as classically cut as the white flannel skirt, $23. Bonwit Teller.

Summer Blacks

Grown-up Cottons

1-Piece, 1-Colour

Urban Prints

1. Black—with pockets that become a peplum. Celanese rayon |47 sheer. Sizes 10 to 20, $20. Altman.
2. Black pencil of a dress, field-day for accessories. Everfast spun rayon, 10 to 16. $20. Lord & Taylor.
3. Black in a festive mood, with a new hipline. International dress. 10 to 20. $20. Arnold Constable.
4. Black for the spare-ribbed. Sleek midriff rayon crêpe town dress. Sizes 10 to 20, $20. Bonwit Teller.
5. Black, pretty for a summer supper. Tucked rayon tissue faille dress. Sizes 10 to 20, $20. Stern's.

6. Cotton taffeta jockey shirt, $9. Briefly-slit skirt, $8. By Duchess Royal. 10 to 18. Franklin Simon.
7. 1860-neckline dress by Mary Stevens. Everfast gingham. Sizes 10 to 16. $15. Franklin Simon.
8. Bare-back, pink-and-black Wesley Simpson cotton. 10 to 16. $13. Dusky cotton scarf. $5. Altman.
9. Worldling evening cotton. Two-piece peplumed Everfast cotton. Sizes 10 to 18. $15. From Altman.
10. Assured city-cotton. Pink, black candy-striped cotton twill. Sizes 10 to 18. $16. At Peck & Peck.

11. White refreshment for town. Green belt, badge, on rayon shantung. 10 to 20, $17. Peck and Peck.
12. Wild-plum-coloured rayon shantung. Alternate for city-black. 10 to 18. $15. Franklin Simon.
13. Emerald sheath, slim as a blade. Rayon shantung. A Nantucket Natural. 10 to 18. $18. At Altman.
14. Sky-blue dress with a shoulder-flutter. Foreman rayon shantung. 10 to 20. $20. Jay-Thorpe.
15. Creamy spun rayon. With nice detail. Mary Stevens dress. Sizes 10 to 16. $20. Lord & Taylor.

16. Ruffled, black-dotted white cotton. By Claire McCardell. 10 to 18. $20. Lord & Taylor.
17. Black smoke-rings printed on aqua-striped Doucet cotton. 10 to 18. $20. Bendel's Young-Timers.
18. Red-and-white rayon shantung dress, cool as a claret cup. 10 to 16. $20. Bendel's Young-Timers.
19. New directions for stripes: Black-and-white Celanese rayon jersey. 10 to 18. $20. Lord & Taylor.
20. Cool brown blowing feathers printed on white Heller rayon jersey. 10 to 20. $18. Bonwit Teller.

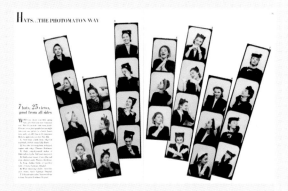

HATS...THE PHOTOMATON WAY

7 hats, 25 views, good from all sides

COLLAGE
Liberman instituted a collage style, which he himself called "anti-design." An unusual positioning of photos and titles and a journalistic typography made the pages more attractive, increasing their impact and vitality without sacrificing order or elegance.

the *Vogue* art department." And Agha said, "Yes, Mr. Nast." Agha never said another word about it, I never said a word, and that's how I started on *Vogue.*

From the beginning of his time at *Vogue,* Liberman held a position of privilege. Working in the design department with six other layout artists, Liberman devoted himself to the covers. Hardly a month after joining, he created one that impressed Nast and the rest of the editors. The photograph depicted a model in swimwear lying on her back, her feet up in the air playing with a large red beach ball which—through Liberman's creativity—did double duty as the letter O of the word "Vogue." From that moment on, Liberman became an almost constant consultant to Nast. This piqued Agha, his immediate boss, who saw his power being eroded little by little. Liberman was intrigued by the fact that Nast was trying to convert

Vogue into something more like a newsmagazine: "I always thought that was why he seemed interested in me," Liberman told Kazanjian and Tomkins, "because of my journalistic background at *Vu*. He sent out memos calling for captions on the pictures and titles at the top of the page. He wanted labels on the cover to let people know what was inside; that was really the beginning of cover lines. He wanted a much clearer presentation, and, as it turned out, I worked very closely with him on that."

The situation with Agha—who could not tolerate anybody encroaching on his turf—came to a head after Nast's death. "Either Liberman goes," Agha said to Patcévitch, "or I go." The decision of the new president of the company was not long in coming:

On February 13, 1943, Agha's resignation from Condé Nast was announced, and a month later

Liberman assumed the position of art director. Patcévitch explained many years later: "I was not in the habit of accepting ultimatums from employees. Besides, I liked Alex very much, he was very talented, and he was Russian."

Thus it was that at age thirty, with only two years of work at *Vogue*, Alex Liberman took over the art direction of a magazine whose covers had excelled in representing the diverse pictorial trends of the preceding decades. Immediately, his links with European artists and his cultivated and modern tastes began to be reflected in the pages of the magazine.

The first change he made was to eliminate hand lettering. Then he introduced Franklin Gothic, a bold typeface that was being used by such tabloids as the *Daily News*. Headlines, headings, and text now appeared neater and more informative. All this was in line with Nast's wish to abandon the concept of an album and to transform *Vogue* into something more like a newsmagazine. "The album-type layout was static and out-of-date. It didn't have the cinematic flow that I was interested in. I also thought it would be provocative and exciting to use practically the same type as a tabloid newspaper in this very different context. It brought vitality to the page."

At that time, *Vogue* and the Liberman-Chase management team faced stiff competition from editor Carmel Snow

and art director Alexey Brodovitch at *Harper's Bazaar*. The *Bazaar* team was tightly knit, with shared ideas that changed and were renewed constantly. The situation at *Vogue* was entirely different. Chase, who had once heard Nast say that "the day that an art director is more important than the editor in chief will be a bad day for the magazine," was less a teammate than an adversary. She clung ever more firmly to the magazine's conservative style, opposed any and all changes, and was little inclined to listen to the philosophical arguments put forward by Liberman. Every so often, in the presence of her anointed successor Jessica Daves, she would summon Liberman to her office—she never went to the art department—and by way of reaffirming her authority would demand explanations regarding some design she had not liked or a photograph that she considered inelegant.

Liberman, tolerantly and patiently, would give her his explanations and, as if he were a teacher, would try to convince her of the merits of his artistic plans for the magazine. Invariably on these occasions the name *Harper's Bazaar* came up, for by then it was considered a more avant-garde magazine than *Vogue*. Liberman, who admired the design and the content of the rival magazine, asserted nevertheless that *Bazaar*'s focus was wrong, for it continued to see fashion magazines as luxury products for upper-class readers. His own percep-

tion of what *Vogue* should be, enunciated in Dodie Kazanjan and Calvin Tomkins's *Alex*, was rather different:

Elegance was Brodovitch's strong point. The page looked very attractive. But in a way, it seemed to me that Brodovitch was serving the same purpose that Agha had served, which was to make the magazine attractive to women—not interesting to women, attractive to women. What I wanted—and what Condé had been trying to do—was to make it something more than lovely and attractive. I thought there was more merit in being able to put twenty pictures on two pages than in making two elegant pages. The one clear idea that I brought was the idea of anti-design. What is design? It's making the use of the material—the way it's used—more important than the material itself. In my experience with *Vu*, design didn't count. I never designed a layout at *Vu*. I'd look at the material and say, this is a wonderful picture, let's make it big, don't let's have the title damage it. Or, conversely, I might allow the journalistic content of the title to dominate the image. I came to believe in the unexpected, in chance, in doing things that hadn't been done before and didn't conform to any established design principles. At *Vogue*, I wanted to break the design obsession, so I defended a more journalistic approach—rougher lettering, no white space, crowded pages, messier layouts.

COVERLINES

It was Liberman who enhanced the expository titles on the covers, using boxed text to announce the contents of the magazine.

VOGUE

Beauty Issue

10% REDUCTION DIET
How to take off pounds
How to keep them off

Whether to
DYE YOUR HAIR
— and how

10 NEW COIFFURES
for 10 new hats

MAKE-UP
new theory for 4 types

ADVANCE
RETAIL
TRADE
EDITION

see section facing page

NOVEMBER 1, 1941
PRICE 35 CENTS
40 CENTS IN CANADA

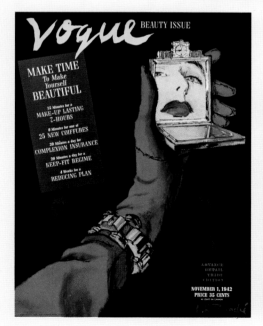

Vogue BEAUTY ISSUE

MAKE TIME
To Make
Yourself
BEAUTIFUL

15 Minutes for a
MAKE-UP LASTING
7-HOURS

8 Minutes for one of
25 NEW COIFFURES

20 Minutes a day for
COMPLEXION INSURANCE

20 Minutes a day for a
KEEP-FIT REGIME

4 Weeks for a
REDUCING PLAN

ADVANCE
RETAIL
TRADE
EDITION

NOVEMBER 1, 1942
PRICE 35 CENTS

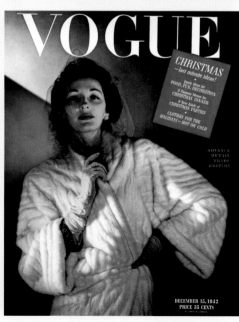

VOGUE

CHRISTMAS
—last minute ideas!

Quick Ideas for
FOOD, TREE, DECORATION
2 Famous Menus for
CHRISTMAS DINNER
New Kinds of
CHRISTMAS PARTIES
CLOTHES FOR THE
HOLIDAYS—HOT OR COLD

ADVANCE
RETAIL
TRADE
EDITION

DECEMBER 15, 1942
PRICE 35 CENTS

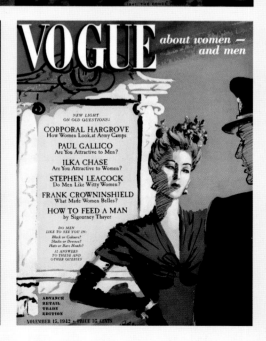

VOGUE *about women — and men*

NEW LIGHT
ON OLD QUESTIONS:

CORPORAL HARGROVE
How Women Look at Army Camps

PAUL GALLICO
Are You Attractive to Men?

ILKA CHASE
Are You Attractive to Women?

STEPHEN LEACOCK
Do Men Like Witty Women?

FRANK CROWNINSHIELD
What Made Women Belles?

HOW TO FEED A MAN
by Sigourney Thayer

DO MEN
LIKE TO SEE YOU IN:
Black or Colours?
Slacks or Dresses?
Hats or Bare Heads?
31 ANSWERS
TO THESE AND
OTHER QUERIES

ADVANCE
RETAIL
TRADE
EDITION

NOVEMBER 15, 1942 • PRICE 35 CENTS

1940–1950: FROM CAFÉ SOCIETY TO CHRISTIAN DIOR

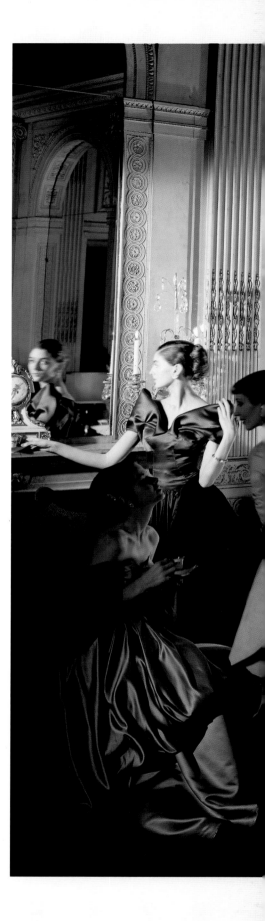

"When people speak to me about the war, they ask me, 'Is it going to be incredibly difficult to edit a luxury magazine like *Vogue* in times like these? Do you think that you can hope to survive?' My answer is . . . what kind of a magazine do you think this is? Fashions would not be fashions if they did not conform to the spirit, the needs, and the restrictions of the current time." The year was 1941, the speaker Edna Woolman Chase, addressing the Fashion Group of New York in a speech that aimed to motivate American designers to move into creative areas that British and French designers had been forced to give up because of the war.

Typical of *Vogue* articles during this period was "Women in Defense Work," a special ten-page spread published on July 1, 1941. The cover showed model Sandy Rice and a flight instructor climbing into a biplane. Insofar as personalities were concerned, Chase decreed that society portraits would be published only if their captions mentioned volunteer work done in the war effort by the subjects. The first coverage of the destruction wrought by the war came from Cecil Beaton,

then residing in London, who carried out fashion shoots amid the rubble of bombed-out buildings. He also sent *Vogue* pictures of burned-out German tanks, taken in 1942 in North Africa in his official capacity as a photographer for the Royal Air Force, and in 1945 he photographed models wearing Pierre Balmain creations in the ruins of Paris (page 139).

However, no graphic document was as shocking as the pictures taken by Lee Miller in April 1945, which *Vogue* published in June of that year. Miller, who had been a model and appeared on the cover of *Vogue* in March 1927, had learned photography with Man Ray in Paris and was in London when the war broke out. Accredited as a war correspondent by the U.S. Army in 1942, she created memorable photo stories following the Normandy landings, covered the liberation of Paris, and was one of the first American women to enter the Dachau concentration camp. What she depicted there was a far cry from fashion photography. Under the heading "Believe it: This is the Buchenwald concentration camp, in Weimar," her photographs showed piles of dead bodies, victims of hunger and torture and hanging.

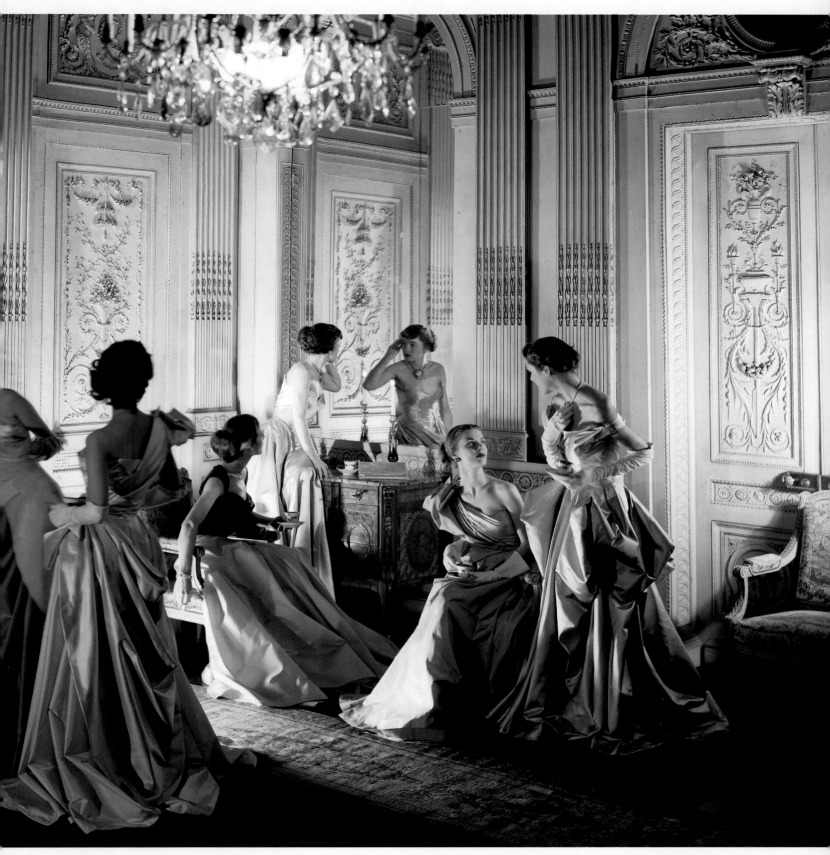

CAFÉ SOCIETY
In 1948 Beaton took this picture to illustrate the story "Café Society," referring to the select group of socialites who for a decade had been synonymous with fashion.

137

DIOR AND THE NEW LOOK
The "wasp waist" dresses of
Christian Dior were presented
in April 1947 (above). Two years
earlier, during the war, *Vogue*
published pictures of Pierre
Balmain dresses amid
the ruins of Paris (opposite, top).
In 1942 Toni Frissell photo-
graphed the American sporty
style (opposite, bottom).

The war was all-embracing and had
changed everything, from habits to
fashions to the images of women.

Dressed in austere clothes, and in
many cases in uniform, women in
1941 clung to one of the last accou-
trements of femininity: silk stockings.
Vogue asked, "Will it come to this?"
and showed a woman in frumpy
argyle socks drinking tea. In the
United Kingdom fears were confirmed
on the first of June when strict ration-
ing went into effect, with quotas on
the purchase of cloth, apparel, and
shoes. The fashion world called it the
year of "sock shock," when the use
of synthetic silk was forbidden for any
purpose other than the manufacture
of parachutes. When two years later
the United States government
absorbed all nylon for military uses
and rationed rayon, *Vogue*, which
strove throughout the war to see the
brightest possible side of things,
wrote: "Socks can contrive to look
charming." Socks became familiar
items and a badge of youth.

By 1944 the sporty style took firm
root in the United States, presaging
the rise of prêt-à-porter. Pleated skirts,
jerseys, and bobby socks became
the American Look, using such non-
luxury fabrics as cotton crêpe.
American domination in the field of
fashion, whether couture or everyday
clothing, was almost total. Within a
few years, however, the French would
initiate a new fashion revolution.

It came in February 1947, when in
the Paris collections Christian Dior
unveiled his New Look, the most
extreme change of direction in fashion
since the advent of Coco Chanel.
Characterized by full skirts, tight
bodices, and wasp waists, the New
Look was an immediate success,
and Dior became the king of haute

couture, restoring to Paris its preeminence in fashion and setting the standard in dressing women for a decade. The Dior style, which aimed to bring back the Belle Époque, aimed also to erase memories of wartime suffering and to bring back women's taste for glamour, luxury, and femininity. As Dior said, "I designed clothes for flowerlike women, with rounded shoulders, full, feminine busts, and hand-span waists above enormous, spreading skirts. I brought back the art of pleasing."

The Dior reign extended through eleven years, twenty-two collections. His influence was apparent in the creations of other designers as well as in the prêt-à-porter lines, which were very successfully introduced in France in the 1950s.

In a November 1999 special issue of *Vogue* dedicated to the century of fashion design, Bill Blass, one of the younger fashion talents in Dior's day, recalled the phenomenon precipitated by the French designer: "Dior really was a savior. He almost single-handedly revived women's interest in clothes. What that meant was that as soon as he opened after the war, any woman who could get over to Paris went to Dior. He was a revolution!" Blass explained very clearly how the fashion world then worked:

All of Seventh Avenue immediately flocked back to Paris, as well. Which was a great thing from my standpoint. I had come to New York from Indiana and I was not from a rich family. My dad was in the hardware business and he killed himself before the Depression. As the assistant to Earl Luick, the top designer at Ann Miller and Company, I got to go to Paris and was exposed to the French couture—to Dior, Balenciaga, Jacques

Fath, and eventually to Chanel. Although the only person who understood Chanel after the war was Bettina Ballard, that very grand fashion editor at *Vogue*. We claimed we went for "inspiration," but really we went to buy clothes. You had to pay a "caution" to each house before you could see the show, of course, but in those days the Paris couture depended not just on the "custom-made" departments at Bergdorf Goodman and Bonwit Teller, but on Seventh Avenue, particularly the coat and suit people. You'd take the old double-decker Pan Am clipper, and there would be Hattie Carnegie and Nettie Rosenstein, someone from almost every house in New York. Each house had a "commissionaire" in Paris who actually bought the clothes, although it was more a rent-a-car kind of thing, because you could have them for only six months, then you had to send them back. I mean, you could buy them, but the duty would have been enormous. But we became absolutely dependent on Dior's New Look, because that's what everybody wanted. You might get an idea or two from Balenciaga's tailoring or from Madame Grès, but no question about it—everything we did was derivative of Paris. In those days that was considered the norm. Even Norman Norell, the leading American designer at the time, would quietly go over after the initial openings to see Madame Grès and Balenciaga. You just can't imagine the difference between New York and Paris then. Women in America, no matter how rich, all wore these black rayon crepe dresses because the war restrictions limited you to something like two-and-a-half yards of fabric. So, after years of that, to suddenly see these opulent clothes in Paris, well, it was just sort of "This is rich. We're rich. Screw you."

In its June 1948 issue *Vogue* introduced its readers to a character dubbed Mrs. Exeter, whom the magazine called "our 50-year-old heroine" and who would carve a niche for herself with her fashion commentary for women of a certain age. For decades Mrs. Exeter dispensed advice on clothes, cosmetics, lifestyle, and philosophy in the face of wrinkles and gray hair and a progressively less elegant silhouette. One reason for the invention of Mrs. Exeter was the postwar emergence of a new style of American woman—young, blonde, athletic, outdoorsy. This image did not fit the women over thirty who, in general, were the ones *Vogue* addressed, most particularly women in the select group popularly called café society. Distinguished by their style and elegance, they frequented such fashionable supper clubs as the Colony, El Morocco, the Barbe Room, and (briefly) Fefe's Monte Carlo. Among the most notable women of café society were the Duchess of Windsor, Daisy Fellowes, Babe Paley, Gloria Guinness, Lady Ashley, Valentina Schlee, Slim Keith, C. Z. Guest, and Elsie de Wolfe. In 1948 Cecil Beaton saluted café society and all its era in his photograph for *Vogue* showing eight models in a richly appointed drawing room, dressed in sumptuous gowns and costly jewelry, combing their hair, conversing, and drinking after-dinner coffee.

Among designers, while Dior reigned in the 1950s, Cristóbal Balenciaga was still at the height of his powers, a defender of the European style of dressing and a master of the cut. Other outstanding figures were Pierre Balmain, Hubert de Givenchy, Jean Dessès, Edward Molyneux, and Jacques Fath. A variety of shapes appeared—the wrap-around, the princess, the tulip, the A-line, the H, the sack—with one designer inevitably influencing another.

Undoubtedly, the news event of the decade was the return of Coco Chanel, who reopened her Paris salon at 31 rue Cambon on February 5, 1954, at the age of seventy-one. She had been tarnished by her relationship with the German occupiers during the war, and the press was not friendly. *Vogue* treated her kindly, praising her new ideas, and in less than a year Chanel had reasserted her style, this time characterized by tweed and cardigan wool suits, silk skirts, and bead and pearl necklaces. Fully aware that her classic style had been copied incessantly, she accepted the adage that imitation is the sincerest form of flattery: "I am no longer interested in dressing a few hundred women, private clients; I shall dress thousands of women. But a widely repeated fashion, seen everywhere, cheaply produced, must start from luxury. At the top of the pinnacle—'le point de départ' must be 'luxe.'"

In the meantime, in the United States a new style made itself felt among the young women who were joining the workforce and the ranks of consumers. That new image was based on the film world, and its main figures were sweater-girl Lana Turner, wholesome June Allyson and Doris Day with their scrubbed look, Audrey Hepburn in pants flashing her doe eyes, and uncombed blonde Brigitte Bardot. The movies and movie stars from then on exercised a phenomenal influence on fashion—and not only among women: witness Marlon Brando in *A Streetcar Named Desire* or *On the Waterfront*, with his body-hugging T-shirt.

Christian Dior died in 1957 and was succeeded by Yves Saint Laurent, a twenty-one-year-old who immediately had disagreements with the owners of the firm. Saint Laurent soon left the house of Dior to open his own establishment, and in the following decade his distinctive creations, often outlandish but always attractive, would make him the undisputed star of haute couture.

DIOR AND CHANEL
This photo, used by *Vogue* to open its article on the Paris spring collections in 1948, showed how the Dior style influenced everyday dressing. At right, the news of Chanel's return in 1954.

CHANEL
DESIGNS
AGAIN

LEE MILLER:
WAR REPORTS

When D-day arrived on June 6, 1944, London-based *Vogue* contributor Lee Miller had already been an accredited war correspondent for two years and had done memorable reporting during the Blitz. Miller soon joined the Allied troops in Normandy, filing stories that ran in both the British and the American editions of *Vogue*. Her first dispatch came from a U.S. Army field hospital, where she photographed wounded soldiers and other war victims. One picture was accompanied by the caption "[A] wounded man had watched me take his photograph and had made an effort, with his good hand, to smooth his hair. I didn't know that he was already asleep with sodium pentothal when they started on his other arm. I had turned away for fear my face would betray to him what I had seen."

Miller followed the U.S. 83rd Division into France, witnessed the liberation of Paris, then proceeded through the Low Countries and into Germany, sending back stories as well as photographs along the way. It was after seeing the newly captured concen-tration camps at Buchenwald and Dachau in April 1945 that she wrote and photographed her most touching and wrenching war documentary. *Vogue* published it in its June 1945 issue with the headline "Believe It" and the subhead "Lee Miller cables from Germany." The text read:

"This is Buchenwald Concentration Camp at Weimar." The photograph on the left shows a pile of starved bodies, the one above, a prisoner hanged on an iron hook, his face clubbed.

Lee Miller has been with American Armies almost since D-Day last June: she has seen the freeing of France, Luxembourg, Belgium, and Alsace, crossed the Rhine into Cologne, Frankfurt to Munich. Saw the Dachau prison camp. She cabled: "No ques-tion that German civilians knew what went on. Railway siding into Dachau camp runs past villas, with trains of dead and semi-dead deportees. I usually don't take pictures of horrors. But don't think that every town and every area isn't rich with them. I hope Vogue will feel that it can publish these pictures. . . ."

Here they are.

After this macabre two-page spread, the next one was Miller's as well: eight photographs captioned in taut telegraphese under the headline "Nazi Harvest." In all, the issue carried seven pages of Miller war pictures and several pages of her polished but profoundly unsettling text.

Editor in chief Edna Woolman Chase recalled in her memoirs: "We hesi-tated a long time and held many con-ferences deciding whether or not to publish [the photographs]. In the end we did it and it seemed right. In the world we were trying to reflect on our pages, the wealthy, the gently bred, the sophisticated were quite as dead and quite as bereft as the rest of humankind. Anguish knows no barriers." In *On the Edge* Alexander Liberman noted: "*Vogue* had evolved from a purely artificial magazine of ladies in attractive clothes to something with a closer relationship to reality."

WITNESS TO HORROR
Lee Miller was with the American troops almost from D-day as they battled their way across western Europe. Her most wrenching and vivid account came after the liberation of the concentration camps at Buchenwald and Dachau. *Vogue* published her photographs of piled-up skeletal corpses and other horrific scenes, along with her harrowing text, in the June 1945 issue.

"BELIEVE IT"
Lee Miller cables from Germany

"This is Buchenwald Concentration Camp at Weimar." The photograph on the left shows a pile of starved bodies, the one above, a prisoner hanged on an iron hook, his face clubbed.

Lee Miller has been with American Armies almost since D-Day last June; she has seen the freeing of France, Luxembourg, Belgium, and Alsace,

Retribution overtakes the Germans: the people shamed, humiliated; the country destroyed, and honour lost

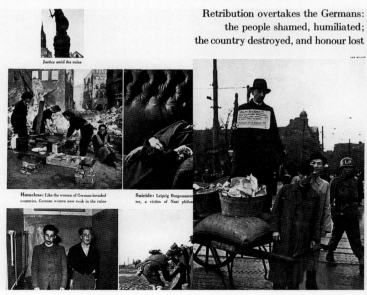

Justice amid the ruins

Homeless: Like the women of German-invaded countries, German women now cook in the ruins

Suicide: Leipzig Burgomaster, a victim of Nazi philos

143

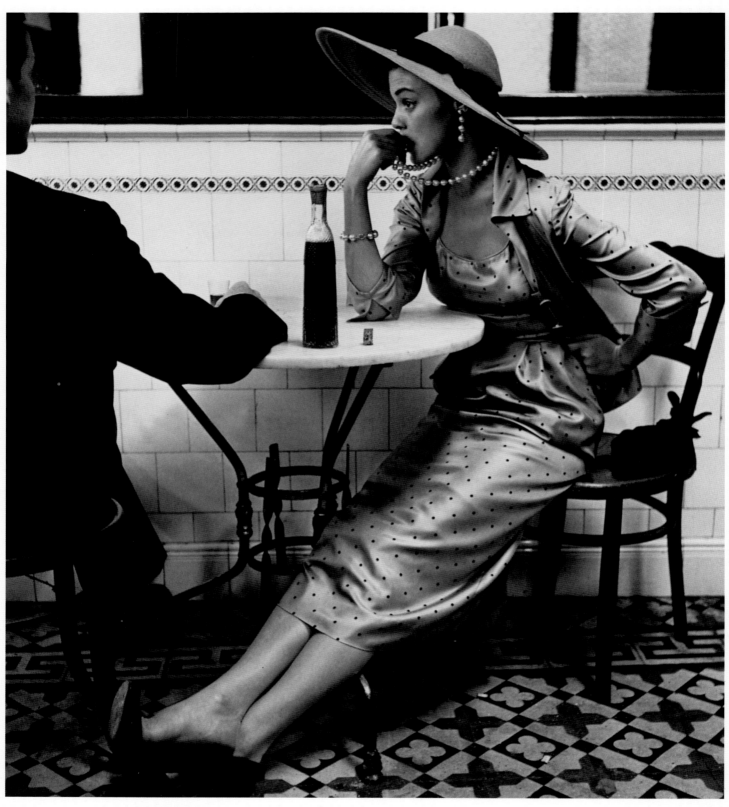

LIMA

INFORMAL POSE
Published on February 15, 1949, this picture changed the way *Vogue* showed fashion. Irving Penn photographed the model Jean Patchett during a moment of relaxation in Lima, Peru, as she bit on her pearl necklace while kicking off one of her shoes.

IRVING PENN'S ARRIVAL

In 1943, the same year Alexander Liberman became art director, another transcendental event took place at *Vogue*: Irving Penn joined the staff. For more than sixty years he would make his indelible mark on *Vogue* photography. The hiring of Penn served an aim that Liberman had from the very beginning, to change the formal appearance of the magazine—not only the design but the very core image, the photography. Liberman believed that fashion photography needed more movement, and he believed that real-life situations could be infused with charm and fantasy. To achieve this he needed new visions, new ideas, and new photographers capable of interpreting his philosophy. The staff he had at the time consisted mainly of Cecil Beaton, Toni Frissell, Horst P. Horst, Frances McLaughlin, and John Rawlings, of whom only the last two shared Liberman's approach.

Irving Penn had studied painting in the mid-1930s at the Philadelphia Museum School of Industrial Art. There he met Alexey Brodovitch, art director of *Harper's Bazaar*, who taught design. In 1940, when Brodovitch became art consultant to the Saks Fifth Avenue advertising department, he took Penn along as his assistant and, soon, his successor. It was at this time that Penn met Liberman. Penn wanted to go to Mexico to pursue his vocation as a painter, and in 1941 he offered Liberman his position. Liberman declined, but the two established a friendly relationship, and when Penn returned from Mexico in 1943, having given up painting, Liberman hired him as assistant art director at *Vogue*.

His job was to come up with ideas for the cover and transmit them to the photographers, explaining the new concepts that he and Liberman wanted to develop. His efforts ended in resounding failure, because professionals of the stature of Beaton, Rawlings, and Erwin Blumenfeld, each of them possessors of known techniques and styles, were totally uninterested in the aims put forward by the art department. Undaunted, Liberman invited Penn himself to take the pictures he had thought up, giving him an assistant and assigning him space to work within the *Vogue* photo studio.

In this early part of his career, Penn is recognized as having taken three very distinct types of photographs, indisputable evidence of his professional capability to handle all kinds of productions with excellent quality and style. His interest in contemporary art trends is reflected in the entire body of his work.

Penn started out as a photographer of still life. For his first *Vogue* cover, on October 1, 1943, he placed an array of fashion accessories on a wooden table, using as background a picture of oranges and lemons hanging on the wall above. Clear-cut and strong, with no superfluous detail, this image was especially noteworthy because its documentary style seemed more suited to a technical magazine than a fashion publication such as *Vogue*. Images of objects formed a considerable part of Penn's early work. He brought his lens up close and explored in detail the material, the texture, the weave of wool,

and the lacings of dresses across the naked backs of women.

In 1944, like many other young men who wanted to help the war effort, he volunteered for the American Field Service. He drove ambulances and took pictures of the troops in Italy and India. When he returned in 1946 he launched the second stage of his professional work, the stage of portraiture. During this period he photographed practically every important actor, actress, sports figure, writer, designer, and painter—but with a twist: The subject was invariably posed in Penn's Corner, the convergence of two plain walls with a worn carpet as the only decorative element, sometimes flung over a box, sometimes on a chair. Most of these pictures were absolutely austere and in stark black and white.

The third stage in these early decades with *Vogue* was devoted to a theme in which Penn was totally uninterested: fashion. It is quite remarkable that the very photographer who worked at *Vogue* the longest did not like the main subject of the magazine. But whether he liked it or not, fashion became as important in the personal life of Penn as in the professional. In 1947, when he photographed the twelve top models of the day and created an image that is still an icon of fashion photography, he came to know the very attractive Lisa Fonssagrives, whom he married three years later.

Meanwhile, despite Penn's blanket refusal to work on location, in 1948 Liberman persuaded him to travel to

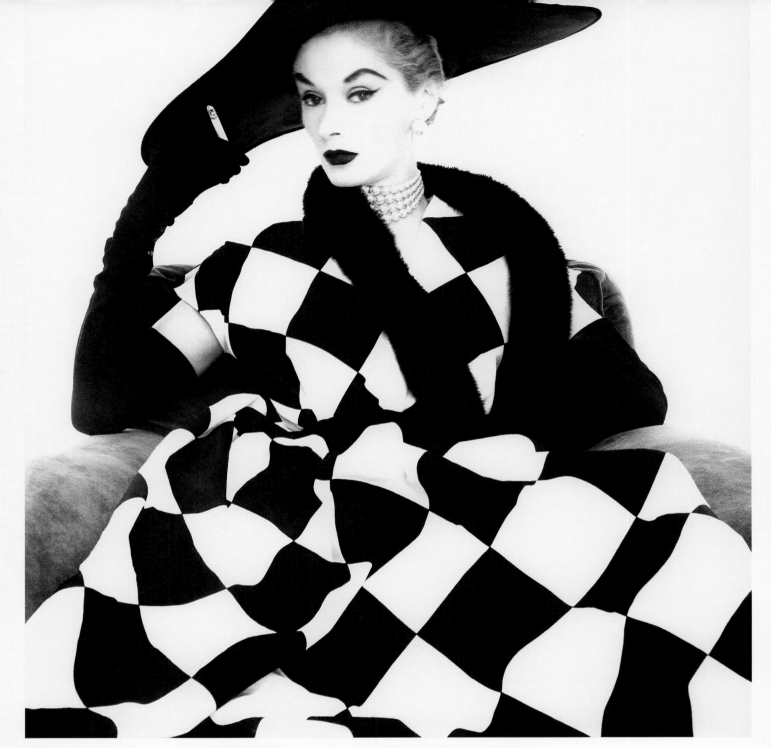

IMPACT
Penn gave full expression to the "precision" trend in this photograph from April 1, 1950. The clarity with which he depicted the very definite shapes in the harlequin dress worn by his wife, Lisa Fonssagrives, imparted a unique visual impact.

THE BLACK
AND WHITE
IDEA

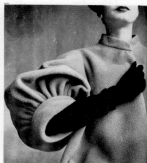

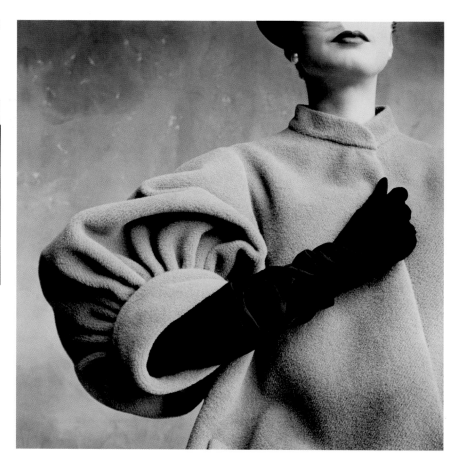

DETAIL

In September 1950 Penn covered the Paris fall collections. He hung an antique gray curtain in a studio as background for the models he photographed. The contrast yielded a detailed and precise presentation of the clothes.

Peru with Jean Patchett, one of the young models most sought after by the haute couture houses. One of the pictures Penn took during this trip is considered a turning point in fashion productions at *Vogue*, for it embodied how Liberman wanted clothes to be shown. Patchett herself, who had not previously worked much with Penn, recalled in *On the Edge* how the photo was taken: "We flew 3,200 miles and after we got there, a week went by and Mr. Penn still hadn't used his camera. I started getting nervous about it. Every day I got up and got dressed but he never took a picture. Finally one day we found this little café, and there was a young man sitting across from me, and I was getting frustrated. So I just sort of said to myself to heck with this and I picked up my pearls and I kicked off my shoes. My feet were hurting. And he said 'Stop!'" The picture taken at that moment was a watershed in fashion photography, with its impression of

sexual tension and the implication that it was part of a more complicated narrative. "From then on," Patchett said, "he gave me stories to play act with every picture we did. I could be in front of a piece of white paper in a studio and he would say, OK, now you're out on Fifth Avenue and you can't get a cab. Or we are at the opera and my gentleman friend has gone to get me an orangeade and hasn't come back and I can't find him and I'm looking all over the place. Mr. Penn gave me all these little stories. And it was really fun."

With Patchett as model, in April 1950 Penn produced the magazine's first black-and-white cover in decades, a memorable issue devoted to fashion, full of stylish and striking pictures (page 129). That same style of photography was applied in another of his memorable works, carried out in Paris for the fall collections of 1950. There in a studio, with a flat gray century-old

curtain as backdrop, he photographed models staring intensely into the camera. The contrast turned the photographs into documents revealing the most minute and precise details of the clothes and the personalities of the models, all of them Americans, tall and high-cheekboned, whose faces radiated energy. Penn had managed, most innovatively, to combine fashion and portraiture.

When I started to work," said Penn in *Vogue Book of Fashion Photography*, "it was important to make pictures that were timeless, that would burn off the page. The ideal setting was the French drawing room. I didn't know what a French drawing room felt or looked like, and the ideal women were remote, with European overtones. They were beyond my experience, as was Huené's work, which was remarkable, but his aristocratic perfectionism was beyond my aspirations. I could photograph only

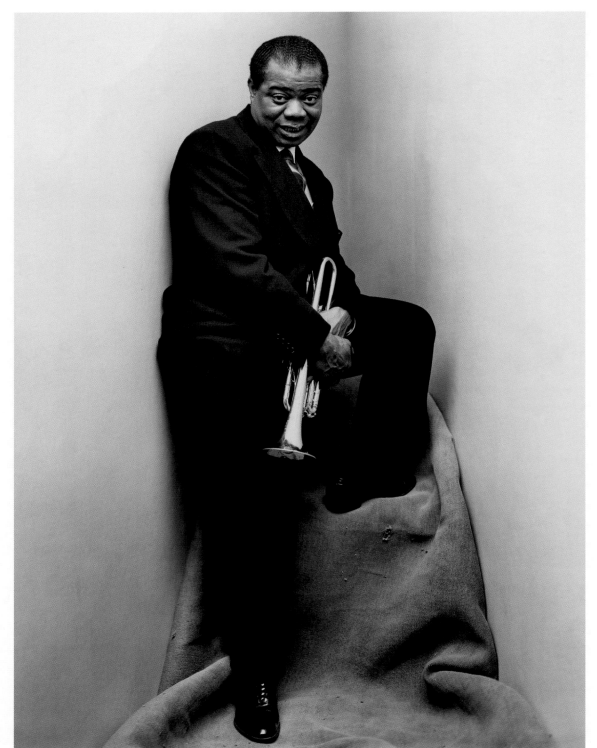

THE CORNER
Truman Capote and Louis Armstrong, in 1948. Both portraits were taken in Penn's Corner, created by the photographer to pose his subjects. The famous site consisted of two converging walls, unrelieved except for a worn carpet draped over a box.

what I knew and felt comfortable with. I made pictures in simple circumstances of women I could imagine and could want to possess. So at first I photographed simple, uncultivated girls, the girls I went to school with. They seemed right for America in the postwar period. The girl has always been important in my pictures because she projects so much, and has so much projected onto her. The models I used were people, and I would have a favorite model with whom I might have more real emotional involvement, which sometimes meant I saw more in the ground glass than was there, and photographed with more objective power than I was going to get back. I was a young man with no knowledge of style, but I knew when an image had guts.

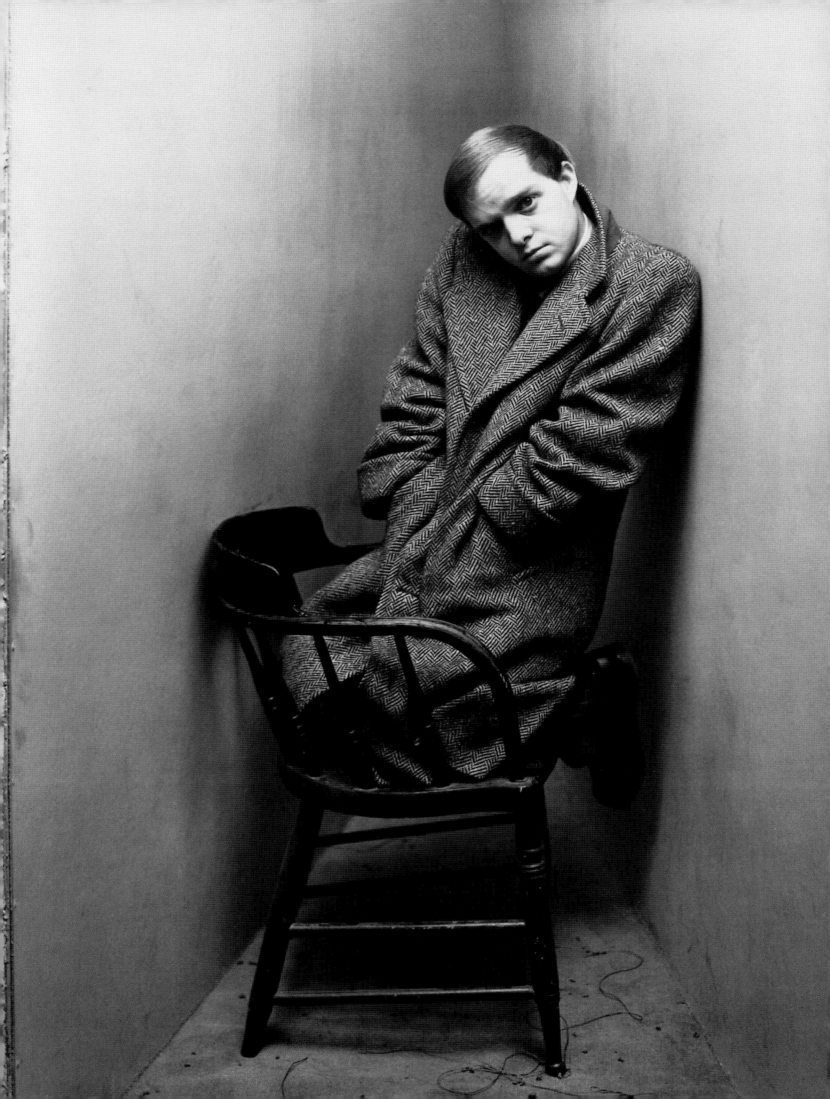

DAVES: EDITORIAL CONSERVATIVE, MARKETING RADICAL

The year 1952 was witness to important changes at the magazine. At age seventy-five, after fifty-seven years at *Vogue* and thirty-eight as editor, Edna Woolman Chase retired. She took with her the last vestiges of an era of work shared with Turnure, Condé Nast, and Iva Patcévitch. It was Chase who had guided the magazine through two world wars, and who had witnessed and contributed to the birth and development of American fashion. Chase was the editor who took illustration of articles from line drawings to the most glamorous photographs, who had seen the transition from black and white to color. It was she who had brought the first international editions into existence, and who was considered an authority on haute couture not only in New York but in London and Paris as well. In short, a large portion of *Vogue* history departed with Edna Chase, and a heavy burden of responsibility was placed upon her successor.

The person chosen to be the new editor in chief was Jessica Daves, who had joined the magazine in 1933 from the advertising department of Saks Fifth Avenue. She was initially an administrative employee, advanced to managing editor and then in June 1946 to editor of American *Vogue*. Daves, daughter of a Georgia pastor,

progressively assumed Chase's editorial responsibilities, and although she spent more than a decade as editor in chief, from the time of her appointment in 1952 it was always said extraofficially that her presence would be transitory. Rumors that she would not be at the magazine's helm for long were influenced by several factors. First, she was not considered a fashion expert, with her own original ideas or will to innovate. She was seen, rather, as a very conservative person, too old to introduce changes. She had taken on the job at age sixty, but her manner of dressing and her personal behavior made her seem even older. Second, she was not internationally known. Actually, she was hardly known at all in the haute couture salons and the expositions of Paris. Lastly, her physical looks—she was a stout woman who wore old-fashioned, graceless clothes—did not reflect the "*Vogue* style" of glamour and the presence that was to be expected of the editor in chief of the most famous fashion magazine in the world.

However, Jessica Daves cared nothing for rumors. She was a person of great experience and held her own views about directing the magazine, about *Vogue*'s areas of weakness and how they could be corrected.

Daves surrounded herself with editors of excellent taste and style who lived for nothing but fashion. Her editorial staff, following the lines laid down by Nast in his day, consisted of two elements: On the one hand, young women from wealthy and socially active families with important surnames and almost no experience in publishing; on the other hand, professional specialists in fashion, beauty, and the accessories featured in the magazine. The first group, solely by reason of being on staff and participating in social events, validated *Vogue* as a society magazine. The second produced the entire magazine and instructed the first group how to dress with style and glamour and how to behave as ladies. Daves knew how to put together and direct a great team.

Daves was aware of her limited knowledge of photography. She knew she was not creative enough to plan fashion shoots or to choose locations. She therefore handed all graphic responsibilities over to Liberman—not only design but the handling of photographers, the planning of fashion articles, and the ultimate selection of the pictures. She also pushed for articles on the art world, in an effort to give the magazine a more intellectual aura.

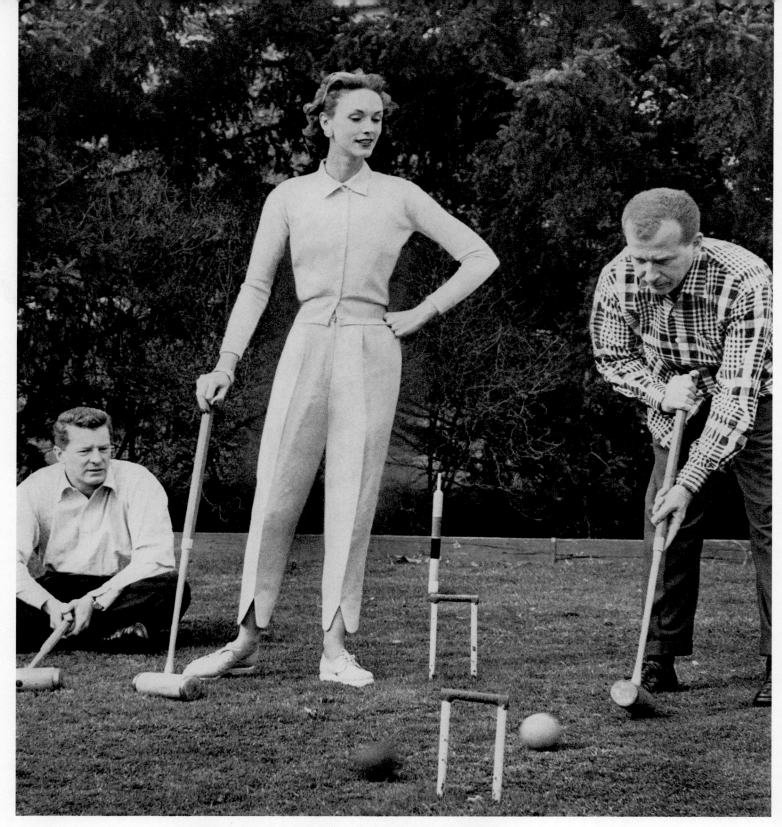

PRACTICALITY

The years Daves headed the magazine coincided with the advent of less conservative and more practical sports clothes. Films and film stars contributed to popularizing this type of clothing for the more independent woman.

Party week end *continued*

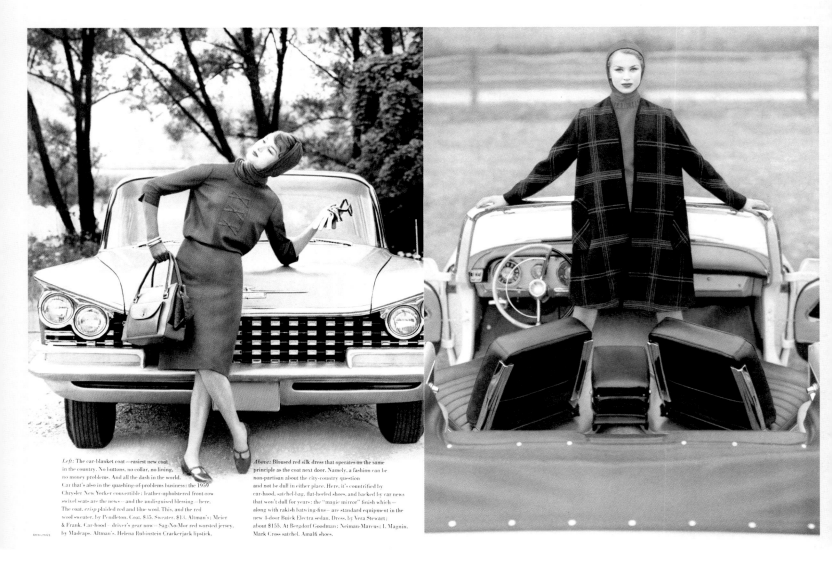

Left: The car-blanket coat—easiest new coat in the country. No buttons, no collar, no lining, no money problems. And all the dash in the world. Car that's also in the quashing-of-problems business: the 1959 Chrysler New Yorker convertible; leather-upholstered front-row swivel seats are the news—and the undisguised blessing—here. The coat, *crisp* plaided red and blue wool. This, and the red wool sweater, by Pendleton. Coat, $45. Sweater, $13. Altman's; Meier & Frank. Car-hood—driver's gear now—Sag-No-Mor red worsted jersey, by Madcaps. Altman's. Helena Rubinstein Crackerjack lipstick.

Above: Bloused red silk dress that operates on the same principle as the coat next door. Namely, a fashion can be non-partisan about the city-country question and not be dull in either place. Here, it's countrified by car-hood, satchel-bag, flat-heeled shoes, and backed by car news that won't dull for years: the "magic mirror" finish which—along with rakish batwing-fins—are standard equipment in the new 4-door Buick Electra sedan. Dress, by Vera Stewart; about $155. At Bergdorf Goodman; Neiman-Marcus; I. Magnin. Mark Cross satchel. Amalfi shoes.

Writing was her great obsession. Married to Robert Allerton Parker, a writer and art critic who influenced her work greatly, Daves concerned herself with improving the quality of the printed text. She signed well-known writers such as Joan Didion and Terry Southern, and offered excellent coverage of everyday matters under the byline of reputed writers. Daves was an outstanding editor of these writings and possessed a wealth of cultural knowledge. This effort showed—as she would often say—that the world of women did not consist solely of "ornaments and clothes."

Daves's team of fashion editors clearly understood that women had emerged from World War II with a less sophisticated and more practical desire, not only to dress properly, but to buy intelligently and well. Daves is credited with recommending more comfortable apparel for women who

had to drive automobiles and with creating the *Vogue* shopping guides to stores and manufacturers.

Before the 1940s and 1950s, all fashionable women dressed in Chanel and Balenciaga, or in Courrèges dresses or in Ben Zuckerman suits—because that's what the women were wearing in *Vogue*. And the women with less money and as much desire for style bought high-fashion knockoffs at Ohrbach's and the look was the same. That's why, when *Vogue* began promoting sportswear, it was an event. The terms of appropriateness changed; you weren't going to start dining at The "21" Club in the same clothing you'd wear to the Automat, but you *could* go in a tweed jacket and a plaid skirt. Clothing became *sportive*, and women followed.

With these words Grace Mirabella, in her memoir, *In and Out of Vogue*, described the influence the magazine already wielded in the clothing business, an influence that allowed it to dictate fashions and trends. Mirabella, who joined *Vogue* in 1952 and became its editor for most of the 1970s and 1980s, also analyzed the reasons that drove the choice of more practical, less conservative and sophisticated fashions, and why Daves had been one of their main proponents:

Jessica Daves was often mocked for saying that what brought about the moment of sportswear in American fashion was the fact that cars had gotten smaller and that women needed more comfortable clothing so that they could get in and out of them. It was a rather pedestrian way of putting things, but, in reality, it wasn't far off the mark. One fashion invention of the late 1950s—the

California:
Serious
about sports—
and dressing
for them

The active life: You notice this the minute you cross the Rockies—how sports are an accepted part of everyday existence. Swimming? Most Californians would just as soon swim as walk. Tennis? Count the backyard courts; there's one in every block. Golf? Drive in any direction; there's always a course ahead.

Active clothes: A big Southern California specialty—their bathing suits, for instance, are famous as far as Italy. *Above left:* Black taffeta bathing suit woven with Lastex. One-piece with the merest snippet of a skirt at the front. By Cole of California, in Celanese acetate, about $17. At Altman; Marshall Field; I. Magnin. Joyce sandals, Altman. Poolside, of black brick—the new "flagcrete" designed by architect Burton Schutt. *Below left:* White piqué tennis set—a very short sleeveless coverall with a pleated button-on skirt. By De De Johnson, $35. Grey wool herringbone cardigan sweater (convertible turtle neck), $15. By Hollywood Knitting Mills. Both, at Rosette Pennington; Harzfeld's. Scene: the Ladd pool pavilion (page 80). *Above right:* Quick-drying new bathing suit—Orlon-and-wool woven with Lastex. White with blue strip-ins. By Gantner, $18. At Bonwit Teller; Famous-Barr; I. Magnin. Here again, a Burton Schutt poolside; notice the backdrop of ferns. *Below right:* Great California golf look (great for tennis back East), long shorts and a drawstring top designed in white cotton ottoman. By Pat Premo, in Hope Skillman fabric; about $20. Saks Fifth. The white concrete grillwork decorating the Ladd pool pavilion (see page 80).

For shops in other cities, see page 138.

VOGUE, APRIL 15, 1954

VOGUE, APRIL 15, 1954

KAREN RADKAI

ON THE MOVE

Clothes allowing comfortable access to automobiles became popular toward the end of the 1950s. Bathing suits, according to Daves's precepts, were always shown frontally or from the side.

culotte—really did come about to enable women to move in and out of cars with greater ease. And sportswear *was* about movement. It wasn't clothing for women who languished, or who lounged on their settees—the favorite pose of *Vogue* fashion models in the 1940s. In the 1950s the women of *Vogue* were shown modeling separates alongside shiny red Cadillacs. The inference was that America was on the move, and so were they. (We didn't realize just *how* "on the move" they were.) And they needed clothing that could get them places. Which isn't to say that the women of *Vogue* were hopping off the page into boardrooms; they weren't. But they were at least branching out beyond their living rooms. What sportswear, and its presence in *Vogue*, acknowledged was that even the debutantes, society matrons, and women of leisure who were *Vogue*'s stock readers

did things sometimes, and needed clothing for living in the world. And this acknowledgment, partial as it was, marked a profound shift in *Vogue*'s thinking about women. It was an awareness that women needed to live in the world—a conviction that I would try to bring into force and up-to-date two decades later.

However unfashionable, however old-fashioned she might herself have been, Jessica Daves brought *Vogue* into the post-war era and positioned it so it could survive in an increasingly democratic America. A career woman, with no particularly great social aspirations or standing, she was perfectly suited to the "real world" message of sportswear.

Despite being a practical woman, open to new trends, Daves was always an archconservative with regard to the images of fashion. This caused

CARS AND CLOTHES

The automobile was a symbol of feminine independence, representing movement, change, and evolution. The clothing of the day followed that looser and less formal trend.

occasional clashes with Liberman, who for some time had been in charge of everything concerning photography and the photographers. Liberman wanted to show women in new attitudes, in movement, dressing or undressing in the intimacy of their bedrooms or bathrooms. In this respect Daves followed the line laid down by her predecessor, who on one occasion had said: "I have remonstrated when the editors have passed photographs of models who do not look like ladies and therefore are not *Vogue* material . . . but they contend that it is what ladies of today look like, and as journalists we should show them as they are, and not as we think they should be." Daves would veto any photograph that struck her as too suggestive—a category that included, for example, a picture of a young girl's hips, "generally that part of the body that is not usually shown or is covered by an item of apparel," or a model wearing a negligee next to a bed. This happened quite frequently during her era, especially as lingerie acquired a larger presence on the fashion pages when new synthetic materials started appearing on the market. Daves even vetoed a photo by Horst because it showed a young woman in a nightgown reclining on a bed. She was horrified when the

dimensions of the new two-piece bathing suits began to shrink.

Behind the times in some ways, in others Daves's concepts kept the magazine very much up to date. In the realm of service, she opened the pages of *Vogue* to moderately priced clothing. She demanded of her editors that in each of their photo shoots they include not only expensive clothing by recognized designers but also quality items priced for the middle-class woman. This policy generated much criticism among the editors, who considered it an affront to the good taste and social standing of the woman reader. But because Daves was so knowledgeable in marketing and merchandising, while she was running the show this change took place, and for the first time *Vogue* was genuinely dedicated to service. The names of designers and of stores carrying their creations began to appear on the same pages as the clothes themselves, so readers would know where to buy them.

Daves was also the inventor of the store guide—"all about how to use this issue of the magazine"—which was printed on a special grade of paper in the front of *Vogue*. To assist in this facet of the business, Daves had an

executive editor, Mildred Morton, the magazine's liaison with advertisers. Morton was in charge of organizing and promoting events such as fashion shows, and generally improving the magazine's outside relations. Daves and Morton instituted an editorial practice—very unethical and deserving of much criticism—called the Must List. This list named manufacturers whose wares had to be selected by the editors and had to be featured in each issue. These manufacturers were the magazine's heaviest advertisers, and the Must List was a way of thanking them for their business. In addition, Mirabella said, "Stores were very important to the magazine in those days. They had a great deal of power, and a great deal of money, much more than they do today. And there were more big, fashionable stores then than there are today. The store guides were designed to help them plan sales by summing up the main fashion themes of the issues, highlighting what the trends and hot colors were. It was a highly successful venture, if not, in fact, at times overdone, to the point that *Vogue*—like other fashion magazines at the time—almost seemed to operate from the point of view of the stores, and chose to make its fashion points with the numbers we knew the stores had bought."

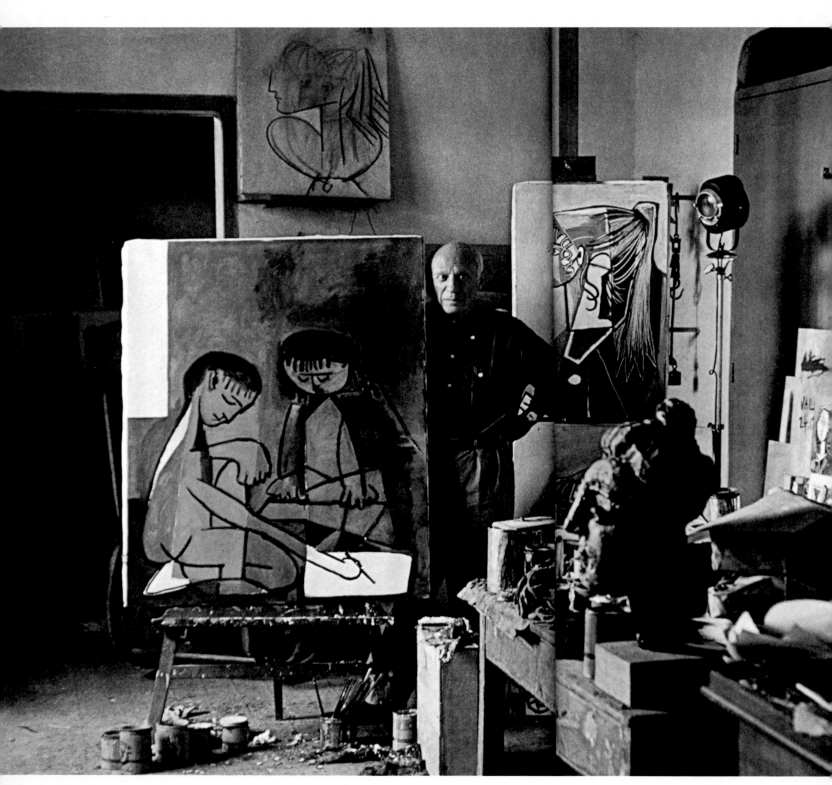

PAINTERS IN THEIR STUDIOS
It was Liberman's idea to photograph master painters in their places of work and inspiration. The atelier of Pablo Picasso appeared in the November 1, 1956, issue.

ART AND WRITERS
COME TO *VOGUE*

Liberman said over and over again that the magazine had only four digits of information per issue, and that it was made up of forty photographs and two hundred words. Although this was an exaggeration, it was not far from the truth. Writing had never been the strong suit of the magazine—a situation Jessica Daves tried to alter with the close collaboration of Liberman himself. Lifting the magazine's intellectual level was a concern inherited from the Nast era. Condé Nast was always sensitive to the criticism that *Vogue* writing was bland and unassertive. In the 1930s he had hired writers away from *Vanity Fair*, and in 1935 he took an extra step by instituting the Prix de Paris, an award for writing by young college women. The main prizes included the possibility of a job at *Vogue*. This came to pass for Margaret Collette in 1949 and for Jacqueline Lee Bouvier in 1951—two years before she married Senator John F. Kennedy. The future first lady won the prize with an essay titled "People I Wish I Had Known," in which she discussed poetry, drama, and ballet in the persons of three major figures: Charles Baudelaire, Oscar Wilde, and Serge Diaghilev.

Daves was a strong promoter of this event, and more than once she personally presented the awards to the winners. While she was in charge, she incorporated intellectual topics into the magazine, publishing writings of known authors and spreads that focused on artists, their lives, and their oeuvre. One of the most successful pieces of that time appeared in the February 1953 issue under the title "A Conversation with Stravinsky." The composer was interviewed for *Vogue* by the equally celebrated writer Aldous Huxley.

The editorial innovations included articles about celebrities, with photographs taken by Penn in his "corner," travel pieces, and essays on little-known cultures and peoples. New sections such as "People are Talking About . . ." and "Eye View," which formerly had made only sporadic appearances, now regularly imparted news about art, film, and the theater to counterbalance double-page fashion spreads. Virtually every issue included an article written by an important art critic, as Harold Rosenberg, Lawrence Alloway, and Clement Greenberg became frequent contributors to the magazine. So did Terry Southern, coauthor of the screenplay for *Easy Rider*, who teamed with actor-photographer Dennis Hopper to tour the country and report on the American lifestyle. The captions of the pictures were written by a young Joan Didion. All these developments took place during the editorship of Daves, and over time attracted other literati to the magazine. Among those who wrote pieces exclusively for *Vogue* were John Updike, Frank O'Hara, Bertrand Russell, Arthur Miller, Truman Capote, Anthony Burgess, and Susan Sontag.

Liberman's contribution to the elevation of *Vogue*'s intellectual level was fundamental. Widely knowledgeable about the art world—he himself was a sculptor and painter—he supervised every article published on art and gave readers a chance to learn about the work of modern masters. The timing was propitious, as interest in art was flourishing in the postwar United States. In 1951 *Vogue* published articles on Alberto Giacometti and Maurice Utrillo, the latter with photographs by Liberman, and the December issue devoted six pages

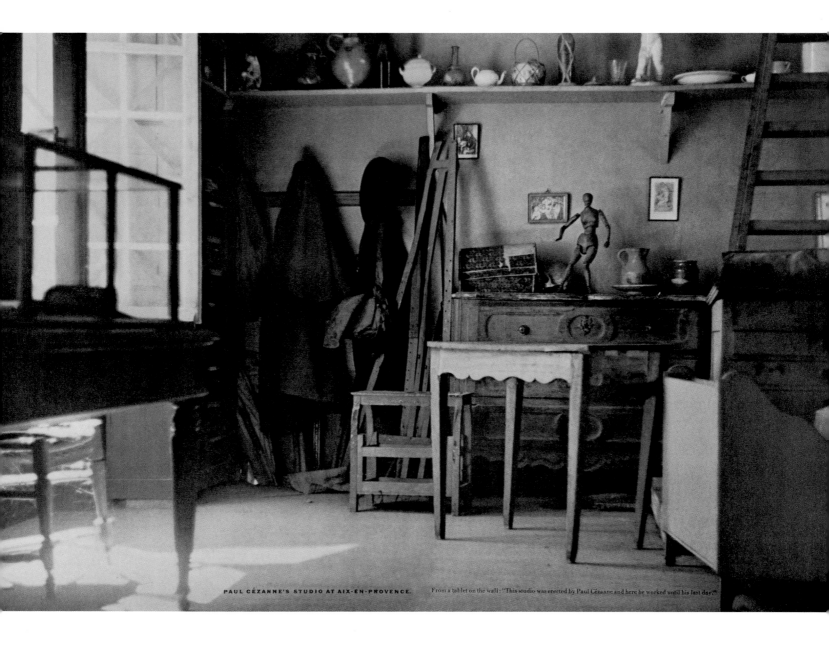

PAUL CÉZANNE'S STUDIO AT AIX-EN-PROVENCE. From a tablet on the wall: "This studio was erected by Paul Cézanne and here he worked until his last day."

to the work of Henri Matisse at the Chapelle du Rosaire in Vence, with pictures by Liberman and text by Marie-Alain Couturier, the Dominican priest largely responsible for securing the church commission for this transcendental work of art.

For years Liberman made it a personal project to photograph the workshops of great painters. The idea was born in 1948, when he visited the Normandy home of Georges Braque, and pursued the following year in Paris when he photographed the ateliers of Matisse, Utrillo, Marie Laurencin, and František Kupka. Liberman wanted to focus on what art books rarely dealt with: the

studios of artists, their work methods, and the materials they used.

"I thought that would be meaningful to a young painter," said Liberman, "all that practical side of art. As I went further, I also felt that the twentieth century had been an extraordinary moment in French art, and that all that flowering of creativity was on the verge of dying out. I wanted to try to preserve some evidence of how those artists had lived and worked." The first article about painters' workshops appeared in *Vogue* in April 1952. It dealt with the atelier of Cézanne, whose house in Aix-en-Provence had been bought by a poet who kept the

workshop just as the artist had left it. There followed articles on the ateliers of other artists, all of them living— Braque, Matisse, Picasso, Giacometti, Jacques Villon (brother of Marcel Duchamp), Marc Chagall. These photographic essays, incorporating the stories of Liberman's experiences, were put together by his stepdaughter Francine du Plessix, already a promising writer, and features editor Allene Talmey, formerly of *Vanity Fair*. Taken as a group, the essays were a fine example of the new content, art, and good writing that *Vogue* brought to the culture of fashion.

BRAQUE'S STUDIO *(right):*
*he usually has several paintings in work
at the same time; one on his easel, which
belonged to his father. (He calls the bird
in the painting "the spirit of the studio.") On a stand
he made of a rough tree branch, his open sketchbook.*

*The studio, built in 1948 according to Braque's own
logical plan, faces unconventionally south.*

*On a shelf, next to a vivid bouquet, a French
primitive landscape bought at the Flea Market;
pinned to the wall, a leaf pattern.*

Pebbles, net, starfish brought back from the beach.

*Braque made this palette-stand himself out of a
tree-trunk and twisted wires.*

ALEXANDER LIBERMAN

**FROM CÉZANNE TO
BRAQUE**
Liberman visited the studio
of Cézanne in Aix-en-
Provence (opposite), and
published his photo essay
in the issue of April 1952.
The studio of Braque in
Normandy (above), was
depicted in *Vogue* in 1954.

BLUMENFELD AND KLEIN:
VOGUE PHOTOGRAPHY IN THE 1950s

Liberman's plan to change the face of the magazine required new faces in the area of photography, alongside the already established presences of Horst, Beaton, and Penn. The first to join—or, rather, the first to return, since he had worked at *Vogue* a few years earlier—was Erwin Blumenfeld. Born in Berlin in 1897, Blumenfeld had lived in Holland after World War I and moved to Paris in 1936. An aspiring painter at first, he turned to photography to pay the bills. After doing portraits of Rouault and Matisse, social photography, and picture albums for models, he began to be known for his work in the advertising field. His first pictures for the French and British editions of *Vogue* were taken in 1938. One of his most memorable fashion shoots of this era depicted the model Lisa Fonssagrives leaning out from the top of the Eiffel Tower and spreading her skirts to the wind against the backdrop of the Parisian skyline, an image that provocatively counterpoised beauty and danger. Blumenfeld's relationship with *Vogue* lasted only one year, as Agha refused to renew his contract. His work, however, had impressed other editors, and he immediately started working in Paris for *Life* and *Harper's Bazaar*. In 1940 he was jailed by the Nazis. Following liberation, he chose to emigrate with his family to the United States. His first work there was with Carmel Snow, Diana Vreeland, and Alexey Brodovitch at *Bazaar*. At the insistence of Beaton he was hired by *Vogue* in 1946. Blumenfeld brought to the magazine the photographic style that had made him one of the most outstanding professionals in the field. He was an expert in darkroom

techniques, experimenting with solarization, multiple exposures, and reticulation of negatives.

Liberman called him "the most graphic of all photographers and the one who was most deeply rooted in the fine arts." For the art director, Blumenfeld was the ideal photographer for magazine covers. His technique called for focusing the camera between the shoulder and the hip of the model, which showed off the clothes very elegantly, and also allowed for convenient placement of the logo, the date, and the titles of the magazine's articles. Blumenfeld was one of the first to use a Hasselblad. Developed in Sweden for aerial photography, the Hasselblad allowed him to capture bold perspectives. Blumenfeld was responsible for a dozen magazine covers in a single year, one of which was to be his major claim to fame. The cover of the January 1950 issue had as its model Jean Patchett, and a beauty product as its subject. In the laboratory Blumenfeld worked his wizardry until the model's face was reduced to an arresting eye, a luscious mouth, and a perfectly placed mole. This image came to be an icon of sophisticated womanhood, speaking at one and the same time of fashion, beauty, and feminine individuality.

Blumenfeld worked for *Vogue* until 1955, the year that William Klein arrived. Born in New York in 1928 of German background, Klein too had started out as a painter before becoming a photographer. He studied art in Paris at the Sorbonne and with Fernand Léger. His first photographs were of buildings and abstract forms,

ORIGINAL AND COVER
For years afterward this 1950 image evoked the quintessence of *Vogue*, identifying the magazine as the epitome of female sophistication. Masterly darkroom work by Erwin Blumenfeld totally transformed his original black-and-white photograph of the face of model Jean Patchett, taken to present beauty products.

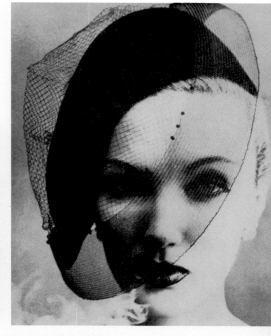

FILM INFLUENCE
In March 1958 William Klein photographed Brigitte Bardot at her home in a candid moment. He always aimed at making his fashion pictures part of a story, as with the series above, taken at the Musée Grévin, a wax museum in Paris.

CIGARETTE AND HAT
Klein's cinematographic style is on display in this picture from September 15, 1958, with the tendrils of cigarette smoke bringing the fore-grounded hat to life.

which were published by the archi-tectural magazine *Domus* beginning in 1952. It was this body of work that brought him to the attention of Liberman and *Vogue*, where he started taking fashion pictures. He turned to fashion photographs only in 1957, with great success. Klein evoked a special ambience in his images and a special attitude in his models. Using the city streets as backdrops, he set his shoots amid automobiles, traffic lights, people run-ning, everything real, with no prepara-tion whatsoever. His models had to forget they were posing and simply act as ordinary people would. All this magic captured by Klein was made possible by telephoto and wide-angle lenses, which nobody had ever used before for fashion photos. Very fre-quently Klein used movement to alter the picture or exaggerate the posture of the model, obtaining stunning images. His best pictures were taken during the years 1957–63, when he covered the fashion collections. One remarkable picture was "High-Powered Fashion," taken in July 1958, in which he turned his models loose in the dense Manhattan traffic and photographed them from a distance with a very long lens; another was taken in Rome's Piazza di Spagna, depicting two young girls in identical dresses in the midst of a crowd. In an innovative technique involving night takes, Klein used a powerful flash and and an extended exposure time to capture movement around a model's dress. Also significant was a series of pictures shot at Paris's wax museum,

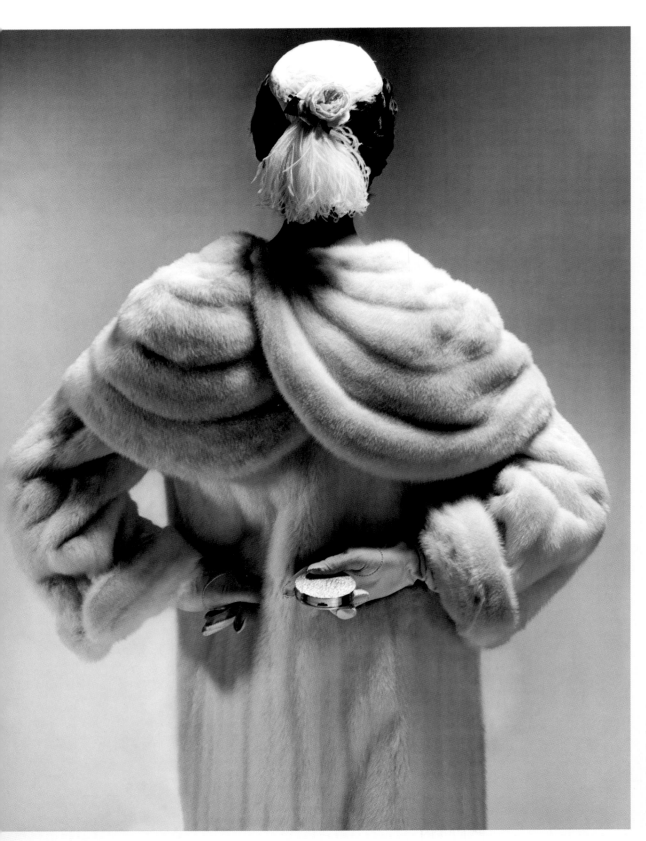

TWO STYLES
At left, the Blumenfeld technique, focusing between the shoulder and the hip, with space above and to the sides for titles. At right, one of Klein's trademark urban settings, this time with the fashion model braving the traffic of Manhattan.

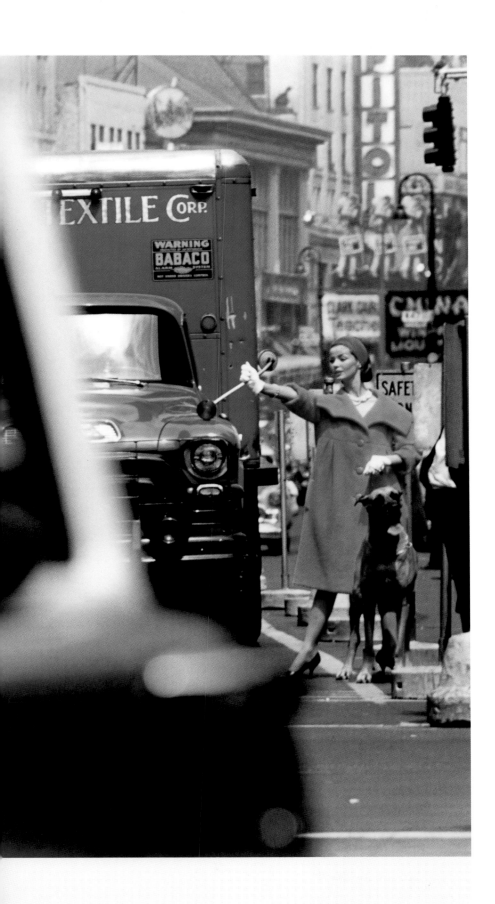

the Musée Grévin, where Klein set
out to show fashion as an illusion.
One model was photographed resting
a hand on a wax bust of Napoleon;
other models were pictured in mirrored
rooms that repeated their images
indefinitely and from different angles.
Klein mixed solid technique and real-
ism with imagination and fantasy.
He continued to work for *Vogue* until
1963, when he retired to pursue a
career in motion pictures.

Other photographers did outstanding
work during this period—Norman
Parkinson, Antony Armstrong-Jones,
Clifford Coffin, Constantin Joffé,
Frances McLaughlin, Toni Frissell,
Cecil Beaton, John Rawlings. But the
decade and the revamped style of
Vogue were dominated by Blumenfeld
and Klein and, always and especially,
by Irving Penn.

S. I. NEWHOUSE:
VOGUE'S NEW TYCOON

While all this was taking place on the editorial side—a new editor in chief, new writing, new graphic design, new photographers, new fashion trends—there was another major change looming at the Condé Nast company. Lord Camrose, the British financier who had rescued Nast from bankruptcy in the 1930s, died in 1954. His shares and all those of the Amalgamated Press Group passed to his son, Michael Berry, who in 1958 decided to sell the firm to Cecil King, owner of the *Daily Mirror* and other sensationalist British tabloids. *Vogue* and the rest of the Nast publications thus passed into the hands of a journalistic group that had little use for style, glamour, and good taste.

News of the transaction was explosive and created alarm at the management level. Iva Patcévitch traveled immediately to London to meet the incoming owner. His horror at the prospect of *Vogue* being a dependent of the *Daily Mirror* was not assuaged. However, the agreement between Lord Camrose and Nast included a clause stipulating that if the former ever sold his shares, the latter would enjoy a six-month option to repurchase them. Accordingly, upon his return, Patcévitch launched an urgent search for somebody to buy Condé Nast. Neither Crowell-Collier nor Time Inc., who were offered the firm, could meet Patcévitch's price. It was then that publishing tycoon Samuel I. Newhouse stepped in.

Newhouse, who had started out very young in the publishing world, lived a varied and colorful life before becoming the businessman he was when he took charge of the empire created by Nast. The eldest of eight brothers, he had gone to work at age thirteen to help his family after his father fell ill. The Newhouses lived in Bayonne, New Jersey, where Sam became an office boy and messenger for lawyer Hyman Lazarus. Lazarus was also a majority shareholder in the weekly *Bayonne Times*, whose stock he had acquired as payment of an otherwise uncollectible debt. Aside from his duties in the Lazarus law office, once a week the young Newhouse made some extra money as a newspaper delivery boy. One day in 1912, when the Bayonne publication was on the verge of bankruptcy, Lazarus proposed to Sam that he take over its management until a buyer could be found. Sam was seventeen years old and full of ambition and ingenuity. He saw in the offer a real challenge and a promising opportunity, and in a few months he made the business profitable. He enlisted the cooperation of local stores and promoted their wares in the weekly, cramming its pages with advertisements which soon pulled it out of the red. Sam did not take a salary for his work but instead arranged to be paid a percentage of future profits. In a scant four years Sam's annual income topped $20,000. As his business expanded, he placed his brothers and cousins in positions of confidence and responsibility, and

in 1922, ten years after taking over, he bought his first newspaper, the *Staten Island Advance*. At age twenty-seven he launched the meteoric career that would eventually make him owner of twenty-nine newspapers throughout the United States.

Although he granted his editors considerable local independence and never interfered with journalistic decisions, Newhouse's economic strategies were sometimes criticized. He would, for example, buy two newspapers in the same city, the better of which would eventually absorb the other; his domination of the local market would then allow him to increase his advertising rates. He pulled off something similar, after acquiring control of Condé Nast, by purchasing the Street and Smith Group, the oldest magazine chain in the United States, publishers of *Charm*, *Mademoiselle*, and *Living for Young Homemakers*. *Charm* became part of *Glamour*, and *Living for Young Homemakers* went to *House & Garden*. Simultaneously he rented out *Vogue Patterns* to the Butterick Publishing Company and closed down the Condé Nast gravure workshop in Manhattan and the company's printing plant in Greenwich, cutting costs and increasing profits.

Besides these steps to improve the firm's bottom line, other changes crept into its overall structure. First, with ownership now in New York and not in London, Patcévitch's freedom of action was reduced. Following

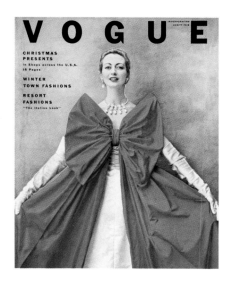

several disagreements with Newhouse, Patcévitch was demoted from president to director in the company hierarchy, and in 1968 he retired. Sam Newhouse remained true to his nepotistic style of direction—more than half of the local managers of his periodicals were relatives, and at one point he had more than sixty family members on the staffs of his corporations—and in 1961 he brought his son Samuel I. Newhouse Jr., known as Si, to Condé Nast. Si Newhouse became publisher of *Vogue* in 1966 and would later become head of the entire magazine business, while his brother Donald took over the newspaper, radio, and television enterprises.

Within the company Liberman grew in importance as he became a permanent consultant to the Newhouses on the daily management of the magazines, even when Patcévitch was still a presence. In December 1962 Liberman was named editorial director of all the Condé Nast publications, a post at which he remained until the 1990s. It was Liberman who brought to *Vogue* the woman who was to succeed Jessica Daves and who would be responsible for a revolution in fashion—Diana Vreeland, perhaps the most provocative, imaginative, extravagant, uncontrollable, and spendthrift of all the editors who ever occupied the throne at *Vogue*.

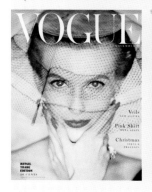

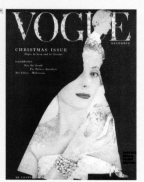

CHRISTMAS AT *VOGUE*

The covers at Christmastime rated special treatment, both in design and in photography. To mark December 25, Liberman repeated a red Dior dress twenty-five times, to stunning effect. In other years Clifford Coffin showed a red evening hat and a romantic veil, Blumenfeld cropped a fashion photo into a silhouette, and Beaton opted for a large bow.

VOICES IN *VOGUE*

For the first seventy years of the twentieth century, women's magazines typically offered fiction—short stories or serialized novels—aiming to strike a balance between practical information and diversions with intellectual or emotional appeal. Although *Vogue* chose not to publish fiction, the magazine always placed a high value on the quality of its writing, and in 1935 it created the Prix de Paris, a contest open to college students across the United States, with the goal of finding and grooming young writers for the magazine. One first-prize winner, in 1951, was a George Washington University senior named Jacqueline Lee Bouvier. In addition to encouraging young talent, over the years *Vogue* invited famous writers, critics, philosophers, artists, and entertainers to contribute original pieces.

Jacqueline Lee Bouvier, "People I Wish I Had Known," *Vogue*, February 1, 1961. Two years before her marriage to Senator John F. Kennedy, Jackie had won the 1951 Prix de Paris with this essay. It was published in *Vogue* just after she became First Lady.

"I would say that the three men I should most like to have known were Charles Baudelaire, Oscar Wilde, and Serge Diaghileff. They . . . specialized in three different fields . . . yet I think a common theory runs through their work, a certain conception of the interrelation of the arts. Baudelaire and Wilde were both rich men's sons who lived like dandies. . . . Both were poets and idealists who could paint sinfulness with honesty and still believe in something higher. The Frenchman, an isolated genius who could have lived at any time, used as his weapons venom and despair. Wilde, who typified the late Victorian era, could, with the flash of an epigram, bring about what serious reformers had for years been trying to accomplish. . . . Though not an artist himself, [Diaghileff] possessed . . . the sensitivity to take the best . . . and incorporate it into a masterpiece . . . If I could be a sort of Over-all Art Director of the Twentieth Century . . . it is their theories that I would apply to my period. . . . And they would make such good steppingstones if we thought we could climb any higher."

" A M E R I C A N S
A R E . . . "

The impact of
America upon
European culture

BY BERTRAND RUSSELL, O.M.

Bertrand Russell, "The Impact of America upon European Culture," *Vogue*, February 1, 1950. The celebrated English philosopher, then seventy-seven years old, received the Nobel Prize in Literature later the same year.

"A great deal of nonsense is talked about American so-called "materialism" and what its detractors call "bathroom civilization." I do not think Americans are in any degree more "materialistic," in the popular sense of that word, than people of other nations. We think they worship the "almighty dollar" because they succeed in getting it. But a needy aristocrat or a French peasant will do things for the sake of money that shock every decent American. Very few Americans marry from mercenary motives. A willingness to sacrifice income for idealistic reasons is at least as common in America as is in England. I think the belief that Americans are fonder of money than we are is mainly inspired by envy. It is true that, where there is no recognized aristocracy, wealth is the chief means of winning general repect. But where aristocracy has prevailed, individual aristocracts have been respected because aristocrats were rich. Now that this is no longer true in Europe, American standards, as regards snobbery, are rapidly coming to be accepted. . . . An American middle-class housewife, compelled, like an English housewife, to do her own cooking, does it with less labour than is required in most English kitchens. . . . It is not only in utilitarian ways that the best Americans are admirable. What could be less utilitarian than the study of extra-galactic nebulae? Yet here far and away the best work has been done in America. True, the best reason is that America has the best telescopes, and has them because there are very rich men in America who think this is a good way of spending some of their money. But they would not think so if they and their public were as earthbound as is often supposed by Europeans."

WHAT
FELLINI
THINKS
MASTROIANNI
THINKS ABOUT WOMEN

BY FEDERICO FELLINI

EDITOR'S NOTE: One of the most attractive men in the world is Marcello Mastroianni, a good-looking, quirky man, with a wide bold face over which his emotions blow easily. They have blown so effectively that by now this Italian actor is the phantom lover of innumerable women in movie audiences. They have seen him as a spiv, as a Dolce Vita character, as a bored Sicilian husband, as the marvellously bewildered film director of the movie, "8½," written and directed by Federico Fellini who is just about the second most attractive man—devil eyebrows, rumpled hair, his air of being just two inches beyond this world.

* * *

Here is part of the disjointed monologue that, in my films, I have put in the mouth of Mastroianni. As a result I have come to believe that Marcello feels exactly as I do. I wish that he would rise up to deny it, that he would get back at me by inventing a Fellini in order to give me a shock and to push my self-knowledge and development a step further.

"... Look here, Federico, wouldn't you like to live with a careless, disorderly, light-headed, deliciously useless woman, one that would never call you to account or hark back to the past, a woman without a memory, living in the present, as completely as if she were born yesterday? What peace! What freedom! ...

"No, to my mind the ideal woman is the perfect housekeeper, who surrounds you with quiet and order, with restful coolness or discreet warmth, as the case may be, who builds a home as if it were a temple. A woman who has a knack for choosing colours, who figures out your income tax, who shows the passports when you cross a frontier and deals with the customs agents. A woman who answers the telephone and extricates you from rash promises and thorny relationships. A perfect hostess who says the right thing and even knows how to answer the report-

Federico Fellini, "What Fellini Thinks Mastroianni Thinks about Women," *Vogue*, August 15, 1963. The Italian filmmaker had by this time directed Marcello Mastroianni in two acclaimed films, *La Dolce Vita* and the just-released *8½*.

Here is part of the disjointed monologue . . . I have put in the mouth of Mastroianni. . . .

". . . Federico, wouldn't you like to live with a careless, disorderly, light-headed, deliciously useless woman, one that would never call you to account or hark back to the past, a woman without memory, living in the present, as completely as if she were born yesterday? . . .

"No, to my mind the ideal woman is the perfect housekeeper, who surrounds you with quiet and order, with restful coolness or discreet warmth . . . who builds a home as if it were a temple. A woman who has a knack for choosing colours . . . who answers the telephone and extricates you from rash promises and thorny relationships. A perfect hostess who always says the right thing and even knows how to answer the reporters. . . .

"After thinking it over what tempts me most is to join two of the extremely contrasting facets of woman: the virgin, the prostitute. But wouldn't such a combination be tedious in the long run? . . . Yes, true wisdom is in the diversity of shapes and faces. Every epoch, every year, creates a different type of woman, and I mourn for the five thousand years of civilization when I was not around to marvel at an iridescent wealth of faces, figures, smiles, and mannerisms."

Conversation with STRAVINSKY

BY ALDOUS HUXLEY

Aldous Huxley, "Conversations with Stravinsky," *Vogue*, February 15, 1953. The British novelist and essayist, a frequent contributor to *Vogue*, interviewed the Russian-born composer in California, where both had relocated before the war. The seventy-year-old Stravinsky had been a naturalized American since 1945.

"To be a good talker, one needs a quick intelligence and a fund of readily available knowledge. To be a good listener, one must be charitable, one must be sensitively aware of other people, and one must be interested in everything. Stravinsky possesses all these qualities and can therefore listen as well as he talks. True, he does not suffer bores very gladly, nor fools—[but] he exhibits a politeness, whose core is inborn kindliness and whose exquisitely polished surface is the result of an upbringing in the best kind of aristocratic tradition. This politeness . . . is the more admirable in one whose temperament is far from lymphatic. There is an energy which is steady, pachydermatous, almost sleepy; and there is an energy of a more bird-like kind, swift, tremulously awake. Stravinsky's energy, which is enormous, is of the second variety. He is a prodigious worker, never satisfied with any achievement however high. . . . "

BURTON WRITES OF TAYLOR

Richard Burton, "Burton Writes of Taylor," *Vogue*, March 1, 1965. The Welsh actor and Elizabeth Taylor had been married a year when he wrote this description of his first look at her.

". . . a girl sitting on the other side of the pool lowered her book, took off her sunglasses and looked at me. She was so extraordinarily beautiful that I nearly laughed out loud. . . . I smiled at her and, after a long moment, just as I felt my own smile turning into a cross-eyed grimace, she started slightly and smiled back. There was little friendliness in the smile. . . . She sipped some beer and went back to her book. . . . She spoke to no one. She looked at no one. . . . Was she merely sullen, I wondered? I thought not. There was no trace of sulkiness in the divine face. She was a Mona Lisa type, I thought . . . and she is famine, fire, destruction, and plague, she is the Dark Lady of the Sonnets, the onlie true begetter. . . . Her breasts were apocalyptic, they would topple empires down before they withered. Indeed, her body was a miracle of construction and the work of an engineer of genius. It needed nothing except itself. It was true art."

"EXTREME MAGIC"
AN AWAKE-DREAM, CRUISING UP THE YUGOSLAVIAN COAST
BY TRUMAN CAPOTE

Truman Capote, "Extreme Magic: An Awake-Dream," *Vogue*, April 15, 1967. Capote's magnum opus *In Cold Blood* had been published in 1966.

"August, 1966! aboard the 'Tritona.' Others aboard: Gianni and Marella Agnelli (hosts), Stash and Lee Radziwill . . . Seven Italians, one Dane, one Pole, and two of *us* (Lee *et moi*). Hmm.

Point of departure: Brindisi. . . . Destination: the islands and coast of Yugoslavia, a twenty-day cruise ending in Venice. . . .

Groan. Moan. Oh, oh, oh hold on to the wall. And crawl, Jesus, please. Please, Jesus. Slowly, slowly, one at a time: Yes, I am crawling up the stairs from my cabin (where green waves are smashing against the portholes), *crawling* towards the presumed safety of the salon.

The 'Tritona' is a luxurious craft constructed on a wide-bottomed principle of a Grecian caïque. The property of Conte Theo Rossi, who lent it to the Agnellis for their cruise, it is furnished throughout like the apartment of an elegantly humorous art collector: The salon is a greenhouse of flowering plants—a huge Rubens dominates the wall above an arrangement of brown velvet couches.

But on this particular morning . . . the salon, when at last I've crawled my way to it, is a rocking wreck. A television set is overturned. Bottles from the bar are rolling on the floor. Bodies are strewn all over like the aftermath of an Indian massacre. One of the choicest belongs to Lee. . . . As I crawl past her, she opens a seasick eye and, in a hospital whisper, says: 'Oh. It's *you*. What time is it?'

'Nine. Thereabouts.'

Moan. 'Only *nine*? And this is going to last the *whole* day. . . . we shouldn't have come. How do you feel?'

'Maybe I'll live.'

'You look incredible. Yellow. Have you taken a pill? They help. A *little*.'"

DIANA VREELAND:
THE DARING SIXTIES

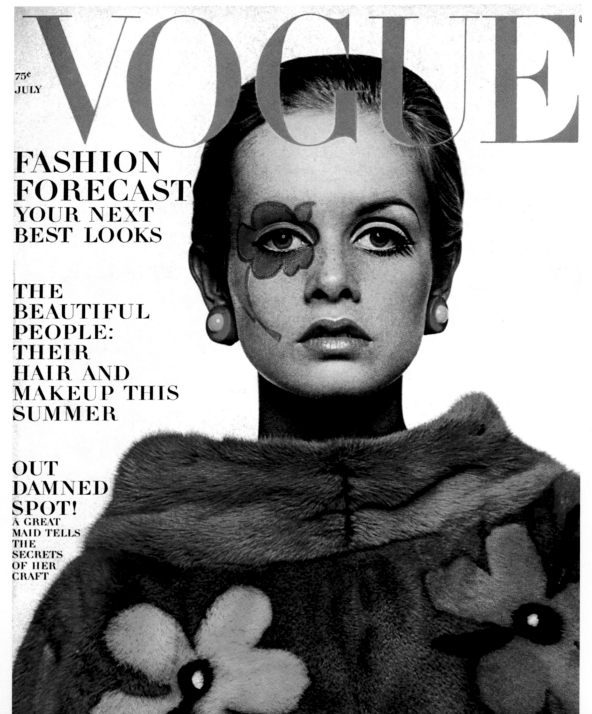

VOGUE

75¢
JULY

FASHION
FORECAST
YOUR NEXT
BEST LOOKS

THE
BEAUTIFUL
PEOPLE:
THEIR
HAIR AND
MAKEUP THIS
SUMMER

OUT
DAMNED
SPOT!
A GREAT
MAID TELLS
THE
SECRETS
OF HER
CRAFT

SIXTIES SYMBOL
The July 1967 cover paired
Avedon, a master of fashion
photography, and Twiggy, the
first very young supermodel,
to produce a fanciful image
evoking the "Peace and
Love" look of the 1960s.
Photograph Richard Avedon.
Courtesy the Richard
Avedon Foundation.

"From the moment she came to *Vogue*, she created a revolution. Diana Vreeland shook up years of tradition that needed to be reexamined. She brought iconoclastic daring. She encouraged the breaking of rules and taboos. She was able to do it because she was so brilliantly disciplined. She was not wild; she was a disciplined savage. She was the first editor to say to me: 'You know, this is entertainment.' In many ways, she acted as a brilliant theatrical producer. She visualized *Vogue* as Theater. She pushed a certain excess because she understood that you have to pass the stage lights and reach out beyond to your audience. She was the most talented editor of her period because she was able to stamp an era in the reader's mind." These valedictory words, in the December 1989 issue of *Vogue*, were written by Alexander Liberman, who during the entirety of Vreeland's tenure at the magazine was editorial director of Condé Nast. He was also the instigator, in 1962, of her transfer to *Vogue*, stealing her away from *Harper's Bazaar*.

Vreeland was born in Paris, the daughter of a Scottish father and an American mother who in 1914 moved to New York. In the mid-1920s she married the American banker T. Reed Vreeland and moved to London, where her husband, to provide her with a socially acceptable diversion, backed her in opening an elegant lingerie shop. It was there that she struck up a friendship with one of her most important clients, Wallis Simpson. In 1937 the Vreelands and their two children returned to New

York. "I had never thought of working," Vreeland would say later, "and the only thing I knew was where to go to have my clothes made, so it seemed only natural to go into fashion." Carmel Snow, who had heard about her from the Duchess of Windsor, asked her to come to *Harper's Bazaar*, where almost overnight she was named fashion editor. When Snow retired in 1958, Vreeland hoped to be named editor in chief. However, the post went to a niece of Snow's, Nancy White, editor of *Good Housekeeping*. It seems that, before retiring, Snow had advised the Hearst organization that Vreeland did not have the necessary discipline and judgment for the top job. Four years later, when Liberman approached her about moving to *Vogue*, Vreeland was more than willing. In her memoir, *D.V.*, she pointed out that at *Harper's Bazaar* she had never earned more than $18,000 a year, and that *Vogue* "offered me a very large salary, an endless expense account . . . and Europe whenever I wanted to go. That's what hooked me."

Vreeland joined *Vogue* as associate editor, while Jessica Daves continued as editor. From the very start, relations between the two women were prickly. Vreeland's inexhaustible energy and innovative ideas clashed with Daves's unswerving vision of the magazine as a bastion of good taste. Before long Daves yielded and withdrew into retirement. At the turn of the year, Vreeland took over Daves's title as editor in chief and the vast office that had belonged to Condé Nast. The changes she introduced came so

swiftly, and were so avidly discussed in the publishing and fashion worlds, that on May 10, 1963, *Time* magazine profiled her in its Modern Living section:

She dwells in a world of beauty, yet no one has ever called her pretty. She likens other women to swans and skylarks, but finds herself described . . . as "an authoritative crane." . . . Her walk has been described as a camel's gait. . . . Yet thousands of women cut their hair because of her, cream their skins, shorten their sleeves, and belt their coats. . . . At close to 60, she moves with supersonic speed. She doesn't walk, she strides; she doesn't talk, she broadcasts. She surrounds herself with the calculated and the outlandish, paints her Manhattan office walls adulterous red, covers the floor with simulated leopard skin, burns incense through the day. . . . Vreeland took over *Vogue*'s helm only four months ago on the retirement of longtime (30 years) Editor Jessica Daves. . . . In her 27 years at *Harper's*, most of them as fashion editor, she had already established her legend as a human maelstrom. She tore in and out of offices, trailing hats, belts, secretaries and photographers behind her . . . patted on makeup and cut models' hair herself. It was while she was at *Harper's* that she originated the now legendary "Why Don't You?" column, peppered with such items as "Why don't you bring back from Central Europe a huge white baroque porcelain stove to stand in your front hall? . . . Why don't you have your bed made in China? . . . Why don't you wash your child's hair in champagne?"

MARILYN MONROE:
HER LAST PHOTOGRAPHS
IN *VOGUE*

In 1962, while Daves and Vreeland were sharing decision-making at the magazine and creating sparks with their differing styles, there occurred an event that made headlines around the world: the death by suicide of Marilyn Monroe, the woman who had been the sex symbol for an entire generation. As the news broke, *Vogue*'s issue of September 1 was being printed with an eight-page fashion shoot, photographed by Bert Stern, featuring the much sought-after and unfortunate Marilyn.

Stern had begun to work for the magazine in 1959, having made his name in advertising with a picture taken in Egypt for Smirnoff vodka—a martini glass standing in the sand, reflecting the pyramid of Cheops at Giza. Like all the photographers of his day, Stern sought to immortalize celebrities in his pictures. Horst had done this with Coco Chanel, Steichen with Greta Garbo, and Penn was doing it in his original "corner" with a host of notables. Liberman had chosen Stern for the Monroe production because of his unusual creativity—Liberman called his fashion work "very stimulating"— and his familiarity with the art world through his wife, Allegra Kent, a prima ballerina of the New York City Ballet. The shoot was carried out in two sessions, on different days, at the Hotel

MODEL MONROE
The shoot took place in two sessions at the Bel-Air in Los Angeles. In the first session Marilyn posed almost nude, but Daves had the pictures retaken. For the opening portrait Marilyn is dressed in black, with a pensive expression.

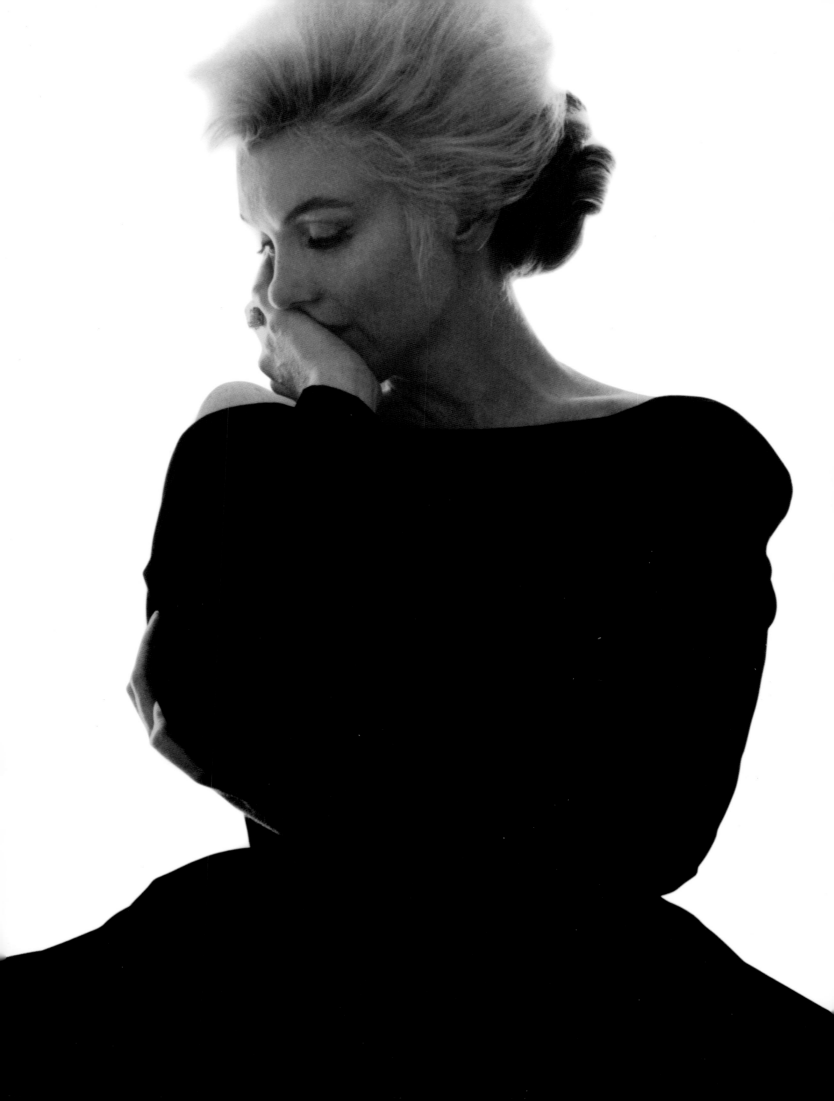

Bel-Air in Los Angeles. Because these were the last production photos ever taken of Monroe, and because she agreed to pose for them dressed and undressed, they constituted a unique graphic document of the last days of her triumphal and tormented career. For the first of the two photo sessions, Stern provided red scarves and costume jewelry, plus a crate of Dom Perignon champagne, which Marilyn was very fond of. For the second session—Daves asked for a repeat because she thought the first takes were too daring for the magazine—fashion editor Babs Simpson contributed black dresses, a long chinchilla fur coat, sequined gloves, hats, veils, and pearl necklaces. *Vogue* presented the article in its issue of September 1, 1962, which is now a collector's item.

MARILYN MONROE

...magnificent blond image
...he American memory-stream,
...he great film collections,
...novie houses as
...ikely as Tehran's.

MARILYN MONROE

Shy, witty, inventive,
she talked through the
long Vogue sittings
in what Norman Norell called
her "funny short-cuts."
(One of his favourites, on
Joe DiMaggio's looks: "He's
just a Michelangelo.")

LAST PRODUCTION
Three double spreads completed the shoot, an homage by *Vogue*. The producer was Babs Simpson, who had brought a number of black dresses, long, sequined gloves, a chinchilla coat, hats, veils, and pearl necklaces. The photo shoot with Bert Stern, during which the star's favorite 1953 vintage Dom Perignon flowed freely, lasted into the wee hours.

THE DECADE OF YOUTH

For fashion the 1960s were a unique decade, signaling on the one hand a retreat from haute couture and on the other a radical rupture with prevailing tastes and trends, in which Youth was the symbol, driving force, and source of inspiration. Linda Watson captured the spirit of the decade in *20th Century Fashion*: "The 1960s turned every preconceived idea on its head. As fashion zoomed into overdrive, everything whined in reverse. The teenager, previously persona non grata, had opinions and pulling power. Makeup turned from haughty to baby looks. Models played gauche, boutiques mixed genders, and unisex made an entrance. Secondhand clothes, once associated with charity and poverty, were chic and eclectic. Paris, veering towards a Left-Bank, existentialist look, was called 'no dictator, but gentle persuader.'" In this social climate clamoring for changes and new power spaces, the Youth Fashion phenomenon flourished.

Vogue in the early 1960s was notably influenced, like the rest of the population, by a figure who had become a paradigm of the American woman: Jacqueline Kennedy. The First Lady of the United States was among the first to understand the power of clothing as political weapon. Together with designer Oleg Cassini she formulated a clean, refined style that nevertheless spoke of youth and vitality. Her dense, sculptured hairdos, knee-length dresses, Chanel-style suits, and timeless evening gowns became a trademark look that was emulated by fashion-conscious women everywhere. *Vogue* commented in its March 1961 issue: "She has resolutely eschewed the bun-fights and the honky-tonk of the American political scene, and is inclined instead to the gentler practices of painting, conversation, literature and fashion."

A new style was coalescing, and that new style had Youth as its focus. After the war the birthrate had increased dramatically, and now these young people had become the segment to consolidate in the market. For this new influential class, elegance and fashion had different parameters. As Tom Wolfe pointed out in an analysis of the emerging culture: "Once it was power that created high style, but now high style comes from low places . . . from people who are marginal . . . who carve out worlds for themselves . . . out of the other world of modern teenage life, out of what was for years the marginal outcast corner of the world of art, photography, populated by poor boys."

MINIDRESS
Marisa Berenson, in a Saint Laurent minidress, was photographed on the street by her sister Berry in 1969. The minidress, originating in Manchester, was introduced by Mary Quant in her 1965 collection.

As the youth phenomenon took hold, fashion's hallowed status symbols vanished. Jeans, T-shirts, and the recently born miniskirt—it appeared in 1965—supplanted the stiffer garments of the 1950s. Fashion became more individual, set rules were dropped, and attention shifted to ready-to-wear clothing, with designers creating second and third echelons of cheaper, youthful apparel, which they referred to as the "spread."

The young people of the time, who dictated the currents of fashion, rebelled against all expressions of authority—parents, church, state—and made music their sole credo, erasing even differences of class, race, and gender. From this decade onward, the relationship between music and fashion intensified to such a degree that

very often it was the rock stars who dictated the fashions. The Beatles led the way in spreading the "English look."

The English look came from King's Road and Carnaby Street, from London shops such as Biba Boutique and Quorum and Bazaar, whose owner, Mary Quant, called it "a kind of permanently running cocktail party." The uniform of the young girls was based on a view of fashion as entertainment, translated into miniskirts, short vinyl raincoats, tight knit pullovers, pale lipstick, and false eyelashes. The haircut that became the rage was created by Vidal Sassoon: geometric, wedge-shaped, cut long at the side and ending in a sharp point at the chin.

For the first time ever, clothing fashions came from the streets, as the

young began to use dress to express their roles and their interests. The quest for deeper meaning led them to the hippie movement and "flower power," to delving into the occult, astrology, philosophy, music, and oriental religions. Leather and ethnic clothing were adopted as symbols of a return to nature. The second half of the decade also witnessed a spate of protest movements: in Britain the ban-the-bomb crusade, in the United States the escalating activism against the Vietnam War, and in France the student revolts of May 1968.

In the meantime, the erogenous zones of women moved from the timid territories of the neck and the shoulders to parts hitherto unexplored, such as the thighs and the abdomen. The miniskirt was born in Manchester and first worn

by art students in that English city. In New York one of the miniskirt pioneers was Edie Sedgwick, a protégée of Andy Warhol. In 1965 Mary Quant included a miniskirt in her collection and marketed it worldwide. In 1969 Berry Berenson photographed her sister Marisa, one of the most attractive models of the day, as she walked down a crowded street dressed in a tiny minidress by Saint Laurent. Her image became the graphic symbol that most eloquently caught the spirit of freedom that infused the fashion of the 1960s.

This was the Space Age—in 1961 Russian Yuri Gagarin became the first man to circumnavigate the earth in space; in 1969 Neil Armstrong was the first to tread on the moon—and in 1964 the Space Age style appeared.

Its creator was the French designer André Courrèges, who had learned his trade with Balenciaga. Courrèges broke with everything seen until then and became the most spectacular designer of the decade, showing white boots with no heels, geometric dresses in white and silver, hats like helmets. Along the same futuristic lines, in 1966 Francisco Rabaneda Cuervo, known to fashion as Paco Rabanne, presented his sophisticated designs combining such materials as aluminum, nylon, vinyl, and rigid plastics in garments that looked like astronauts' space suits. Linda Lawson recalled that "artifice increased with the space race. Before man landed on the moon, the unwritten rule, which said plastic was for picnics, metal for cutlery and paper for printing on, was thrown out of the window. Dresses

were made from every conceivable material—from paper to plastic discs, leather to PVC—all cut along baby-doll lines. There were obvious hairpieces and outrageous eyelashes, and hair was cut at obtuse angles, courtesy of London's most experimental coiffeurs, Leonard and Vidal Sassoon. Hairdressers, models and photographers—normally on the periphery of the industry—were the new VIPs. It was the defining moment when the world realized celebrities had less mystique, but more fascination, than royalty."

Fashion photographers were indeed being transformed into culture heroes, and the movies had much to do with this. The first hint of this developing relationship had come in 1957 with the film *Funny Face*, starring Audrey

Hepburn, in which Fred Astaire played a fashion photographer inspired by Richard Avedon and Kay Thompson played a magazine editor based on Diana Vreeland who exhorted her editors to "think pink." In 1966 the main character of the Michelangelo Antonioni film *Blow-Up* was inspired by British photographer David Bailey, known for his pictures of one of the most famous models of the decade, Twiggy. Both photographers worked at *Vogue*—Avedon had first risen to stardom at *Harper's Bazaar*—and Bailey was one of the most conspicuous representatives of Swinging London, the locus of all the new artistic trends that flouted the traditional canons. Bailey conducted lengthy romances with two models, Jean Shrimpton and Penelope Tree, whose faces and legs were among the most sought-after by the fashion houses of the day, and who owed their fame to their frequent appearances in the pages of *Vogue*. Bailey was also married to one of the most

beautiful women to ever grace the silver screen, Catherine Deneuve.

Meanwhile in France, the Nouvelle Vague films of Truffaut, Resnais, and Godard were causing a great stir. Young actresses began to take part in fashion events. Among those who posed for the cover of American *Vogue* were Deneuve, Samantha Eggar, Julie Christie, Jane Birkin, Britt Ekland, and Ursula Andress. The links between still photography and motion pictures consolidated a new alliance between fashion and popular culture. For instance, the beret and coat worn by Faye Dunaway in the 1967 film *Bonnie and Clyde* and the casual, feline look of Honor Blackman as Emma Peel in the British TV series *The Avengers* created an entire new style that was imitated by many designers to satisfy popular demand.

What was happening meanwhile in the pages of *Vogue*? How were these changes in fashion reflected? What

was the message about elegance to be transmitted to the reader? According to Polly Devlin, "there was a curious contrast between these parallel themes and images of women: on the one hand, the glamorous, recherché, poised lady; on the other, the free, freaky individualist dressing in whatever mood took her. Gradually the two images came together to make one amazing composite creature—or were drawn together by Diana Vreeland, who had become editor of American *Vogue* in 1962 and who loved the new style, especially in its more romantic and successful manifestations. She adored the young, embraced their idiosyncracies, endorsed their style, and coined the term 'youthquake' to describe the new movements and trends, as well as the people who instigated and followed them. In fact, she was famous for her metaphors and her fast descriptive labels, and *Vogue*'s use of the phrase 'the beautiful people' became a password for a chic, rich style of life in the 1960s."

AN AUDACIOUS FORMULA FOR AN AUDACIOUS DECADE

IN THE OFFICE
Diana Vreeland was at the helm of the magazine until 1971.

OUTLANDISH FASHION
This July 1968 production, photographed by Franco Rubartelli in the Arizona desert, shows the extravagance of the clothes sometimes proposed by Vreeland. The model for "The Magnificent Mirage" was Veruschka.

In the right place at the right time—the phrase was made to order for the combination of Vreeland, *Vogue*, and the sixties. With bold and spectacular fashion productions of innovative, sometimes outlandish clothing, the magazine was a faithful witness to the unbridled 1960s. "I don't think anyone has ever been in a better place at a better time than I was when I was editor of *Vogue*," Vreeland said. "*Vogue* always did stand for people's lives. I mean, a new dress doesn't get you anywhere; it's the life you're living in the dress, and the sort of life you had lived before, and what you will do in it later."

Vreeland intended to position *Vogue* at the forefront of fashion journalism, and she now had the authority to mold the magazine to her vision. She devel-oped a formula based on her own extravagant personality, supported by a phalanx of editorial pillars.

Until Vreeland's arrival, it was the designers of haute couture who dictated the fashions that the magazines would carry. The role of the magazine was to ensure that the models' makeup and hair were perfect, that the clothes they wore looked good, and that they wore them in the right places. But the magazines were limited to choosing and presenting the clothes, not to creating or even modifying them. Vreeland changed all this. She reinvented clothing. As her successor Grace Mirabella wrote, "Vreeland made fashion out of her dreams. If her dream for the fall was Veruschka as Queen Christina . . . then a Queen Christina wardrobe had

NUDE

Under Vreeland, fashion at *Vogue* became far more sensual, in step with the unfolding sexual revolution. Marisa Berenson, photographed by Irving Penn, appeared in the April 1970 issue wearing only a metal necklace.

to be made. If her dream for winter was 'Arctic White,' and no adequately Snow Queen–like costume could be found, she'd commission one." *Vogue*, under Vreeland, influenced more than ever the latest fashion news. She was an inveterate critic, pointing out to designers the errors of their new lines and how to correct them. She was also an irrepressible enthusiast, celebrating the advent of the miniskirt and calling the bikini, which Jessica Daves had banned from the magazine's pages, "the most important thing since the atom bomb." One of her main virtues–or, for her detractors, one of her worst excesses–was that she would present the whole range of fashion news, from very stylish clothes to the most eccentric lines, making *Vogue* into must-read entertainment but an unreliable reporter of wearable clothing for the real-life woman.

"Fashion is a show, not a service," Vreeland repeated insistently to her editors. She also often said, "We are in show business, and exaltation must preside," and "Give the readers what they never knew they wanted." She considered the magazine a vast stage, on whose pages a spectacular show was taking place. And the stage had to have suitable sets and props. To provide them, she thought up fashion production locations at the most exotic and remote places–India or Japan, Turkey or Tahiti, the Libyan desert or the glaciers of Greenland. Her eccentricities knew no limitations, as she admitted in *D.V.*: "Now I've never been to Tahiti, but I bet it's much plainer than people imagine. Gauguin was such a romantic. Perhaps he lived in Tahiti, but he could have made the whole thing up.

I'll tell you why I say this. During the romantic years at *Vogue*, I organized a trip to photograph the models surrounded by what was there, and these were the orders: 'Never mind the big girls who sit there with one flower in their hair. That you can't photograph, because Gauguin did a good job of painting them already. Our line of country is the most beautiful white horse with a long white tail on a pink beach–no little horse like a Gauguin, but a big romantic horse like the ones they have in a big way in Friesland in Northern *Holland*–all tail and mane. Go *all the way*!' They always had their orders before they'd leave on these trips. Everyone thinks I'm getting ill natured in my old age, but I was a terror then–just a terror. But everyone beautifully understood. It wasn't what they *might* find, it was what they *had* to find And if they couldn't find it, fake it. Fake it. That's a big thing with me." To carry out the production in Tahiti, and to carry out the whims of Vreeland, Kenneth, the hair stylist for the trip, prepared a voluptuous white tail of synthetic hair, to be appended to the horse Vreeland had stipulated. On an island almost totally lacking in horses, they managed to locate one aged steed, but he resisted having the tail attached and ran away into the mountains. It took the crew five days to find him. "Somehow, he came around. . . . They got the tail on. The horse probably came back because for the first time in his life he was getting some attention. And they got the picture, which is too delicious for words. They knew they couldn't come home to me without a picture of a white horse, and, sure enough, they came home with a horse and he was white."

TURQUOISE TUNIC...
JEWELLED MINI-PANTS

NEW MODELS
In the sixties the magazine
showed new, youthful faces.
From left, Veruschka, Lauren
Hutton, Penelope Tree, and
Jean Shrimpton.

Vreeland had a very particular view of photography and how it should be used in the magazine. Photographer David Bailey, in a reminiscence in *Vogue* in November 1999, recounted his initiation: "When Diana Vreeland became editor in chief of American *Vogue* in 1963, I thought she'd fire me. She didn't, but I really don't know why. One of the very first things I remember her saying was, 'Bailey, I don't care about photography. I don't want art. I want to sell frocks! So if you want to work for me, I want to see the frocks.' She was something. Once, I handed her a set of pictures I'd worked incredibly hard on, and she looked at them and said, 'Bailey, these pictures are wonderful, *divine!*' And I said, 'Great.' Then she said, 'But darling, I can't use them.' I said, 'Why not? You just said they were wonder-

ful, *divine!*' And she said, 'Look at the lips, Bailey. Look at the lips. There's no languor in the lips.'"

From the moment of Vreeland's arrival, *Vogue* fashions became more suggestive, the photography bolder and more sensual. Fashion was picking up ideas from the streets. Typical of this period is the beautifully composed nude picture Irving Penn took of Marisa Berenson, wearing nothing but a necklace. Vreeland, who was very precise and brimmed with detail when she imparted instructions to models and photographers, maintained that a picture had to transmit unique moments and sensations. In a memo to model Penelope Tree, who was traveling to India for a fashion shoot, and who at the time was romantically involved with the

photographer Bailey, Vreeland wrote: "Penelope: please look very very happy—*because I know you are*—and please make it radiate through each and every picture. . . . When you think barefoot is best—by all means, bare feet. . . . If you find the houseboats in Kashmir appear a bit shabby, by all means buy some cheap Indian cotton and sari material and drape them and cover the pillows etc. so that everything looks very delicious and like a fairy tale. . . . If there are some dripping trees—*get under them*."

New locations, new styles, and new photographers called for new faces to exhibit the fashions. Until then the pages of *Vogue* had been graced by models of aristocratic mien and refined glamour. The models were not mature women, but the preferred look was

Wrapped in reptiles— the Shrimp and Penelope Tree in Hawaii

Snake-green pants and scarf, far le[ft]
wrapped around a Tree on Kau[ai]
Printed Ban-Lon costume by Se[...]
Barrie, of nylon (S. Edward fabric[...]
Pants, $28; scarf, $12. At Best[...]
Co. Leather thong, by Bruce Rudo[w]
Fringed snake, left—printed sha[...]
and long sarong in Shrimp-pink a[nd]
brown. Oscar de La Renta Boutiqu[e]
Antron nylon (Loomskill fabric[)]
about $145. At Saks Fifth Avenu[e]
Maison Blanche; Sanger-Harri[s]
Tortoise print, above, rust with y[el]
low—bare-midriff top, bikini pan[t]
long sarong. Ban-Lon turnout [by]
Ginori, of nylon (Gilbert Frank fa[b]
ric); about $65. Best & Co.; Har[tz]
feld's. Leather thong choker wit[h]
square medallion: Bruce Rudo[w]
Snake toga, below, tied over a ti[n]
bodice, bikini pants. Printed Ba[n]
Lon turnout by Ginori, in brown-t[o]
beige nylon (Gilbert Frank fabric[)]
about $65. Best & Co.; Hartzfeld'[s]

perhaps thirty years old and some-what curvaceous. Vreeland changed all that. She brought in sixteen-year-old Twiggy (whose real name was Leslie Hornby) and seventeen-year-old Penelope Tree, both with an under-nourished look that became the new standard. She made them celebrities by printing their names with each production, a new departure for *Vogue*. Twiggy, an icon in the history of mannequins, was the first adolescent supermodel: She was fair, with dreamy eyes and an innocent, angelic expression; Tree was a brunette, with an unconventional, almost androgynous beauty. Also from England came the long-legged Jean Shrimpton, whose athletic and flexible poses had very little in common with the static elegance of past years. Two others who reflected the personality of the maga-

zine and of the era were the German model Veruschka, who played a featured role in Antonioni's film *Blow-Up*, and Lauren Hutton, a memorable beauty with a gap-toothed smile who a few years later would sign a multi-million-dollar contract to be the face of Revlon cosmetics. Veruschka appeared on thirteen *Vogue* covers, while Lauren Hutton beat all records, appearing on twenty-six.

Fashion editor Susan Train recalls: "Diana liked unusual looking girls, girls with a face. She was always finding new faces. . . . Diana really didn't enjoy people her own age. She was always surrounded by young people. She was very unjudgmental, but she wanted young photographers, young models—anything but the girl next door." In June 1965 *Vogue* used the

189

term "youthquake" for the first time, and two months later published a production about "youthquakers"—people who were being talked about or should be talked about, such as Liza Minnelli, Zubin Mehta, Joan Rivers, Edie Sedgwick, and Andy Warhol. Youthquake, Vreeland would explain years later, "was a small revolution, and not bloody, thank God. Youth went out to life, instead of waiting for life to come to them, which is the difference between the sixties and any other decade I've lived in."

Everything that happened at *Vogue* during the 1960s revolved around the participation, the direction, and the caprice of Diana Vreeland, who had a very particular vision of what life and style should be, not to mention women's journalism. Her vocabulary was studded with superlatives such as "extraordinary" and "divine" and "spectacular." When she described colors, she would call for "a deep clay pink" or "Catherine the Great lapis lazuli." Truman Capote, one of her closest friends, once described her as "the kind of genius that very few people will ever recognize because you have to be a genius yourself to recognize it. Otherwise you just think she's a rather foolish woman." She always wore the best clothes, favoring long skirts and vividly colored shawls. In her Chinese red office with its lacquered furniture and faux leopard carpets, she would burn fragrant candles and incense, and every midday without exception she would have a peanut butter sandwich, a dish of ice cream, and a glass of whiskey. Every afternoon a nurse gave her an injection of vitamin B-12 for energy. People who worked at *Vogue* said that Vreeland acted more like an empress than like an editor. She might order an article redone two, five, ten, any number of times. Nobody could argue with her about costs or deadline pressures. The magazine would go to press when she considered it was "divine." The quest for perfection generated crises of logistics, budget overruns, frayed tempers, tears, desertions, and fifteen-hour workdays.

Two anecdotes reveal her editorial work style and her way of extracting the maximum creativity from others. The first anecdote is related by Kate Lloyd, then a features editor at *Vogue*, in the Liberman biography *Alex*:

I had done a sixteen-page spread on Bettina, whom Mrs. Vreeland always called a grand courtesan. She was the mistress of Ali Khan. It had everything—her house in Paris, her trip down the Nile, her exercise program, her clothes, her beauty secrets. It had taken an awful lot of work. . . . I sent the portfolio, text and pictures, down to Mrs. Vreeland, very pleased with myself, and a while later the phone rang.
"Mrs. Lloyd?"
"Yes, Mrs. Vreeland."
"I don't think you've quite gotten the feeling for this portfolio." I was turning red in the face, because I'd been there a hell of a lot longer than Mrs. Vreeland. "Mrs. Lloyd," she said, "I don't think you quite understand what *Vogue* is."
The steam started coming out of my ears at that point. I said, "Tell me Mrs. Vreeland, what is *Vogue*?"
She said, "*Vogue* is the myth of the next reality." And I got it. I absolutely got it. Take the words apart and they don't mean a thing, but I saw exactly what she was driving at, and I never had a moment's difficulty with her again.

FASHION AND SHOW BIZ
Vreeland believed that fashion should be a spectacle, and she chose Hollywood-style locations for shoots. For this picture by Leombruno-Bodi, published on August 15, 1965, the location was the sphinx at Giza.

IGH-BANDED HALTER, *above, a gathering grace of white jersey rushing past, in a freshet, to the floor. Oleg Cassini. GATHERED CORSAGE, opposite, done with a twist of the waist, brings white jersey beautifully in line with evening. Malcolm Starr. Photographed at the shrine of the God Ganesa in the Hall of Heroes. Details of both dresses on page 283.*

EXOTIC LOCATIONS
In December 1964 palaces and mosques in India were the locations for a spring-summer fashion shoot featuring chiffons, bold prints, and turbans. The photos were taken by Henry Clarke.

The second anecdote comes from Mirabella, at the time a *Vogue* fashion editor, later Vreeland's second-in-command and ultimately her successor. In her memoir Mirabella tells of her first appearance before Vreeland for a "run-through," in which a staffer would present chosen fashions and make a pitch for space in the magazine.

I selected three racks of dresses and presented them, making a case for a story about how the look of dresses that season was wool jersey. Vreeland listened, not saying a word. At the end I asked her if there was a problem.

"Well," she said, "I wasn't looking for a market report. I thought you were going to *give* me a little something."

"Like what?" I asked. I thought I had given a good deal.

"A *little something*," she said. "A *dream*."

I went back to my office and hung my head in my hands. How was I supposed to turn a Harvey Berin cocktail dress into a dream? Vreeland had made some suggestions: "Go back into the market and think about *what might be*. Think about putting women in bias black. Or in things with hoods. Or in chemises and long skirts over pants. Think about what might be wonderful."

"What the women who shop in my market want is quite simple," I said. "They want us to tell them what Norman Norell wants them to wear and where to find it."

"If that's the case," Vreeland said, "I have a solution for you. *Give 'em what they never knew they wanted.*"

What Vreeland wanted didn't exist in my market. Often, it didn't exist at all. She wanted a fantasy, made real in fabric. If the look didn't exist, she'd invent it, and she'd leave it up to us, her fashion staff, to find a way to produce it.

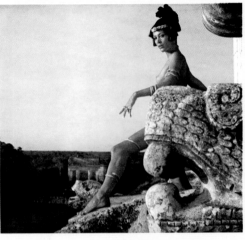

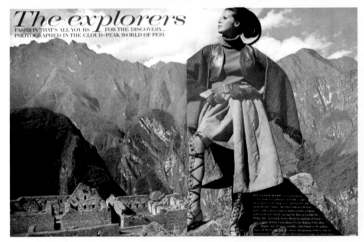

ETHNIC FASHION
Vreeland was the originator of the unexpected, exotic location. But in her determination to impress the reader, she gave preference to showiness and to eccentric garments (right) over practical, wearable clothes. With ethnic clothing the rage, she spared no expense to have pictures taken in the most remote places—above, from the top, Byzantine caverns in Turkey, Mayan ruins of Chichén Itzá in Mexico, and the ruins of Machu Picchu in the Peruvian Andes.

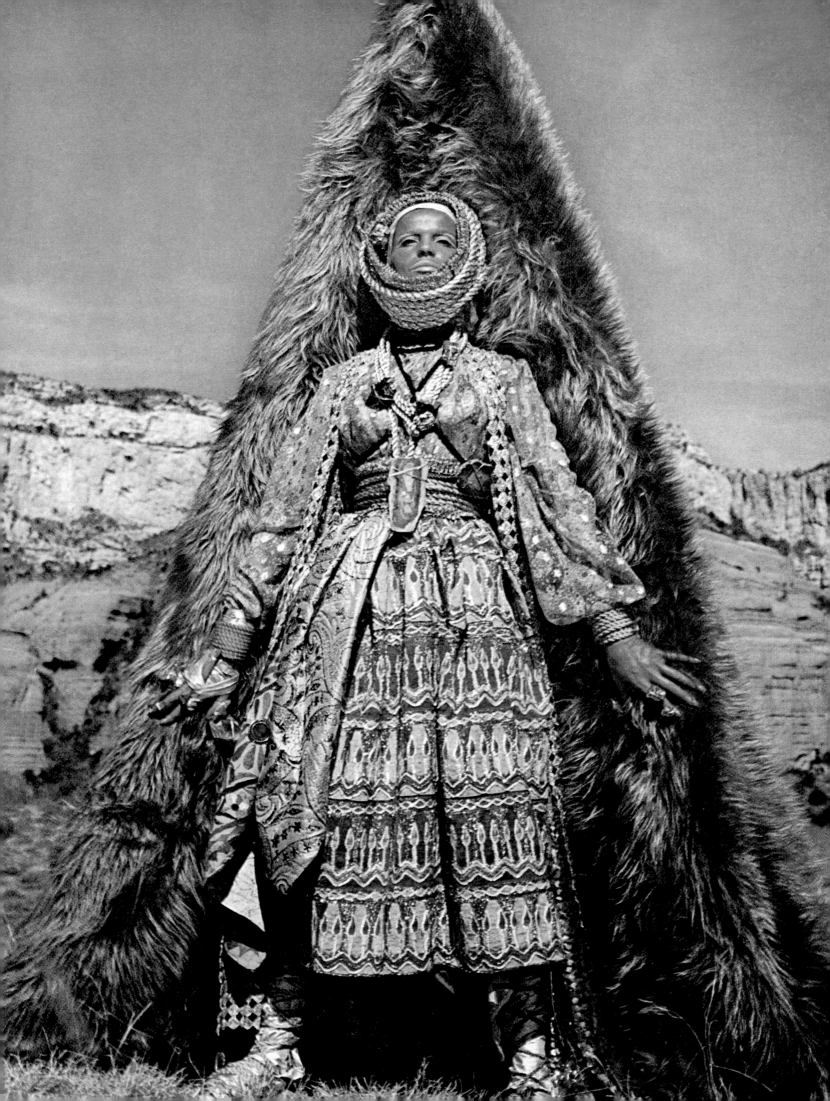

RICHARD AVEDON:
FASHION IN ACTION

In 1965 another key figure was to join *Vogue* and put his stamp on the magazine's visual style: Richard Avedon, internationally acclaimed as the best and most influential fashion photographer of his time. Avedon had started out at *Harper's Bazaar* in 1945, and by 1948, together with Alexey Brodovitch and Diana Vreeland, he was a vital part of that magazine's cutting-edge editorial team. Liberman recalled in *On the Edge*: "Shortly after Vreeland arrived, we realized that we were missing a top fashion photographer. . . . We all felt that if we could get Avedon, *Vogue* would be at the top."

Avedon, born in New York in 1923, devoted himself to poetry as a young man. He studied philosophy at Columbia University, and his first amateur photographs were of family subjects on Long Island and of his merchant marine comrades during World War II. His first professional relationship was with *Harper's Bazaar*. It was Brodovitch who discovered him, at the New School for Social Research, where Brodovitch was teaching a design course that Avedon attended. In 1947 Avedon began to cover the Paris collections, and his pictures caused a sensation in the publishing world. His action photographs, with models jumping on sidewalks or mingling with people on the streets of the French capital, offered a different way of looking at fashion. One of his best-remembered photographs of this time, a classic example of his theatrical style of

AVEDON POSE
Avedon would have his models jump, dance, spin around. Liberman said this style "gave life to fashion." Vreeland brought Avedon to *Vogue* in 1965. This 1972 shoot featured the model Veruschka. Photograph Richard Avedon. Courtesy the Richard Avedon Foundation.

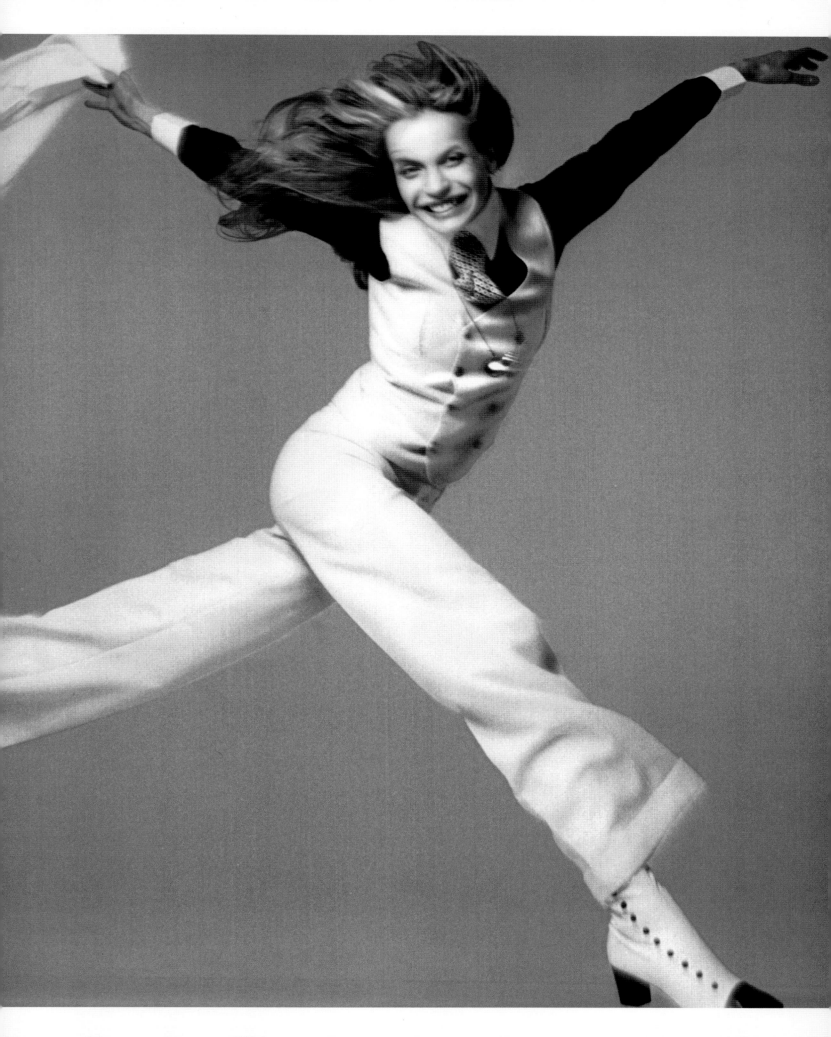

picturing fashion, shows model Dovima at the Cirque d'Hiver in Paris, attired in Dior, resting an arm on a moving elephant. In an Avedon picture, the important fashion component was not only the clothing but also the lifestyle of the person wearing it.

Vogue had always wanted to enlist Avedon in the ranks of its photographers. The first attempt was made by Liberman in 1945. From that year on, the two men stayed in touch, and over the years the possibility always lingered that Dick Avedon would move to *Vogue*. The opportunity came in 1965, when neither Brodovitch nor Vreeland was still with *Harper's Bazaar*. It fell to Vreeland to put the question: "Are you even remotely interested in listening to what Alex Liberman has to say?" An agreement was quickly arrived at—it was rumored that Avedon received an advance of one million dollars for agreeing to switch magazines—and his photos immediately began to appear in the pages of *Vogue*.

When Avedon joined *Vogue* he was in his early forties and had been a renowned photographer since his twenties. He brought to the magazine a style known the world over as the

Avedon Look, imitated by hundreds of other photographers, a style he defined as "a series of no's. No to exquisite light, no to compositions, no to the seduction of poses or narrative. And all these no's force me to the 'yes.' I have a white background. I have the person I'm interested in and the thing that happens between us."

In portraiture, Avedon believed that "all photographs are precise, but none represents the truth," and what he did was capture an image of the special relationship he established with his subject. Critics hailed his portraits as minimalist, bitingly honest photographs. *Time* magazine's Roberto Lacayo said of them: "The results can be pitiless. With every wrinkle and sag set out in high relief, even the mightiest plutocrat seems just one poor mortal." When Henry Kissinger was about to be photographed by Avedon, he pleaded: "Be kind to me."

In fashion work, the Avedon Look meant fresh, modern young girls who, as *Alex* put it, "danced, leaped through the air, rode bicycles, watched TV, bared their breasts, turned cartwheels, and somehow managed to look perfectly comfortable wearing

PENELOPE TIMES FOUR
Penelope Tree, one of Avedon's favorite models, was photographed here in a sequence on black pantsuits. Photograph Richard Avedon. Courtesy the Richard Avedon Foundation.

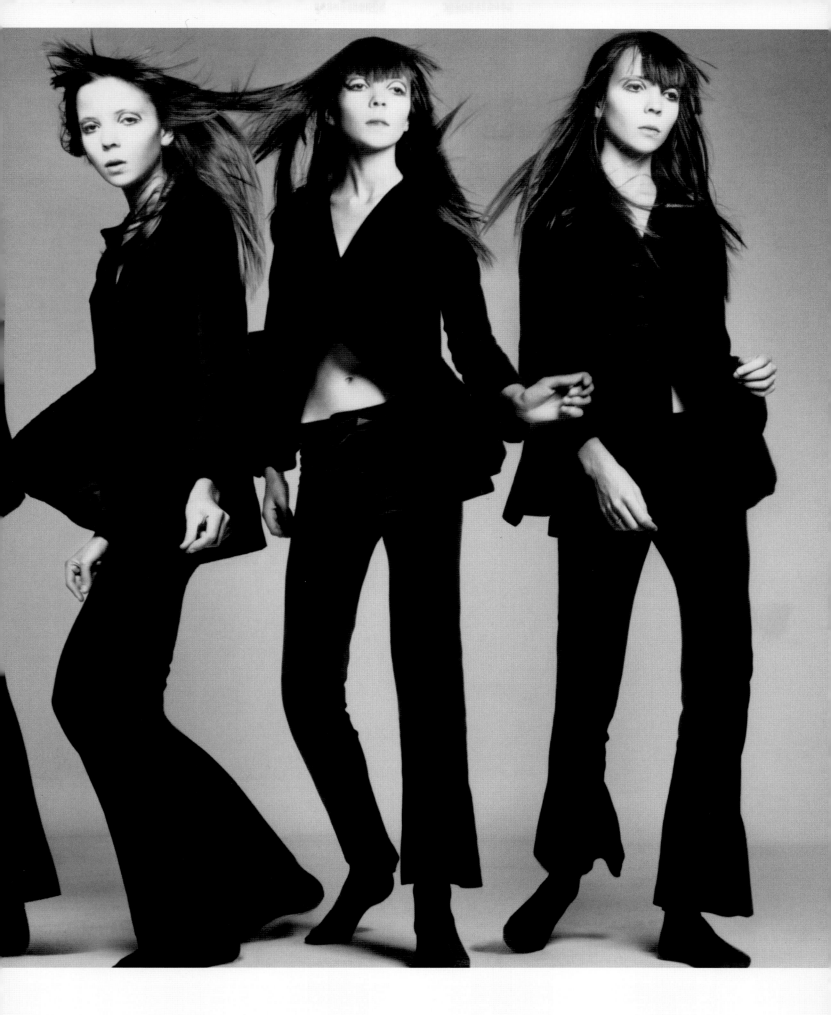

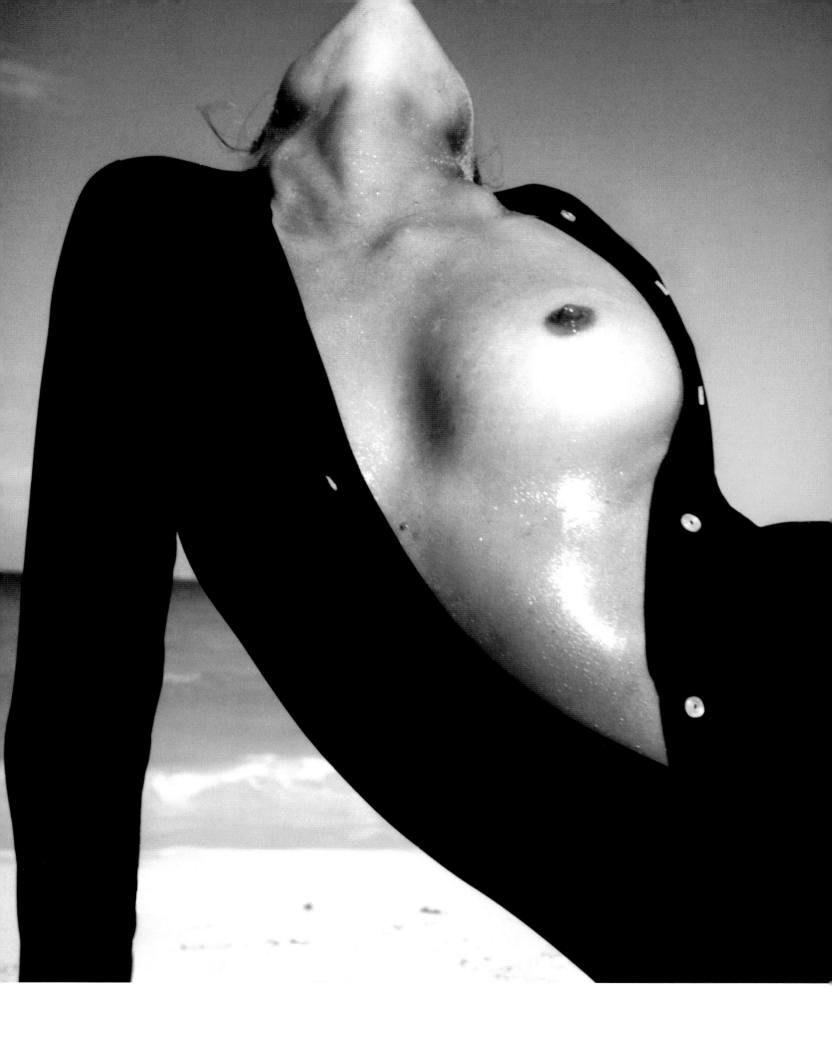

CLASSIC BEAUTY
This photo in the January 1, 1969, issue came to be an icon of beauty. The model is Lauren Hutton dressed in a body stocking. Photograph Richard Avedon. Courtesy the Richard Avedon Foundation.

the absurd metallic and plastic garments that Courrèges and Rudi Gernreich and other sixties designers cooked up." Avedon not only showed the clothes exceptionally well but established a special rapport with the models (he married one of them, Dorcas Nowell) and dispelled the distant attitude they had traditionally assumed before a camera. Liberman recalled that "Dick had perfected a certain kind of jump-walk that made fashion come alive and the woman's presence come alive." He photographed all the supermodels of the day: Twiggy, Lauren Hutton, Veruschka, and especially Penelope Tree. *On the Edge* recounts that "Avedon's arrival at *Vogue* ushered in what Liberman calls 'the period of intellectual eroticism,' exemplified by the model Penelope Tree, 'a curious, sort of non-high-fashion young woman,' the daughter of the socialite Marietta Tree. Polly Mellen, who had worked with Avedon at *Harper's Bazaar* and would be his closest collaborator at *Vogue*, remembers being fascinated by Tree at their first meeting. 'She was gawky, a little hunched over, with stringy hair, absolutely not a beauty at all.' When Tree came to the studio for a sitting one summer morning in 1967 in her bell-bottomed black Beatles suit, Mellen thought that 'she looked like a gangly little urchin. . . . I came out and said to Dick, "I don't know. She doesn't fit the clothes. Look, the arms are much longer than they should be." He said, "She's ready. Don't touch her. She's perfect."' And he was right. *Vogue* called Tree 'the spirit of the hour.'"

THE COVERS THAT
IDENTIFIED A DECADE

The *Vogue* covers of the 1960s clearly reflected the changes occurring in society and in fashion. Editorially, these changes occurred on several levels:

From the beginning, the mission of the cover models had been to transmit glamour and elegance. Their bearing was aristocratic, their beauty refined and restrained. They projected an image of the ideal woman—socially well placed, a good wife, an accomplished hostess—for that image was what sold magazines. But with the 1960s the predominant concepts shifted: The models broadcast sexuality and a more liberated image, less oriented toward romance and luxurious domesticity than toward self-realization.

PROVOCATIVENESS
The covers projected the exuberance of the inside pages of the magazine. For the first time ever, the models looked directly at the reader. In a touch of sensuality, the lips are slightly open. This page, bottom cover and opposite photographed by Irving Penn.

DEC.
$1

VOGUE

SPECIAL
CHRISTMAS ISSUE

A Feast for the Eye

The Most Extraordinary Eyes
in the World… Barbra Streisand…
The Beatles… Catherine Deneuve…
Fabulous Nepal… Articles by:
Elizabeth Bowen, Anthony West,
Arthur Schlesinger… India's Greatest
Dancer… White Whales… A Glory of
Peonies… The Onassis Yacht…
Fashion for Bright Nights
and Days in
the Sun

VERUSCHKA August 15, 1965

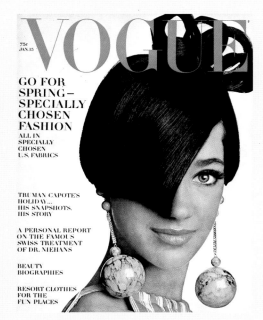

MARISA BERENSON January 15, 1966

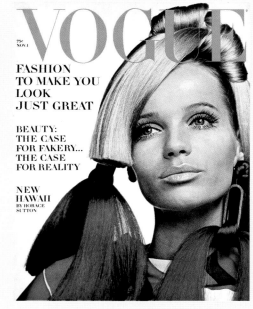

VERUSCHKA November 1, 1966

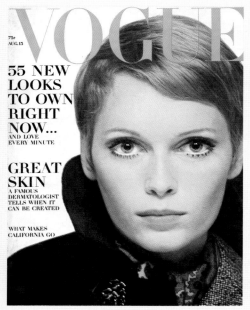

MIA FARROW August 15, 1967

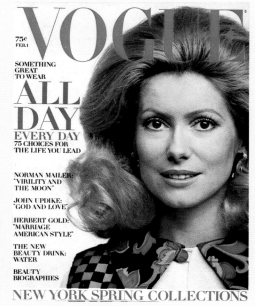

CATHERINE DENEUVE February 1, 1971

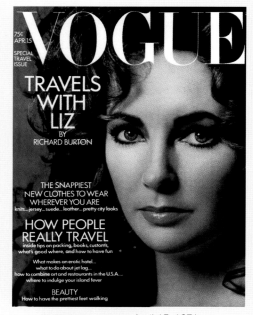

ELIZABETH TAYLOR April 15, 1971

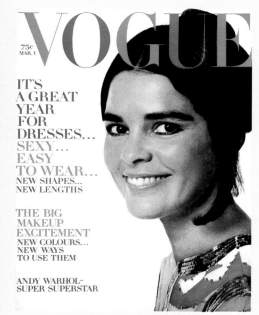

ALI McGRAW March 1, 1970

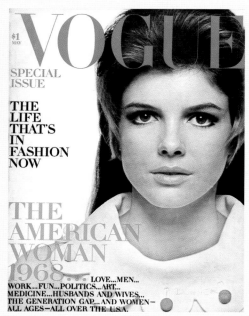

KATHERINE ROSS May 1, 1968

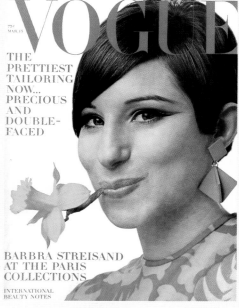

BARBRA STREISAND March 15, 1966

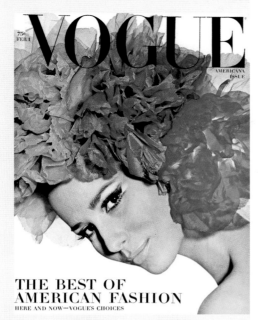

VOGUE

75¢ FEB. 1

AMERICANA ISSUE

THE BEST OF
AMERICAN FASHION
HERE AND NOW—VOGUE'S CHOICES

WILHELMINA February 1, 1965

EXAGGERATION
Vreeland's idea was to transmit trends, whether the fashion of colored hair or flower-printed apparel, with the utmost possible exaggeration.

The model's face became the central image of the cover, with attention focused on the eyes and mouth. The eyes invariably looked straight at the camera. It was the lips, however, that gave a sensual touch to the image: They had to be slightly parted, expressing a provocative sense of sexual freedom. Makeup and hair became fundamentally important, and the art director assumed a growing influence over the composition of the cover.

As the face became the primary vehicle to convey the identity and style of the magazine, the cover conveyed more information about cultural trends than practical ideas about fashion and beauty. Covers showed new fashions at their extreme, not alternative ways to adopt the fashion in part or in moderation. If exaggeration was the order of the day in makeup, the covers would exaggerate that trend even

more, with images painted around the eyelashes or the cheeks.

To transmit these ideas of fashion and beauty, *Vogue* created its own team of iconic faces—among them Jean Shrimpton, Marisa Berenson, Veruschka, Twiggy, Lauren Hutton, and Penelope Tree. It also found that young actresses who embodied the current movie trends were effective exponents of the new informal, eccentric, and bold fashions. Emerging actresses who appeared on the covers of *Vogue* were Julie Christie, Mia Farrow, Ursula Andress, Katherine Ross, Marie Laforêt, Samantha Eggar, and Catherine Deneuve. Whether with models or with actresses, the covers of the 1960s were the boldest and most bizarre in the history of the magazine. In short, they expressed the spirit of an era.

CELEBRITIES
During the Vreeland years, the *Vogue* cover frequently carried images of celebrities, most of them movie stars, reflecting the bond between fashion and popular culture.

203

THE END OF THE VREELAND STYLE

"Nicky, what *is* the name of that designer who hates me so?" asked Diana Vreeland.

"Legion," answered fashion editor Nicholas de Gunzburg.

More than a witticism, the anecdote reflects the disenchantment with Vreeland's *Vogue* that prevailed in the fashion business—from the designers to the stores—in the early 1970s. It was a time of nationwide economic recession, which was affecting advertisers, fashion houses, and magazines alike. Suddenly, everything about Vreeland's tenure that had been invigorating in the 1960s collapsed in the new decade. The extravagant clothes and exotic combinations ceased to appeal, the painted-face makeup became passé, the paradisal locations for photo shoots too expensive, the models no longer modish. As advertisers deserted the magazine's pages, the editor's whims and eccentricities became impossible for the company to support. In 1971 Vreeland was nearing seventy, and the outré, ornate, and overbearing style that she had imposed on the magazine had already lasted eight years. During that time women had been changing, in both their personal and their professional lives. And *Vogue*, as a mirror of reality, needed to change with them. Today, at a full generation's remove, the causes of Vreeland's fall at *Vogue* are well summarized in the words of those who worked with her.

After he became art director, Alexander Liberman always said, no picture had ever been published without his authorization. That changed with the arrival of Vreeland and her favorite photographer Avedon, who would study the pictures alone together and "in an almost clandestine way" pass along the chosen ones to layout.

Liberman recalled in *Alex*, "It was like trying to catch up with a wild horse. . . . Everything was extravagance and luxury and excess. She was given too much power; she took too much power. I was the editorial director. I would be presented with a layout that she had done with Priscilla Peck, and I would say, 'We can't give sixteen pages to this, it's too much,' but she had her court of admirers who would say, 'No, Alex, it's wonderful, you're wrong,' and I would be sort of impotent. The business side was very upset. Circulation was dropping, there were complaints from the stores, we were losing advertising—the whole thing just got out of control."

Grace Mirabella described the end of the Vreeland era in *In and Out of Vogue*:

> Her work habits were incredibly expensive—something that only a strong economy could sustain. Inventing a look like "Queen Christina" or "Scheherazade" meant drawing up a Concept, finding fabric swatches, commissioning the clothes, working out the accessories and hair with all the different fashion editors, dress rehearsing the look in the office, sometimes with the actual model, and Polaroiding it, so that every detail would be absolutely perfect on the day of the sitting.

Vreeland had always sent editors on extremely expensive trips to exotic locales for *Vogue*'s special Christmas issue. These trips took an immense amount of planning. They often had to be arranged through the State Department, which, despite travel editor Despina Messinesi's wonderful connections, could take months to approve visas. Then, to clear customs, we had to put together a carnet listing every single blouse and dress

EXCESS
Veruschka in an extravagant halo of plaits. The 1967 photograph by Rubartelli typified the exaggerated vision of fashion that made the Vreeland style irresistible for a time and then, as the decade ended, no longer appealing.

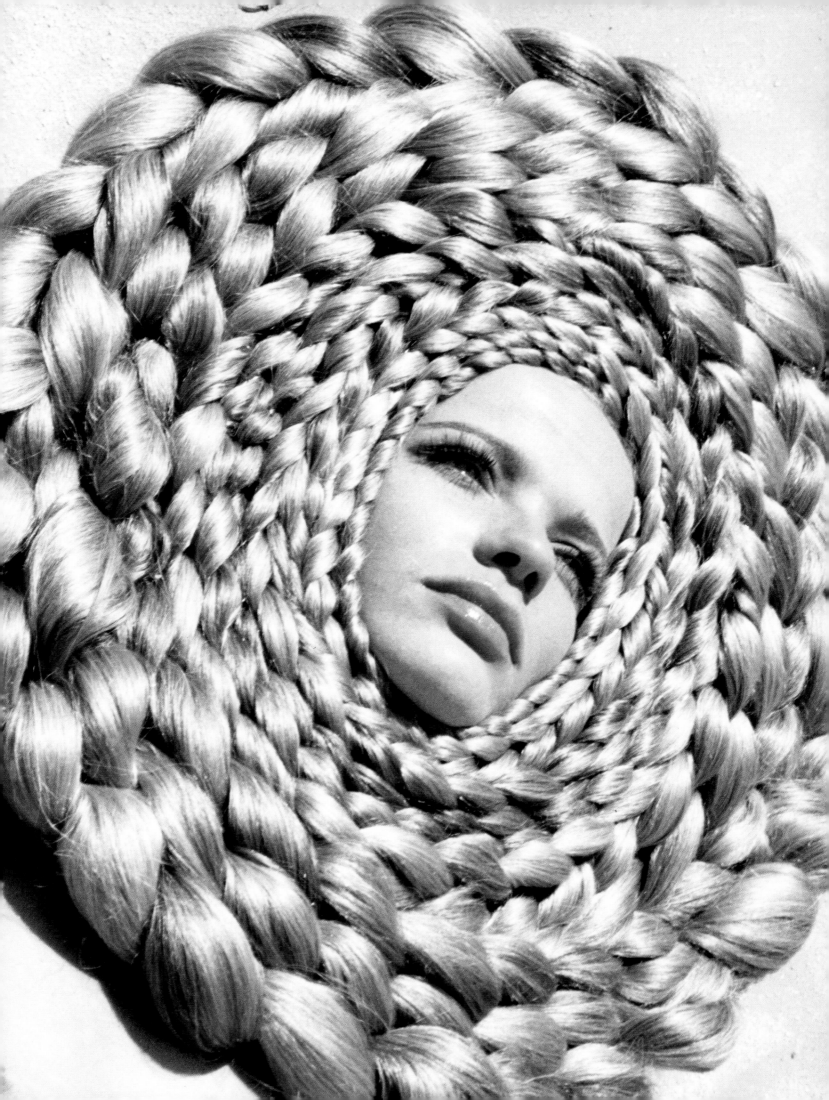

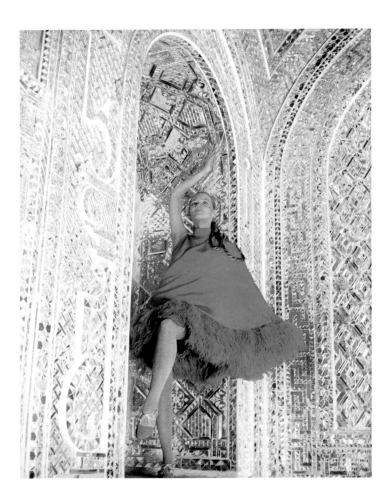

and shoe and earring and bead that we were taking out with us, and make sure that we had every single item upon our return.

Usually, Susan Train would be sent out on trips from our Paris office. Susan was very disciplined but Vreeland had no faith in her creativity. So we'd Polaroid every single aspect of the sitting for her in advance: we'd write out every step and fit every skirt and hat and shoe on the model, often redressing her and re-Polaroiding the clothes late into the night as Vreeland found last-minute inspiration. The model bills and Polaroid bills were gigantic. The transportation costs were too. For if Vreeland insisted, as she once did, that Susan Train use an enormous hat for a particular sitting in the Himalayan mountains, then that hat, in its box, was carted uphill, by car and by Jeep and by camel and by donkey, until it reached the top in one piece. Irons and ironing boards also had to be carted around. Which meant more expense, and more time spent, on the top of a mountain or in the middle of the desert, keeping the model standing around preparing for a shoot.

"Dee-Anne almost wrecked the magazine," fashion editor Babs Simpson stated in *Alex*. "She was there for ten years, and the first four or five were absolutely glorious, wonderful. She was the greatest fashion editor who ever lived. But what brought us down was that she persisted in doing flower children and blue faces and orange hair long after all that was over. She would take a beautiful evening dress by Norman Norell and put boots with it. She'd try to disguise clothes she thought were dowdy. The Seventh Avenue designers were up in arms—Adele Simpson said she didn't want her name on our pages. In Paris, Dee-Anne only went to the collections that amused her, Balenciaga and Givenchy and Saint Laurent, and this, of course, infuriated all the others. Periodically she would say, 'I've been called upstairs by the men again; they say we're losing business,' but she would just dismiss that. 'The men don't know what they're talking about,' she'd say."

As Mirabella explained, "Vreeland had always liked to call *Vogue* 'the myth of the next reality.' It was her way of convincing herself that her inventions were meant to exist.

But the real world was changing in a way that had nothing to do with Vreeland's myths. Women were changing, their needs were changing. *Vogue* was becoming more and more out of touch with their lives. Women were entering the work force for the first time in record numbers. They needed something to wear. And they wanted something they felt good wearing, something that, they could feel, expressed *them*. Mary Quant once summed up the moment very well, I think: 'Until that stage, either women would be their father's little daughters, their clothes paid for by their fathers, or they were the wife of the doctor. This was probably the first time women had their own careers—and therefore dressed for themselves.'

"What Vreeland had to offer them was purple vinyl raincoats, see-through blouses, silver ankle boots, and body stockings. The message was: she didn't care about the 'new woman.' And *Vogue*'s readers took that message to heart. Animated by the antifashion hippie spirit of the time, and the message from the women's movement that fashion magazines were The Enemy, they turned their

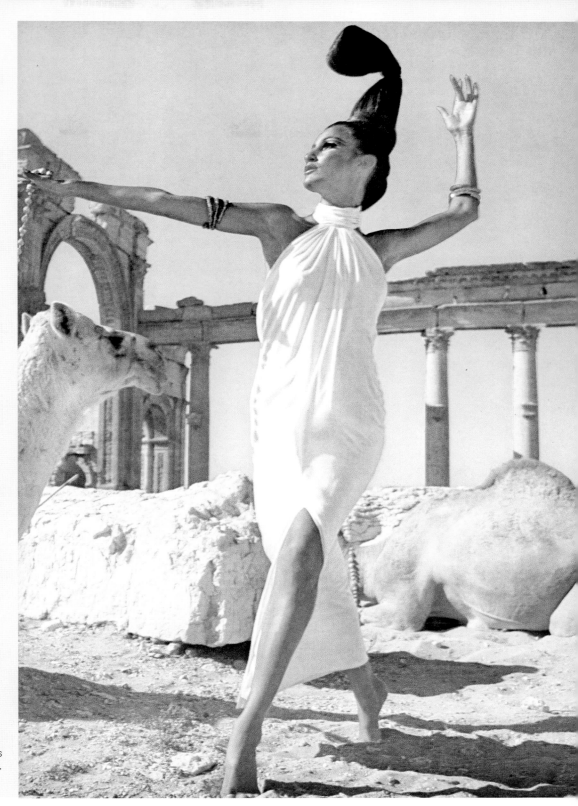

ANYTHING GOES
Vreeland's photographers captured her extravagant taste and whimsy with their cameras, often traveling to far away places for fashion shoots that would incorporate historical monuments. The results were photographs that suggested dreamscapes.

backs on *Vogue* and simply stopped buying the magazine. Newsstand sales plummeted. The women stopped shopping. And, in the first three months of 1971, sales of advertising pages at *Vogue* fell nearly forty percent."

One spring day in 1971 Vreeland returned from a visit to "the men upstairs," the company directors, and announced what had been circulating

as a rumor for quite some time: She had been fired. The official announcement of May 17, signed by Perry Ruston, president of Condé Nast, said that Vreeland was stepping down but would continue to be closely involved with *Vogue* as consulting editor. Seven months later Vreeland left the company definitively. She was the first editor to become a celebrity, and her splendid photo

shoots changed the way fashion was presented; she made *Vogue* truly a show in its own right, not just a witness to the culture of fashion but also a participant.

The magazine began a new chapter with the July 1971 issue under the stewardship of Grace Mirabella, who was to be *Vogue*'s main figure for the next seventeen years.

"LOOKING WITH **AVEDON**"

On September 14, 1978, *Avedon: Photographs 1947–1977* opened at the Metropolitan Museum of Art in New York. For its September issue of that year, *Vogue* commissioned an article by the philosopher and cultural critic Susan Sontag, who had explored the art of the camera and its implications two years previously in her seminal essay "On Photography." Here Sontag raises profound and thought-provoking questions on the nature of fashion photography, in particular the photographs of Richard Avedon, and their ability to open up new avenues of seeing.

WOMAN, 1972
This picture was published in the May 1, 1972. Avedon's work with women and fashion was accorded an analysis by Susan Sontag. Photograph Richard Avedon. Courtesy the Richard Avedon Foundation.

Haunting commerce! Irrepressible art! Fashion is more than propaganda of couturiers, department stores, makeup firms, or even fashion editors. These efforts to get women to buy more clothes and makeup are also a repository of immobilizing fantasy, of useless delights. Many fashions are more avidly followed than heeded. The industry's feverish, inventive, ever-so-calculating propaganda for the erotic and beautiful has an often indirect, even perverse relation to what people actually *wear*.

Fashion is an acute mentalizing of the erotic. Its subjects are beautiful women, and women comprise most of the audience for these images when they first appear in magazines: women scrutinizing images of women—for an idea of the erotic. Like art generally, fashion concerns itself with dematerializing the material world. In particular, the body itself is made as incorporeal as possible. Skin is transmuted into ivory, its texture purified of imperfections by makeup and lighting. The face is smooth; the silhouette is refined, pared down. The flesh becomes itself a garment, to be presented in mint condition. Always intent on providing an idea of the erotic, fashion transposes the erotic into an image. The ideal would be something very close and quite inaccesible, an image both realistic and preposterous, titillating and chaste, nude and in drag.

Fashion deals out a succession of imperious images, but fashion itself is, first of all, a way of seeing. And not just a way of seeing that is crassly emulative, hooked on staring and shopping; but also disinterested, often ironic, one of civilization's more agreeable excruciations. It is about appreciation, or connoisseurship, based on the recognition of the profundity of surfaces. But a series of statements which assert the superiority of appearances cannot decline to indicate *which* appearances are superior. Hence, the dismaying imperfection of all such attempts to view the world in a superior way.

A superior way of appearing, when it is named, becomes what people understand as a style. Of course, to name a way of appearing as a style dooms that way of appearing to an all-too-predictable mortality. Its destiny is to be *seen through*, to cease to fascinate, to become obvious, then forgotten and to be replaced by another, no less perishable, style. But styles are now granted a kind of immortality. Once dead, a style can be scheduled for a number of posthumous appearances. When revived, it can be cherished in a fresh way.

Similar rules of succession govern the scope of fashion as such. Since for a long time fashion centered on how people looked indoors in formal settings (at the Court, at a ball, at a theater, at a reception), it became necessary that a vocabulary of fashion for outdoor informalities (on the street, at the beach) be developed. After fashion photography came to be typified in static posing, it was inevitable that it would want to show exaggerated, improbable movements. So far as fashion models looked romantic or poetic or at least dignified, someone was bound to come along and make them droll, grimacing, self-mocking. The minimum achievement that defines fashion: that whatever is will be allowed to generate its opposite or its complement.

Once fashion meant a rivalry in reckless ostentation, an all-consuming sport of the upper class. Eventually, fashion also came to mean something more solemn, more anxious, more middle class: the seriousness of the consumer, accumulating well-made products on intelligently planned shopping expeditions, concerned not to be ridiculous or feel deprived, eager to conform. The more fashion came to mean seriousness, the more it was inevitable that in the late twentieth century it would promote liberating frivolity, playfulness, a salutary vacation from looking "right." Fashion becomes the discovery that anything is all right—if worn by the right person.

But fashion hardly died, as is sometimes said, just because "the world of fashion" (a phrase first used in England in the early eighteenth century)—that is, the upper class; later called "society"—has been democratized. That fashion could no longer be understood as a singular directive, a standard to conform to or take one's

distance from, did not kill fashion. As transformed, to mean what fashion must in a consumer culture, it is as strong as ever. Fashions exist to be contradicted, to negate themselves. And fashion is a mix, an anthology. Fashion is no longer a "world"—but a flux of enticingly juxtaposable, often interchangeable images.

This ongoing transformation of fashion, its so-called death and its rebirth as a much larger subject for photography, explains much of the shape of Richard Avedon's prodigious and varied activity. Many other photographers of fashion have produced memorable images; none has a body of work which deploys so intelligently all the powers and ironies of fashion photography. Endlessly knowing about and loyal to fashion as spectacle (the theatricalization of beauty; the erotic as artifice; the stylization of appearances as such), Avedon has taken pains to show that fashion photography is not limited to fashion—a development that now seems inherent in fashion photography itself.

Fashion photography is the record of fashions but it is not about fashions. It is about appearances that fascinate. But fascination tends to exclude identification. (It would be as easy to identify with the woman in Avedon's 1953 photograph of Marella Agnelli as with a Brancusi statue.) Fashion treats the world as decor—like the still intact pre-war Paris of the late 1940's to mid-1950's one can glimpse in the backgrounds of Avedon's famous photographs, behind the visiting angels modeling their New Looks. Dovima posing with elephants, in front of the pyramids in Giza, cavorting with cape in a Paris square: the body and face in their perfection are seen in sharp focus against the (usually) out-of-focus "picturesque."

Much of the earlier Avedon photographs—bodies preening, prancing—have something of the unremitting jollity or languidness of Balanchine's *Union Jack* or *Vienna Waltzes*; the models look impeccably beautiful and overbred, in the way that ballerinas are supposed to look. The women in fashion photographs are not partnered, as in ballet; they do the "lift" themselves. The image shows a woman caught at the peak of some audacious, improbable movement—swooning or vamping; a skittish, rather than an unabashed, romanticism.

Avedon's photographs of the last decade or so are likely to have less background, if any. The subject occupies an ideal, therefore unspecifiable, space. Beauty is free-standing; it does not need to be validated or explained or commented on by a decor. These isolated figures are capable of looking pensive, as well as euphoric and sly. Movements and static poses are less obviously choreographed. Beauty is no longer perfect: it includes Tina Turner, not just Lena Horne. June Leaf, all grainy character, an emblem of anti-glamour, looks out from the page facing the picture of Marella Agnelli; and that juxtaposition pointedly closes Avedon's new book surveying three decades of work in and near fashion photography. The idea of fashion is less a noun, an entity that is, at any given moment, fixed. It is adjectival, a free-floating commendation that can be attached to anything.

How it went according to the older idea of fashion: someone, usually well-born or rich, looked marvelous (through meticulous grooming, expensive clothes), was seen in the right places, became fashionable. Now: someone is marvelous, because of some power or energy or aura; therefore, what that person looks like becomes a standard of fashion. When people started deploring the death of fashion, what they meant is that fash-

ion seemed no longer to be fashionable. But the norms of fashion have adjusted to take care of the threat. Now, fashion—to be fashionable—must include what is *not* fashionable: the ungroomed, the inexpensive. So Avedon includes women artists and writers in the uniform (man's shirt and jeans) of those who dress "down" instead of "up." Being well-dressed can make one fashionable, but one can be fashionably dressed without being well-dressed. Whatever fashionable people wear tends to look "right." Thus, many images that show nothing to emulate, nothing to buy, are still part of fashion. The gestures that create or inspire fashion are defined by the camera. It is the photograph that confers celebrity, that makes something fashionable, that perpetuates and comments on the evolving idea—that is, the fantasy—of fashion.

Originally, fashion meant a current usage or a mode of action, demeanor, air. Even when the word acquired the meaning of exclusiveness, and was connected to class and snobbery, fashion continued to embrace conventions of both dress and behavior. Being fashionable was not only a matter of appearance, a particular choice of clothes. It covered general deportment, etiquette, style of speech, diction, accent, skill at forms of social and artistic perfomance. Fashion referred to how people behaved, as well as how they looked. Now, fashion is hardly at all about what people do but almost exclusively about how they appear—and where they are seen. It has become something that is almost entirely visual—that is, photographic. As fashion becomes pure appearance, it finds its perfect summing-up in photographs. What people understand of fashion is now mostly set by photographic images. More and more, fashion *is* fashion photography.

The greatest fashion photography is more than the photography of fashion. With photography, context is almost everything. But the photography can never be locked into one context, any more than it can remain something cut out of, or saved from, the mutations of time.

The camera stops time. But what our reactions to photographs principally register is the passage of time. It is fashion photography that most vividly represents photography's perennial impulse to record the perfect, to glamorize reality. But an important part of what the photograph is as an object—that it dates—is also expressed acutely in fashion photography. The abiding complexity of fashion photography—as of fashion itself—derives from the transaction between "the perfect" (which is, or claims to be, timeless) and "the dated" (which inexorably discloses the pathos and absurdity of time).

The pictures themselves change. Avedon photographs once published in *Vogue* change because the new places—a book, a museum—invite us to look in a different, more thoughtful, more abstracting way. Time has changed them, too. Seen in this retrospective form (compiled in a book, on the walls of a museum), images that started out as fashion photographs become a commentary on the idea of the fashionable. Everything seems, is, dated—faces and bodies as well as the clothes. What was fashion photography is now a manneristic branch of portrait photography, whose strenuously imagined subjects continue to fascinate. In Avedon's work fashion—a reflection on clothes as costume, on the face as mask, on styles as signs—becomes a reflection on the nature of seeing and posing; that is, a reflection about art.

GRACE MIRABELLA: REAL FASHION FOR REAL WOMEN

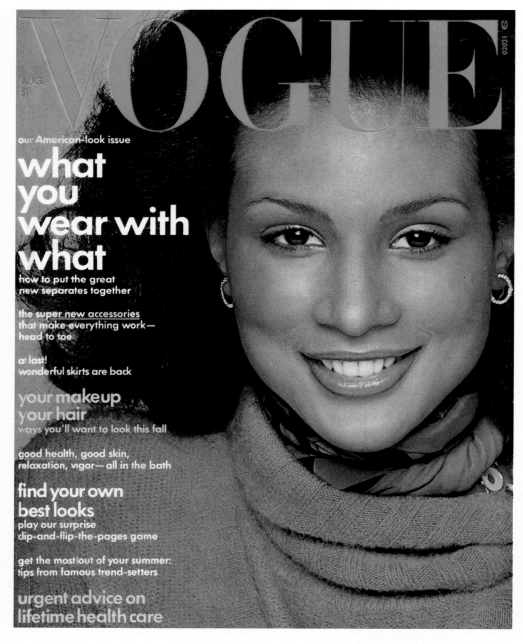

VOGUE

AUG. $1

our American-look issue

what you wear with what

how to put the great
new separates together

the super new accessories
that make everything work—
head to toe

at last!
wonderful skirts are back

your makeup
your hair
ways you'll want to look this fall

good health, good skin,
relaxation, vigor— all in the bath

find your own
best looks
play our surprise
clip-and-flip-the-pages game

get the most out of your summer:
tips from famous trend-setters

urgent advice on
lifetime health care

CHANGE OF FACE
During the Mirabella years
a black model appeared
for the first time on a *Vogue*
cover. The month was
August 1974, the model
Beverly Johnson. The step
was part of a makeover the
editor in chief had started
three years earlier.

The day she was made editor of *Vogue*, Grace Mirabella wasn't even in town. She was doing a fashion sitting in California when Perry Ruston, president of Condé Nast, called and asked her to return urgently to New York. It was spring of 1971, and twenty years had passed since the young girl from New Jersey had joined *Vogue.* Her first job, in the magazine's nascent marketing department, had been to check photo caption data on the stores that carried the clothes shown in the pictures. In time Mirabella moved up to sportswear editor, and after Vreeland took over at *Vogue*, Mirabella became her right-hand assistant and second in command. As she would often say, she was the buffer that softened the complaints coming at the editor's office from all directions, and she also made practical the exuberant, glamorous, and often impossible ideas of her immediate boss. In such a role Mirabella earned a reputation as pragmatic, hard-working, and well-organized, open to suggestion and to compromise. As a successor to "the Vreeland earthquake," she was Liberman's unequivocal choice.

"I suppose," she told the authors of Liberman's biography, "that Alex looked around and said to himself, 'Who is likely to think the way I do?' And there I was. We rarely disagree on anything." She assumed her duties as editor in 1971 at age thirty-nine, though it was only in 1973 that she was named editor in chief. One of the first things she did was redecorate her office, doing away with the Chinese red walls, the black lacquered furniture, and the leopard-skin carpets of her predecessor. A soft, soothing beige now prevailed. The new decor was a visible omen of impending changes. She soon met with all her key editors and, seated next to Liberman, implicit supporter of her pronouncements, Mirabella outlined the future course of *Vogue*:

"Times have changed," she said. "Fashion is different and women are different and this magazine has to be thought about differently. . . . We must change our focus. From dress-up fantasy to real life. . . . We must relax the look of the magazine. We're going to take the stiffness out. We're going to make it move. We're going to lose the pomposity. We're going to lose that let-'em-eat-cake attitude that says that if a woman isn't Wallis Simpson and can't afford to dress like her then she has no place reading our magazine."

Her first speech was received with misgivings at the magazine and in the fashion world, where malicious whispers—largely originating with editors who had hoped to move into Vreeland's job—warned that the magazine would lose quality, forsaking haute couture and devoting itself solely to middle-price, middle-taste fashions for the middle-class woman. Several issues of the magazine had to appear before the "Mirabella style" was understood. "I wanted to give *Vogue* back to *real women*," she wrote. "And even though I'd repeatedly been told that my idea of reality, 'as seen in *Vogue*,' bore no resemblance to the real thing, I still wanted to create a new image of reality, a 'heightened reality,' as I always called it, that would show women working, playing, acting, dancing—*doing things* that mattered in the world and wearing clothes that allowed them to enjoy them. I wanted to give *Vogue* over to women who were journalists, writers, actresses, artists, playwrights, businesswomen. I wanted to make *Vogue* democratic—not 'middle class' in the sense of being pedestrian and narrow-mindedly moralistic or down-market, but in being accessible to women like me. I wanted the magazine to be something that a woman like me—educated, reasonably well cultured, discerning in her tastes, attractively social, but not necessarily a socialite—could pick up and read and be both entertained and enlightened by. I wanted her to be surprised by *Vogue*, to learn things about fashion, politics, personalities, travel, and the arts that she never knew before. I wanted her to come away from *Vogue* with her eyes opened. And never to feel that she was smarter than the magazine. This meant raising the level of the text, and putting more of a demand on the intelligence of the magazine."

In the July 1971 issue, the first one for which Mirabella was entirely responsible, she announced to the readers the return of "the fashion of real life": "What we want to say first about the clothes you're going to find in these pages is: just that. You-are-going-to-find-clothes!! And you are going to find the kinds of clothes you've been looking for—clothes you can see your lawyer in or your lover in or go to the park in when the rest of the company is wearing 3 to 6X. Clothes to enjoy your life in."

THE ONE-MILLION FORMULA

The years between 1973 and 1979 constituted one of the most flourishing periods of *Vogue*'s history. From an average of 400,000 copies, *Vogue*'s circulation grew to one million by the end of the decade; gross profits increased from $9.1 million to $26.9 million over the same period. What had happened? What brought about such a boom?

As with every success in the modern publishing world, there was no single cause, no one person or motive force. Beginning in the 1970s a fundamental transformation took place in society: Women were incorporated into the workforce in vast numbers and at all levels. No longer were they mere secretaries or administrative assistants. The new figure of the female executive appeared, who had ambitions, who struggled and climbed just as men did for top positions. Work, then, became an activity for women, even for those who did not need to for financial reasons.

With these changing circumstances, the magazine radically changed its focus, especially on fashion. It came to grips with the needs of working women who had to look smart the entire day—at the office, at a meeting with lawyers, at a business lunch, at a cocktail party, at dinner. Its pages showed "real fashion for the real woman," as Mirabella liked to call this new style. The clothes were still elegant, but fantasy increasingly gave way to ease and practicality.

At the same time, the magazine became more journalistic, devoting increased space to such subjects as health and beauty and to articles that furthered Mirabella's aim of "converting the magazine into a new talent society." For that purpose *Vogue* enlisted columnists who were recognized disseminators of thought, and the space reserved for the arts was enlarged. The words repeated most often at editorial meetings were, "We are looking for a more intelligent woman."

SENSUAL
Fashion photography began to show more sensual women, in provocative poses such as this one in a 1974 photograph by Helmut Newton. The models were Cheryl Tiegs and Rene Russo.

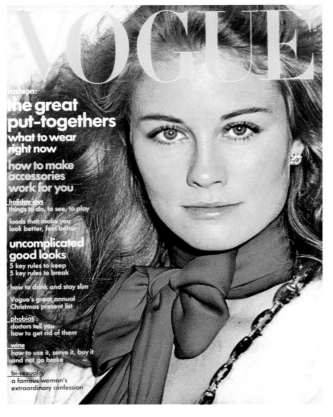

MONTHLY
Cybill Shepherd, photographed by Helmut Newton for the November 1973 cover of *Vogue*. The magazine had become a monthly in December 1972. After more than sixty years, the weaker-selling midmonth issue was eliminated.

Unlike the previous regime, when everything had to be processed through Diana Vreeland, the new era saw a leadership pyramid grow with editorial director Alexander Liberman at the apex and Grace Mirabella just one level below. Liberman supervised everything, from design and layout down to the wording of captions. But as he abundantly agreed with Mirabella's vision of the magazine, the two formed an ideal team that transmitted with exceptional clarity and uniformity its directives, whether concerning fashion shoots or the general-interest articles that were getting more and more space. The unanimity of the pair, and the smooth working of the chain of command, proved decisive for the growth of *Vogue*.

Si Newhouse made the risky decision of making the magazine a monthly, rather than a bimonthly as it had been for more than sixty years. Newhouse had noted that the issues appearing on the fifteenth of the month sold fewer copies than those appearing on the first. By eliminating the issues that sold less well, beginning in December 1972, he increased the magazine's circulation immediately by about 50,000 copies a month. Also, mindful that large-circulation publications such as *Life*, *Look*, and the *Saturday Evening Post* had folded after failing to increase their advertising revenues to cope with growing production and circulation costs, Newhouse boosted the cover price of the magazine several times. Sales continued to expand, proving that the once-a-month magazine put out by Mirabella-Liberman increased the interest of women readers. As for advertisers, they realized that their products benefited from the longer permanence of the magazine in hands and the homes of its readers.

Lastly, the growth and profitability of *Vogue* were assisted immeasurably by targeted advertising. Once the mass-circulation magazines were gone, highly specialized publications such as *Vogue*, devoted to the middle- and upper-middle-class woman who commanded purchasing and decision-making power, became the darlings of both agencies and advertisers. Simultaneously, another phenomenon contributed to turning the magazine into a powerful marketing vehicle: the unprecedented réclame enjoyed by fashion designers, who rode the success of their brand names to become fashion celebrities in their own right—stars such as Yves Saint Laurent, Ungaro, Halston, Ralph Lauren, Calvin Klein, Zandra Rhodes, Laura Ashley, Karl Lagerfeld, Geoffrey Beene, Jean-Paul Gaultier, Donna Karan, Vivienne Westwood, Gianni Versace, Giorgio Armani, John Galliano, Nino Cerruti, Sonia Rykiel, Anne Klein, Christian Lacroix, and the Japanese designers Kenzo Takada, Rei Kawakubo, Yohji Yamamoto, and Issey Miyake. All of them had the pages of *Vogue* as their show windows, either through fashion spreads presenting their creations in the editorial section or through their presence in the increasingly numerous advertising pages.

These were the factors that pushed *Vogue* to break all barriers and sell more than a million copies a month, a level that would be maintained for the rest of the twentieth century and into the twenty-first.

the <u>clothes</u> to <u>live</u> in now...

On these ten pages, you're going to see the kinds of clothes that work when and where you need them most. And you're going to see them at their best. But it isn't just clothes...the way they're worn—the accessories, the hair and makeup, the attitude—is as much a part of the story. The whole point—not only of these pages but of this issue—is the look of a modern woman at her best. Everything that goes into that...that has to do with ease and attractiveness, with a pulled-together-yet-casual polish, has to do with fashion today

Symbol for the look now — the look of you-at-your-best. The elements: makeup done with that end in mind — not for special effects. Hair, soft, cared-for, with more line to it. And the jacket — symbol for the new finish — the new pulling together — in fashion. One of the best — with skirts, pants, everything — thin mahogany suède, from **Donna Karan** and **Louis Dell'Olio** for Anne Klein & Co. About $530. Saks Fifth Avenue; Kaufmann's; Woodward & Lothrop, Montaldo's; Rich's; Higbee's; Hudson's; Famous-Barr; Ballet's; Sakowitz. Hair, Harry King; makeup, Ariella. Accessories, next to last pages. *Beauty Note* . . . The secret of an underplayed-but-pretty makeup: sheer texture, soft color. Here, from Helena Rubinstein — Silk Fashion Liquid Silk Foundation in Sunny Beige, The Sheer Shadow for eyes in Polished Amethyst, and Sugarberry Brush-On Lips.

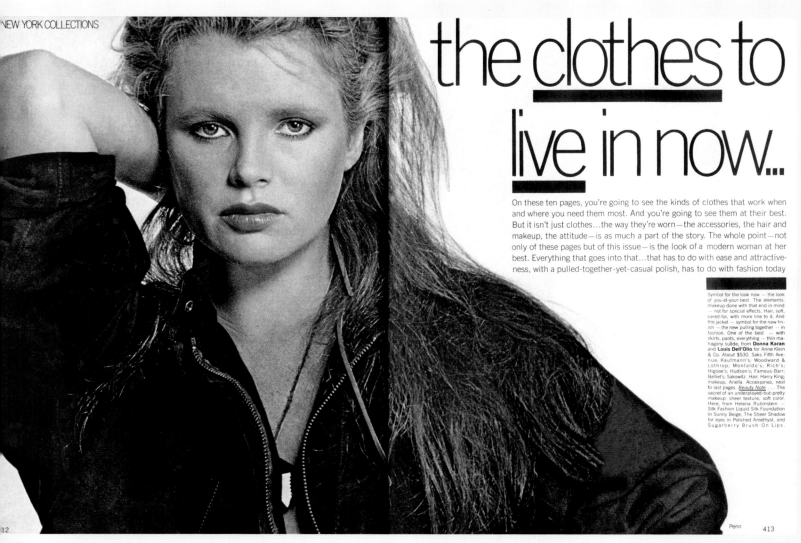

12 Penn 413

PERFECT LOOK
Kim Basinger, photographed by Irving Penn for the September 1978 issue, posed on several occasions for the magazine. Her looks— self-assured, strong, and healthy—fit the new style of *Vogue* to perfection.

217

NEW MODELS,
NEW VOICES, AND THE
"REAL WOMAN" STYLE

Central to the Mirabella-Liberman agenda was the alteration of the magazine's image. This meant new faces, new clothes, and a different way of showing both. In her memoir Mirabella wrote of the new *Vogue* of the 1970s:

Not only did we change our fashion coverage to fit the changing times, we were changing the look of the magazine: filling it with text, changing layouts so that the pages were more eye-catching, clean and direct and information-packed. We were changing the look of our covers, translating my convictions to make *Vogue* more accessible into cover lines that invited the reader to look at stories about fashion and beauty and health, and cover girls whose wide eyes and open smiles beckoned and whose all-American looks shouted stylish informality. It was an entirely different effect than the exquisitely elegant, but coldly stylish covers that Alex and Irving Penn had devised in the 1950s. We did away with the look of cool and aloof cover models who warned readers that *Vogue* was a rich persons-only magazine. Those attitudes went with couture thinking, the culture of exclusion, and they had no place in an expanding, democratizing *Vogue*. We simply couldn't afford to push women away anymore.

So we looked for girls who welcomed readers, models with great looks, marvelous young women like Lisa Taylor, Patti Hansen, Roseanne Vela, Lauren Hutton, and Karen Graham—one of the greatest cover girls ever, whom no one wanted to use for fashion sittings because she was a 'tiny' five-foot-five. It was a time of models with blue eyes and blond or red hair and tiny noses and big white teeth. A notable exception, of course, was Beverly Johnson, the first black model ever to appear on the cover of *Vogue*, but even she was all-American in her healthy good looks.

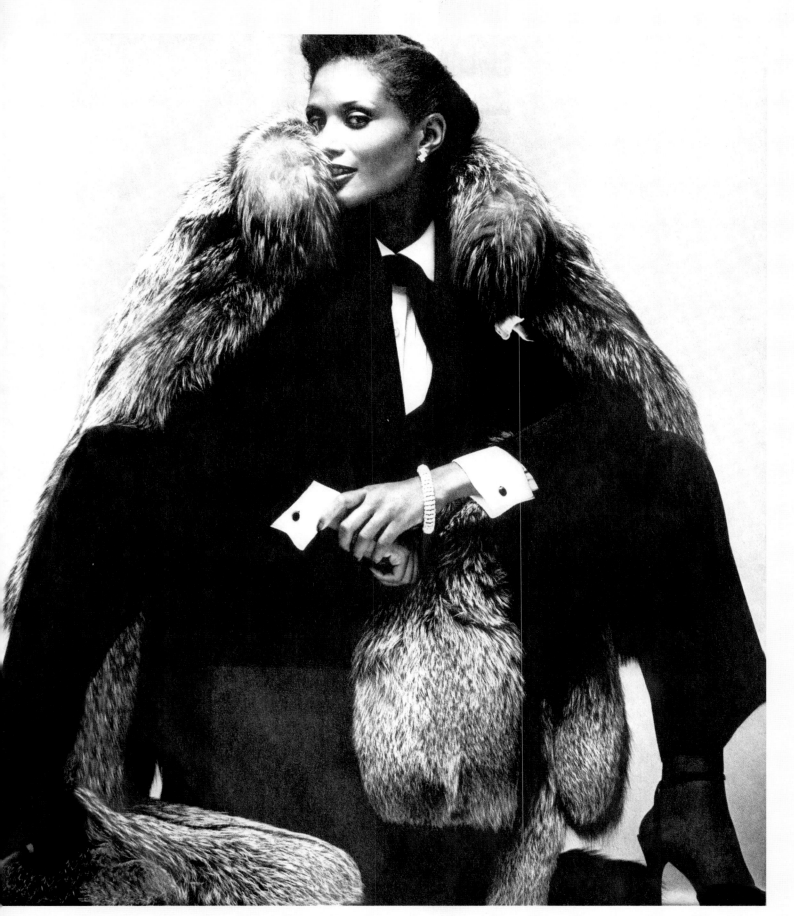

MODELS
Beverly Johnson posed for photographer Albert Watson for the October 1977 issue of *Vogue* wearing a black wool gabardine pantsuit by Dior topped by a silver fox coat.

We weren't running images of dyspeptic, anorexic-looking models anymore. Exotic, 'interesting'-looking girls were not for me. The word of the day was 'pretty'. Everyone was always on the lookout for pretty girls. Eileen Ford traveled around the world looking for them; Alex Liberman would watch the TV news at night and come in the next day with the name of anchorwomen on a slip of paper. And we would call them.

The pages of Vogue were invaded by new ranks of very attractive models with strongly expressive faces, nothing like the waifs of the sixties. These were vibrant young women, brimming with energy and health, and almost always they were posed in real-life situations, putting on makeup or combing their hair or striding out confidently, in everyday settings in which they stood out by virtue of their sheer presence. To the list of names mentioned by Mirabella were added Rene Russo, Cher (discovered by Vreeland), Beverly Johnson, Brooke Shields, Kim Basinger, Cheryl Tiegs, Daryl Hannah, as well as leading actresses, such as Charlotte Rampling. Vogue in 1978, discussing the most important American models, said: "These girls have the looks that are changing the whole meaning of beauty today. The glorious charge of health and vitality and fitness each of them has. The clear clean skin. The thick shiny hair. The strong wonderful bodies. The extraordinary sense of well-being. The 'high' of health. It's what American good looks are all about."

The clothes too were fresh and down-to-earth. Mirabella recognized that at the end of the 1960s the fashion magazines, with their parade of eccentric clothing, had lost credibility with the women of America: "There had to be a rationality behind our fashion pages. We had to give the new woman of the 1970s what she needed—clothes that could carry her from work to cocktails to dinner and home, perhaps with a quick business trip thrown in for good measure."

ENGLISH BEAUTY
Charlotte Rampling embodied the sexual allure of the seventies in this 1974 photograph by Helmut Newton.

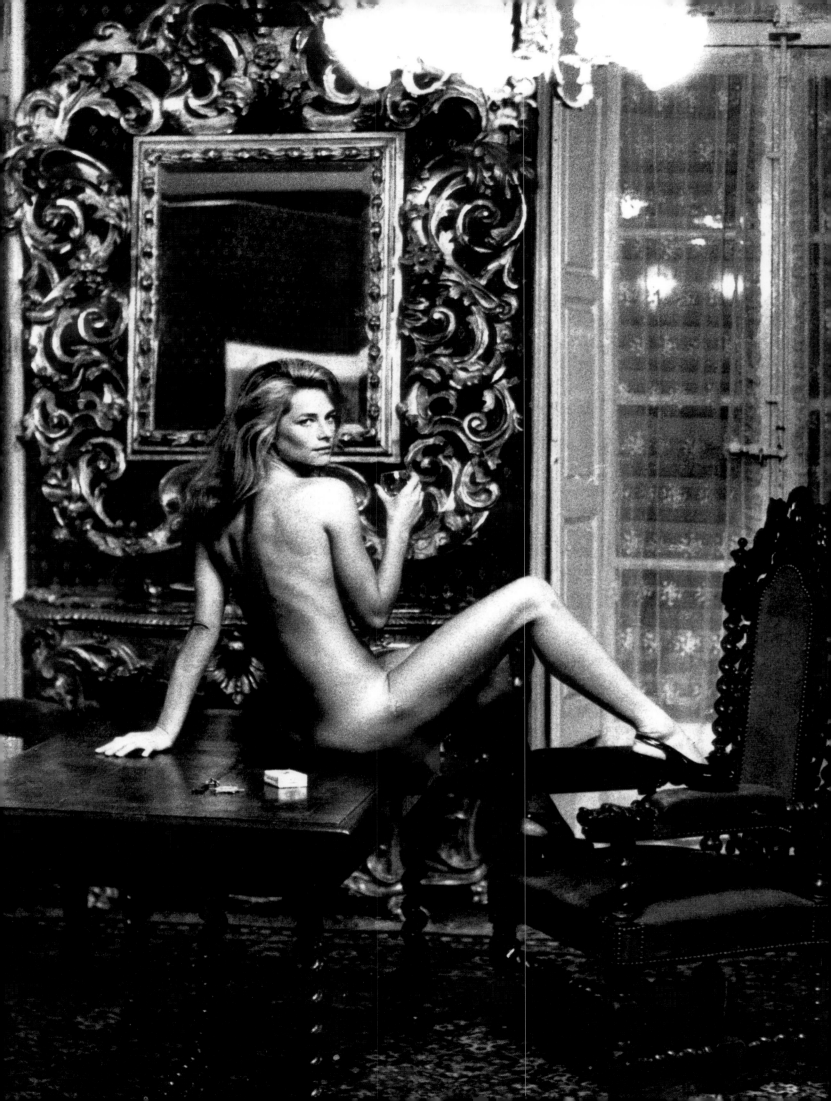

Fashion editor Polly Mellen said in *On the Edge*: "The kind of woman that Grace wanted to build as a reader of *Vogue* was a young woman who was aware of who she was. A woman who would take a good look at herself in the morning when she got dressed and then go out and forget what she had on and live her day. Grace didn't believe in too many bracelets. And she was conscious of how young women made decisions about buying expensive clothes." Happily, Mirabella's predilection for simple, easy-wearing clothes coincided with a powerful current in the fashion world: the sportswear revolution, which had opened a new door for the real woman by introducing new fabrics, new technologies, and a new generation of designers who contributed a less formal vision to the art of dressing. At the couture level, the great pioneer was Yves Saint Laurent, who toward the end of the 1960s brought out his wonderfully tailored pantsuits. Suddenly women had a stylish alternative to the informality of sportswear separates and the regimentation of Chanel suits and shirtwaist dresses. Saint Laurent's sophisticated daywear, Mirabella felt, "set a new standard for the fashion industry" which she embraced wholeheartedly, and as editor of *Vogue* she made it her mission to transmit on its pages a fashion that would serve the dynamic, multifaceted lifestyle of the *Vogue* woman who enjoyed economic independence and who was assuming an ever expanding role in society.

Pants—the masculine icon par excellence and perhaps the best symbol of the strides being made by women—continued to be central to the fashion scene in the 1970s, as other designers followed Saint Laurent's lead. Emanuel Ungaro came out with pants expertly cut on the bias, in improbable but intriguing contrasting patterns. Geoffrey Beene offered go-anywhere pants that owed their ease of movement largely to the designer's

Slash!

Racy! casual!, *left:* soft red dinner-dressing in plissé crêpe—slidey shirt and the sultry, hip-snugging news of a sarong (in a year of peasant skirts, this is the switch that refreshes!) —Blass at his best! Bill Blass Ltd., of Abraham silk. About $530. Saks Fifth Avenue; Joseph Horne; Hutzler's; I. Magnin. Hair, Harry King, makeup, Ariella.

Now-you-see-it, now-you-don't, *right*—Geoffrey's arrow-narrow black hammered satin—the killer dress-shape! By Geoffrey Beene, in Abraham silk-and-wool. About $1,140. March, Bergdorf Goodman; Nan Duskin; L. S. Ayres; Sakowitz. Hair, Marc Pipino of Pipino-Buccheri Salon; makeup, Ariella. Other stores and accessories, next to last page.

Geoffrey Beene's style

Penn

The perfect coat

Coat dressing

SAINT LAURENT

REAL-LIFE FASHION
Fashion photography began to show women in real-life situations such as business meetings and social events. The clothes, although easy to wear, were always elegant and alluring (above), and luxury continued to be present, as in this 1978 spread (opposite) photographed by Arthur Elgort, featuring eveningwear by Yves Saint Laurent.

223

Being Bernsteins

tor Leonard Bernstein, cia, and children at their romantic family-anhattan apartment

broke the Watergate story
how?

wo won't-quit reporters

Woodward and Carl
e assigned by
on Post to cover a burglary-
ripped drilling set.

NEW THEMES
Articles on beauty and health began to enjoy more space in the pages of the magazine, with Penn the preferred photographer. The larger photograph was taken in February 1978. More space was also given to interviews and contemporary issues and the arts. According to Mirabella, "The magazine had to have diversity and bite."

knowing way with wools and other fine fabrics. And Roy Halston raised to exquisite heights the art of dressing down, creating pants and evening pajamas that followed the shape of the female body with effortless fluidity in fabrics ranging from chamois to cashmere to shimmering crêpe. In time others such as Giorgio Armani, Ralph Lauren, and Calvin Klein joined the list of designers whose easy-wearing styles would attract admirers all over the world and would make their names household words in the wave of designer celebrity that arose in the 1970s and has rolled on across the turn of the century.

Liberman recalled in *Alex*: "In the early years with Grace, it was like a young adventure. We'd play hookey sometimes and have long lunches at The Four Seasons or at Chateaubriand. I liked Grace's mind. She was very sensitive to a sort of modernity in the American woman, to a no-frills attractiveness that I also admired. Vreeland had been much more involved with European culture, whereas Grace was completely American. She was one of the first to appreciate Halston. For a while, Grace would be the only woman wearing pants at an evening party. Tatiana [Liberman's wife] was shocked, but I loved it. Her interests were all in the working woman and in the whole feminist gain of strength in those years."

The journalistic instincts of Mirabella and the art-world connections of Liberman, who had the last word in everything, combined to alter the contents of the magazine. In 1972 Leo

Lerman came over from *Mademoiselle* to take charge of all *Vogue* articles not related to fashion, and he created a sort of magazine within the magazine, which reported to Liberman. Theater, film, literature, music, and dance began to enjoy more coverage, as the pages of the magazine featured artists including Alvin Ailey and Mikhail Baryshnikov, Luchino Visconti and Woody Allen, Leonard Bernstein and Tina Turner. There appeared articles about Bob Woodward and Carl Bernstein during their investigative reporting on Watergate, art criticism by Barbara Rose, journal entries by *New York Times* correspondent Gloria Emerson from Vietnam, as well as pieces on such hot topics as abortion and "the pill." Mirabella recalls: "We were changing the content of the magazine—getting away from visions of loveliness. . . . The magazine had to have diversity and bite, I felt. Reading it couldn't be like driving down a long straight road that lulled you to sleep. You couldn't have all the articles written at a fever pitch. Or all the fashion shoots taking place in Tahiti. There had to be texture, a mix: light stories and serious ones. We started bringing wonderful new voices into the magazine: Susan Sontag, Anne Roiphe, Calvin Trillin, Ada Louise Huxtable, just to name a few. On another level we were changing the way we talked to *Vogue* readers. . . . We no longer were suggesting that women dressed for men. We no longer were telling them to exercise because it would make them more adorable and alluring. We told them to exercise because they needed the extra stamina and energy for life."

During the Mirabella years, the close-up image that had begun to look out at readers in the 1960s took definitive hold on *Vogue*'s covers. In this "looking at you" formula—the term used in-house by sittings editors and photographers—the model's face moved boldly up front, occupying the cover almost entirely. The eyes of the cover girl were large, the smile full, as the shot tightened to enhance a typical American beauty attuned to the present age, showing a confident and competent woman out to conquer the world. To complete the cover, changes were made to the print component as well, with cover lines announcing articles that ranged from fashion through beauty and health to topics of general interest.

JULY 1978
Model: Farrah Fawcett
Photographer: Patrick Demarchelier

JUNE 1979
Model: Kelly Emberg
Photographer: Patrick Demarchelier

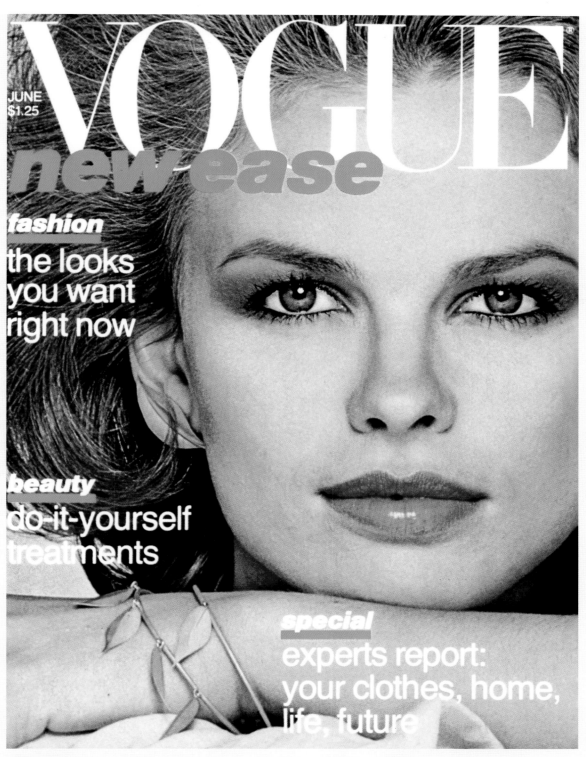

JJUNE 1977
Model: Lisa Taylor
Photographer: Albert Watson

STREET-PHOTOGRAPHY STYLE
Elgort burst onto the scene with his seemingly casual and spontaneous style, producing images of real women in real-life situations, like this October 1976 picture of a wind-blown Lisa Taylor at the wheel of a car.

The new fashion, the "real woman" style, posed for photographers a new challenge: How to show practical items of everyday clothing without depriving them of the fantasy and glamour necessary to captivate the readers? They no longer had fantastic, showy items of apparel to work with, and the pictures had to maintain a delicate and elegant balance between fantasy and reality, dreams and possibilities. One way the photographers solved the problems posed by the new clothing was to adapt a paparazzi style to fashion shoots. But unlike the candid-camera freelancers who would take celebrities by surprise and, indeed, virtually by assault, the fashion photographers only made it look as if the models had been captured unawares while working, driving, window shopping, or out for a stroll with friends. The sessions took place on the streets, and the takes of the models in motion achieved a "surprise effect" that imparted to the pictures the flavor of news.

THE RIGHT MOMENT
Elgort's technique captured precisely the right moment of the model's movement to show the clothes flowing naturally.

The best sundressing

RELAX AND ENJOY **the maillot,**

A SHAWL can do it...

The gold-dazzled shawl, left, to throw around a marvelous reversible cardigan in in dark-brown mink and nutria. With more gold (more dazzle!)—instant easy-evening when you're sweater-dressing at night. Jacket, Bill Blass for Michael Forrest, of Sabra Dusk mink and natural nutria. About $6,500. At Bonwit Teller, N.Y. and Chicago; Nan Duskin; Mon-taldo's; Furs by Weiss, Cleveland. Lou Lattimore, The Denver; Bul-lock's Wilshire. Saint Laurent shawl, of cashmere, silk, and lamé. About $90. At Bergdorf Goodman; Neiman-Marcus; I. Magnin. Gold and semi-precious stones: Madeleine van Eerde for Boris Jewelry. . . . **To turn a make-up for evening:** try blushing with a touch of shimmer—e.g., Frances Denney's Incandescent Cheek Paint in Flapper Peach. Plus a little Frosted Cream to highlight eyes. **The look turns right**—Saint Laurent's fling of lamé print shawl that can turn anything you own into something terrific. Here, wrapped over a soft two-piece "peasant" dress in thinnest gold metallic, with Bul-gari's ruby-tasselled chain; links of enamel and diamonds. Shawl, of cashmere, silk, and lamé, about $160. Bergdorf Goodman; Nei-man-Marcus; I. Magnin. Dress, Giorgio Sant'Angelo for the Cou-ture Collection, of acetate and metallic (Ross Zeldin fabric). About $450. To order, Saks Fifth Avenue, N.Y.; Sakowitz. All jew-elry, Bulgari Danaos Ltd. All these pages, hair, by Christiaan; make-up, by Ariella.

What to wear with what the new DAZZLE

ARTHUR ELGORT

Among the photographers who had to master this new way of portraying fashion—Chris von Wangenheim, Barry Lategan, Albert Watson, Duane Michaels, Kourken Pakchanian, Stan Malinowski—one who stood out from the rest was Arthur Elgort. A Midwesterner, a former art student at Hunter College, and an admirer of the "street photography" style of Henri Cartier-Bresson, Elgort became one of the main exponents of the sponta-neous fashion photograph. His favorite subjects were children, ballet, jazz, and Western scenes with cowboys and horses.

Elgort, who has worked for *Vogue* for several decades and authored innumerable "thematic shoots"—a way of showing fashion created by Grace Coddington when she was fashion editor at British *Vogue* and later developed in American *Vogue* during the Wintour years—was a particular favorite of Mirabella. She wrote of him that "what Arthur innovated was outdoor photography that *wasn't* operatic, and wasn't flashy (and often shoddy) like the work of the paparazzi. Arthur knew how to photograph three girls walking together and to catch not only the movement and sway of their clothes, but their stride, their gestures, the trivial details of their movements— a hand to the mouth, a sideways glance—that were true and fresh and present. For a beauty feature, he took a marvelous picture of Lisa Taylor driving in a Mercedes convertible over the George Washington Bridge. In the close-up, you see the detail of her sweater, her hair whipping back, her watch half-raised in the gesture of commuter impatience. It was a won-derfully stylish, wonderfully *real* shot, and like the best of his work, it cap-tured the sense of the moment, of the transitory, which Baudelaire identified with modern life."

SEXUALLY CHARGED IMAGES:
THE HOUR OF HELMUT NEWTON

PROVOCATIVENESS
Newton's May 1975 image of Lisa Taylor with her legs spread, playing with her hair and looking appraisingly at a shirtless man walking by, is one of the most sensual images of fashion photography.

Early in the 1970s American *Vogue* hired the photographer who would create the most provocative and sensual images of the latter part of the twentieth century. Helmut Newton's pictures showed a new woman, determined, aggressive, conquering, a protagonist of the sexual freedom of the times.

Newton was born in Berlin in 1920 and already in his teen years showed an interest in fashion photography. "I was obsessed with photography. My mother was a subscriber to *Vogue*," Newton recalled in *On the Edge*, "and I was fascinated by the pictures in it. All I wanted to be was a fashion photographer, a *Vogue* photographer." In 1936 he was an apprentice to the photographer Yva (Else Simon), and he became an admirer of the works of Brassaï, who would exert great influence on his future photos, especially night pictures. In 1938 he left Germany for Singapore, where he worked as a photojournalist for the *Straits Times*. By 1940 he was in Australia, where he joined the army and lived until 1956. In 1948 in Melbourne he opened his first photographic studio with his wife, June Brunell, an actress and photographer. It was in Melbourne that he met Grace Mirabella. Then the sportswear editor of *Vogue*, she

came to town in 1956 at the time of the summer Olympic Games to do a fashion shoot, for which she employed Newton. After this first contact with *Vogue*, Newton did work for the British edition, and in 1961, by then a resident of Paris, he became a regular contributor to French *Vogue*. His work, some of it republished in American *Vogue*, impressed Liberman, who offered Newton a job in New York.

From the beginning, Newton's pictures were different, loaded with sensuality. Outstanding examples were his 1974 photos of a nude Charlotte Rampling, and of Cheryl Tiegs and Rene Russo in a provocative dance on a Hawaiian hillside. However, he created his first great impact in the magazine—and his first scandal—in the May 1975 issue with a series of pictures shot in Saint-Tropez and called "The Story of *Ohhh*. . . ." The photographs, in addition to showing the clothes, strongly suggested erotic adventures between two women and one male model. In Mirabella's words, it "didn't go over well in the Bible Belt—and brought a spate of angry letters and canceled subscriptions." Perhaps his most provocative image was one that Mirabella described as "a picture of Lisa Taylor sitting in a very pretty, soft cotton dress with her legs spread apart, absently playing

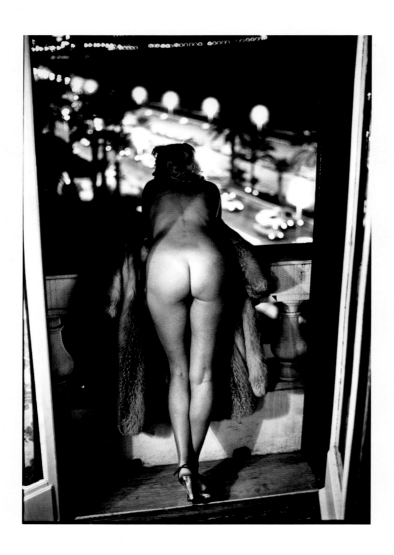

PORNO-CHIC

Newton's images created a scandal. In 1984, in a fashion shoot on bikinis, he photographed Daryl Hannah as a woman trying to calm her crying baby in the presence of her lover, just as her polo-playing husband returns home unexpectedly. At right, Newton photographed the model Winnie looking out the window in Nice, in 1976.

with her hair and coolly checking out a faceless man walking in front of her in tight white pants and no shirt." Such photographs, sexually charged to a degree unparalleled in the magazine, earned Newton the nickname "King of Kink," and his work was called "porno-chic."

Over the years, Newton's work centered basically on fashion, nudes, and portraits, with the three categories often mixing. "Newton's contribution to the history of twentieth-century photography," wrote Françoise Marquet in her essay in *Helmut Newton: Work*, "lies not merely in his extremely provocative approach but also, and most importantly, in his prescience

and intuition, in his ability to imagine and visualize women exactly as they are today, at the dawn of the third millennium; women who take the lead rather than follow it; women who love and desire whenever and whomever they like, and in whatever way they like; women full of health and vigor, enjoying the resplendence and vitality of their sinewy bodies, bodies over which they themselves have sole command; women who are both responsible and willing.

"His photographs also afford us immeasurable scope for our dreams, our maddest desires, the fulfillment of all that was hitherto impossible or forbidden. In Helmut Newton's world of

photographs we become another person, our own double; we become part of the dream and poetry evoked by the stories he narrates, stories written in the states of tension that exist between his protagonists, between their desiring gazes and their desirable bodies."

One other *Vogue* photograph by Newton that made waves was published in May 1984 and featured the actress Daryl Hannah. In that shoot, in Malibu, Newton recorded in just one magisterial photograph an entire story: A voluptuous young woman's polo-playing husband, seen in a bank of mirrors, returns unexpectedly to find her in the company of a

naked-torsoed young man in jeans. The woman, wearing a black Fiorucci bikini, is lying on a red-satin-sheeted bed, her hand on the bassinet of her crying baby beside her, and her eyes on the lover standing before her. It is the perfect image of deceit and its discovery. Newton, in *On the Edge*, called it a "very Californian story . . . my romantic notion of what America is, or should be, like."

Newton continued to work for *Vogue* until the end of the century, always providing the magazine with new, stunning, and sensual ways to appreciate fashion.

There's
more to a
bathing
suit
than meets
the eye

SCANDAL

In the same May 1975 issue that carried Newton's photos from Saint-Tropez, another fashion shoot touched off readers' anger, and certain states even banned the sale of the issue. The pictures were taken by Turbeville in a public bath-house in New York. Many saw the five models as portraying a lesbian scene.

DEBORAH TURBEVILLE:
EROTICISM WITH WOMAN'S EYES

Newton's fashion shoot in Saint-Tropez was published, perhaps by coincidence, in the same May 1975 issue as another piece that scandalized many readers. The photographer was Deborah Turbeville, an American who had been by turns a model and assistant to designer Claire McCardell, then a fashion editor at *Harper's Bazaar* and *Mademoiselle*. She had become a photographer after participating in a seminar held by Richard Avedon and art director Marvin Israel, and had just been brought to *Vogue* by Alexander Liberman. The offending spread, ten pages on bathing suits, was her debut in the magazine. The sitting depicted five slim girls in beach attire against the stark, spartan background of a disused bathhouse on Thirty-third Street in New York. In the most controversial of the photographs one of the models, the one closest to the camera, seems to be masturbating.

Turbeville recalls in *On the Edge*: "When we made the prints I knew that they were spectacular, and then I heard that Mr. Liberman thought they were extraordinary and that they were getting these huge spreads. When the magazine came out there was an explosion, because of what Helmut

had done too. People began talking about the pictures being immoral, and saying was it Auschwitz or a lesbian scene or an orgy. Or were they in an insane asylum. But if you start out trying to do an insane asylum or a lesbian scene or an orgy it looks fake. It is only when you don't set out to do it that things come off."

Liberman, who played a leading role in the magazine's sensual approach to fashion, was an ardent defender of "porno-chic" as produced by Turbeville and Newton. However, Turbeville tried to differentiate her style, vision of women, and eroticism from those of male photographers. "I am totally different from photographers like Newton and Bourdin," she is quoted as saying in Polly Devlin's *Vogue Book of Fashion Photography: The First Sixty Years*. "Their exciting and brilliant photographs put women down. They look pushed around in a hard way, totally vulnerable. For me there is no sensitivity in that. I don't feel the same way about eroticism and women. Women should be vulnerable and emotional; they can be insecure and alone; but it is the psychological tone and the mood that I work for."

Perhaps one of the best definitions of the Turbeville style is provided by Devlin: "Men photographing women often leave them as something only to be desired. Turbeville shows women with desires for something more than men can give. Her sense of how to place models in a setting is unequaled, and her groups of women look delicate and disturbing as they congregate in their odd environments. Their oblique glances have a certain enigmatic, intriguing quality, and sometimes they can look disturbed or isolated. Often their surroundings seem dream-like and insubstantial, and their bodies say one thing, their clothes another. These ambivalences speak directly to many women."

UNIQUE VIEWPOINT
Two pictures depicting Turbeville's style, published in December 1985 (right), and August 1977 (top). The backgrounds and the women's attitudes give Turbeville's work a unique erotic quality.

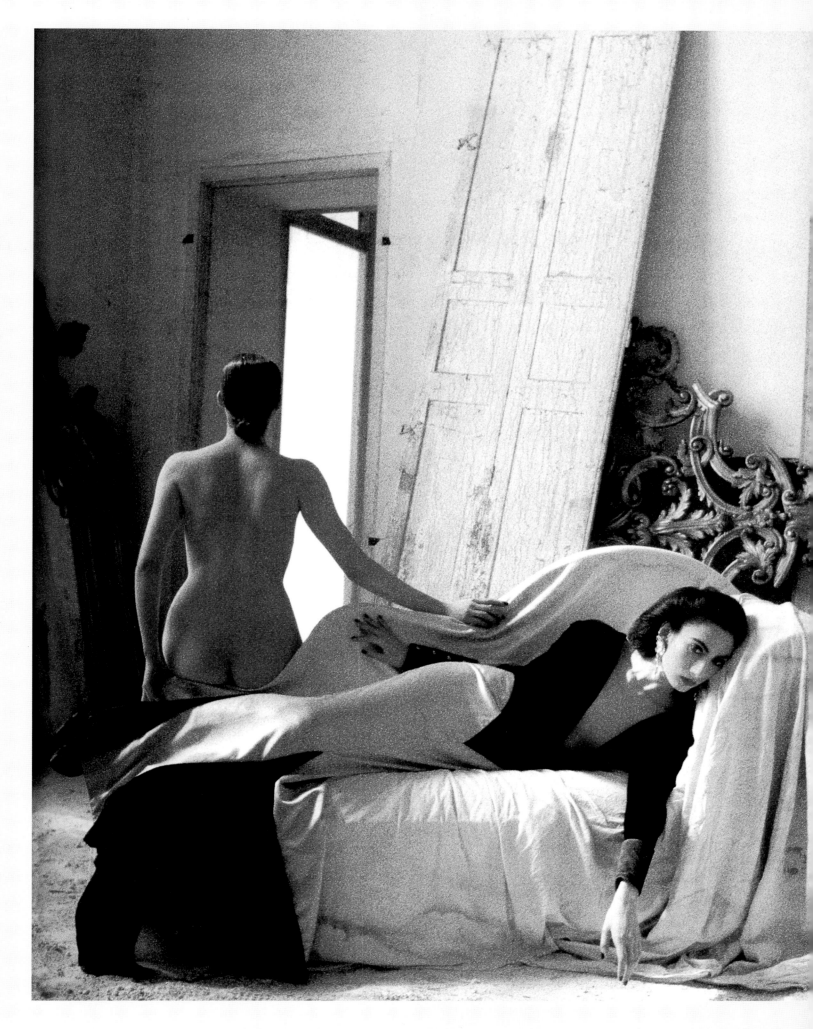

VOGUE

easy...

MAY
$1.50

all-out
summer
fashion

fragrance—
the new
sex appeal

special feature:
Vogue in India

751104

Mirabella heard about it on the telephone, on June 28, 1988. Just as seventeen years earlier a phone call had summoned her to the editorship of *Vogue*, now another call came, this time from her husband, saying he had just heard on television that as of August she would no longer be at the helm; that she was being replaced by Anna Wintour. "I'm afraid it's true," said Liberman when Mirabella confronted him. Thus ended her thirty-seven-year career with the magazine, seventeen of them as editor in chief, a period during which *Vogue* had recorded the greatest growth in its history, a circulation increase of more than 700,000 copies.

Mirabella's dismissal was food for comment and speculation in the press all that summer of 1988, as the publishing world evinced amazement at the removal of, according to John Tebbel and Mary Ellen Zuckerman's *The Magazine in America: 1741–1990*, "the most powerful woman of the day." What particularly drew their attention was the inelegant way Mirabella had heard of her termination. She was later to say that "it was a classy corporation that behaved towards me with very little class." When all the writings and pronouncements on Mirabella's replacement by Anna Wintour were sifted, four main factors emerged.

From the beginning of the Mirabella-Liberman management, it was quite clear that the final word on any subject belonged to the editorial director. Under a division of jurisdiction that put Mirabella in charge of fashion and beauty while Liberman oversaw arts and general-interest articles, the pair worked together during the initial years in harmony. But as the 1980s unfolded, disagreements over the focus of the magazine became ever more frequent. Liberman believed that Mirabella had remained stuck in the "real woman" mentality of the 1970s, that times were changing and *Vogue* was not adapting to them. The first great confrontation came when Liberman, who always tried to be in the forefront of the "modern," wanted Mirabella to endorse Christian Lacroix's new baby-doll designs. She did include the collection in the haute couture report, but not in the section showing the magazine's picks of the season. This angered Liberman bitterly. Mirabella wrote in her memoir: "Until the moment of Christian Lacroix, Alex and I never lost our sense of pleasure in working together. But after Lacroix, our relationship started degenerating. Alex was often cross, wandering through the art department changing things. I started arguing with him more and more about the look of the magazine, particularly criticizing the nudity and what I saw as the anti-woman imagery in the work of photographers like Helmut Newton or even Deborah Turbeville. I hated it when we did fashion pages like the ones entitled 'Hidden Delights' in our March 1987 issue, which showed two models

blindfolded, one binding herself tight in her corset strings, and another with her ankles tied together. We started fighting over everything: whether a sleazy sex piece by Mary Russell was worth running because it was 'modern' (Alex) or 'poor' (me); whether or not Le Cirque had surpassed La Grenouille briefly as *the* place to eat at the moment (I said yes, Alex said no), and whether it mattered at which restaurant the food was actually better. All of Alex's opinions, no matter how trivial the topic, appeared to have been handed down to him by the highest authority. When I wanted to do a story on breast cancer, Alex told me '*Vogue* readers are more interested in fashion than breast cancer.' I replied, 'Alex, I've been a woman longer than you, and they're interested in both.' In the past I had grinned and borne them. Now, I couldn't bear to acquiesce anymore. I was exhausted with trying to feed Alex's ego. And I was tired of being perceived as a pushover just because I believed in collaboration."

Another struggle with the male power structure centered on the subject of tobacco. Mirabella, herself a reformed smoker and the wife of a prominent cancer surgeon, had forbidden the use of cigarettes in photographs, and

Vogue's editorial content included ample mention of the hazards of smoking. She wanted to carry this campaign to its logical conclusion and ban tobacco advertisements. However, such advertising was bringing *Vogue* more than $3 million a year, a sum the business side was unwilling to lose. Worse, as tobacco companies were becoming vast conglomerates, more than tobacco advertising was at stake. *Vogue* was already fielding complaints about its antismoking stance, and Mirabella in turn was pressured to curtail her coverage. Liberman suggested that she "lighten up" about lighting up. Mirabella replied that, if pushed on the subject, she would have to resign. She believed that a magazine with *Vogue*'s influence could, and should, commit itself to something that would improve the lives of women. This struggle set Mirabella not only against Liberman but against the rest of the company, Si Newhouse included.

The year 1986 saw the successful launch in the United States market of the French magazine *Elle*, which as early as 1988 attained a circulation of approximately 800,000 copies, supplanting *Harper's Bazaar* in second place among the "class publications." *Elle* was considered the magazine of

the day, with colorful pages and sexy, youthful fashions. Years later Liberman was to say: "I'm not sure *Elle* took many readers from *Vogue*, but its success certainly impressed us. There was no feature content—just bright colors, page after page of flash. It made *Vogue*'s earnestness and nobility, its respect for art and for women's intelligence, look a bit quaint." The higher-ups at Condé Nast, faced with this reality, decided that *Vogue* needed a makeover. In 1987 Liberman proposed a new design, but Mirabella dug in her heels and refused to "turn our magazine into *Vogue* lite." She pointed out in her memoir that *Elle* was "a magazine for kids, a pure product of the MTV sensibility: trendy, cartoonlike, light on text, heavy on jokey fashion modeled by young and adorable girls. *Elle* made its fashion points by showing, say, an arm loaded with bracelets like Madonna's, or showing crayon-colored clothes, or browns and reds surrounded by licorice. It was cute, as far as it went. But it wasn't *Vogue*."

The decision to remove Mirabella was made in May 1988, and its main instigator was Si Newhouse, who hastened things along because he believed it was important that the new editor take over while Liberman—by

PENN
Irving Penn was the photographer most often used to illustrate articles on behavior, health, and beauty. The cigarette butts were published in August 1975. Mirabella conducted an intensive antismoking campaign, which caused clashes with *Vogue*'s advertisers.

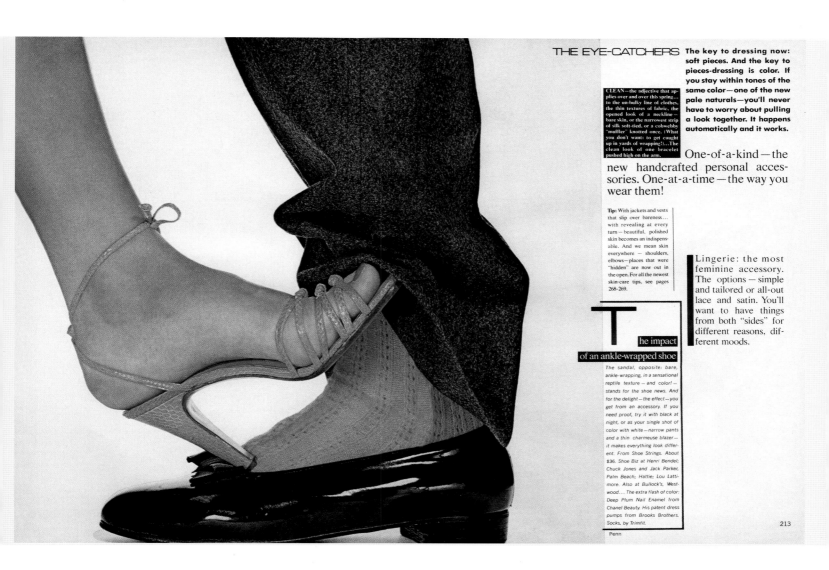

The key to dressing now: soft pieces. And the key to pieces-dressing is color. If you stay within tones of the same color—one of the new pale naturals—you'll never have to worry about pulling a look together. It happens automatically and it works.

CLEAN—the adjective that applies over and over this spring...to the un-bulky line of clothes, the thin textures of fabric, the opened look of a neckline—bare skin, or the narrowest strip of silk soft-tied, or a cobwebby "muffler" knotted once. (What you don't want: to get caught up in yards of wrapping!)...The clean look of one bracelet pushed high on the arm.

One-of-a-kind—the new handcrafted personal accessories. One-at-a-time—the way you wear them!

Tip: With jackets and vests that slip over bareness... with revealing at every turn—beautiful, polished skin becomes an indispensable. And we mean skin everywhere — shoulders, elbows—places that were "hidden" are now out in the open. For all the newest skin-care tips, see pages 268-269.

Lingerie: the most feminine accessory. The options — simple and tailored or all-out lace and satin. You'll want to have things from both "sides" for different reasons, different moods.

The impact of an ankle-wrapped shoe

The sandal, opposite: bare, ankle-wrapping, in a sensational reptile texture — and color! — stands for the shoe news. And for the delight — the effect — you get from an accessory. If you need proof, try it with black at night, or as your single shot of color with white — narrow pants and a thin charmeuse blazer — it makes everything look different. From Shoe Strings. About $36. Shoe Biz at Henri Bendel; Chuck Jones and Jack Parker, Palm Beach; Hattie; Lou Lattimore. Also at Bullock's, Westwood....The extra flash of color: Deep Plum Nail Enamel from Chanel Beauty. His patent dress pumps from Brooks Brothers. Socks, by Trimfit.

213

Penn

then over seventy-five and having health problems—could be part of the transition. In *The Magazine in America: 1741–1990*, Tebbel and Zuckerman wrote of the changes taking place at *Vogue*: "Newhouse admitted that his editor had reflected the spirit of the 1970s. She had exploited the rise of women in the work force and anticipated the twistings and turnings of fashion with a high degree of accuracy. Now, however, as Newhouse observed, times were changing again— as decisively in the 1990s, he predicted, as from the 1960s to the 1970s. He saw an era of more informality dawning, with guidelines blurred between art and kitsch and a consequent difficulty in distinguishing between high and casual fashion. It would be a decisive change, he said, and clearly felt that an old hand like Mirabella was not equal to it."

The person chosen by Newhouse to manage the magazine was the Englishwoman Anna Wintour, who had joined *Vogue* as creative director in 1983, was later entrusted with British *Vogue*, and since 1987 had been in charge of *House and Garden*. Wintour took over *Vogue* at age thirty-nine—the same as Mirabella when she became editor—and under her guidance the magazine ended one century and moved into another.

MY DAYS AT *VOGUE*

Grace Mirabella

Although she left the magazine in 1988, Grace Mirabella continues to read *Vogue* and here recalled her days at the helm with humor and a touch of nostalgia. In her New York apartment, pictures from the *Vogue* days are intermingled with signed photographs by Irving Penn, Horst, Francesco Scavullo, Steven Klein, Deborah Turbeville, and Helmut Newton, along with a mélange of awards and mementos from her career.

IN THE ART DEPARTMENT
Mirabella was at the helm of the magazine for seventeen years, a period during which *Vogue*'s circulation tripled to 1,200,000 copies.

When you arrived at *Vogue*, Edna Woolman Chase had retired and Jessica Daves was editor in chief. The photographers were Beaton, Steichen, Horst, Hoyningen-Huené, Blumenfeld. How do you view that era?

Even in the Depression years, the magazine prospered under the direction of Condé Nast and Edna Woolman Chase. In 1953 I worked for the executive editor, Mildred Morton. (I started at *Vogue* in 1952.) My desk was in the office of Bettina Ballard, the fashion editor. My assignment was to watch that editorial fashion selections included clothes from the list of "musts." Waiting for the elevator one night, trying to make conversation with the marvelous Bettina Ballard, I said something about my vacation in Rome, where I wished I could work. Ms. Ballard introduced me to Simonetta and Fabiani, who were in New York at the St. Regis, and I soon found myself working in Rome. When I returned to New York and to *Vogue* a year and a half later, big changes were taking place at the magazine. Bettina Ballard had just resigned. Before long Diana Vreeland would resign from *Harper's Bazaar* and join *Vogue*. Jessica Daves remained in charge—for a while. Daves was hardly a fashion person, and how she was perceived by the designers in Paris or New York, or, indeed, by the fashion industry, I don't think I ever knew. Jessica Daves's strength, I was

told, was her marketing expertise. She worked closely with the many fine American retailers all over the country, and the store names mentioned under each editorial fashion picture informed the reader where to find the item pictured. The stores supported the magazine, the magazine supported the stores. *Vogue* fashion shows were presented in key stores in major cities, and merchandising aids and fashion news were sent out to those *Vogue* stores.

In your book you talk about working with a legendary editor like Vreeland. From today's perspective, what do you think were the positive and the negative aspects of Vreeland's editorial tenure?

Diana Vreeland, a remarkable editor, innovative, a woman of exaggerations, of extravangances, produced very beautiful magazines. And, as I was to learn as her associate, a woman who, with me, was the straightest talker, a woman whose words I could depend on. The fantasy was for the pages of the magazine.

Diana Vreeland and Alex Liberman changed the editorial pages of *Vogue*. Vreeland changed the content. Fantasy, fantasy—in clothes and in beauty—plus the first very well reported plastic surgery articles. Alex changed how the pages looked, bringing a team of photographers who had talent and strength, in New York, Paris, Milan.

Penn and Avedon were the stars. Penn's covers, his memorable beauty pictures, and his French and American collections. His ideas were magazine treasures. Avedon's work was superb and extended through the magazine. Beyond his studio photographs of fashion, there were the trips with Polly Mellen and with Verushka—one time as Queen Christina, another time as the heroine of their trip to Japan—the endless luxe and beauty of it all!

And there were beautiful trips done by Henry Clarke for December issues. The trips were to India, to Iran, to mountaintops, and nowhere did they go without having to take the largest hatbox (for a remarkable hat that was never used). All of these trips, the clothes, the destinations, were planned by Vreeland.

Despite her excesses or because of them, Diana Vreeland produced a very beautiful magazine. And yet, with all the glory, the excesses mounted. The budget was excessive. Manufacturers refused to make the special clothes for those trips. Only Bonwit Teller would accept an editorial credit on the clothes and only on a to-order basis. Meanwhile, the reader and the market were losing interest. The women's movement was allowing women to think differently, to see themselves differently. Alex Liberman tried to curb this total lack of reality. And while I was in Los Angeles on a fashion shoot, I was told to fly back to New York imme-

diately, having no idea why. I did not know that Diana Vreeland had been fired.

How do you explain a magazine like *Vogue* going from a highly conservative editor in chief to one as extravagant and excessive as Vreeland?

Looking back, it seems that the management of *Vogue* always had a very clear eye. The company saw the need for change, and each new editor very much defined her time. Life was changing dramatically. Women were changing. Fashion was changing. Magazine content, presentation, how the reader was spoken to—all had to change.

You came from an editorial regime characterized by eccentricities. However, when you took over as editor in chief, you shifted to a completely different approach to fashion. Can you tell us the reason for that shift?

In one of the company's "quick changes" I became the new editor in chief. I had the good fortune to become editor in chief in 1971, following the fantasy of Diana Vreeland and after the sixties settled down a bit. We had a fashion meeting. I asked for a kind of calm, and for style. Clothes that could be worn. Models who looked great. Alex Liberman, the editorial director of Condé Nast, welcomed

my thinking and supported it with ter-rific photographers, and we moved outside to the street or to locations, and inside to studios, all for the best of fashion news and style and a cer-tain ease. Alex was my mentor as I made the change to editor in chief. His choice of photographers made ease and style possible and consistent. And the strength of Penn and Avedon and Bill King and Arthur Elgort gave us fashion news we were proud of.

While Mirabella was editor in chief, *Vogue* had the most phe-nomenal growth in the history of the magazine, tripling to 1,200,000 copies.

The most important reason for this growth was our regard for women, tak-ing them seriously, wanting to present to them a magazine with rich content. In fashion: the best design, the best in style, clothes that were easy to wear. The clothes we chose and presented were all very much part of our time.

Our timing was fortunate. The bursting forth of American designers in the seventies, the style and the ease of their clothes: Geoffrey Beene, Bill Blass, Ralph Lauren. Also Giorgio Armani, Karl Lagerfeld with Chanel. Thanks to Liberman, we worked with photographers who aided our change from fantasy to style and to what we termed "real life," with Penn and Avedon in the studio, and Bill King,

Arthur Elgort, Helmut Newton, Chris von Wagenheim, Deborah Turbeville, and Kourken Pakchanian on location. Covers and fashion were pho-tographed on models, for the most part. The cover faces were more var-ied than before. Beverly Johnson was the first African-American beauty to be on the cover.

The models were changing, photog-raphy was evolving, not simply by going out-of-doors. Sections of pages were planned with Alex Liberman and the photographer. And Helmut Newton entered our "lives," our pages. "The pill" changed mores in the sixties, and Helmut Newton changed *Vogue*'s pages in the late sixties, early seven-ties. Helmut Newton, better than any other photographer, brought sex into his photographs—with style and wit. In one May issue of *Vogue*, Helmut Newton, Deborah Turbeville, and Richard Avedon each had a beautifully photographed, very sensual portfolio, all in the same issue. In Florida the magazine was taken off the news-stands. It was then we realized we had overdone it.

Feature pages: *Vogue* was enriched with fine-art features, medical features, and timely, well-written articles. We reached out to women all over the country, brought them to our offices for conferences and seminars to discuss women, the changes in their lives, their health, their politics, their work.

During your tenure, there was a new wave of models, then the supermodels. Now *Vogue* covers are practically taken over by celebrities. Does this point to a new social perception of fashion, or is it simply a fad?

Cover faces, and approaches to covers, change. In Diana Vreeland's time there were very beautiful "personality covers": Grace Kelly, Sophia Loren, Barbra Streisand, Audrey Hepburn, Cher. These covers, now called "celebrity covers" but still featuring movie and theater stars, are even more frequent, and dealing with the press agent is part of the equation. What will happen when actresses who have their own fashion labels are asked to pose for covers? Then must the star wear her own clothes, or are there to be more of her clothes inside?

One of the most talked-about aspects of Mirabella's dismissal at *Vogue* was how she heard the news.

My words were, "For a magazine about style, they certainly didn't have any." Styleless firings are a kind of Condé Nast style. No one ever told me why I was fired. Does it matter? Was it about too many antismoking articles? My wanting to become editor of *Self* at some point? Did I want to spend more time with my husband, who was retiring from surgery? Was I bored? Most

important, management knew the time was coming to change editors.

What's your take on the magazine today and how do you see its future?

Today I think *Vogue* is presenting a magazine that its readers want to see. Readers are disinterested in fashion. They know there is no fashion. But they are interested in clothes, wearing them, combining them. It is a very different time for magazines. Don't proclaim what to do, just show the possibilities. No one really knows what is ahead of us or what the moment will bring. A brilliant designer comes along, as Yves Saint Laurent did in the seventies, eighties, nineties, and everything changed and was energized. New fabrics bring new thoughts, different lifestyles bring new thoughts. The world is changing and clothes must change.

Vogue is helping to find young talent though the foundations it sponsors. Anna Wintour is giving the industry the help needed—a job that is as important as the magazine itself.

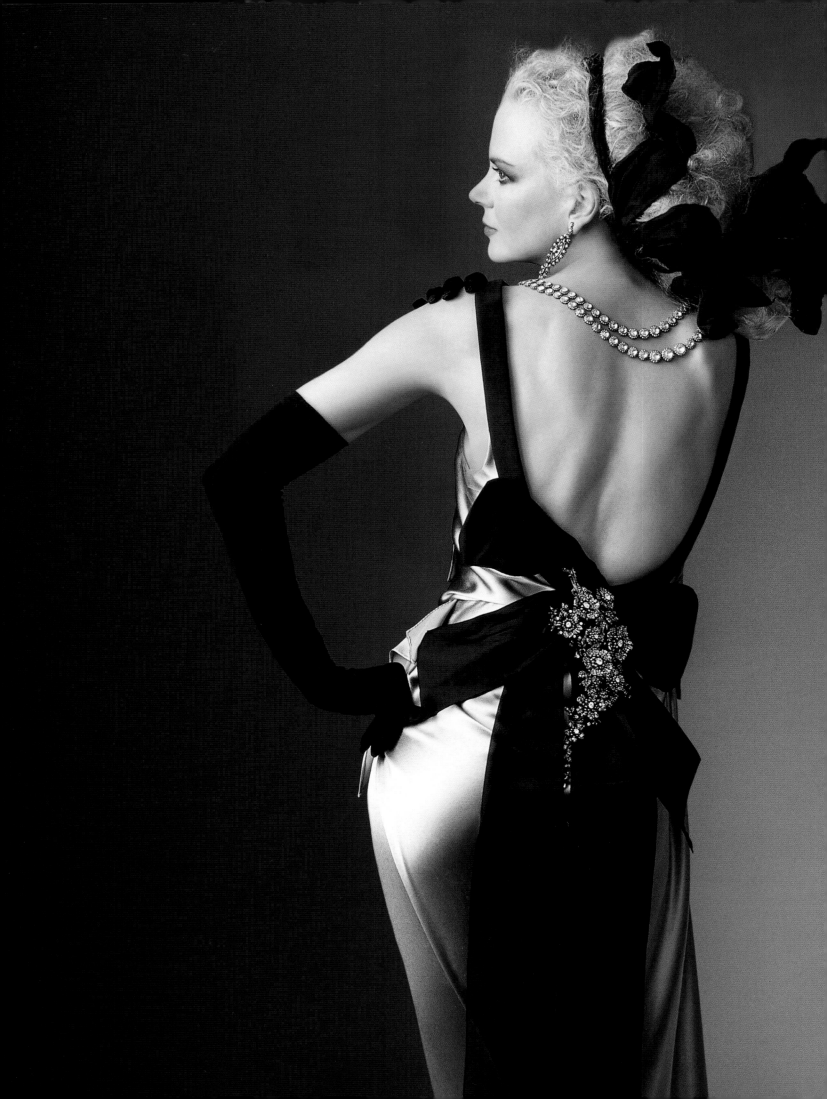

PART 3

THE MAGAZINE OF THE NEW CENTURY

THE ANNA WINTOUR ERA

When Anna Wintour took charge of the magazine in August 1988, she had a clear mandate: to modernize its look while reenergizing its long journalistic tradition. "I made changes when I arrived, but if you look at what *Vogue* has always stood for, there is so much that can easily be tied back to the past," she said when interviewed in her office eighteen years later. "*Vogue* reflects changes in fashion and society. It touches pop culture, art, politics, sport, design. We respond to what we see and to the times. It's vibrant, it's serious—and it's fun." Her vision of *Vogue*, then and now, is that each issue should feel like an event—more like being part of a roomful of witty, sophisticated, and intelligent people than reading a fashion tome. "For me, planning an edition of *Vogue* is like coordinating and hosting a great dinner party. I always try to invite several influential people who don't necessarily know each other and are from different worlds. You need an extraordinary photographer like Irving Penn, Annie Leibovitz, Steven Meisel, or Mario Testino, and a great writer such as Julia Reed, Joan Juliet Buck, or John Powers, who can discuss everything from politics to movies. Add a beautiful and intelligent woman like Nicole Kidman or Uma Thurman, and a fantastic food writer like Jeffrey Steingarten. When you throw them all

in the mix, the conversation turns passionate, interesting, funny, provocative, unexpected. Life is like that, and *Vogue* should be, too."

Her perception of the *Vogue* paradigm was not gleaned from studies or market research. Anna Wintour's instinct for the magazine's editorial culture was a legacy of her childhood, when *Vogue* was part of her London family's household reading, and had been further honed by practical experience as a fashion editor and later senior fashion editor at *New York* magazine (1981–83) and as editor in chief of British *Vogue* (1986–87) and of Condé Nast's *House and Garden* (January to July 1988), which she retitled *HG*. She arrived with an appreciation of the intrinsic values of *Vogue* and a knowledgeable and decisive eye for what she liked in fashion and photography. And, just as important, she stepped into the job equipped with an objective view of the magazine's place in the competitive landscape. This was shifting in the late 1980s and has continued to reconfigure itself ever since.

The first external challenge at the end of the eighties was the success of the American version of *Elle*, which had been launched in 1986 with a young, informal outlook. In September 1993

the Time Inc. magazine *In Style*, which anchored its fashion and beauty content to the lifestyles of celebrities, found a wide readership. New social and financial realities emerged from the economic downturn of the early nineties, the dot.com and stock-market booms—and busts— in the runup to the new millenium. In 2001, the magazine had to respond to the terrorist attack on the United States and the shock waves that shook the publishing, advertising, and fashion worlds. *Vogue* has since energetically expanded its audience, through the internet by setting up its website www.style.com, and through the launch of *Teen Vogue* and *Men's Vogue*. The success and development of the magazine has depended on Wintour's creative leadership, her recognition of new opportunities, and her vision of the multiple roles *Vogue* could fulfill, both for its readers and for the fashion industry at large.

As much as reflecting the times in her pages, Wintour stresses, she has worked to develop a dimension unique to *Vogue*'s preserve: the contribution the magazine and its team makes to the workings of fashion behind the scenes. "*Vogue* is both a witness to the world of fashion and a protagonist in it," she says. "We reflect what we see, but we also help

to create what we see. Covering the collections and the direction of fashion is terribly important, but what we do outside the magazine is crucial: supporting young talent through the CFDA/Vogue Fashion Fund, our work at the Costume Institute of the Metropolitan Museum of Art, listening to retailers, giving advice to designers and businesses, forging relationships on every level in industry. All this makes us more than just a magazine. We are rather a real force in fashion. For me, this vital part of the life of the magazine is almost as important as what we put in the pages, because it supports fashion in a way nobody else does."

The period since Wintour's tenure began has spanned huge swings in fashion, all of which she has interpreted with a characteristic sense of optimism from her office, now situated on the twelfth floor of the Condé Nast building at 4 Times Square. Her workplace mirrors her priorities: There is no door separating her suite from the editorial floor. If she looks up from her desk, she has an uninterrupted view of every staff member, every visitor, and every piece of clothing that passes in and out of the magazine. Inside, the walls and the table at which she works are covered with paintings, photographs, and sketches, mementos charting a major portion of her professional and family life.

The woman who speaks passionately of her editorship and of the contributions made by the magazine she runs took her first steps in the fashion world in her native England. Journalism is in her family. Her father, Charles Wintour, a prominent London journalist, was appointed at age forty-two as editor of the *Evening Standard*; her American mother, Eleanor Baker, was a writer and film critic. Apart from bringing home a sense of involvement in current affairs and the stories of the

day, the Wintours also instilled in their children a love of theater, travel, cinema, and sports. All of this has stayed with their older daughter as a way of life that informs her work: "I go to the theater two or three times a month; I have friends who are actors, producers, directors. It's particularly important to me not to live in a fashion bubble, but to be out there in the worlds of art, politics, sport, medicine. What these people are thinking, who they're hearing about and find exciting, are the things I want to bring to the magazine as much as what Nicolas Ghesquière or Karl Lagerfeld are designing."

Of the four siblings in the family, Anna was the one who had a fascination for clothes. Charles Wintour noticed. When she was ten years old, he told her that when she grew up, she should be the editor of *Vogue*. As long as she can remember, she was scrutinizing every fashion magazine that fell into her hands, and by her teens she knew what was going on in every store and boutique in London, and what news was arriving season by season from Paris. When it came to deciding which way to go after leaving school, her innate passion for fashion and the journalistic influence of her father made it obvious her interest would lie in women's magazines— in the fashion department. After five years at *Harpers and Queen*, Wintour decided in 1976 to move to New York, where she worked at *Harper's Bazaar* and then as a freelance stylist before she was appointed fashion editor at *New York* magazine in 1981. Her first experiences with *Vogue* came in 1983 when Alexander Liberman named her creative director. She later left this position to become editor of British *Vogue*, but she returned to the United States in 1987, at the behest of Si Newhouse, to take over *House and Garden*, and she was appointed editor in chief at *Vogue* a year later.

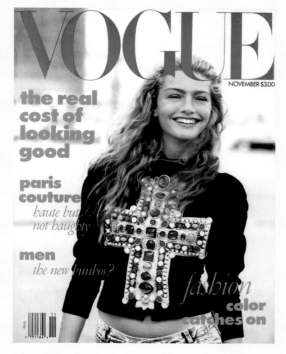

NEW EDITORIAL ERA
In November 1988 the inaugural cover of the Wintour era was a total departure. For the first time ever, a model wore jeans on a *Vogue* cover. The couture jacket is by Christian Lacroix—an expensive item paired with an inexpensive one. The model was Michaela Bercu, and the photographer Peter Lindbergh.

(PREVIOUS PAGES)
NICOLE KIDMAN
The celebrity was photographed by Irving Penn for the May 2004 cover wearing Christian Lacroix Haute Couture, Daniel Storto gloves, and an extravagant array of jewelry, including Lorraine Schwartz black-gold-and-diamond earrings, a Munnu 18-karat-gold-and-silver double-strand diamond necklace, and a Fred Leighton nineteenth-century diamond flower brooch.

(OVERLEAF)
SATIN AND LEATHER
This September 1991 photograph taken by Peter Lindbergh shows the models of the moment dressed by Karl Lagerfeld for Chanel. Featured are Helena Christensen, Stephanie Seymour, Karen Mulder, Naomi Campbell, Claudia Schiffer, and Cindy Crawford.

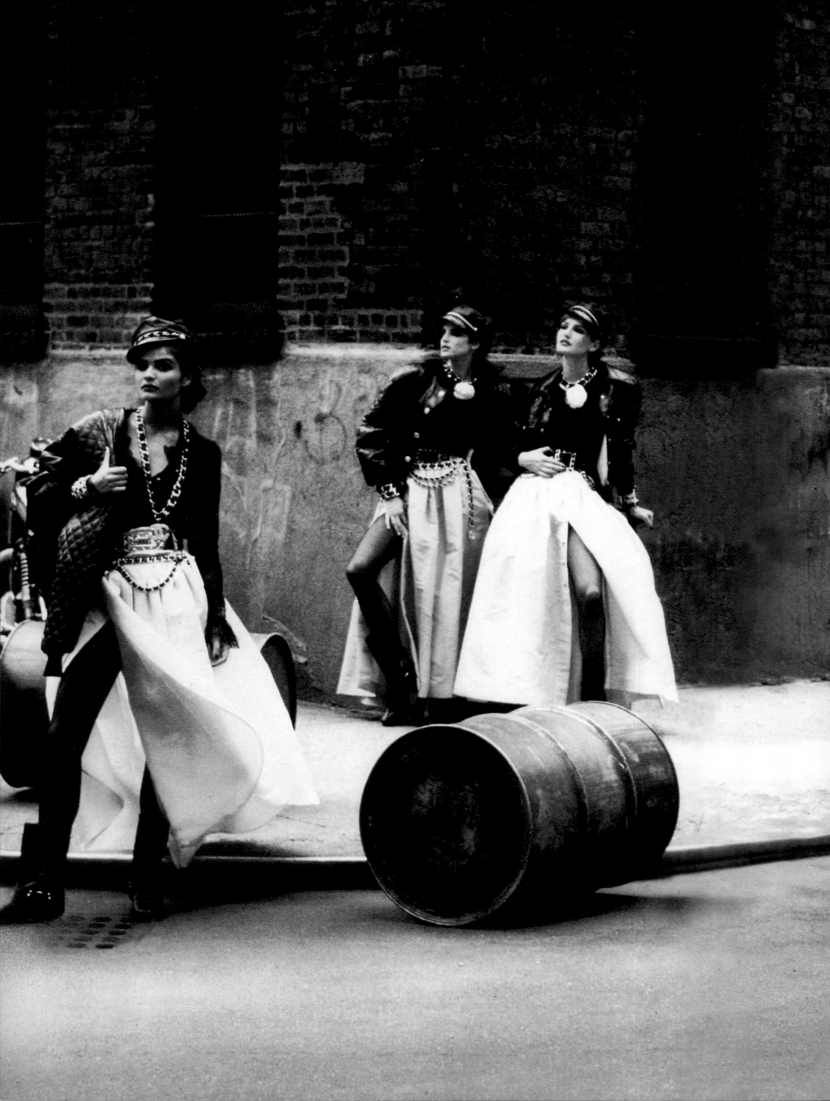

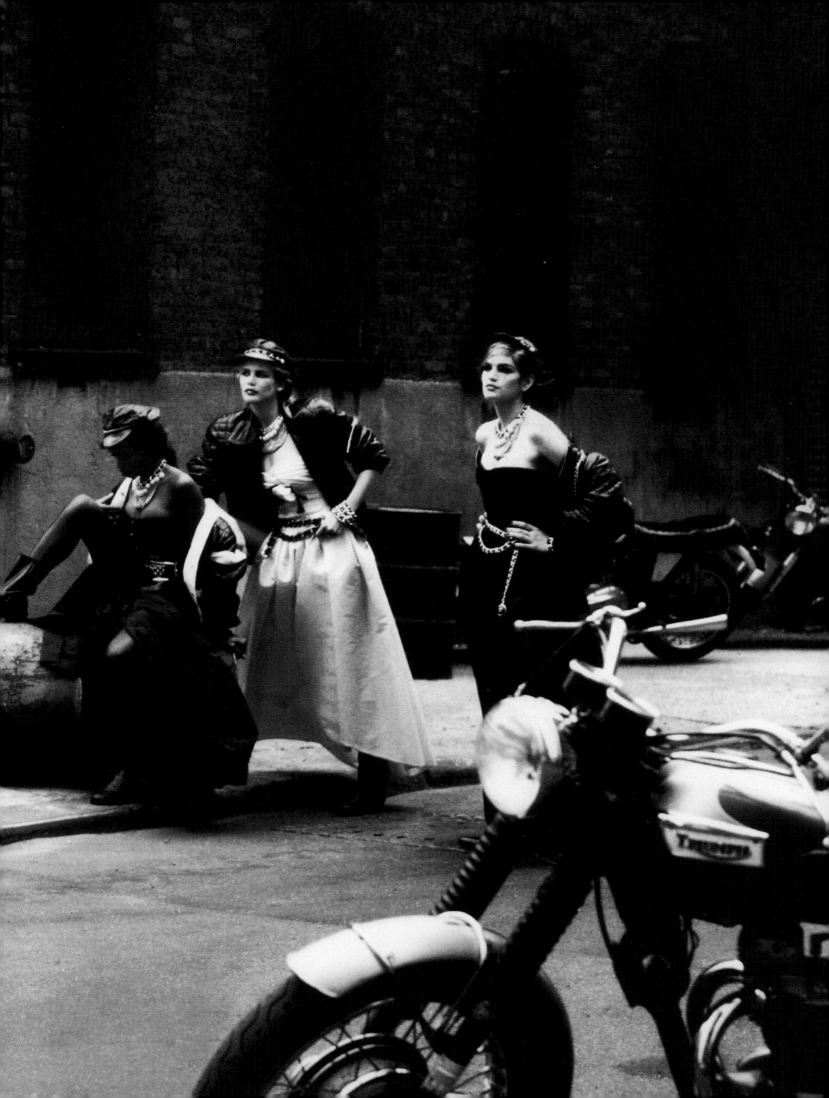

FASHION AT THE END OF THE CENTURY:
FROM OPULENCE TO "LESS IS MORE"

The 1980s marked the appearance of a new phenomenon that would strongly influence the culture of fashion at the end of the twentieth century. It was a boom era for designers, who marketed and promoted themselves as celebrities in their own right. It was a phenomenon that played alongside other seismic changes that affected society. Politics swung to the right, as Margaret Thatcher became prime minister of Britain in 1979 and Ronald Reagan was elected president of the United States in 1980. Romance swirled around the fiancée of the Prince of Wales, nineteen-year-old Lady Diana Spencer, turning her into a figure who combined youth, style, and royalty in a way that drew global fascination. A new class of yuppies rose out of corporate America—men and women defined by work, money, and conspicuous consumption. It became the Designer Decade.

These circumstances, together with the television series *Dallas* and *Dynasty*—perhaps the most watched TV shows of the decade, which flaunted the symbols of status and opulence characteristic of the time—and movies such as *American Gigolo*, which memorably featured Richard Gere's wardrobe by Giorgio Armani, were direct influences on the world of fashion. Huge shoulder pads spoke of power. Gold and red flashed. Fashion shows became highly theatrical events that helped turn the designers into household names and propelled top models into positions akin to those of Hollywood film stars. Karl Lagerfeld woke up the house

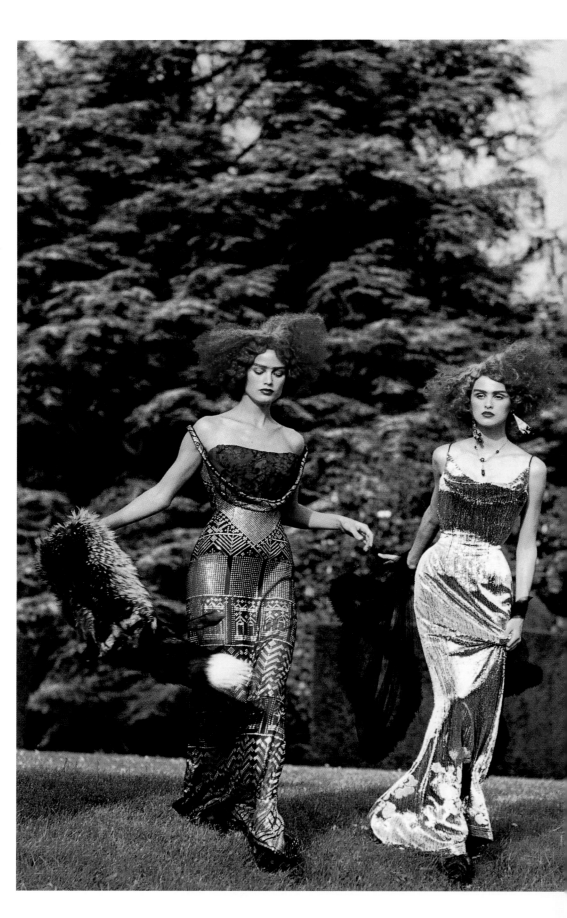

COLOR AND OPULENCE
Taken by Peter Lindbergh and published in October 1997, this picture celebrates couture's glorious excess. Dresses by Christian Dior Haute Couture.

of Chanel with strong doses of pop reference and color; Christian Lacroix burst onto the social scene with his hot-pink, satin pouf dresses; Giorgio Armani dressed trouser-suited armies of upwardly mobile businessmen and women; the Japanese designers stormed Paris with their asymmetrical, apocalyptic vision in black; Vivienne Westwood laid on skits about royalty; Calvin Klein stamped his name on the underwear of the world; Azzedine Alaïa sculpted body-conscious dresses to stretch over aerobically perfected Amazonian models; Jean-Paul Gaultier put Madonna in outrageous conical bras; Donna Karan perfected the five-piece jersey wardrobe for the executive woman on the run; Gianni Versace glorified the hedonistic excess of an explosive and flamboyant fashion era.

As always happens with excess, the opulence of the eighties was to come to an end. According to Harold Koda, curator of the Costume Institute of the Metropolitan Museum of Art, "When the economic corrections of the financial markets in 1987 occurred, these diverse stylistic strands appeared to be subsumed into a more austere sensibility. The reality, however, was that the extravagant effects of Nouvelle Society style were waning, and the subsidiary trends of fashion which had always been present became more clarified by the end of the decade. The emergence of Jil Sander and Helmut Lang on the international fashion scene, and the first collections for women and then men by Miuccia Prada at the end of the

eighties, were both harbingers of and accelerants toward the minimalist aesthetic of the 1990s."

After the markets had recovered from the ramifications of that financial shakeout, by the mid-nineties, the look and feel of "stealth wealth" crept back, first in highly expensive matte-black minimal design, and then at full throttle, in the celebration of sex and glamour when the American designer Tom Ford took over at Gucci. In the later part of the decade, fashion empires were consolidated around the buzzwords "luxury" and "brand." LVMH, the Gucci Group, and Prada became as talked about in the financial press as their stables of designers and collections and accessories were discussed by fashion spectators. Designers were stars: John Galliano at the helm of Dior, Tom Ford and his CEO Domenico de Sole at Gucci; Marc Jacobs bringing cuteness to Louis Vuitton; Alexander McQueen adding shock value to Givenchy—and on it went.

By the end of the millenium, buoyed on this surge of confidence, there was an accompanying boom in advertising, which benefited mostly the highly reputed women's magazines, as luxury-goods houses competed for attention for their clothes, shoes, and handbags.

It was in the dynamic watershed between those two decades that Anna Wintour's era at *Vogue* began.

MINIMALISM
Minimalism began to find favor in the late nineties, exemplified here by Helmut Lang in this photograph by Steven Meisel for the January 1997 issue.

CAPTIVATING THE NEW WOMAN

When Anna Wintour became editor in chief of the American edition of *Vogue*, her mission was clear. Although she had made radical and speedy editorial changes at British *Vogue* and *House and Garden*, the fine-tuning of *Vogue* needed a different touch. As she says, "You have to remember that this was a very successful magazine. There was a lot the readers liked, and no one thought it was in trouble. However, there was a feeling in the company that the magazine was a little formulaic and old-fashioned. At the time I worked very closely with Alex Liberman. My plan was to use younger girls, more energetic models, a few different photographers, a different approach to photography. I really acted more on instinct than on research, trusting my sensibility and how women were dressing at the time. I wanted to translate that into the pages of *Vogue* while still maintaining our authority."

Her first moves were to appoint Grace Coddington fashion director and to bring in André Leon Talley as creative director as well as assembling her

WINTOUR IN HER OFFICE
The new editor in chief gave the magazine a fresh look. She made fashion the centerpiece of the magazine, redefined the photographic approach, and mixed high- and low-priced clothes.

core photographers, including Steven Meisel, Bruce Weber, Herb Ritts, Ellen von Unwerth, and Arthur Elgort. The success of *Vogue* during these first years of the Wintour era rested on several cornerstones.

"I used to look at the covers of *Vogue*, and the images struck me as not only unapproachable but indistinguishable from one another," Wintour recalls. "They were all close-up head shots of overly made-up faces wearing long earrings, one the same as the next. The photographic concept was stylized and excessive. I wanted the models to have a modern look, for readers to see a cover and think, 'I could be that girl.'" Breaking with tradition, Wintour liberated the cover style to give *Vogue* a happier face, a move also calculated to give a strong reply to the challenge *Elle* magazine represented. She briefed photographers Steven Meisel, Peter Lindbergh, and Arthur Elgort to capture the liveliness and spontaneity she wanted on her covers. "It wasn't so much that the models we used were actually any younger, because with heavy hair and makeup, you can make a seventeen-year-old look forty-five. I just wanted to make them look more like themselves—the way I would see girls backstage at shows, or arriving here to see me. I wanted that approachability and attractiveness, to convey the idea that you could reach out and touch that girl, not some kind of plastic image."

A variant introduced by Wintour within the first two years of her tenure was the repeated use of the same model photographed by different photographers, a practice that reinforced the idea of the personality of the cover girl as innately bound up in the exclusive circle of *Vogue*'s world. In the late eighties, the lives of supermodels like Linda Evangelista, Christy Turlington, Cindy Crawford, Naomi Campbell, Tatjana Patitz, and Claudia Schiffer had themselves become the story of the moment. "Those girls were so fabulous for fashion and

totally reflected that time," Wintour remembers. "Linda Evangelista once remarked, 'We *are Vogue*,' and that was totally right. They helped shape the magazine and give it a character and vitality. They sold fashion, too, and we must not forget that's what we're here to do: to celebrate and sell fashion, and make that world interesting and exciting to our readers. Those girls were like movie stars. They had fabulous boyfriends, exotic lifestyles, and were photographed everywhere they went, like Angelina Jolie, Gwyneth Paltrow, or Scarlett Johansson today."

Later, *Vogue*'s cast of cover girls altered again when young Hollywood actresses began to embrace fashion with an enthusiasm their elders had rejected in the late 1980s. Movie stars became cover stars, and Wintour used the same editorial techniques to communicate the public interest they were generating. One of them was the use of multiple photographers to shoot an actress in a single issue. Nicole Kidman appeared in the September 2003 issue in sittings by Irving Penn, Craig McDean, Annie Leibovitz, and Helmut Newton. This gave the pictures a degree of freshness that Wintour found "astonishing and marvelous."

Head shots disappeared from the cover of Wintour's *Vogue*, to be replaced by images that showed what the model was wearing. This move came at the very start of her editorship, to reinforce *Vogue*'s authority as a magazine that celebrates fashion. For Wintour's debut issue in November 1988, the cover showed Israeli model Michaela Bercu in unbelted low-cut jeans and a Christian Lacroix couture top (page 251). "I thought I should have a fashion element on the cover," Wintour recalls, "and also have a girl looking believable, wearing a kind of enhanced version of the style I saw on the street. So I ran that cover, which became a memorable one. Christian Lacroix's jacket with a cross was

VOGUE

JUNE $3.00

BEST LOOKS FOR SUN, SEA, AND SHADE

fast fashion QUICK PIECES WITH IMPACT

tanning WHY WOMEN WON'T QUIT

genetic discrimination IS IT THE FUTURE?

FULL LENGTH
This photo of Linda Evangelista, taken by Patrick Demarchelier for the June 1990 issue, is an example of Wintour's new cover style.

VOGUE

AUGUST $3.00

100 GREAT DAY LOOKS

BARBARA BUSH: A NATURAL FIRST LADY

DONNA KARAN: AMERICAN STYLE AT WORK

RETIN-A: THE ANTIAGING FUTURE?

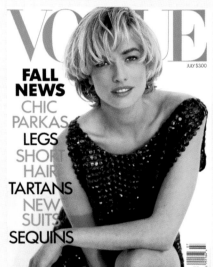

VOGUE

JULY $3.00

FALL NEWS CHIC PARKAS LEGS SHORT HAIR **TARTANS** NEW SUITS SEQUINS

SAME MODEL, DIFFERENT PHOTOGRAPHERS
The practice of using the same model on more than one cover, photographed by different photographers, was one of Wintour's innovations. Here, model Tatjana Patitz was photographed for the cover of the August 1989 issue by Peter Lindbergh and for the July 1989 issue by Herb Ritts.

paired with jeans, which had never been shown on a *Vogue* cover before. I think it became so famous because it was such a statement about the new direction of the magazine."

By hiring photographers of the caliber of Annie Leibovitz, Steven Meisel, Arthur Elgort, and Patrick Demarchelier, and by confirming the positions of Helmut Newton, Bruce Weber, Herb Ritts, and the legendary Irving Penn, the Wintour team transformed the pages of *Vogue* into a cavalcade of art, originality, and sophistication, and the magazine itself into not only an inspirational but also an educational entity. Annie Leibovitz stood out for her fantasy and strong portraiture, Meisel for his great documentation of fashion, the multifaceted Penn for his powerful images of fashion, beauty, and fitness. Newton brought with him a sensual and provocative view, Weber a narrative talent, and Ritts a spontaneous and optimistic style. Wintour also added to the variety and texture of the magazine by encouraging Mario Testino to fuse a glamorous kind of photojournalism with fashion, and Steven Klein to deliver a moody and modern edginess.

A commitment to showing clothes at various price points was reflected in the very first issue of the magazine for which Wintour was responsible. This drastically changed the stereotypical image of *Vogue* as an elitist magazine, instantly communicating a fashion message that read as younger and more informal. "I have always believed *Vogue* should include clothes of different prices," says Wintour. "We needed to show a range of what was happening that was great in every category. *Vogue* always had the philosophy that we deliver class to the masses: mass with class and class with mass. In the beginning, we showed the couture, but understood that a GAP shirt was as relevant to our reader as a Christian Lacroix one. What I loved was that fashion was becoming much more about personal interpretation and individuality. It was about finding ways to express your-

self, finding looks that were good for you personally, rather than everyone aspiring to look the same. And I wanted the pages of the magazine to reflect that."

One of Wintour's first decisions as editor in chief of *Vogue* was to energize its pages by opening up the environments of fashion sittings to include more outdoor shoots, showing models in motion and bringing a sense of context and storytelling to the pages: "I very much like photographs that involve environment and place. I love strong studio photography, too, that really shows the clothes, especially when we're introducing them as news at the beginning of the season. But basically I like to situate the image, to make thematic shoots and tell stories through a narrative." For the December 1988 issue, *Vogue* sent Linda Evangelista and Carré Otis to the beaches of the Greek island of Santorini, where Peter Lindbergh took their cover picture and shot an eighteen-page fashion story. Three months later, the German photographer Ellen von Unwerth went to Seville to shoot a ten-page story titled "All White Moves." The mood of both stories was naturalistic, without over-stylized hairdos, and with little or no makeup. "I was trying to break the traditional image," Wintour explains. "I remember a shoot we did with Claudia Schiffer without makeup, and she looked terrific. It was all part of showing real girls in real life. Of course you need the fantasy, too, but I always love a mix of styles." To this day, Wintour feels that if everything appears too perfect on the cover and the inside pages, the readers will not "connect" with the magazine. Her changes were soon noticed. "They weren't radical, but they were changes that needed to be made," Wintour says, "like bringing the age of the readers down, which we were able to do right away. *Vogue* needed fresh winds to blow through its corridors and hallways. If I have learned anything in this business, it is never to underestimate the readers, who understood the difference right away."

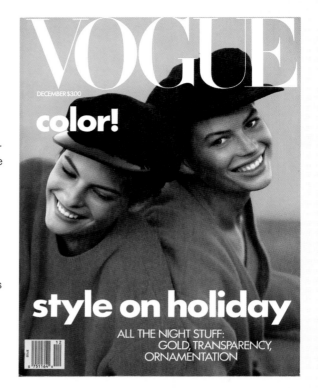

YOUNG, HAPPY, AND OUTDOORS
Shown here are Linda Evangelista and Carré Otis, photographed by Peter Lindbergh on the Greek island of Santorini for the December 1988 issue.

NATURAL WOMAN
Claudia Schiffer without makeup, wearing a robe, was photographed by Steven Meisel for the April 1993 issue.

resort to color

THERE'S A HIGHLY ORNAMENTAL
SIDE TO HOLIDAY DRESSING.
THEN THERE'S THE OTHER SIDE:
DRESSING FOR A RESORT—
BASED ON BARE SKIN, A GREAT BODY,
AND NOTHING BUT VIVID COLOR

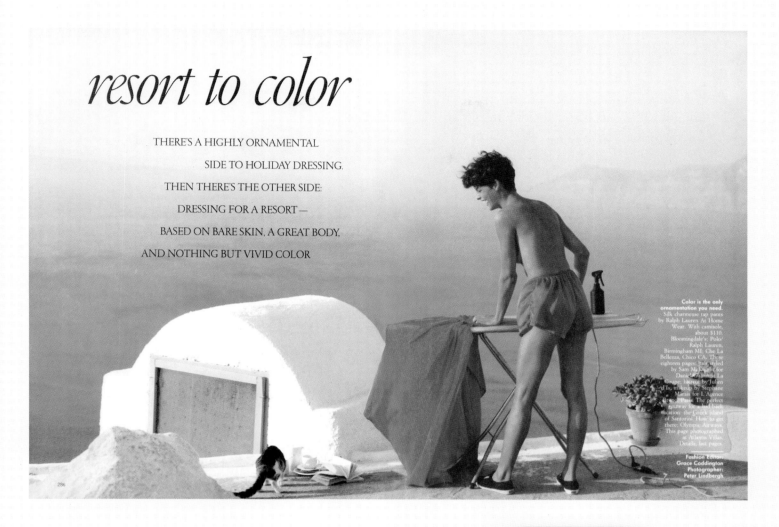

Color is the only ornamentation you need. Silk charmeuse tap pants by Ralph Lauren At Home Wear. With camisole, about $110. Bloomingdale's; Polo/Ralph Lauren, Birmingham MI; Che La Bellezza, Chico CA. These eighteen pages: hair styled by Sam McKnight for Daniel Galvin at La Coupe; hair also by Julien (T), makeup by Stephane Marais for L'Agence Beauté Paris. The perfect getaway for a laid-back vacation: the Greek island of Santorini. How to get there: Olympic Airways. This page photographed at Atlantis Villas. Details, last pages.

Fashion Editor:
Grace Coddington
Photographer:
Peter Lindbergh

olor is the news in the resort collections. Brights, verging on fluorescent, turn up in everything from shocking fuchsia to vibrant purple. The way color is worn is also new. Brights are mixed with brights instead of with black. The unorthodox result: a jubilant explosion of color. Bareness reigns. Bathing suits replace T-shirts. Thong sandals look new. Beaded necklaces substitute for bandeau tops. Bareness also comes from transparent fabric. By day, short skirts and pants show up in chiffon; swimsuits have the sheerest of tops. Worn in an offhand way–with flat shoes and little or no jewelry–transparency has a softer, more appealing look.

Maximum exposure calls for maximum protection—from one of the highest SPFs available. Opposite: Elizabeth Arden's Superblock Cream 34. Craft Caravan necklaces. Over the shoulder: Mary McFadden's satin skirt. About $900. Bloomingdale's; Nan Duskin; Balliet's. Below: the island uniform is the bathing suit. The latest version? Liza Bruce's T-back pink maillot. About $118. Barneys New York; Georgina, Hewlett NY; Fred Segal, Melrose CA. Details, last pages.

A CELEBRITY IN HER OWN WORLD

When asked why her choice of model for *Vogue*'s May 1989 cover was Madonna, Anna Wintour explains: "I picked her because she was the girl of the moment, not so much because she was a celebrity but because she was a fashion icon. In the photos we wanted to illustrate Madonna's sense of fashion and show her in her own world. The production was representative of the visual-editorial course we wanted to follow with our magazine, to show women in their own environments."

Madonna appeared on the cover with her back to the camera, wearing a bathing suit, smiling over her left shoulder, photographed by Patrick Demarchelier. Inside—and this was the remarkable innovation—under the title "Madonna Holds Court," the story was spread over nine pages, alternating fashion shots with views of her newly acquired mansion in the Hollywood Hills: exteriors, interiors, furnishings. André Leon Talley described her personal wardrobe: "Madonna is definitely into basic black. Her closets are full of black coats, stacks of black lacy French corsets, black kid gloves. Even her three-piece luggage set is black."

In the shoot, Madonna wore her own cut-off jeans, ate popcorn—her favorite snack—and posed in clothes and accessories from Patrick Kelly, Yves Saint Laurent, and, in one photo, a Christian Lacroix jacket edged in silk flowers which revealed a glimpse of nipple. It was quite obvious that Anna Wintour's idea was not to project fashion onto Madonna passively but to portray her as a style leader with an individual and personal way of pulling together high fashion, personal favorites, and inexpensive trinkets. *Vogue* positioned her as "both a creative artist and a strong executive of a multimillionaire corporation," describing her influence as an inspiration for millions of women through her edgy "high and low" fashion. Alternating fashion with eighteenth-century furniture and artworks by Léger and John Kirby, the article achieved its objective of showing "the private woman behind the public merchandise," as the caption put it. This focus, merging exclusive-access reportage with fashion, underscored another of Wintour's editorial directions.

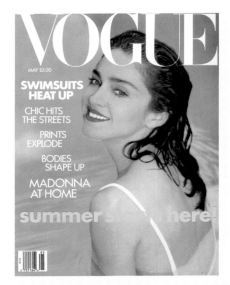

MADONNA AT HOME
For the May 1989 cover and feature story, Anna Wintour chose Madonna as a model, shown at right wearing Patrick Kelly Couture. Photographed by Patrick Demarchelier with interiors shot by Oberto Gili.

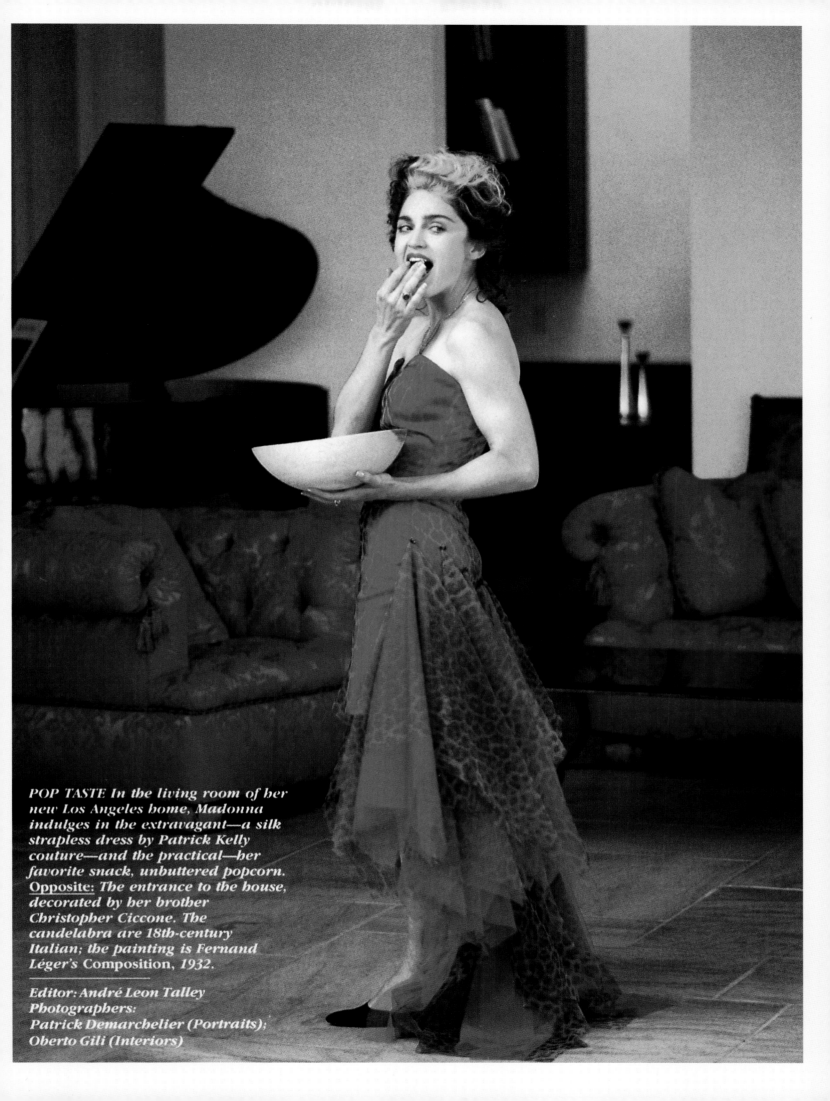

POP TASTE In the living room of her new Los Angeles home, Madonna indulges in the extravagant—a silk strapless dress by Patrick Kelly couture—and the practical—her favorite snack, unbuttered popcorn. <u>Opposite:</u> *The entrance to the house, decorated by her brother Christopher Ciccone. The candelabra are 18th-century Italian; the painting is Fernand Léger's Composition, 1932.*

Editor: André Leon Talley
Photographers:
Patrick Demarchelier (Portraits);
Oberto Gili (Interiors)

the total lady

Proper suits smattered with
sequins ... neat-as-a-pin dresses paired
with fishnets and fur ... fall's
polished looks mind their manners
(with a wink and a smile).
Photographed by Steven Klein.

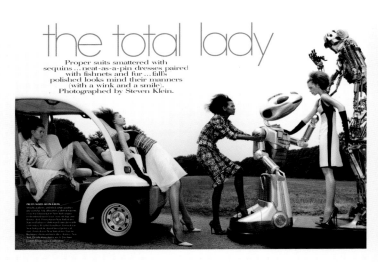

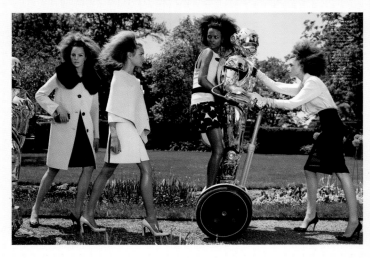

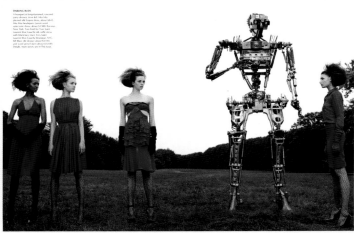

FASHION WITH ROBOTS

The Style Essay tells a story and shows seasonal fashions or trends. This story in the September 2003 issue was photographed by Steven Klein, who matched robots with models wearing, at left, fashions by Donna Karan New York, Narciso Rodriguez, Miu Miu, Lanvin, Tom Ford for Yves Saint Laurent Rive Gauche, Bill Blass, Celine by Michael Kors, Louis Vuitton, and St. John Knits. In the photograph below, the model at left is in a Behnaz Sarafpour gold brocade top and skirt, and the model at right wears an Oscar de la Renta dress.

Just as the photo-essay that *Life* magazine instituted in its day is studied at schools of photography, art, and fashion, so the tradition of the fashion narrative that has become a unique and central feature of Anna Wintour's *Vogue* deserves attention. This thematic narrative, designed to generate a sense of surprise and glamour, is framed as an epic visual fantasy and often carries a subtext of commentary relating to a cultural event, mood, or celebration. It aims to go beyond the mere task of transmitting fashion

news to captivate the reader by means of a story in which clothing, background, and narrative all come together with great visual and emotional impact.

The earliest prototypes of this kind of *Vogue* production can be seen in British *Vogue* between 1968 and 1986 under the editorship of Beatrix Miller. At that time the British edition of the magazine was hiring talents of the stature of Helmut Newton, Norman Parkinson, Guy Bourdin, and

DÉJEUNER SUR L'HERBE
Staid brocade sheds its ladies-who-lunch image when tailored low and tight. *From left:* Behnaz Sarafpour gold brocade top (about $690) and skirt (about $515). Barneys New York. Mikimoto (*top*) and Cartier South Sea pearls. Oscar de la Renta claret silk belted dress. Neiman Marcus. Martin Katz white-gold-and-diamond earrings. Details, more stores, see In This Issue.

Piano Lesson

Call it a case of fashion following film:
One of the most acclaimed movies of late,
The Piano, had all of Europe talking at precisely
the time designers were sketching their
spring collections. Now its influence comes
to light as evening dresses sail into more
romantic territory, echoing the full, classically
feminine silhouette seen on the screen.
Photographed by Ellen Von Unwerth

jean seberg
Breathless made actress Jean Seberg a star in 1959; here she's the inspiration for Christy Turlington

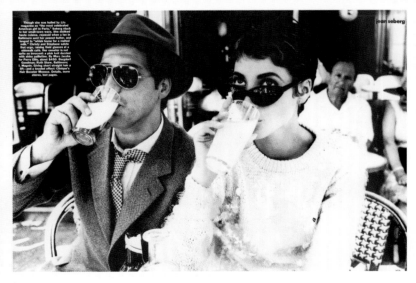

Though she was hailed by *Life* magazine as "the most celebrated American girl in Paris," Seberg stuck to her small-town ways. She disliked haute cuisine, rejoiced when a fan in Cannes sent her peanut butter, and longed to "whisk home for a malted milk." Christy and Stephane salute that urge, raising their glasses at a sidewalk café. Her sweater is not quite as innocent: a pink knit dazzled with shiny paillettes. By Marc Jacobs for Perry Ellis, about $780. Raglan Goodman, Bloomingdale's. Giving short straight hair a lift—and a tousled effect: Clinique's Hair Booster Mousse. Details, more stores, last pages.

jean seberg

FILM-INSPIRED FASHION
The larger picture, part of a Style Essay shot by Ellen von Unwerth for the March 1994 issue, is based on Jane Campion's highly acclaimed film *The Piano,* whose costumes influenced the spring collections of that year. Featured here is a John Galliano silk top and a layer of his grand black wool skirts. The two October 1990 pictures (left), by the same photographer, show Christy Turlington and Stéphane Ferrara playing Jean Seberg's and Jean-Paul Belmondo's parts in Jean Luc Godard's *Breathless.*

(OVERLEAF)
FLIGHT OF FANCY
This closing image of a twenty-page March 1998 fashion narrative was photographed by Ellen von Unwerth in San Miguel de Allende, Mexico, where old-world charm meets exotic romanticism and accentuates the fashion, here Christian Lacroix.

David Bailey. It was Miller who first insisted on imprinting a journalistic outlook on the coverage of fashion, and it was she who used the magazine as a stage for the first tryouts of the "style essay."

Early in Miller's editorship, in 1969, a young woman named Pamela Rosalind Grace Coddington joined British *Vogue*'s fashion department. Already well established as a model, Grace Coddington was gifted with an instinct that enabled her to change her look overnight, often ahead of fashion. In time, she would become creative director of the American edition of *Vogue* and the main producer of the Style Essay. It was she who would make the genre international and would develop its new variations.

Born in Wales, Coddington went to London to further her modeling ambitions and was first photographed for *Vogue* by Lord Snowdon. At age twenty-nine she became junior editor at British *Vogue* and worked there for nineteen years, producing an enormous quantity of thematic fashion spreads. She then relocated across the Atlantic to New York and briefly became design director for Calvin Klein. Although this was a position of tremendous influence and power within the industry, she did not hesitate to leave it when in 1988 Anna Wintour offered her a position at American *Vogue*, first as fashion director and later as creative director.

Since then, Coddington has been in charge of most of the magazine's Style Essays, which have become regular landmarks in the magazine's year. Coddington is considered the most experienced, knowledgeable, and innovative fashion editor working today. "She has the eye and the instinct to know which look could inspire," says Wintour, "and an uncanny ability to take the seed of an idea and turn it into a famous narrative. . . . She always sees fashion in terms of stories, of an amusingly romantic bent. . . . Little wonder all the photographers want to work with her: She inspires them and challenges them like no one else."

For Coddington, the reasons that led her to develop this narrative technique for the showing of fashion are intimately related to her way of seeing life: "I am a very romantic person, and in British *Vogue* you were allowed to be very romantic. I like a narrative outdoors, but I also like the studio. It's fascinating to be able to do both. . . . I hate to show just loose, unconnected pieces of clothing. I'd rather show them linked together through a theme or a story. It's more fun, and readers remember the piece better at the time of choosing their own clothes."

Coddington developed two distinct types of Style Essay in two different decades. During the 1970s Coddington and Miller promoted fashion travelogues (which Diana Vreeland had introduced in the previous decade at American *Vogue*) photographed on trips abroad to show clothes in different locations. Coddington produced some of them with Norman Parkinson and others with David Bailey, developing ideas for thematic stories in the Soviet Union and China, Barbados and the Indian Ocean. The other kind of Style Essay emerged in the 1980s when, with photographers Bruce Weber and Ellen von Unwerth, Coddington conceived a new way to show fashion through epic or pastoral tales and the evocation of movies.

The Style Essay refined and perfected itself over the years, influenced by the vision of each photographer. With von Unwerth, for example, in the 1990s, Coddington evoked the fashions of movies such as Jean-Luc Godard's *Breathless* or Jane Campion's *The Piano*. Others were inspired by fairy tales, novels, or shows. For one story, says Coddington, "we chose Ellen to do an essay on the Amish, an idea which had come up for several reasons. In the early nineties, fashion seemed to be divided into two camps: the opulent and the austere. For a shoot on the designers whose clothes fit the latter description—Helmut Lang, Jil Sander, Calvin Klein—nothing seemed to capture the homespun spirit quite like the Amish. We even found an Amish family who allowed us to 'fashionize' their farm in Pennsylvania. As they went about their usual daily chores, they let us use whatever we needed, including a team of mules (and their son, whose youth allowed him to be photographed) for a shot in the field. Far from being suspicious of outsiders, they even invited us to dinner!"

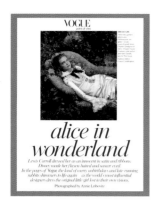

VOGUE
point of view

alice in
wonderland

*Lewis Carroll dressed her as an innocent in satin and ribbons.
Disney made her flaxen haired and saucer eyed.
In the pages of Vogue the kind of merry unbirthdays and late-running
rabbits shimmers to life again as the world's most influential
designers dress the original little girl lost in their own visions.
Photographed by Annie Leibovitz.*

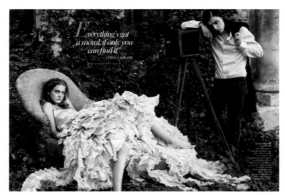

*'Everything's got
a moral, if only you
can find it'*
LEWIS CARROLL

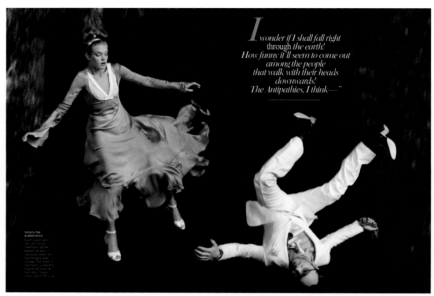

*'I wonder if I shall fall right
through the earth!
How funny it'll seem to come out
among the people
that walk with their heads
downwards!
The Antipathies, I think—'*

DOWN THE RABBIT HOLE

In its December issue *Vogue* usually features
a thematic fashion essay based on a fairy tale
or story. *Alice in Wonderland*, photographed
by Annie Leibovitz, was published in 2003.
Natalia Vodianova was cast as Alice with
leading designers as various characters in the
story. In the top left photograph "Alice" wears
a Chanel Haute Couture satin jacket and skirt,
and at top right a Rochas dress specially
designed by Olivier Theyskens, who is cast as
Lewis Carroll. At right she wears Tom Ford for
Yves Saint Laurent Rive Gauche, with Tom
Ford as the White Rabbit. In the photograph
below the dress is by the Helmut Lang made-
to-measure studio.

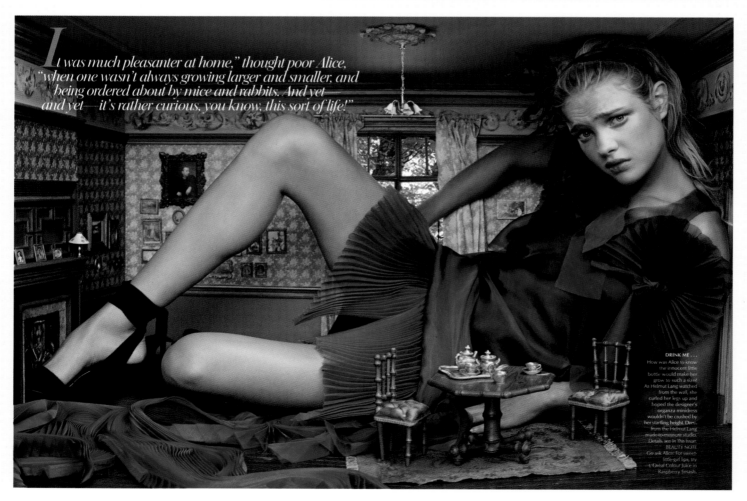

*'It was much pleasanter at home," thought poor Alice,
"when one wasn't always growing larger and smaller, and
being ordered about by mice and rabbits. And yet—
and yet—it's rather curious, you know, this sort of life!'*

DRINK ME . . .

How was Alice to know
the innocent little
bottle would make her
grow to such a size?
As Helmut Lang watched
from the wall, she
curled her legs up and
hoped the designer's
organza minidress
wouldn't be crushed by
her startling height. Dress
from the Helmut Lang
made-to-measure studio.
Details, see In This Issue.
BEAUTY NOTE
Go ask Alice for sweet
little-girl lips, try
L'Oréal Colour Juice in
Raspberry Smash.

IN WONDERLAND
In the larger photograph below, "Alice" wears a chiffon minidress by Marc Jacobs, who's posing as the Caterpillar. At bottom left, she wears Chanel Haute Couture, with Karl Lagerfeld as himself, and at right, a dress by Gaultier Paris with Jean Paul Gaultier as the Cheshire Cat.

The idea for a Style Essay, Coddington explains, may be hers or may come from Wintour, from the photographer, or from an editor: "It is really not important who comes up with an idea first." But for Coddington, the opinion, participation, and influence of the photographers in the conception and evolution of an essay is crucial. "When I did 'Snow White and the Seven Dwarfs' with Bruce Weber for a Christmas issue, Bruce imagined a Snow White who was nothing like what her name literally implied. We hired the black model Beverly Peele for the role, and cast the rapper group Another Bad Creation as the seven dwarfs, and singer Aretha Franklin, dressed in Chanel, as the Wicked Queen. Another year, I did *Alice in Wonderland* with photographer Annie Leibovitz. It was Wintour's idea to have all the designers play a part in the story. I had all designers make dresses in blue because in my head Alice in Wonderland always wore blue dresses. Annie and I cast the various designers in their roles. One problem

The Caterpillar and Alice looked at each other for some time in silence: At last the Caterpillar took the hookah out of its mouth, and addressed her in a languid, sleepy voice. "Who are you?" said the Caterpillar

As visiting royal Karl Lagerfeld looked on, Alice caught the baby, which grunted violently. "If you're going to turn into a pig," she declared, "I'll have nothing more to do with you"

We're all mad here. I'm mad, you're mad. "How do you know I'm mad?" said Alice. "You must be," said the Cat, "or you wouldn't have come here"

*I know what you're
thinking about,"
said Tweedledum,
"but it isn't so, nohow."
"Contrariwise,"
continued Tweedledee,
"if it was so, it might be;
and if it were so,
it would be;
but as it isn't, it ain't.
That's logic."*

was that Karl Lagerfeld did not want to be the White Rabbit. He said he wanted to play himself, so we cheated a little bit there, and we agreed to let him do so, but it later turned out that Tom Ford was eager to play the rabbit, and we were thrilled at the news."

Fairy tales, epic narratives including cowboys, pastoral fashions in the countryside, hit movies from Hollywood, fashion fantasies such as *The Wizard of Oz*, Broadway shows, or futuristic stories about robots—all these are subjects that, touched by the magic wand of the Style Essay, turn fashion into a cultural phenomenon in which clothes become intertwined with photography, art, literature, or technology. The only limit is the imagination.

*"Your hair wants cutting," said the Hatter.
He had been looking at Alice for some time with great
curiosity. "You should learn not to make personal
remarks," Alice said with some severity. "It's very rude."*

MODEL DESIGNERS
At top left, opposite, "Alice" wears a dress by Viktor & Rolf with the designers as Tweedledee and Tweedledum. In the bottom photograph she wears a Christian Lacroix Haute Couture dress, with Stephen Jones in a custom-made hat and Lacroix as the March Hare. On this page she's in Dior Haute Couture by John Galliano, who is cast as the Queen of Hearts; in Versace, with Rupert Everett and Donatella Versace as the Gryphon; and in the bottom photograph she's in Balenciaga by Nicolas Ghesquière.

Oh, Kitty! How nice it would be if we could only get through into Looking-glass House! I'm sure it's got, oh! such beautiful things in it!"

THROUGH THE LOOKING GLASS
Wrapped in ocean-blue Balenciaga couture, Alice perched on the mantel, longing to escape into the shadow world, as her black kitty purred nearby. Balenciaga by Nicolas Ghesquière crystal-pleated silk chiffon dress and gray ankle boots. ShotCon location at the Château de Corbeil-Cerf. In this story: hair, Julien d'Ys/Island d'Ys; makeup, Gucci Westman. Set design by Mary Howard. Prop fabrication by Jean-Hugues de Chatillon. Details, see In This Issue.

271

FROM SUPERMODELS
TO CELEBRITIES

Anna Wintour's editorship has seen many phases and transitions in fashion, of which the first and perhaps the most dramatic was the appearance, rise, boom, and decline of the supermodels. The term *supermodel*, coined in the 1940s by Clyde Matthew Dessner, the owner of a small modeling agency, was used to describe the star faces of the 1960s—Twiggy, Verushka, Jean Shrimpton, Penelope Tree, Lauren Hutton—and later Patti Hansen, Roseanne Vela, Iman, and Brooke Shields. However, none of them attained the fame and worldwide renown bestowed upon Linda Evangelista, Christy Turlington, Cindy Crawford, Naomi Campbell, Tatjana Patitz, Stephanie Seymour, Claudia Schiffer, Amber Valletta, Yasmeen Ghauri, and Karen Mulder in the late 1980s and early 1990s.

These models burst out beyond the pages of the magazines. Many became the faces of cosmetics brands and perfumes; had their own television programs and physical-fitness videos and their own lines of lingerie. Their love lives attracted interest of Hollywood proportions and featured a changing cast of movie stars, musicians, and even a boxer (Naomi Campbell dated Mike Tyson) and a magician (Claudia Schiffer was engaged to David Copperfield). Their lives, activities, influences, and images were the subjects of all types of sociological and historical analysis. In his book *Model*, Michael Gross wrote of the supermodels:

"They were the visual projection of the dream of millions, the contemporary repositories of glamour and power, sought after and celebrated as the legendary movie stars of Hollywood's heyday. The supermodels were icons, cultural emblems of an industrial society that is ever more accomplished in the replication and use of selling imagery. Though they exist in an apparently superficial milieu, those models were metaphors for matters of cultural consequence like commerce,

TRIBUTE
The cover of the November 1999 issue, photographed by Annie Leibovitz, celebrating the millennium, paid homage to the leading models from the 1970s through the year 2000. From left to right: Kate Moss, Gisele Bündchen, Lauren Hutton, Iman, Naomi Campbell, Stephanie Seymour, Amber Valletta, Christy Turlington, Claudia Schiffer, Lisa Taylor, Paulina Porizkova, Carolyn Murphy, and Patti Hansen.

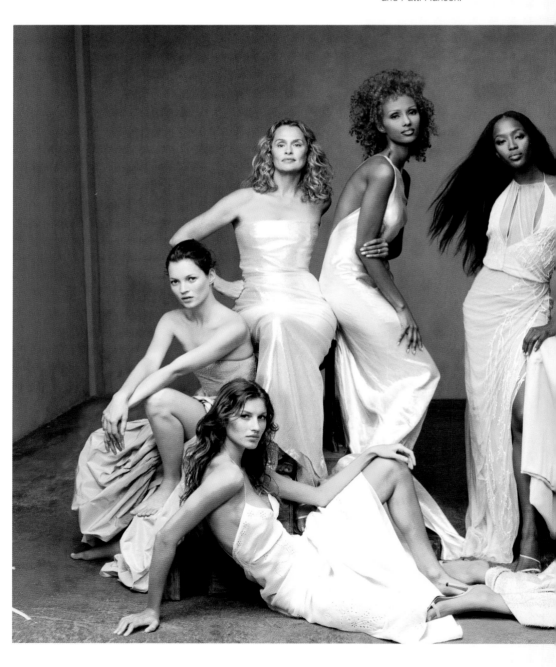

sexuality and aesthetics." In Alex Kuczynski's article "Trading On Hollywood Magic: Celebrities Push Models Off Magazine Covers," published in the January 20, 1999, edition of the *New York Times*, the author Leo Braudy is quoted as saying, "They are ego ideals and body ideals for consumers. Hardly anyone thinks they can look like a supermodel, whereas a movie star, as unrealistic as it sounds, offers some sort of attainability."

Vogue celebrated and cultivated the phenomenon as a central part of its culture of the time, gathering ten supermodels for the April 1992 cover. The cover of the hundredth anniver-sary issue in November 1999 reached further back, assembling thirteen great supermodels spanning about three decades. The photograph, taken by Annie Leibovitz, was titled "Modern Muses." The accompanying article began: "During the past four decades, supermodels have become part of our collective unconscious, practically without uttering a word."

During the 1990s the phenomenon of the supermodels began to decline, giving way, little by little, to a new trend: celebrities. The magazine *In Style*, which premiered in 1993, had much to do with this turn of events, as it started to place its main focus on the fashions, beauty, and lifestyles of

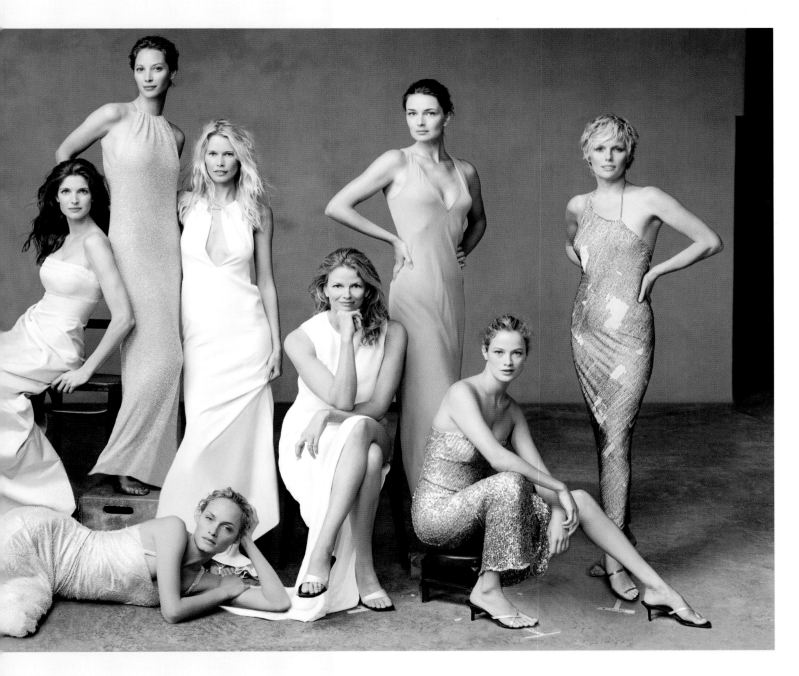

CELEBRITY MODELS
In the late 1980s, supermodels gained celebrity status. Some dated celebrities; Naomi Campbell is shown above with boxer Mike Tyson, photographed by Bruce Weber for the December 1989 issue. At left, Linda Evangelista, a top celebrity model, photographed by Steven Meisel for the September 2001 issue, modeled a Christian Dior fox-hunting cap.

the rich and famous. Women's magazines, which until then had only sporadically written about celebrities, began to cover them more intensively, to the point of making them into icons of fashion, capable of replacing models in photo shoots. The new trend exploded and, as had happened in the previous decade with the supermodels, experts tried to interpret the phenomenon. "Neil Gabler, a cultural historian who has written widely about the phenomenon of celebrity, said that the models had disappeared from the covers of women's magazines because people grew bored with the one-dimensional nature of the models, who offer no substance, just beauty. Celebrities, he said, at least offer the illusion of substance," wrote Kuczynski.

Vogue was one of the first magazines to capture and interpret the change. In 1998 four of the magazine's twelve covers were of celebrities, among them Oprah Winfrey and Hillary Clinton. For Wintour, the change in emphasis was a calculated engagement with the changing socioeconomic times and the mindset of the reader. The move toward using "real" people instead of models began, she says, "when the stock market broke in the early nineties. It was pretty grim. There wasn't a lot

of disposable cash around, and fashion went black, dour, and minimal. It was happening, and we had to deal with it." The change was fueled by a journalistic perception that a shift was taking place in who was interesting in the public eye: "Don't forget that when we were covering all these supermodels they were personalities, stars in their own right. They were getting as much coverage then as movie stars do today—they *were* the celebrities of that time. What happened later was that those celebrities were superseded by other types of celebrities. Modeling changed, too. Except for Gisele and Kate Moss, there weren't girls of that caliber who could capture the world's imagination like the previous ones. If we could find them, I would happily develop them."

The trend progressed until in 2003 celebrities were on all twelve of the year's covers. According to Sally Singer, fashion news/features director at *Vogue*, "Both the fashion editors and the designers began to prefer actresses to models, because the readers attach more value to women who walk and talk and do things than to those who are merely photographed smiling all the time."

POWER, SHAPE, AND AGE:
A TARGET FOR ALL WOMEN

"What is it that all women have in common?" the *Vogue* editorial team asked itself at one of the strategy meetings that are held, away from the office headquarters, to examine and improve the magazine. "The question of how to dress at different ages, and how to make the best of one's figure, was the general reaction." These subjects had often been touched on in *Vogue* articles, but now at the start of the millennium the idea arose to publish two special editions a year, one devoted to each theme. "It all began as an editorial change," Wintour explains. "It had nothing to do with publicity pressures or market research or focus groups." After the meeting, it was editor Sally Singer who proposed the name "Age" for one of the issues, and Wintour who gave the name "Shape" to the other. "It was an editorial attempt to address all women, with no exceptions," said Wintour. "We wanted to tell them about fashion in an attractive and accessible way, and make them understand that *Vogue* was there for everyone. I don't think that we had consciously been excluding anyone, but perhaps until then we had not been addressing these issues so openly."

The first year of the new century would also provide a test run for the special issue themed "Power," the idea for which had emerged as an article titled "Corporate Chic" published in the August 2000 issue of *Vogue*. The text tackled the need to find the right look and clothes for women in any profession or job, emphasizing that "modern executive women no longer tolerate anything less than a stylish wardrobe that is as personal as it is sophisticated."

The special "Power" issue debuted in March 2001. On the cover the actress Penélope Cruz, covering her bare breasts with her crossed arms, represented "The Power of Beauty." Inside, the articles explored other kinds of power and the personalities that embodied it: Hillary Clinton in politics and government, the tennis-playing sisters Serena and Venus Williams in the field of sports, Jane Fonda as a symbol of willpower, Jacqueline Kennedy as the power of a legend, and Camilla Parker Bowles as the power behind the British throne. "The issue coincided with a moment in fashion when everything was about strong women," Wintour explains. "That's why we decided to devote an entire issue to the idea of Power. It was so successful that we went on to repeat it."

The first special issue titled "Age" appeared in August 2001 with model Amber Valletta on the cover, photographed by Steven Meisel, and the cover line "What to Wear from 17 to 80." Wintour's "Letter from the Editor" said the novelist Judith Krantz had written to ask why women of her generation, who loved clothes and shopping, generally came out of the stores empty-handed. Besides giving Krantz the issue's "Upfront" column to allow her to expand on the subject, Wintour answered her question: "The new equality has obscured an inevitable truth: that an adolescent 17-year-old must dress differently from a 70-year-old woman. That's why we have chosen women of all generations whose style says something of the wisdom and the pleasure of accepting one's years and learning how to carry them with style."

Starting from the tenet that, both for young women and for those of a certain age, fashion is less related to what the manuals say than to refinement, imagination, and the knowledge of what works best for them, *Vogue* selected six women, from teenager Elizabeth Jagger to Sigourney Weaver for the fifties age group and decorator Mica Ertegün for the over-sixties.

THE POWER OF BEAUTY
The special "Power" issue debuted in March 2001 and included model Gisele Bündchen, photographed by Steven Klein against the backdrop of a Mack truck wearing a leather bra top and kilt by Azzedine Alaïa.

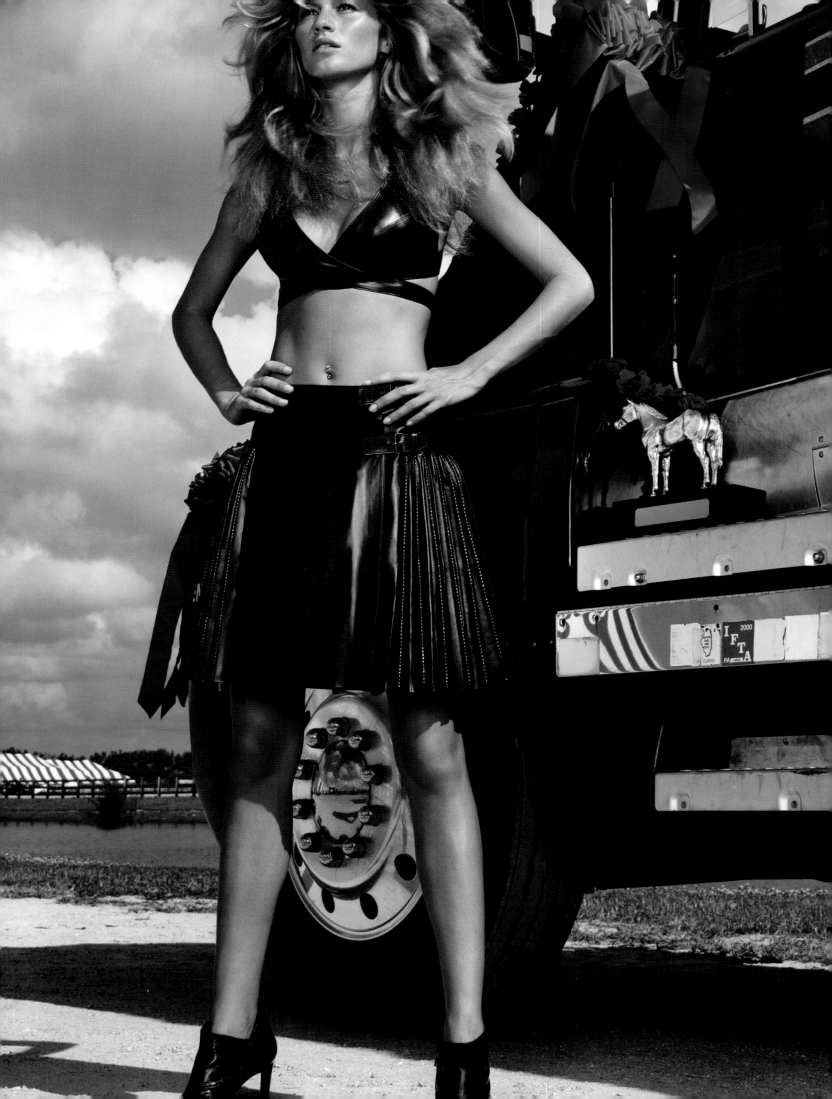

FASHION FOR ALL SHAPES
The special "Shape" issue first came out in April 2002 with Angelina Jolie on the cover (left), photographed by Annie Leibovitz. This and later issues on the subject (below, pages from the April 2006 issue photographed by Patrick Demarchelier) have been devoted to women of all body types.

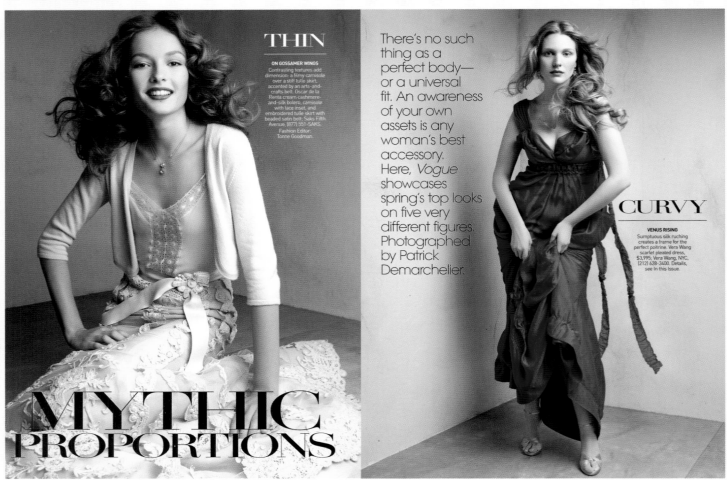

THIN

ON GOSSAMER WINGS
Contrasting textures add dimension: a filmy camisole over a stiff tulle skirt, accented by an arts-and-crafts belt. Oscar de la Renta cream cashmere-and-silk bolero, camisole with lace inset, and embroidered tulle skirt with beaded satin belt; Saks Fifth Avenue, (877) 551-SAKS. Fashion Editor: Tonne Goodman.

MYTHIC PROPORTIONS

There's no such thing as a perfect body—or a universal fit. An awareness of your own assets is any woman's best accessory. Here, *Vogue* showcases spring's top looks on five very different figures. Photographed by Patrick Demarchelier.

CURVY

VENUS RISING
Sumptuous silk ruching creates a frame for the perfect poitrine. Vera Wang scarlet pleated dress, $3,995; Vera Wang, NYC, (212) 628-3400. Details, see In this Issue.

The third of the regular special issues, "Shape," first appeared in April 2002 with actress Angelina Jolie on the cover, photographed by Annie Leibovitz. It was announced by the cover line "What to Wear When a Woman is Tall, Short, Slim, Curvaceous, Athletic or Pregnant." In her "Letter from the Editor," Anna Wintour said that with this issue "we celebrate those who dress well given the blessings and the restrictions with which Nature has endowed them."

The reaction of readers has been overwhelmingly positive, turning the issue for August—traditionally a month

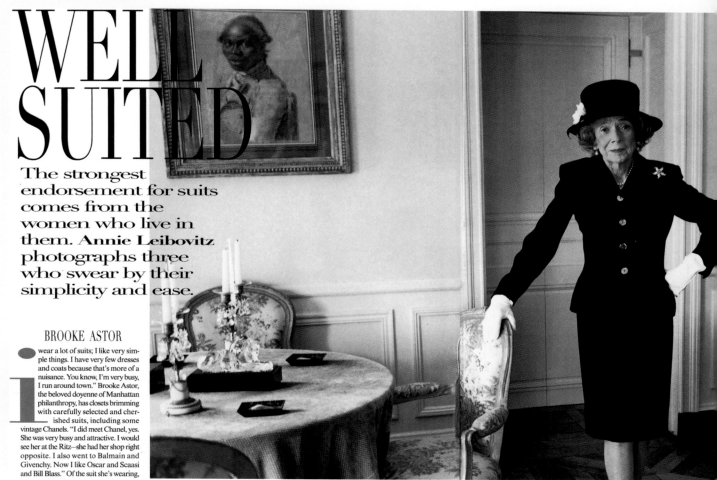

WELL SUITED

The strongest endorsement for suits comes from the women who live in them. Annie Leibovitz photographs three who swear by their simplicity and ease.

BROOKE ASTOR

"I wear a lot of suits; I like very simple things. I have very few dresses and coats because that's more of a nuisance. You know, I'm very busy, I run around town." Brooke Astor, the beloved doyenne of Manhattan philanthropy, has closets brimming with carefully selected and cherished suits, including some vintage Chanels. "I did meet Chanel, yes. She was very busy and attractive. I would see her at the Ritz—she had her shop right opposite. I also went to Balmain and Givenchy. Now I like Oscar and Scaasi and Bill Blass." Of the suit she's wearing,

of lower magazine sales—into one of *Vogue*'s biggest sellers, as readers avidly consume the "Age" issue.

"The readership of these special issues is extraordinary and has benefited advertising. The 'Shape' and 'Age' issues are a way of demonstrating to advertisers that the perception of *Vogue* being unrealistic and inaccessible is not true. They provide the appropriateness and opportunity to show a woman at her best regardless of her age," says vice-president and publisher Tom Florio. "Something similar happens with 'Shape': it drives home what is very much at the core

of *Vogue*, which is individuality, how to be your own best self. Other magazines, when they talk about shape, are talking about weight; they constantly put it in the context of what's wrong with you, and what you need to change. *Vogue* is telling them that whether you're short, tall, round, or pregnant, here's a great look for you. These issues are about empowerment, not about deficiencies."

THE *VOGUE* WORLD UNDER THE NEWHOUSE EYE

S. I. Newhouse Jr., chairman and co-owner of *Vogue*'s parent company, Advance Publications, occupies one of the most influential positions in American publishing today. An active, hands-on presence at the company who prefers to dress in a casual sweatshirt and pants to formal business attire, he arrives at Condé Nast headquarters at five-thirty every morning. From his eleventh-floor office suite, seventy-eight-year-old Newhouse spoke about *Vogue* present, past, and future as the magazine faces up to the challenges of the competitive publishing market in the new century.

In a magazine that is so dependent on advertising, how do you keep the balance between principles and interest?

To say that *Vogue* is advertising-oriented is a little bit of an overstatement. Actually the revenue from subscribers is enormous, and the importance of *Vogue* is measured by the strength of its circulation and by the fact that subscribers are ready to pay a great deal of money for the magazine; it also has a large single-copy sale. This is not purely an advertising vehicle. It carries about 2,800 to 3,200 ad pages a year, with fashion and beauty being the largest categories and then luxury goods—watches and motor and travel. There is a distinct line drawn between edit and advertising. Many fashion people wish they were covered in greater depth, or covered at all. On the other hand, many people who don't advertise receive a great deal of attention from *Vogue*. And also there are many people who do advertise and who do receive a lot of attention. There are all three categories and this has always been the case.

How do you see *Vogue*'s competition today? Do you agree with those who say that, besides competing with other women's magazines, *Vogue* also competes with *Vanity Fair*, an in-house magazine that carries no fashion?

I must admit that *In Style* is a very healthy competitor. It's a strong title, but it does not have the stature of *Vogue* nor the influence. *Harper's Bazaar* is now a weak title. *Elle* is quite aggressive and successful, but not as much as *Vogue* and certainly not as much as *In Style*. In-house now, it is true that *VF* is a strong title: It carries 2,200 pages of advertising a year, it has about the same circulation as *Vogue*, but rarely covers fashion. But it still appeals to the luxury and fashion and some beauty advertisers. In fact, it's seldom in competition with *Vogue*. I think that having two magazines in the same area helps rather than hurts *Vogue*. It's not only healthy but mechanically feasible because people would buy both of them. Editorially, though, that's a different matter. Yes, there is competition for celebrities, but

the fact is that the content is completely different. The competition does not affect any of them. They've found a good way of coexisting.

During your years at the company, you have worked with four *Vogue* editors in chief: Jessica Daves, Diana Vreeland, Grace Mirabella, and Anna Wintour. How would you describe each of these periods from an editorial point of view? In what ways are they similar or different?

Daves was a character: She always wore a hat in the office and was linked with the founding of *Vogue*. Vreeland was quite an extraordinary woman, perhaps modeled herself after Chanel, a character in herself and her own way. She had impulses and inspirations, and one never knew what was going to happen. She was a creature of mood and temperament, quite exceptional. But *Vogue* was very special and didn't start to increase its circulation until Diana retired, to put it in the most generous way possible. Grace Mirabella and, importantly, Alex

Liberman during their era—most of the seventies and eighties—made *Vogue* grow from 450,000 to one million readers, and the foundations of modern *Vogue* were laid primarily by Alex. In the late eighties, Alex hired Anna Wintour as creative director, and she then became editor in chief of both British *Vogue* and *House and Garden* before becoming editor in chief of American *Vogue*. At that point Alex started to spend less time at the magazine. James Truman was appointed editorial director but never had any contact or influence on *Vogue*. Anna took over at a time when Alex was in decline for physical reasons, and eventually he retired and there was no editorial director. Anna was really the first editor in chief who came in and was on her own, so to speak. Anna is quite brilliant and picked up confidence as she went along. *Vogue* has never fallen into the formulaic approach that other magazines have taken. There is something fresh and thought-out in every issue of *Vogue*. The expected is wonderfully combined with the surprise in her. The feature contents and the pre-

sentation of fashion have changed. Anna has managed all this by keeping an important eye on the opportunities for *Vogue* to work in fashion itself, encouraging young up-and-coming designers, encouraging the Costume Institute at the Met, being sensitive to our readers, looking for ways to extend the *Vogue* name—*Teen Vogue* being one, and *Men's Vogue* another. Over the years, *Vogue* has flourished and expanded its scope. Anna is a unique combination of all the elements of all the editors and the uniqueness of her personality. Contemporary *Vogue* is totally her creation. More than at other publishing companies, we have a tradition at Condé Nast of strong editors. Anna epitomizes the strong editor that we like to have in this company.

How do you view *Vogue*, as a witness or an active participant in the culture of fashion?

It has changed with its editors. Under Daves it was very much a witness. Under Diana it was very much a fashion bible—when she thought red, the magazine was full of red. Under Grace Mirabella it was more of a witness again, and under Anna it's definitely both. She combines the two ideas: reporting what's out there and acting as a forecast of what will be. Anna is ahead of the wave. *Vogue* has maintained over the years the intention of exploring the coverage of ideas and endorsing young designers.

Is *Vogue* more interested in changing or challenging the prevailing image of women in an era, or does it simply try to conform to it?

Vogue reports on women who represent the highest standards. The reportage does not come from nowhere. These are women who come to our attention for a number of reasons: women of achievement, women who are particularly attractive. The best example of this is the "Age" issue, where the magazine embraces women of every age. *Vogue* looks for the very best, and it becomes an aspirational magazine. It's something for readers to aspire to: lifestyles, ways of decorating, ways of conducting oneself.

Vogue is actively selecting people we think represent role models.

Some editors have told us that one of the philosophical principles at *Vogue* is to "take class to the mass and mass to the class." Does this principle exist, and what is it based on?

I think there are always the ideas of street becoming fashion and of fashion becoming broadly accepted. It goes both ways, but it's always aspirational. It should be something interesting, attractive, something that filters through the eyes of our editors and particularly through Anna's eyes. It's never passively reporting but actively selecting and calling attention, or looking for higher standards—and what we like.

Photographed by Irving Penn for the September 2005 issue, model Lisa Cant was transformed into a vision of Tudor beauty. She wears a red velvet dress and hat by John Galliano for Dior Haute Couture.

PHOTOGRAPHY IN THE MAGAZINE OF THE NEW CENTURY

"Since the Second World War, *Vogue* has hired some of the best photographers in the world. They each have a very strong point of view: a real eye, real opinions, real style. Their photos have their own personalities and their own vocabulary, and the combination of their different approaches and styles is what makes *Vogue*. We use each of them for their particular strengths. If you need fantasy, you go to Annie Leibovitz or sometimes Steven Klein. If you want pure fashion, you go to Steven Meisel or Patrick Demarchelier. Mario Testino has evolved his own kind of photojournalism, often on location, though you can also see the clothes well; he is always of the moment and is interested in the social fabric of *Vogue*. Penn is the master. His presence is a punctuation mark in the magazine."

This is design director Charles Churchward's take on the *Vogue* team of contributing photographers. Most of them are celebrities in their own right, such as Irving Penn, Richard Avedon, and Helmut Newton, and may also be friends of the stars whom they have been photographing for years. Their personal relationships explain why their subjects are mostly willing to

cooperate with unusual visual concepts and requests, allowing the photographers to get pictures that are fresh, powerful, and unique—images no one else achieves. Bruce Weber and Arthur Elgort are also members of this dream team, as was Herb Ritts until his death in 2002. Others are Jonathan Becker, Raymond Meier, Norman Jean Roy, and Craig McDean, who are increasingly recognized as they enlarge their portfolios at *Vogue*. François Halard, who specializes in interiors and gardens, also belongs on this list.

Photographic shoots are meticulously planned and organized at *Vogue*, from concept to sequence and page count. The preparation for a major story can be comparable to a small-scale film production. "Our level of excellence is similar to moviemaking," explains photography director Ivan Shaw. "We may have teams of forty to fifty people on certain projects, and we will do as many reshoots as necessary until we get what we want." The exceptional lengths *Vogue* goes to behind the scenes far surpass other magazines' standards; the highest quality is expected of, and demanded by, *Vogue* photographers. "They are all," says Shaw, "leaders in their field instead of followers."

FRESH VISUALS
Helmut Newton, whose work embodied radical new ways of melding sex and desire with the glamour of fashion, created this shot published in February 1995 of a wheelchair-bound Nadja Auermann in Chanel stiletto slingbacks and a Marc Jacobs shirt and skirt.

THE RETURN OF
HELMUT NEWTON

In his 1998 book *Pages from the Glossies,* Helmut Newton explained: "Today, American *Vogue* presents a very special problem for a photographer like me. As a true European, my mores are very different from the American sensibilities. The American public is extremely puritanical. . . . Anna Wintour, the editor in chief of American *Vogue,* has made it the most powerful fashion organ in the world. I know where she stands and she knows Helmut. And a little bit of Helmut goes a long way in her magazine. . . . Condé Nast is the most generous employer a photographer can wish for as long as you toe the moral line. Although I admit that Anna did have the courage to show one bare nipple in one of my photos." The photographer was referring here to a May 1997 story titled "The Naked Truth," about how new fashions exposed more and more of the female body; one of his pictures showed model Kylie Bax having lunch, with one nipple exposed.

Generally, Newton's photos for American *Vogue* are limited to sug-gesting rather than revealing. In February 1995 Newton had a woman seated in a wheelchair, holding binoculars, wearing black stockings and high-heeled black shoes. "When I see a woman, I always look immediately at her shoes and hope they're high, because high heels make a woman look sexy and dangerous," said Newton in a pull quote of the story. In November 1995, for a story called "Machine Age," he posed models in a gym, one dressed in a silver robot suit and shoes, others in black patent-leather catsuits and black tanks and tights. In that same issue he showed a massage machine with a reclining model surrounded by four men who were monitoring her. In January 1997 he illustrated a piece on diets with two women fencing in long white dresses and, in another part of the same story, with a rear view of a nude woman surrounded by five men measuring her body. His interest in orthopedic corsets and wheelchairs reappeared with a similar image in October 1997, when he showed two women walking along a railroad track holding hands with two prosthetic robots.

NEWTON'S CINDY CRAWFORD
For the December 1991 issue, Helmut Newton photographed Cindy Crawford in St. Tropez wearing a Giorgio di Sant'Angelo crystal-studded swimsuit.

POWER AND AMERICAN WOMEN
Newton's women usually expressed power, self-sufficiency, and strength, which were sometimes conveyed through a play on size and proportion, as in this image from April 2002.

His editorial masterpiece of this period was a portfolio in the October 1995 issue titled "Big Women with Big Spirits." Newton played with proportion and scale to visually interpret the concept of power and American women's manipulation of the opposite sex. "I have a somewhat myopic view of the American woman of today in relation to the American male," he said in the story.

The photographer, whose work created radical new ways of melding sex and desire with the glamour of fashion, luxury, and beauty, died in a car crash caused by an apparent heart attack on January 23, 2004. During a memorial service at the Théâtre du Palais-Royal in Paris, Anna Wintour bade him farewell with this tribute: "Plenty of shocking things happen at *Vogue*, but there never has been anyone so consistently scandalous as Helmut. He was a visionary photographer who possessed the magical touch to turn the most boring shoot into an erotic happening. The photos he turned in over the years left me aghast, awestruck, and always amazed. . . . I would have liked to have been one of Helmut's women. I can't think of a greater compliment than to have been deemed worthy of Helmut's lens."

The Naked Truth

With bare-backed dresses and sheerness the mainstay of every designer collection, fashion is exposing women like never before. **Ted Mooney** muses on the exhibitionist in us all. Photographed by Helmut Newton.

THE NAKED TRUTH
In May 1997 *Vogue* ran this photo of model Kylie Bax to illustrate how fashions increasingly exposed the female body. "The American public is extremely puritanical," said Newton.

PLAYING WITH SCALE
This photograph by Helmut Newton was for a story in the November 2000 issue on the then eighty-year-old photographer and his often comic nihilism. "I've always loved the idea of upset of scale," he said.

THE ETERNAL PENN

"All of our photographers are exceptional but Irving Penn is by far the most accomplished," says *Vogue* photography director Ivan Shaw. "He defies all the limits of most photographers on multiple levels. He does everything well: portraits, fashion, beauty, and objects. There are few professionals in the world that could be so good in all these territories and specialties. His black-and-white portraits are very different from his color still-life and beauty pictures. Though the same vision informs them both, they look like the work of different photographers. Regardless of the fact that Penn has been doing this for over sixty-two years, he is as good today as he ever was. Most photographers have a limited creative lifespan but Penn's work keeps evolving even today."

Shaw's encomium is wholly warranted. Penn is not only the doyen of *Vogue* photographers—the only one to have worked with five editors in chief, and arguably the best able to shed light on all the editorial transformations of the magazine—but one of the great American masters of photography, whose work has impacted fashion, portraiture, nude photography, still-life pictures, advertising, and ethnographic images.

Anne Wilkes Tucker, curator of the Houston Museum of Fine Arts, wrote for the inauguration of an exhibition of his work: "Penn's career, with its wide-ranging subjects and varied genres, explores the complex relationship between commerce and art in our society. Constantly shifting roles as a photojournalist and an artist, Penn created works of timeless beauty and character."

Until 1960 Penn, who had originally studied painting, was able to show his exceptional body of work only through *Vogue*, for very few galleries and museums would exhibit photographs. When he turned to the platinum process of photographic printing, he moved closer to art than to commercial photography. Sarah Greenough, curator of photographs at the National Gallery of Art in Washington, D.C., suggests in the exhibition catalog *Irving Penn: Platinum Prints* that by reviving this complex printing technique—which requires special platinum paper and the meticulous application of chemicals—Penn sought "a haven from the commercial magazine world." Penn has spent half his career behind the camera and the other half in his

HAUTE COUTURE
At a time when couture was under attack, *Vogue* rallied to the defense of the couturiers' craft. This December 1995 image by Irving Penn (left) of a Christian Lacroix dress illustrates one of couture's cardinal rules—that fabric should dictate form.

BRASH AND BOLD
Penn has long been the photographer of choice to illustrate articles on beauty, health, and fitness. This July 1995 picture shows color being pushed to the extreme.

laboratory. Through the major modulations of detail and texture afforded by platinum printing, he has transformed his photos—for *Vogue* and for advertising agencies as well as for personal projects—into what critics agree are true works of art.

"I want to take my pictures beyond the facts, toward poetry," Penn has said. Asked why he has preferred in the second half of his career to do still-life rather than fashion work for *Vogue*, Penn replied, "To photograph a cake can be art." Yet Penn's occasional forays into fashion continue to be memorable. In 1983, on seeing Penn photos of his creations,

Japanese designer Issey Miyake said: "Here were my clothes, but shown in such a way that they appeared totally new to me."

Penn is an almost mythical figure inside and outside *Vogue*, known for his extreme demands, exaggerated punctiliousness, and high artistic standards. According to Executive Fashion Editor, Phyllis Posnick, "he still loves to photograph fashion, especially what he considers extreme fashion. Although the Nicole Kidman photograph became a *Vogue* cover, he does not shoot covers. He still loves to photograph artists and other cultural figures, including an occasional 'celebrity' and will travel for a special assignment."

CULT CREAMS
This June 1996 picture is Penn's imaginative rendering of how little-known and hard-to-find creams were attracting a devoted following.

FOWL PLAY
In an era obsessed with everlasting youth, when laser treatments and expensive miracle creams were booming, Penn chose to illustrate an article written by Nora Ephron about her neck with this witty picture.

LIPS UNDER ATTACK
Penn's image of lips under siege by a drill bit and chisel was done for a May 1995 story that covered extra-long-wearing lipstick.

EPIC PROPORTIONS
This picture by Penn illustrated an article in the April 2004 issue about obesity in America.

MARIO TESTINO,
PHOTOJOURNALIST OF FASHION

"Testino's photographs represent his approach to life. Every shot, every meeting with his subjects, is a party," wrote Charles Saumarez Smith in the introduction to *Mario Testino: Portraits*. Grace Coddington, *Vogue*'s creative director, goes further: "One can even hear the footsteps in Mario's pictures."

The vitality and energy in Testino's photos, his passion for life and for capturing the moment in his images, have their roots in Lima, Peru, where he was born and raised in a mixed Spanish-Italian-Irish family. In choosing a career, he was initially attracted to economics during his first year at the University of the Pacific, and later switched to law, which he studied for a time at the Catholic University of Lima, and eventually to international relations, which took him to the University of San Diego. It was not until the mid-1970s that Testino recognized photography as his true vocation and decided to move to London.

The first few years were tough: He worked as a waiter to finance his photography studies, and whenever he had free time he would roam the city and take pictures. He spent many hours visiting photo galleries and art museums. Perhaps it was fate that made him rent an apartment across the street from the National Gallery and find work as a waiter at a restaurant where the editors of British *Vogue* often lunched. With his exuberant personality he soon befriended them, and when they learned that he wanted to be a professional photographer, they invited him to submit samples of his work. The rest is history: Testino soon began to freelance for British *Vogue*, starting a professional career that would extend to the magazine's other European editions and eventually, in the United States, to *Vanity Fair* and later American *Vogue*. It was there that he made a name with his practice of putting his models into large groups—as he did in 1997 with Amber Valletta on a beach in Brazil surrounded by locals eyeing her

hungrily, or with Kate Moss in 2000 in the midst of the corps of the Royal Ballet, a half-dozen soldiers, and a punk youth.

Testino's subjects have included celebrities such as Madonna, Kim Basinger, Elizabeth Hurley, Gwyneth Paltrow, Janet Jackson, Julia Roberts, Meg Ryan, Cameron Diaz, and Catherine Zeta-Jones, many of whom became close friends. What definitively elevated him to star rank was his portraits of Princess Diana for *Vanity Fair*. "Those unforgettable pictures he took of Princess Diana certainly stand out in my mind. Although we had seen a million pictures of Diana, we had never seen her looking so relaxed, accessible and modern as when Mario photographed her," wrote Anna Wintour in the introduction to *Front Row/ Backstage*, one of Testino's several books of photography.

Testino is today one of the world's great fashion photographers, the source of numerous covers of the best fashion magazines every month, a man who is nowhere a foreigner (he has homes in London, Los Angeles, and New York), and a celebrity in his own right. When he was enshrined in March 2005 on the Rodeo Drive Walk of Style, a distinction bestowed by the high-end Beverly Hills shopping area for contributions to fashion and show business, the ceremony was attended by a parade of celebrities. The plaque that honors Testino quotes his famous utterance, "Chic is nothing but the right nothing."

According to Coddington, there is no fashion photographer in the world capable of working with the intensity, the quality, and the speed of Testino: "He has no problem going to Venice to shoot twenty fashion pages, jumping two days later to Los Angeles to

KEIRA ROYALE
Testino shot both the cover and the inside pages of this May 2006 story on British actress Keira Knightley, who is shown here wearing Balenciaga by Nicolas Ghesquière.

SCOTLAND YARDS
Model Stella Tennant moved with her family from Manhattan to a Scottish farm estate, which Testino visited for the October 2005 issue, where she is shown playing with her son Marcel Lasnet on the left and a friend's son, James Campbell, on the right. Tennant wears a Jil Sander turtleneck and a Louis Vuitton tweed skirt.

(OVERLEAF)
LIGHTS, CAMERA, COUTURE
Nineteen-year-old American model Angela Lindvall (far left) was flown to Paris by *Vogue* for this shoot that ran in the April 1998 issue. Here she poses in Christian Lacroix Haute Couture with Isabella Blow, the muse for Givenchy, Vanessa Bellanger from Dior, and Amanda Harlech from Chanel, each wearing haute couture from their respective houses.

photograph a celebrity for a cover
and ten double spreads, and then
traveling without a break to a beach in
Brazil for another three-day session
with a model for another twelve fashion
pages. And on top of all that, every-
thing he brings back is marvelous."

The fashion industry also appreciates
Testino's enviable knack of discover-
ing the models of tomorrow. Certainly
Georgina Grenville, Gisele Bündchen,
Lisa Winkler, Carolyn Murphy, and,
more recently, Jacquetta Wheeler
would not be enjoying such stellar
careers had it not been for the eye of
the photographer who saw their
potential and captured their best looks
at their best moments. "But perhaps,"
wrote Anna Wintour, "Mario's most
serious asset is his phenomenal per-
sonality, also, in my experience,
unusual in the business. People love
to be photographed by Mario
because he's so charming and funny
and confident, not to mention so
incredibly clever at seducing his sub-
jects. So, if he's shooting someone
who's terribly famous, like Madonna,
he can make her feel so at ease that
she's not afraid to put herself and
her image into Mario's hands."

WALK OF FAME
Testino, expert at shooting
celebrities, has become a
celebrity himself. Jennifer
Lopez posed for him in a
Narciso Rodriguez turquoise
dress for this January 2005
photograph, to which *Vogue*
gave the caption "Beauty
and the Beasts."

STEVEN MEISEL,
THE DOCUMENTARIAN
OF FASHION

"Fashion always comes first with Steven. Whatever else is going on in one of his pictures—and it's always something interesting—his interpretation of the clothes is as clear and sharp as a documentarian's. He also has an incredible range. He can transform an unknown girl into a top beauty (Naomi Campbell, Kristen McMenamy, Linda Evangelista) or photograph a megacelebrity (Madonna, Lisa Marie Presley) like she's never been shot before. He's just as capable in a studio as he is outside on the banks of the Seine. If models are his actresses, clothes are his muses. The day after he captures the ethereal reality of an evening gown, he'll just as easily get the raw sexiness of a rock and roll wardrobe. Steven can make a bad dress look irresistible."

These warm words of praise come from Grace Coddington in her book *Grace*.

The work of Steven Meisel is saturated with his knowledge and appreciation of the history of fashion, photography and film, high art and pop culture—a highly referenced but effortless-seeming style he arrived at by a process of intense study and practice, leading to an insightful approach that is all his own. His images are modern, but they celebrate the past, often depicting his subjects as

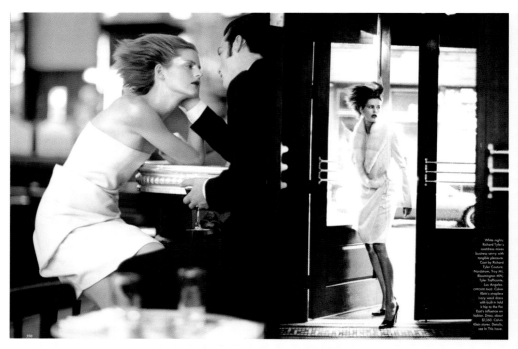

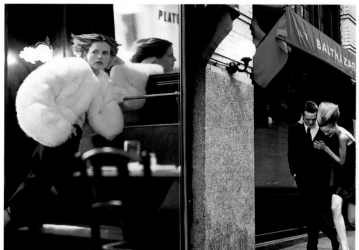

DOWNTOWN ALLURE
Steven Meisel's café sequence, published in October 1997. The model wears a Calvin Klein dress (top, left), a Richard Tyler Couture coat (top, right), a coat by Michael Kors for Pologeorgis with pants and a top by Helmut Lang (bottom, left); and a Helmut Lang dress (bottom, right).

(OVERLEAF)
INCURABLE ROMANTIC
For a story in March 1993 on designer John Galliano, Meisel evoked the designer's romantic fantasies and his puff-sleeved and corseted creations.

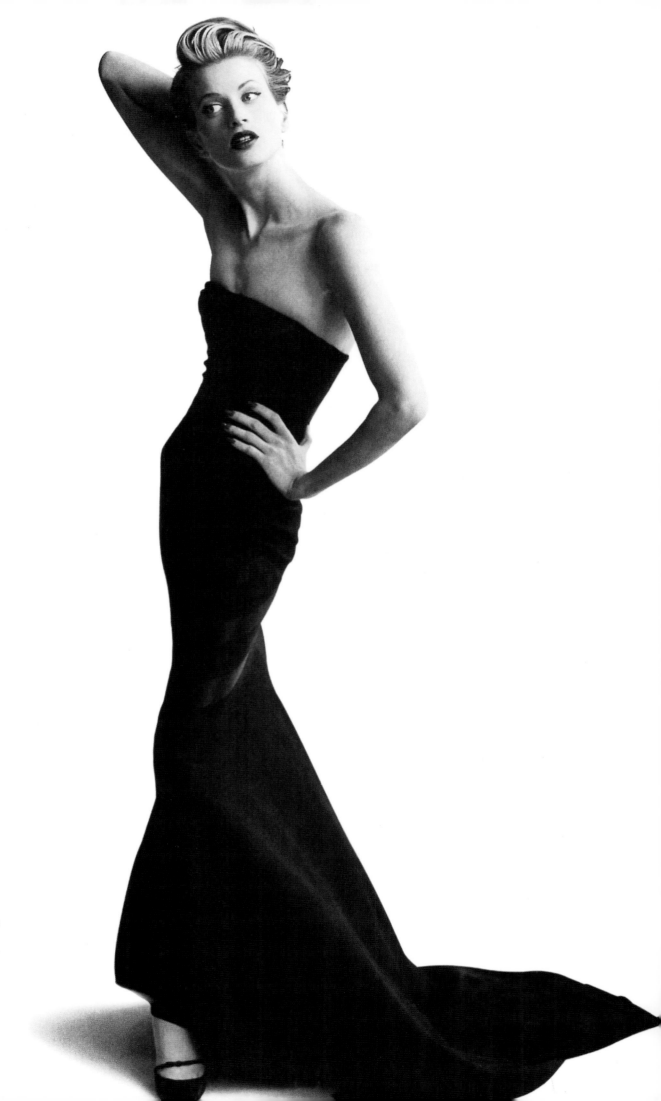

PORTRAIT OF A LADY
The clothes are the muses in Meisel's photographs, as in this image (right) of a model in a John Galliano dress published in March 1995 and included in the article "Portrait of a Lady."

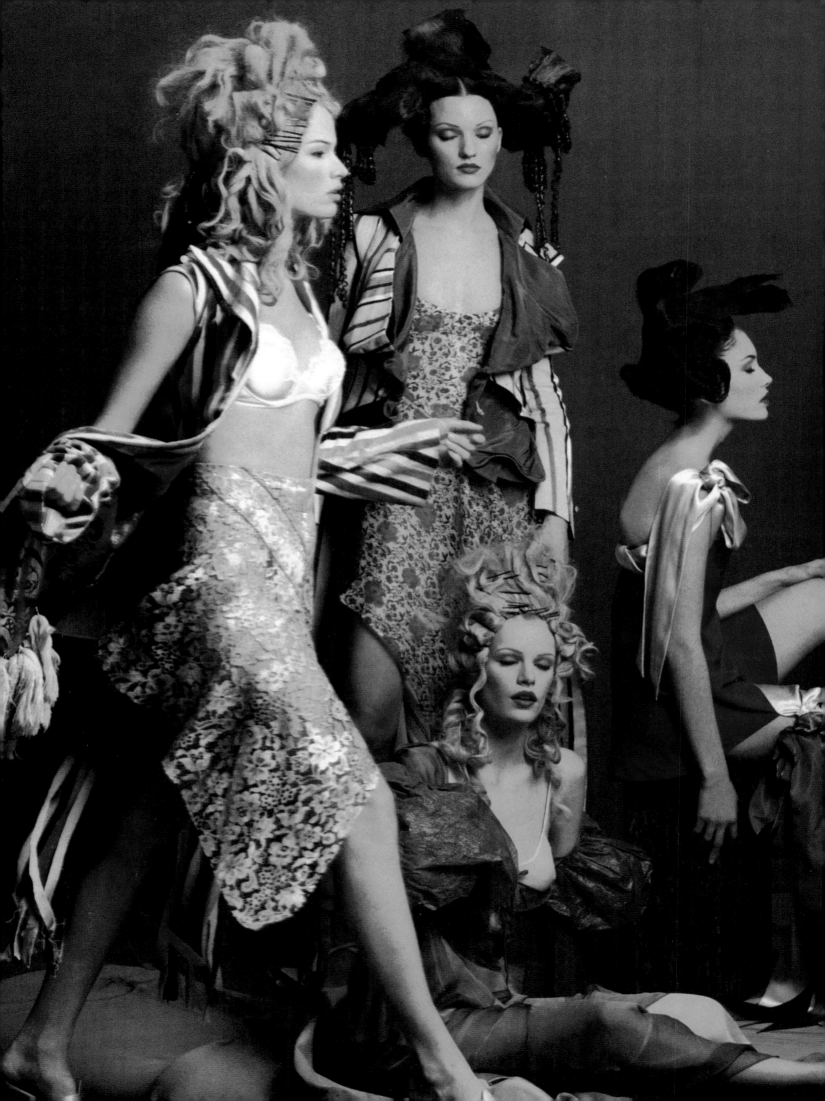

models or actresses of other eras. And his references are never random or irrelevant: He invariably comes up with the right inspiration for the right moment.

Meisel's obsession with fashion began when he was in the fourth grade. He would go to the hairdresser with his mother, and while she was having her hair done, he would read fashion magazines. Later he would use his pocket money to collect them. In his teen years he spent his free time visiting boutiques and standing outside Avedon's studio to watch the arrival and departure of the models. The same passionate single-mindedness led him to take fashion illustration courses and to study for a time at the Parsons School of Design. In the 1970s, after sketching and illustrating for the designer Halston and writing about fashion for the magazine *New York Rocker*, Meisel was hired as an illustrator by *Women's Wear Daily*. Through contacts from Parsons, among them the designer Anna Sui, Meisel started to help young models put together their portfolios, which gave him the opportunity to do some fashion shoots for *Seventeen* magazine and for the *Soho Weekly News*. His credentials soon won him a job as

cover photographer for a new Condé Nast magazine called *Self*. The magazine debuted to great success, thanks in part to its covers, which established Meisel's reputation.

Commissions ensued from *Mademoiselle* and Italian *Vogue*. Models loved Meisel, who became known for discovering girls and making them famous. It was Meisel who discovered the Dutch-Japanese model Ariane and, in the 1980s, propelled to stardom the supermodels Christy Turlington, Stella Tennant, Naomi Campbell, and Linda Evangelista. By then his shoots for Italian *Vogue* were running as long as thirty pages. In 1992 Meisel became the first photographer to sign a large contract with Condé Nast. This landed him at Anna Wintour's *Vogue*, where he continues to take memorable photos. In 2001 he shot Karolina Kurkova dressed in Gucci and Ferré, in the guise of Marilyn Manson. In 2001 he memorably photographed a number of models impersonating other rock stars: Carolyn Murphy with husband and daughter became Courtney Love, Kurt Cobain, and little Frances Bean; Karen Elson and friends became Jimi Hendrix, Jim Morrison, and Janis Joplin. In 1992 his shoot with Linda

Evangelista and Kristen McMenamy parading haute couture through French châteaux and gardens, all in black-and-white, was a classic. Meisel also attracted notoriety for taking the photos of Madonna in her book *Sex*, for creating the controversial 1995 advertising campaign for Calvin Klein jeans—which the press termed "child pornography"—and for photographing model Sophie Dahl nude to advertise the YSL perfume Opium, an image banned in several countries.

Meisel is used to breaking the rules, and he loves to do so. When *Vogue* asked him to evoke the classic Christmas carol "The Twelve Days of Christmas" for the December 1998 issue, Meisel knew exactly how he wanted to depict the seventh day. Having seen Matthew Bourne's Broadway production of *Swan Lake*, with its all-male corps of swans, Meisel brought in these dancers for his picture. Charles Churchward, *Vogue*'s design director, recalls the elaborate shoot: "It was shot on Pier 59, in the largest studio, where snow scenes could be set up and clouds could hang from the sky. The cheeky 'Seven Swans A-Swimming' image bears Meisel's trademark: a sense of beauty and a sense of humor."

(PREVIOUS PAGES)
LONG LIVE FANTASY!
Meisel's photograph, published in October of 1998, shows maximum minimalism, with a clean black-and-white color scheme. The dress is by Christian Lacroix Haute Couture and the tuxedo is Gucci.

BROADWAY SWANS
To illustrate a December 1998 story called "The Twelve Days of Christmas," Meisel combined beauty and humor in "Seven Swans A-Swimming" by using as models seven members of the all-male corps de ballet from Matthew Bourne's Broadway hit, *Swan Lake*, with Shalom Harlow shown here in Chanel Haute Couture.

MAD ABOUT YOU
This Meisel picture from October 2003 shows what happens when, as *Vogue* wrote, "a wardrobe rebel takes deeply classic, statement pieces and makes them a bit *fou*," teaching the reader about making fashion fun, perfectly illustrated with this houndstooth coat by Miu Miu.

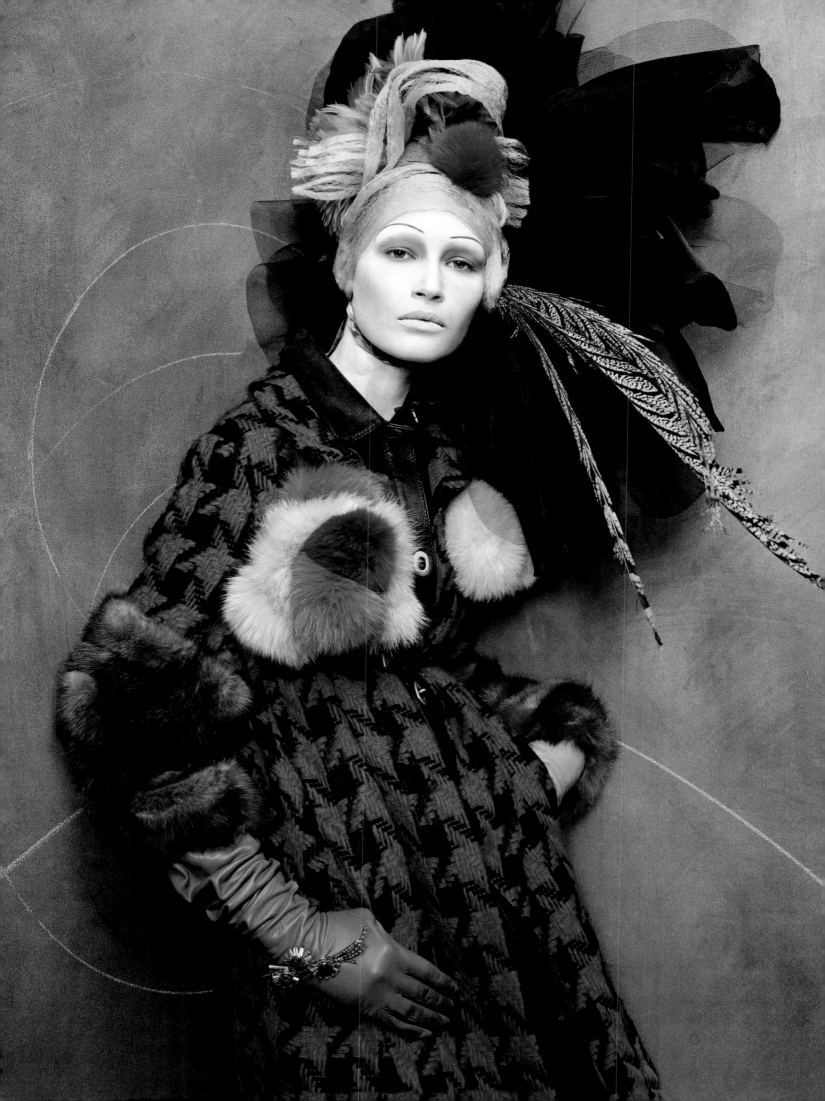

330

RISKY BUSINESS
To show the courage and endurance of
world-class athletes and the extraordinary
limits to which they push their bodies, this
photograph by Herb Ritts for the April 1999
issue shows adventure racer Robyn Benincasa
running with a camel while training for the
Raid Gauloises, a weeklong race that takes
place in a different exotic country each year.

HERB RITTS:
HIGH-FLYING STYLE

Herb Ritts took what would be the most recognized photograph of his career in 1978, when he was twenty-six, during an excursion into the desert outside Los Angeles with his friend the actor Richard Gere, who was also in the early stages of his professional life. Gere, his girlfriend, and some other young Hollywood actors had invited Ritts to spend a weekend in the desert, which they were never to enjoy because the car they were driving got a flat tire and they had to spend a great deal of time changing it on the outskirts of San Bernardino. At a gas station there Ritts, using his simple Miranda camera, took an iconic photograph of Gere with his hands clasped behind his neck, a cigarette hanging from his lips. This image would be the beginning of Ritts's visual style emphasizing young male bodies, vigorous and muscular—a style whose value experts still debate as mere snapshots or as carefully planned shoots backgrounded by small American towns.

Nothing in Ritts's previous life pointed to the destiny he would find in photography. He had graduated in economics from Bard College and was happily selling furniture from his father's factory in his native Brentwood, an upper-middle-class suburb of Los Angeles. Few of his friends and family members knew that he had started studying photography and art history in New York. His move to fashion photography took place in 1978, when he bought a house in Los Angeles and,

(OVERLEAF)
STRANDED BEAUTY
Ritts took model Naomi Campbell, photographed here in a Leilani two-piece, to Jamaica and portrayed her as a shipwreck survivor. The picture, published in May 1996, was taken with a long lens to avoid capturing the hordes of paparazzi.

FOREVER GWYNETH
Ritts photographed actress Gwyneth Paltrow in all her splendor wearing an empire-waist dress by Louis Vuitton for the March 2002 issue, which was devoted to the theme "Power."

MICHELLE IN DISGUISE
For the October 1991 issue, Ritts photographed actress Michelle Pfeiffer as various film characters. Here, wearing a Giorgio Armani tux, she poses as Elyot Chase from Noël Coward's *Private Lives*.

to help pay the mortgage, rented out one of its rooms. His first tenant was Matt Collins, a leading model at the time, who offered to get Ritts a photo shoot for the Italian edition of *Harper's Bazaar*. The shoot was so successful that the magazine devoted twenty pages to it. The fashion editors of the Italian publication *Lei* were impressed and immediately hired Ritts to take fashion photos for their magazine, which jump-started his international career.

Steven Meisel later praised the Ritts style for "the airiness, the cleanliness of Los Angeles, the feeling of openness, that feeling of freedom and the feeling of light." Ritts, in the book *Herb Ritts: Work*, said of his own style: "Coming from California and growing up where I did, I've always had a fondness for and innate sensitivity to light, texture, and warmth. I abstract it in my photographs: I like large planes and spaces, areas of texture and light, like deserts or oceans or monumental places. That's why I felt so at home when I went to Africa. It didn't matter that I was halfway around the world in a foreign country, because all those elements are universal. And I think that's one thing about my work: it's universal." Scholars who have studied his work place his pictures within the tradition of classical Greece and of

ancient sculpture, evoking the kind of Herculean, Samsonian, or martially beautiful bodies that earlier inspired Horst and Hoyningen-Huené.

In time Ritts became one of the best celebrity photographers, and his subjects would do anything for him. For an American *Vogue* shoot with Michelle Pfeiffer, he decided to dress her in men's clothing, a decision he explained in detail to writer Patrick Roegiers in the book *Herb Ritts: Work*: "She wasn't comfortable with being herself and doing pictures in front of a still camera. I think she wanted to break the stigma of being so beautiful. I decided to do her playing different roles, thinking this was a way of taking her out of herself. The photograph we are speaking of is actually a character from a Noël Coward play. I suggested that it would be interesting if she played a man. She had read the play and had the idea of the Noël Coward character, Elyot. We put her in an Armani men's tuxedo. I didn't want to do anything with her face. We literally wet her hair and parted it and drew on a little moustache. She walked down the steps and sat down and she was suddenly Clark Gable. She was in the twenties mode, down to the hand gestures and all. And I didn't tell her what to do."

Another famous photo he took in 1996 for *Vogue* showed Naomi Campbell on a beach in Jamaica. "The idea was that she would be the victim of a shipwreck on an island," Grace Coddington, the sittings editor, recalled, "and as Herb had a special devotion for the natural shapes of trees, we did it that way, sending the message that Naomi had no hopes of being rescued." Nothing could have been further from the truth: Ritts had taken the picture using a long lens to avoid including the hordes of paparazzi from all over the world who had come to the beach to try to photograph the supermodel.

"And who now will be able to give *Vogue* such images of optimism, vigor, and sexuality?" asked Anna Wintour in a tribute she wrote for the photographer after his death in 2002. "Whenever we wanted to celebrate sun and skin and the fun of life: Kate Hudson leaping for joy, Tom Hanks clowning in a Santa hat, Marion Jones running on a beach, Herb was the one we turned to. In a fashion world inevitably given to fluctuations of taste, he stood out for his absolute commitment to making models and actors and friends look gorgeous and happy and like themselves, only better."

THE PERENNIAL PRESENCE OF ARTHUR ELGORT

"What I have always admired in Elgort," said Condé Nast editorial editor Alexander Liberman, "is his ability to catch a revealing moment in a woman's everyday life. I thought this was very important . . . in a time that was still concerned with costuming and artificiality."

For his part, Elgort surely remembered Liberman's advice when he was offered his first job at American *Vogue* in the early 1970s: "Keep it young, young and happy and outside." Elgort did, and he has remained a staple of *Vogue* for the past thirty-five years. His seemingly effortless, open, and easygoing images have found their best backdrops in his native New York City, one of his prime locations for a fashion photo shoot. But he has been equally at home shooting Christy Turlington in Moscow (1990), Linda Evangelista in the mountains near Guilin, China (1993), Shalom Harlow and a baby camel in Morocco (1996), Maggie Rizer with a wedding elephant in India (1998), or a family of stylish vagabonds on a dry lakebed in southern California, a shoot inspired by the movie *Mad Max*. "Arthur is great at capturing real people and always puffing his pipe and chatting with them while he's shooting. He's fantastic at showing the reality of a place," says Grace Coddington. The man she is talking about quit painting and art history in his twenties to take up photography because, he said at the time, "painters are generally lonely and I love to be among people."

A SHOT OF SCOTCH
Arthur Elgort is always open to being surprised. In this Scottish fashion shoot for the September 1991 issue, he captured model Linda Evangelista in an offbeat moment, wearing an Oscar de la Renta coat.

(PREVIOUS PAGES)
LOVE IS IN THE AIR
Elgort shot several Style Essays, among them this one, for the November 1998 issue, with model Ryan Locke as an astronaut who lands on Earth, meets the beautiful Maggie Rizer, and eventually marries her. Rizer wears a jacket and skirt by Bill Blass and boots by Manolo Blahnik.

FASHION AROUND THE WORLD
At top, left, Elgort took this candid shot of model Christy Turlington wearing Yohji Yamamoto, with Russian fashion designer Konstantin Goncharov and Russian model/actress Irina Kuksenaite in a private apartment in St. Petersburg for the September 1990 issue. Below, is Linda Evangelista in a story shot in Shanghai for the December 1993 issue. Opposite, for a spread depicting "barbarian chic," Elgort shot in the dried lakes of southern California, showing the models as desert vagabonds, inspired by the movie *Mad Max*. The model is in a suede dress by Yohji Yamamoto.

(OVERLEAF)
PLAYING WITH FIRE
Elgort shot this image for the August 1992 issue of *Vogue*. The model is wearing a mohair cardigan, silk shirt, and beaded silk vest by Giorgio Armani, and is accompanied by the jazz trumpeter Terence Blanchard and others.

Elgort is well known in the business for not being temperamental. "Most photographers," he claims, "are too self-conscious to make a fashion picture with ease and spontaneity." He has worked with many of the supermodels, some of whose careers he helped establish, from Patti Hansen and Lisa Taylor to Christy Turlington. He took the striking December 1995 *Vogue* cover photo of Cindy Crawford just after her divorce from Richard Gere, wearing Isaac Mizrahi and a smile, with the cover line "Supermodel Style." Elgort's reputation now extends

well beyond the field of fashion, as his work is represented in the permanent collections of the International Center of Photography in New York and the Victoria and Albert Museum in London. He has also gained recognition as a filmmaker: One of his films, *Colorado Cowboy*, about rodeo performer Bruce Ford, was nominated for best documentary at the 1994 Sundance Film Festival.

Some of his trademark photographs are gathered in his book *Arthur Elgort's Models Manual*, where he talks about

the rules of the fashion business. "While other photographers and other styles may come and go," wrote Carol Squiers in *Vogue* upon the launch of the book, "Elgort's youthful, energetic images of modern women on the move have proved remarkably long wearing and have helped define the influential and very recognizable *Vogue* style."

THE CLASSIC LOOK OF
PATRICK DEMARCHELIER

CLASSIC LOOK
Demarchelier worked for
Vogue in two different peri-
ods, the first from 1989 to
1992, the second starting
in 2004.

CUTTING EDGE
Patrick Demarchelier's photo
(left) for a May 2006 story
on the new trend of short
haircuts.

"Most people are afraid of being photographed, and so, when they're sitting in front of me, I talk a bit and tell them I'm starting with a few trial photos. Then they relax and some-times I've got my photo in just ten minutes. Others don't relax until they think everything's over, so I make my photo then. Ten minutes or a whole day, that's how my pictures come about." This is how Frenchman Patrick Demarchelier defines his photo tech-nique, which is widely considered to be more classical than revolutionary.

Unlike other visually gifted colleagues who discovered their vocations early in life and achieved fame in the field of photography in a relatively short time, Demarchelier's road was full of obsta-cles. He was born in a Paris suburb in 1943. His father walked out on the family, and his mother found work in Le Havre, where she moved with her four sons. Patrick's first camera was a birthday present when he turned sev-enteen. From that age on he would take pictures of practically everything he saw. During the day he went to school, and after hours he worked as a soap distributor to help his mother make ends meet. With whatever money he could save he would buy film for his camera. He later landed a night job at a photo laboratory, where he learned how to develop and print, experimenting with different types of paper. When he became expert enough, he was able to move back to Paris, where he worked in the labs of the ad agency Publicis.

"Poverty is a formidable weapon: it teaches humility and perseverance. I was not gifted, I had no talent and

I knew that, and the only way to over-come the problem was with persever-ance," recalled Demarchelier in 1992. He eventually got a job as an assis-tant to the great fashion photographer Hans Feurer, from whom he learned a great deal. Not long after, believing he was ready to become a professional, he took samples of his pictures to *Elle* magazine, where he was ruthlessly advised to take up a different profes-sion. It was quite some time before Demarchelier recovered from this blow. But he kept approaching *Elle* and other fashion magazines, until finally one entrusted him with an assignment. By the early 1970s he was starting to develop his personal style, handling fashion photography with artistic flair rather than as a mere shop window for clothing, and man-aging to elicit in the faces of his models a warmth that in time would become his trademark.

When he immigrated to New York and opened his studio in 1975, his name already figured among the most sought-after professionals, and very soon *Glamour*, *Mademoiselle*, *GQ*, and *Rolling Stone* were clients. But Demarchelier remained as humble as ever: "There is nothing in photography that hasn't been done by someone else before. I don't try to be 'new.' If you do a good picture, it's already new." By this time he was already taking pictures of supermodels such as Naomi Camp-bell and world celebrities including Princess Diana, yet Demarchelier never forgot that the basis of his suc-cess was perseverance. At the end of his shoots he would spend nights in his laboratory developing his pictures and improving them.

Anna Wintour hired him for *Vogue* early in 1989, but he would stay only three years before Liz Tilberis lured him away to *Harper's Bazaar*. Tilberis, British like Wintour, had worked with Demarchelier when she headed British *Vogue*. When she became editor of *Bazaar* in January 1992, she needed a photographer of his caliber to compete with *Vogue*'s Steven Meisel. A financial tug of war between the two magazines ended with Demarchelier at *Bazaar*, where he would be employed for a dozen years. Demarchelier returned in May 2004 to *Vogue*, where his assignments have included what Anna Wintour calls "visual vacations," starting with a trip to Bora-Bora that yielded spectacular pictures in the December 2004 issue.

As Martin Harrison wrote in the catalogue of a 1997 exhibition at the Museo de Arte Contemporáneo de Monterrey, "Demarchelier's fashion photographs are frequently admired, in the fashion business, for their realism, though he is fully aware that fashion photographs are not intended to deal with the real world. . . . He avoids the temptation to overrationalize his photographs, as if to do so might remove, for him, an essential element of mystery. Alexander Liberman described him as 'a gentle pioneer,' sensitive 'to the natural attractiveness of women.'"

REALITY CHECKS
Published in May 1991, the photograph at right is classic Demarchelier. Christy Turlington is in Azzedine Alaïa.

TICKET TO PARADISE
This December 2004 sitting was photographed by Demarchelier on a small private island near Bora-Bora. The models are in Prada (bottom, left) and Chloé (bottom, right).

THE PROVOCATIVE LOOK OF STEVEN KLEIN

No photographer on the *Vogue* team today is doing more to erase the boundaries between fashion and art, or between popular culture and fine arts, than the American Steven Klein. And he is doing so with memorable and iconic images that alter and sometimes subvert traditional notions of glamour and beauty. "The thing that gets frustrating about fashion," he told the authors, "is that you always want to respond to ideas that reflect what's happening in the world, what's in the street. You don't want to just fabricate these dream lives of these idealized Barbie dolls that don't even exist anymore." Klein's visual subtexts abound in provocation, sexual fears and desires, suave sadism, touches of transgression, and incendiary energy. His portraits generally offer provocative and somewhat somber studies of celebrities, which are conceived in deliberate contrast to the fawning and flattering images of those stars in the mass magazines.

In his fashion shoots, Klein displays designer clothes in bold and exciting images: Karolina Kurkova shot in 2001 in a room filled with sinister-looking toys, Maggie Rizer in 2002 with dollar bills under her fingernails, Cristina Ricci the same year surrounded by a bicycle, a gigantic flat-screen TV, and a police radio. "He makes models into visions of women who are tough enough to get what they want," wrote Coddington in *Grace*. The point is clearly illustrated in Klein's photograph of the model Gisele Bündchen, dressed in black leather, against a background of powerful trucks. "I'm basically a storyteller, a photographer with the instincts of a playwright, a moviemaker, a stage director, or an entertainment artist," says Klein himself when asked to define his approach.

OUTSIDE THE BOX
Steven Klein is considered one of the most innovative and provocative photographers of the present day. His pictures often provoke fear or desire, such as this one, published in the February 2001 issue, in which the model is wearing Prada and Christian Louboutin pumps.

(OVERLEAF)
THE GREATEST SHOW ON EARTH
To illustrate a story about sport looks that walk the tightrope between utility and chic, published in September 2002, Klein was inspired by the circus. Fashions by Louis Vuitton.

MODEL AND BOXER
This March 2005 picture of a model in Louis Vuitton with middleweight champion Jermain Taylor and his entourage, was photographed by Klein for the "Power" issue.

As a child Klein was attracted to the fine arts, specifically to ceramics and sculpture, and he later studied painting at the Rhode Island School of Design. Though he started taking photographs at age twelve and developing them in a darkroom he built in the basement of the family home, photography was never a consuming passion in his early years. A schoolmate who shared with him her copies of *Vogue*'s European editions provided his initial connection with the magazine and with fashion.

His beginnings as a professional photographer came in Paris, where he showed some of his pictures to fashion editors and was offered a shoot for Christian Dior. It took him only twelve years to become one of the most influential and sought-after fashion photographers in the business. His style, at once aesthetically outside-the-box and commercial, unleashed a fight for his services between designers such as Calvin Klein, Alexander McQueen, Tom Ford, and Dolce & Gabbana.

As a *Vogue* fashion photographer, Klein has shown his preference for working in familiar places rather than in regular studios with artificial backdrops. Given the choice, he will usually opt for shoots at his country house in the Hamptons, where he has two Great Danes, four horses, and an equestrian course on which he practices show jumping. Another passion that reveals itself in his fashion photographs is the world of high-tech and robots. "Great fashion photography not only understands the clothes and makes them look beautiful and of the moment, but also brings a twist that catches the eye and captures the imagination," says Anna Wintour. "In the case of Steven Klein, you give him a dress and he'll give you a girl in a dress with a robot in a garden. It's clever, conceptual, and ultimately lyrical."

Even if his friend Madonna says that he is an artist rather than a fashion photographer, Klein insists, "I never consider what I do art."

INNOCENCE AND EXPERIENCE
Klein's picture of actress Christina Ricci wearing a Versace bikini was shot for the June 2002 issue.

BRUCE WEBER: SHOW FASHION, TELL A STORY

One of the most prominent photographers of the century is Bruce Weber, who has simultaneously embraced editorial and commercial photography. *Vogue* creative director Grace Coddington, quoted in *On the Edge*, said, "Bruce puts people in certain situations and acts like a paparazzo, which is how he gets that feeling of immediacy in his work. He doesn't want his photographs to be fashion

IMMEDIACY
Bruce Weber does not want his pictures to be "fashion statements" but rather a "document of the moment." This photograph (left) was published in March 1995 and the model is in a Christian Lacroix dress.

STYLE JUMP
Weber's simultaneous embrace of editorial and commercial photography has influenced his style, which is full of action and movement, as shown in this March 1995 photo (right). The pink feather dress is by Pierre Balmain Haute Couture.

(OVERLEAF)
SUMMER SPLASH
The photograph was shot on a lake in the Adirondacks, where Weber owns a country house, for the October 1993 issue.

statements. He wants them to be a kind of document of the moment."

Weber was born and raised in the small farming and mining community of Greensburg, Pennsylvania. His father was a successful businessman who happened to love photography, and Bruce took his first steps in photography very early. His mother was a reader of *Vogue*, so Bruce also knew the magazine at a young age. As his 2001 film *Chop Suey*, which is largely autobiographical, explains, "Sometimes we photograph things or people we were never able to be."

After studying cinematography and photography in New York in 1966,

Weber devoted himself exclusively to taking pictures of men, among them the singer John Lee Hooker. One day in a coffee shop he spotted the photographer Diane Arbus. He introduced himself as a student of photography and an admirer of her work. Later she invited him to show her his portfolio and sent him to attend courses given by Lisette Model at the New School for Social Research. As Weber had to finance his own studies, he began to work as a model for various photographers, one of whom was Richard Avedon. In 1974 Weber met Nan Bush, who would become not only his agent but his best friend and confidante. Another important professional collaborator was fashion editor Grace

Coddington, who had worked for British *Vogue* before joining the American edition of the magazine. Coddington wrote in her book *Grace*: "Anything Bruce photographs certainly becomes part of his life. . . . A vast universe of American hideways, musicians and films, sports heroes, art, photography and dogs. Once you enter that world, you can no longer resist it."

Weber alternated between color and black-and-white photography, shot preferably at his Miami home—where in 1998 he took his famous picture of two dogs getting married, and another black-and-white of the model Talisa Soto—or at his estate in the Adirondacks. However, he also ventured into

DOG'S LIFE
There is humor and tenderness in these photos of two dogs getting married, published in June 1998. The bride wears a veil by Reem Acra and tiara by Simon Tu, and the groom sports a hat by Stephen Jones and a tie by Brooks Brothers.

SNOW WHITE
For the December 1991 issue Weber did one of the first Style Essays for *Vogue*. It was a wild re-creation of "Snow White and the Seven Dwarfs," using model Beverly Peele as the protagonist of the fairy tale and the rap group Another Bad Creation.

SORBETS FOR TWO
Weber shot jazz prodigy
Harry Connick Jr. sharing a
sorbet with his wife, Jill
Goodacre, at the Plaza hotel
in September 1991.

the outside world. In 1989 when Naomi Campbell was dating boxer Mike Tyson, Weber got her to talk Tyson into posing with her. The boxer said all he could spare was three minutes. They were not easy. Tyson was fixated on the idea of being photographed in the nude with his girlfriend. Weber and Coddington persuaded him to appear in the picture with only his chest bare.

It was the visual narrative, whether real or imaginary, that attracted Weber to photography. In *On the Edge* he stated: "When I was growing up, I would look at the stories Richard Avedon had done in Ireland or Spain or Paris, and they would take me somewhere. They weren't just fashion pictures. There was something more to them. It was a revelation to me that a man could make anybody anywhere fall in love with that girl on that page. And I don't think it had anything to do with being a fashion photographer. It had to do with the fact that he loved to take photographs."

ANNIE LEIBOVITZ:
THE MODERN FANTASY

"Annie is one of the most meticulous photographers I know," wrote Grace Coddington. "To prepare for a sitting, she sets up almost all her shots on locations using stand-ins, so that when the people who actually are going to be in the photograph arrive, all that's left is to make it come to life. That's exactly what she's done whenever I've teamed up with her, perhaps most spectacularly on two occasions, when we did couture using the celebrity of the moment to make the story that much more irresistible. From the start I was worried how Sean "Puffy" Combs (1999) and actor Ben Stiller (2001) were going to fit into a rarefied world of French fashion, the opposite of their images. But Annie shot them as if they were naturals. She made the unbelievable believable, with wit and beauty."

This is perhaps her most important visual contribution to *Vogue*, and the reason Anna Wintour usually chooses her to photograph celebrities within a narrative—a fairy tale or a fictitious story that Wintour in her editorial letter might call a "fashion portfolio or pantomime." Over the years Leibovitz has developed the style of fantasy to such a high level that some of her recent shoots are openly cinematic, as in "The Wizard of Oz" in the December 2005 issue. She and Coddington combined their narrative skills with the creative talents of stage designer Mary Howard (who regularly collaborates with Leibovitz as well as other photographers of the *Vogue* team), actress Keira Knightley, artists Jasper Johns, John Currin, and Chuck Close, and others in a magical re-creation of the classic tale. Senior editor for

special projects Alexandra Kotur, who collaborated with Leibovitz on that portfolio, commented that "Annie is capable of taking a famous iconography and reinventing it so that the narrative looks absolutely like her own. This is what makes her brilliant."

Leibovitz's photographic roots go back to the portraits she has taken of her family since childhood, and to photojournalism, a passion that took her at age twenty to the West Coast. There she studied art and aesthetics at the San Francisco Art Institute during the day and at night attended courses in photography. One day Leibovitz dared to show up at the office of *Rolling Stone* magazine to show her work to art director Robert Kingsbury. Kingsbury was so impressed that he urged editor Jann Wenner to take her along as photographer to his upcoming interview with John Lennon. A month later one of the photos she took was the cover of *Rolling Stone*. In his introduction to Leibovitz's first book of photographs, Tom Wolfe said: "Annie's photograph in 1980 of John Lennon, naked and crawling up the fully clothed torso of his wife like a white mouse, is historic. Annie had been the last photographer he had agreed to see and Lennon wanted to be photographed that way. Curiously enough, the cover of *Rolling Stone* magazine came out a few weeks after his death." In 2005 that photograph topped the American Society of Magazine Editors' list of the best cover pictures of the past forty years.

In 1983 Leibovitz began working for *Vanity Fair*, where her photographs

GOLDEN GIRL
Taken for the April 2006 "Shape" issue, this picture of pregnant Melania Trump wearing an OMO Norma Kamali gold bikini and Carolina Herrera long gold silk coat with train, shows both the element of surprise and the subliminal messages of Annie Leibovitz's photographic style. Melania is accompanied by her husband, Donald Trump, in the car.

GROUNDBREAKING ARTISTS

This phoptograph by Annie Leibovitz from the
July 1994 issue is a masterful interpretation
of the video-installation artist Matthew Barney
featuring three of the actors in his *Cremaster
Cycle*, the bodybuilders (left to right) Colette
Guimond, Christa Bauch, and Sharon Marvel.

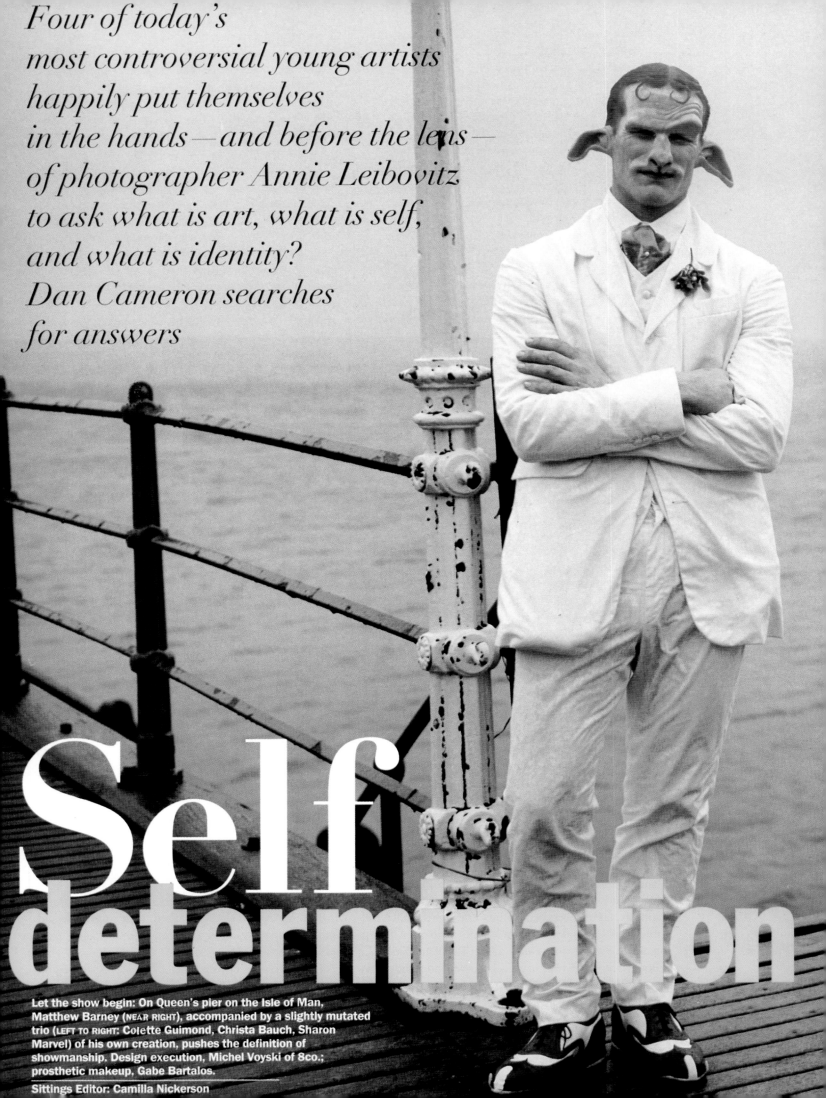

Four of today's most controversial young artists happily put themselves in the hands—and before the lens—of photographer Annie Leibovitz to ask what is art, what is self, and what is identity? Dan Cameron searches for answers

Self
determination

Let the show begin: On Queen's pier on the Isle of Man, Matthew Barney (NEAR RIGHT), accompanied by a slightly mutated trio (LEFT TO RIGHT: Colette Guimond, Christa Bauch, Sharon Marvel) of his own creation, pushes the definition of showmanship. Design execution, Michel Voyski of 8co.; prosthetic makeup, Gabe Bartalos.

Sittings Editor: Camilla Nickerson

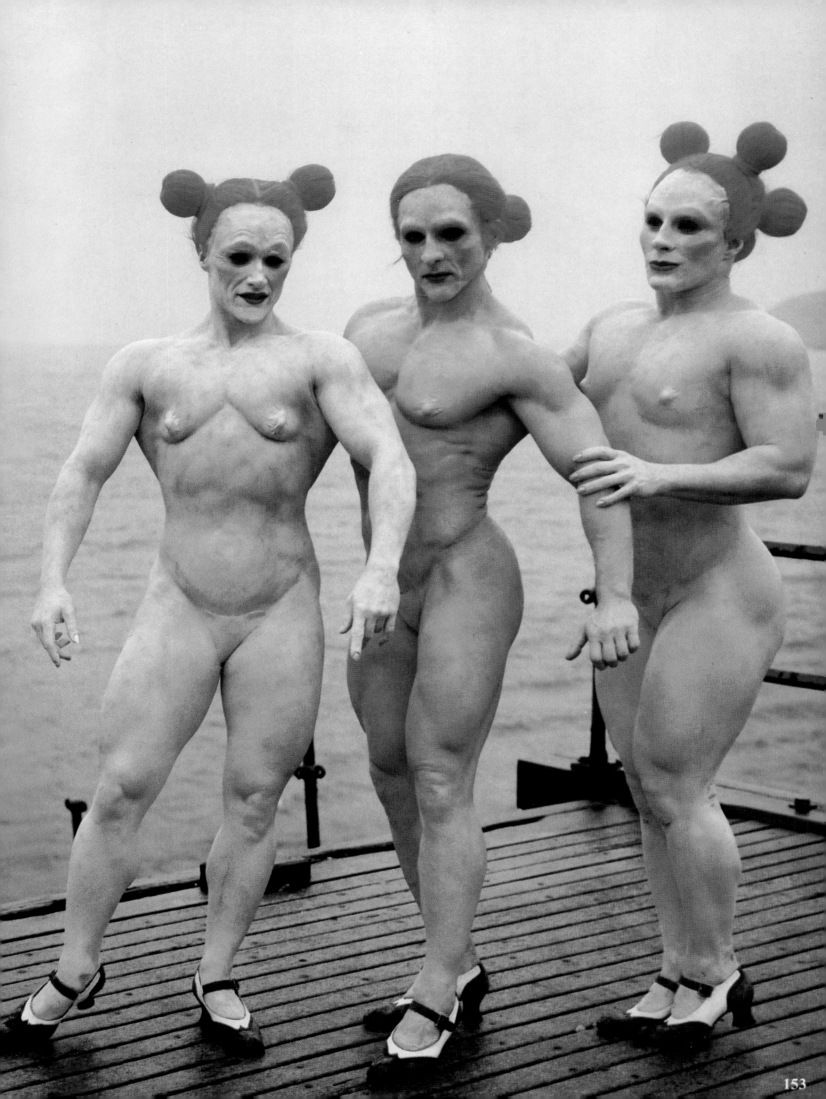

Tina George
wrestler

THE BODY FANTASTIC
Wrestler Tina George
(above, left) and swimmer
Natalie Coughlin (above,
right) were among the
American athletes that Annie
Leibovitz shot for a July
2004 story on the XXVIII
Summer Olympics.

FASHION FRONTIERS
With the headline "The
Cutting Edge," this story,
shot by Annie Leibovitz with
fashions by Rei Kawakubo
for Comme des Garçons,
was published in September
1997.

were outstanding. By 1987 she was creating eye-catching advertising campaigns for clients including American Express, GAP, and the Milk Board. In addition to her work for *Vogue* and *Vanity Fair*, she has published several books of photographs, among them *Olympic Portraits* (1996), *Women* (1999), and *American Music* (2003).

Even as she acquired an eminence comparable only to Richard Avedon's, Annie still had doubts about the career path she had taken: "Suddenly I was selling pictures when the photographers I admire, like Diane Arbus and Cartier-Bresson, were not photographers who worked for magazines. I wondered if I was betraying my principles." However, she progressively reconciled her life and artistic vision, splashing her work with touches of

humor and fantasy. She was praised in the *New York Times* for her "extraordinary ability to inspire her subjects to show themselves as they are," an ability that has made her one of the greatest portrait artists of the century.

As early as 1973 Leibovitz wrote in her book *Shooting Stars*, "When I say I want to photograph someone, what it really means is that I'd like to know them," and she has been faithful to that concept all her professional life. She claims she is not a hundred percent comfortable with traditional glamour. "Accordingly," wrote Ben Brantley, in *Vanity Fair*, reviewing a Leibovitz retrospective, "her work is seldom just glamorous; there's always a touch of grit amid the stardust."

VIVE LE ROI
For this October 1999 story Annie Leibovitz paired Sean "Puffy" Combs, shown here in a fox coat made exclusively for him by Nija Furs, with model Kate Moss in an Emanuel Ungaro Haute Couture coat. Combs had launched his own U.S. men's clothing line Sean John in the spring of that year.

(OVERLEAF)
THE DREAMLIFE OF ANGELS
The following pages show Kate Moss from the same story wearing Lagerfeld's cream chiffon crisscross column with a flowing train, described by *Vogue* as "an exercise in unrestrained luxury."

HOW THE MAGAZINE OF THE NEW CENTURY IS PUT TOGETHER

Anna Wintour's view of her job is informed by a very twenty-first-century perception. As she puts it, "*Vogue* today is much more than a magazine. It is a superbrand." Since the turn of the millennium, in fact, the inherent power of *Vogue* has been extended to reach new audiences, both in America and globally. At home, *Teen Vogue* and *Men's Vogue* have sprung out of what, in the office, is now known as "big *Vogue*." Its influence has been broadened through its fashion-reporting internet site, www.style.com, and new editions are being launched at a rapid rate in South America, Europe, and emerging markets such as China, with India to follow.

Against the backdrop of all that outward activity, however, Wintour's equally important belief is that the inner character of *Vogue* must stay true to itself, with a focus that is, if anything, more defined than ever. "Throughout *Vogue*'s history," Wintour reflects, "the mission has remained constant: to celebrate what is beautiful, creative, innovative, and exciting, and to do so in collaboration with the most gifted artistic talents. I feel very fortunate to be able to play a part in this story. In a world flooded with information, images, and opinions about fashion, I have to think how *Vogue* maintains its authority, what values sustain us, and how

they evolve in the constant flux of modern culture. The final question for me as custodian of this brand is: What is *Vogue*? That's what keeps me coming to work every day—and every time I think I've finally understood it, something new, unexpected, wonderful teaches me otherwise."

A cornerstone of the *Vogue* outlook, now as always, is the energy it brings to fashion. *Vogue*'s "positive edit"—a process that identifies the strongest ideas and filters out the rest—establishes a direction in which the season is navigated for the reader. "A magazine like ours should be positive about fashion," Wintour says. "It's the newspapers' job to critique fashion shows. Our approach is to create a positive message and de-emphasize other things we don't find significant." That does not imply a narrowness of content, or a conservative tendency to stay with the tried-and-tested. On the contrary, Wintour's *Vogue* scans the broadest horizons: "Everything that happens in fashion is of interest to our readers. We've backed a lot of designers before they became famous, like John Galliano and Marc Jacobs or the new crop of young Americans like Proenza Schouler and Zac Posen. But if there is a subject or a person that will matter in fashion, we find it first, and report it, from our own

SUMMER TRENDS
Steven Meisel shot this elegant beachware ensemble for the June 2005 issue. The model wears a Jil Sander ruffled shirt over a Graham Kandiah fern bikini and her hat is by Stetson "Modern" Collection.

(OVERLEAF)
WATER BALLET
This poolside image from an Annie Leibovitz portfolio published in September 2000 shows Mikhail Baryshnikov gracefully diving into a pool, watched by designer Oscar de la Renta, who has dressed the three elegantly gowned members of what he calls "the new generation of New York working women," represented here by Eliza Reed Bolen, Aerin Lauder, and Marina Rust.

SCHNABEL'S

The pursuit of the beautiful Spanish model Olatz was a long and diligent quest for artist Julian Schnabel. His success, DODIE KAZANJIAN finds, has yielded a happy marriage, two sons, and the transformation of his New York living space into a palace worthy of the grandest grandee. Photographed by François Halard.

SPANiSH
MiSSiON

OPEN HOUSE
Artist Julian Schnabel and his wife, Olatz, are seen in their lavish New York apartment in this story, published in January 1995 and photographed by François Halard.

PARADISE IN PROVENCE
This fabulous getaway in the south of France was photographed by François Halard for the September 2004 issue.

angle." The scope now reflects readers' global interests and the notion that they will incorporate good ideas from everywhere into their lives. Fashion trends are documented from as far afield as Shanghai, Dubai, Hungary, and Moscow, and informed attention is drawn to creative forces that are reconfiguring the mass-market landscape on the domestic front.

Structurally, the magazine falls into three major editorial-visual areas: the "front of the book," known as FOB in internal magazine jargon, which is interspersed with advertisements; the "well," or center of the book, COB, where most long features are located, uninterrupted by ads; and the "back of the book," abbreviated BOB, where advertising is also placed.

The front of the book contains fashion news articles, together with a cultural section, and commentaries on food, health, beauty, and fitness. It also contains two columns that have many followers—"Life with André," written by fashion authority and *Vogue* editor at large André Leon Talley, and "Norwich Notes," written by social diarist and *Vogue* contributing editor William Norwich.

The well alternates fashion with features: interviews with designers, artists, celebrities, and personalities of the moment, articles about the cultural world, and photo-driven stories about houses and gardens. Once a year, in the June issue, an "Escapes" theme focuses on "visual vacations," which mix travel reportage with fashion shoots inspired by exotic locations.

The final section of the magazine, the back of the book, opens with "Index," a practical shopping section that,

according to managing editor Laurie Jones, "is not a mere catalog of merchandise but an informative editorial product, containing the chicest items and accessories that have been carefully selected by *Vogue* editors." The magazine ends with a one-page "Last Look," which is generally dedicated to a single, luxurious fashion accessory.

The behind-the-scenes details of how clothes are chosen, how the fashion and cover shoots are put together, how a celebrity is selected for the cover, and how pages are laid out to deliver the best possible visual impact sums up Anna Wintour's editorial vision: "Aim high—very high. Our readers come to *Vogue* to know whether, say, platform shoes and belts are back. But they also expect us to surprise them."

the young master

With the technique of the old masters and the sensibility of high kitsch, Dodie Kazanjian writes, John Currin is reinventing a lost art. Photographed by Jonathan Becker.

ARTS AND ARTISTS
The magazine continues the tradition, started by Alexander Liberman, of bringing the arts, artists, and culture to its pages, as shown by this piece about John Currin photographed by Jonathan Becker for the November 2000 issue.

***t**he guest book of Janet de Botton's dazzling manse in the South of France says it all. Within its Florentine-paper bindings the Red Hot Chili Peppers' anarchic Anthony Kiedis finds an unlikely page mate in the form of dream jeweler Joel Rosenthal of JAR. A sketch by Damien Hirst of a female torso, with fresh-hacked limbs sprouting fountains of blood, is a startling thank-you that jostles eulogies from some of the haute monde's most exacting boldfaced names. But perhaps the rococo volutes of decorator and society scribe Nicholas Haslam's script, wittily paraphrasing Cole Porter, best evoke the magic of the house and its chatelaine:

"It's delightful, it's delicious,
It's South of France, it's de paradise,
It's de Botton, it's de-best, it's de-luxe,
It's de-lovely—"

As her guest book suggests, de Botton is not afraid to mix it up. This stylish Englishwoman is a discriminating art collector in whose London town house works by Francis Bacon and Chris Ofili make unexpected wall mates, and giltwood furnishings of royal provenance, signed by the great eighteenth-century French makers, join the monolithic marble seats of sculptor Scott Burton. De Botton is also smart as a whip—she has a professional bridge team that plays at championship level. She met her match in the charismatic Gilbert de Botton, to whom she was married for ten years before his death in 2000. Born in Alexandria, that subtle, cosmopolitan and mysterious city, de Botton was a visionary financier who shared his wife's passion for art—he was the only man to have been painted by both Lucian Freud and Francis Bacon. The house's library is a testament to his bounding erudition. "I spent hours up a ladder just looking at the titles," says Haslam. "He had such an extraordinary breadth of knowledge."

A decade ago, Gilbert de Botton discovered that the Burgundy château that had once been the home of Montaigne, the sixteenth-century essayist, was on the market. Seduced by the intellectual idea of recreating a library worthy of its former resident, de Botton determined to acquire it. Janet, however, had no intention of spending her time in staid, inclement Burgundy.

SET FOR A FEAST
Alfresco dining on the vine-shaded terrace. De Botton found the linen tablecloth in Lerici. The glazed ceramic plates are by Mary Day Lanier.

772

"I didn't want an uptight house," says de Botton. "I wanted light and spaciousness. And I want people to feel they can do what they want to do"

"Étonne-moi was the theme," de Botton's collaborator says. "Janet is someone who loves to be amazed—but never surprised"

THE FINEST THINGS
THIS PAGE: The provincial Louis XV canvas panels in the dining room were found at Monluc, Paris. The Louis XVI chairs, in their original Aubusson tapestry, at Christie's, London. The mid-18th-century stone dolphin was found at Houdan. *OPPOSITE* PAGE: Lavinia roses flank the entrance to the main allée of the endless rose pergola, underplanted with irises, in the potager.

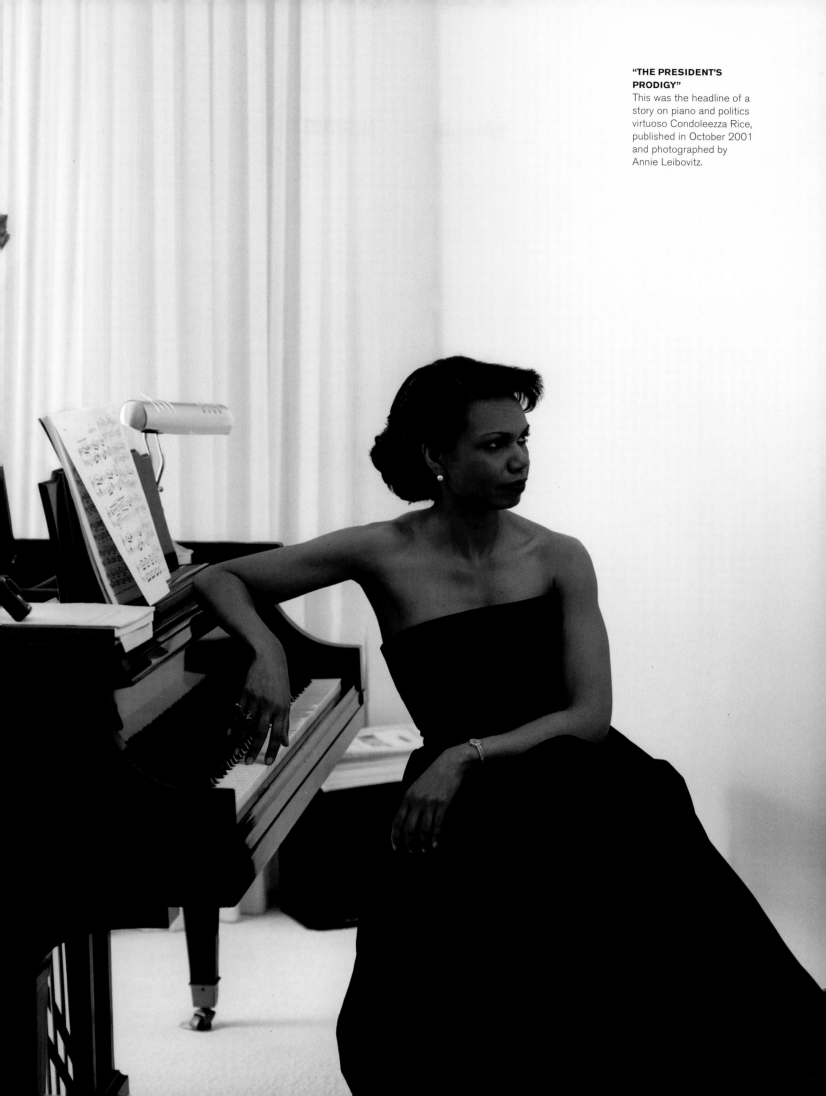

"THE PRESIDENT'S PRODIGY"
This was the headline of a story on piano and politics virtuoso Condoleezza Rice, published in October 2001 and photographed by Annie Leibovitz.

BEHIND THE SCENES AT
A FASHION SHOOT

Fashion Week takes place in New York in February and September, followed by shows in London, Milan, and Paris. With the exception of the fashion shows in New York, which are attended by the entire fashion department of the magazine, attendance depends largely on the schedules and work commitments of each editor. Fashion director Tonne Goodman explains, "Anna Wintour's policy is to personally attend as many shows as she can in New York, London, Milan, and Paris. She's particularly interested in seeing and meeting young designers who are being talked about. Her outlook is quite egalitarian."

Informal reactions are exchanged by the editors during the shows, and a formal evaluation takes place in a post-collections meeting after the staff returns to New York. "It is then that we examine all the information we've gathered and exchange opinions. We put all ideas on the table and start to decide the content of the stories, the designers, and the trends that we are going to cover as well as the ones we are discarding," continues Goodman. The members of the team do not always agree, but there is sufficient flexibility to make possible a general consensus. "One of Anna's great talents is to line up a team that represents the different approaches she wants," Goodman adds.

As the fashion stories are planned, Virginia Smith, fashion market/accessories director, assembles "boards" to present to Wintour. A breakdown of each story is mounted on a pinboard, with photographs copied from the designers' "look books," which show the collections piece by piece, or downloaded from *Vogue*'s style.com website. When the clothes themselves start to arrive from designers, the fashion assistants put together cloth-

ing racks for the shoots. On a single day at the peak of the season, fifty or more racks might be put together, comprising clothes and accessories, as the fashion team processes several stories simultaneously, sometimes for different issues. The contents of all these racks are viewed and vetted by Anna Wintour, sometimes in the form of a run-through with a model in Wintour's office. "We do a run-through for different reasons," says Goodman. "One is to judge how the pieces we've selected really work on the body. Another is when a celebrity can't be present for a fitting and we use a stand-in to help us finalize the look and the accessories."

Anyone leafing through the eighteen pages of the Chekhovian-Victorian-romantic story titled "A Grand Affair" in the September 2005 issue of *Vogue*, photographed by Steven Klein with Grace Coddington as the fashion editor, could hardly imagine the degree of research and hard work behind the scenes, the level of creativity, the on-the-spot trouble-shooting, and the highly complicated logistics that took place before it reached the reader.

The project started when the young Belgian designer Olivier Theyskens presented a collection inspired by the plays of Anton Chekhov for Rochas in Paris. Coddington began her research by renting a couple of films of Chekhov plays, including *The Cherry Orchard*, in order to study the looks, postures, and movements of Russian women at the end of the nineteenth century. She and Klein watched the films to establish the initial outline, atmosphere, and direction of their story.

"In the beginning we thought of doing the shoot in Russia," says Coddington, "but it would have been very expensive, and I know from experience that

Russian customs take forever to release clothes and cameras. The second option was Canada, where you can also find big Chekhovian trees resembling the Russian ones. But we had a very big production team and five models, and we realized that this would also require a very large budget." Klein then suggested doing the shoot near New York, in Long Island's wooded area, whose trees obviously do not have the dimensions of those in Russia or Canada, but they had a particular visual appeal because they had been burned by wildfires. But after exploring the location, Coddington recalls, "We soon realized that it wasn't going to work either, since the logistics became highly complicated with those heavy, big dresses, and models in high heels who would have a terrible time moving around. On top of all of this, the temperatures were getting higher, and the summer storms forecast for the days of the shoot obliged us to shoot in a studio. Of course, we were doing everything that Anna didn't want us to do—she wanted outdoor shots with a lot of energy and movement—but given the circumstances, the studio and the Hollywood setup was our best option."

The choice fell to the Steiner Studios in the old Brooklyn Navy Yard, a complex of five state-of-the-art soundstages generally used to shoot movies. Indeed, the set prepared by the *Vogue* team looked like it could have been made for a major Hollywood production. A total of forty people moved between three clearly defined spaces. The central one, where the photo shoot took place, had two cameras (a Mamiya RZ and a SINAR 8x10) surrounded by dozens of lights and five gigantic Briese Focus 220-H umbrellas. Then there were two hangars, one where all the clothes were arranged and where the models dressed and

STORYBOARDS

Upon returning from the collections, the *Vogue* fashion team identifies the trends and designers of the moment and puts together storyboards with pictures from "look books" the editors receive at the show. Later, clothes are requested and fashion shoots are scheduled. This storyboard shows a "Chekhov" look of long, dark dresses with high collars.

VISUAL RESEARCH

In doing research for the photo shoot, one of the art books consulted by set designer Mary Howard and photographer Steven Klein was Christopher Wood's *The Pre-Raphaelites* (bottom, right), in which they found inspiration for the models' poses and hand movements realized in the finished take (bottom, left). Sixteen outfits, eight of them designed for *Vogue*, were selected for the shoot.

ROCHAS CHEKOV

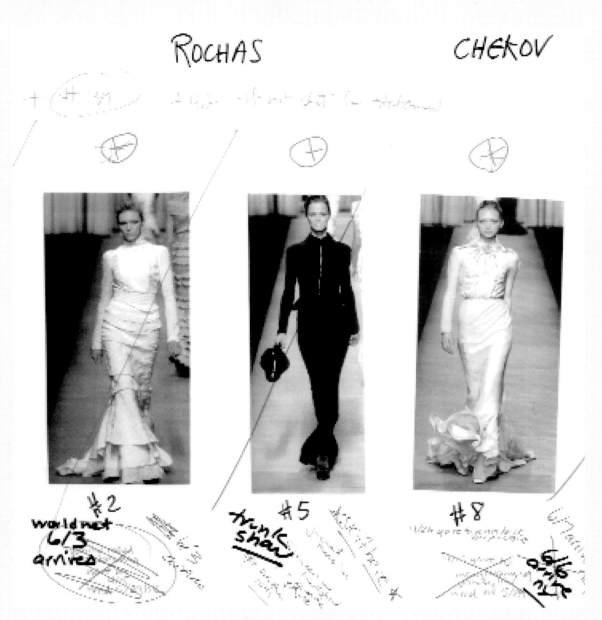

RETHINKING THE STORY
When Wintour reviewed the photos from the shoot she found them too formal and lacking in energy so the story was re-thought and reduced in scale. Using only one model, and a fraction of the wardrobe, the story was shot over and moved from the studio to the outdoors. Top, right, Natalia is in an Alexander McQueen silk-taffeta jacket and pleated bustier dress. In the larger photograph at bottom, she wears a Rochas silk jacket and skirt.

had their hair and makeup done, and another where carpenters, prop handlers, and mechanics worked putting together or altering the set under the direction of set designer Mary Howard.

To one side of the studio entrance, on a large table, forty-one pieces of antique jewelry, loaned by Fred Leighton and valued at more than $2.5 million, were laid out. These items required the vigilance of two armed guards who never left their posts. Every time Coddington came to pick up a jewel, one of the guards would mark a photo of the item with the time it was picked up; he did the same when it was returned. "Fred Leighton has an agreement with the magazine that allows us to use and show their jewelry in our fashion shoots," explains fashion assistant Michal Saad, "but *Vogue* has to take care of the insurance costs, which are very high, for transporting the pieces from their store on Madison Avenue to the selected location."

The objective was to take double-spread photographs in three days to fill a total of sixteen pages, at the rate of two setups a day. Smith and Coddington had chosen some sixteen outfits, eight of them designed in part for *Vogue*: a pink one by Dior, a red one by Alexander McQueen, others in gray by Carolina Herrera and Peter Som, white dresses by Tuleh, prints by Prada, and a white fur by Vera Wang. Klein worked eight hours a day with five assistants, two of them in charge of cameras, lighting, and measurements, one serving as a gaffer, and two others devoting themselves exclusively to the computer and digital equipment installed on yet another large table adjacent to the main set. On that table was also an impressive color printer and hundreds of color cartridges, where prints were constantly checked by Klein and his assistants

as soon as they finished a take. Howard's team, which consisted of ten people, had created a charming winter forest with a lake. The rest of the personnel involved in the production were the five models, three makeup artists under Peter Phillips, three hairdressers under Julien D'ys, two Fred Leighton guards, two fashion editors, several chauffeurs for the Lincoln Town Cars that were made available all day long, and the caterers providing food for forty people.

A book brought by Howard, Christopher Wood's *The Pre-Raphaelites*, circulated on the set and was repeatedly consulted. Howard, trained in art history, is renowned among photographers for her high-quality research. "It was a great source of inspiration to see the poses, the body and hand movements of the women in the paintings, so that our models could imitate or reinvent them," says Klein.

Each finished take was printed and hung from a corkboard, so the entire technical and creative teams could appreciate the results of the day's session and follow the direction of the story. Back at *Vogue*, however, Anna Wintour found the photographs too static, too formal, and lacking the energy she looks for in a portfolio. Result: Everything was to be done over, using only a part of the approved wardrobe, and only one model, the Russian Natalia Vodianova, Calvin Klein's model and one of the current faces of the L'Oréal advertising campaigns. This time it was to be done outdoors, with a smaller production team, at the West Kill Farm owned by Klein in Bridgehampton on Long Island, where Klein's horses and dogs became central characters together with Vodianova and her British husband, Justin Portman. Klein and Coddington worked without a set

The 1870s romantic heroine takes a twenty-first-century beau—proving that highly dramatic, ground-sweeping looks do work brilliantly today. Photographed by Steven

Alexander Mcqueen Chekhov

#57 #38 #39

FORCE OF HABIT
No fashion idea right now is stronger than that of "restraint," as exemplified by the tight contours of this Parisian suit modeled after a 19th-century riding habit. Rochas silk jacket ($2,660) and skirt ($2,995); (888) 8-BARNEYS; Blake, Chicago. Details, see In This Issue.
Fashion Editor: Grace Coddington.

and affair

designer, and this time the computer and digital equipment were portable, surrounded by black curtains to shut out light from the screen and allow perfect definition when the moment came to evaluate a take.

Using two cameras, a Mark II and a Hasselblad, both digital, the team worked on six or seven real-life scenes: Natalia washing her horse and turning the hose on a bunch of nearby youngsters who are looking at the flowers while her husband lies on the grass; jumping on a trampoline while her husband tries to hold her up; with a riding crop to encourage one of the horses to jump (in the image, the horse practically seems to fly); repairing a flat tire on an old car while her husband watches her, bored and anxious, from behind the steering wheel; sitting at a table with a group of people; wearing an evening dress and walking toward a stable as one of the horses looks at her with an awed expression. "I prefer to mix elements of reality with artifice to create a tension of contradiction," Klein comments—his own country house, horses (Typhoon, Paloma, and Ladisko), and three Great Danes. Although the production arrived at the last minute before closing the September 2005 issue, Anna Wintour was charmed by the photographs.

A GRAND AFFAIR
The resulting story was shot on the grounds of Klein's Bridgehampton country house with a cast that included Klein's horses, Great Danes, model Natalia Vodianova, and her husband, Justin Portman. In the larger picture above Natalia wears a Peter Som black silk coat and ivory silk skirt. Fashions in the smaller photograph, far left, include a Vivienne Westwood Gold Label white silk top and paneled skirt; middle, a dress by Rei Kawakubo for Comme des Garçons; and a Carolina Herrera riding jacket and skirt. In the larger photograph at right the model wears a Calvin Klein Collection silk dress, and, below, a Dennis Basso sable coat over a Marc Jacobs Collection silk dress.

BEAUTY, HEALTH, AND FITNESS

Irving Penn primarily shoots photos to illustrate beauty, health, and fitness topics. Penn's *Vogue* editor is Phyllis Posnick. Posnick first worked for *Vogue* as assistant to editor in chief Diana Vreeland and later to editor Babs Simpson; after a period at Calvin Klein, she rejoined the magazine in 1987 and is now executive fashion editor. "Phyllis is a very careful editor and very creative," says Wintour, "and we talk a lot about these pictures. The most successful shoots are the ones that are thought through, which does not mean that we rule out some element of surprise, but we like to plan them carefully."

A good example of how this part of the magazine functions visually, and of the demands made on the editors' and the photographers' imaginations, was a story on how to protect a woman's skin in winter. "The Beauty Editor told me all the products were invisible on the skin, which is difficult to illustrate, as you can imagine. I found a clear plastic mask in a theatrical costume shop and showed it to Penn. He thought this was a good solution to the problem and thought that we needed strong color on the face to make the clear mask really

visible," Posnick recalls. The result was excellent: a face used as a palette for several colored layers of makeup under the mask, making it look more like a painting.

Another example was a story on excessive facial treatments, a challenging assignment. Discussing the possibilities of the subject with Posnick, Penn asked, "What happens when a woman does too many of these treatments?" The editor answered, "Then you don't have much of a face left." Penn thought an old football with lace stitching covering a model's face would illustrate this point perfectly. "We found the football, cut it in half, booked a sympathetic model who was willing to wear it, and photographed her as if she was wearing couture," says Posnick. The final photograph was a success, which not only was published in the magazine to illustrate the article but was enlarged into a giant poster that, to this day, hangs on a wall of the art department on the twelfth floor.

"To illustrate these articles is a process that often requires several meetings with Penn, and a runthru day, to be sure that what we imagine looks as interesting in reality," says Posnick. For an article on osteoporosis, Penn assembled a still life of

DAMAGE CONTROL
Penn's interpretation of the dangers of overprocessed skin, published in November 2002.

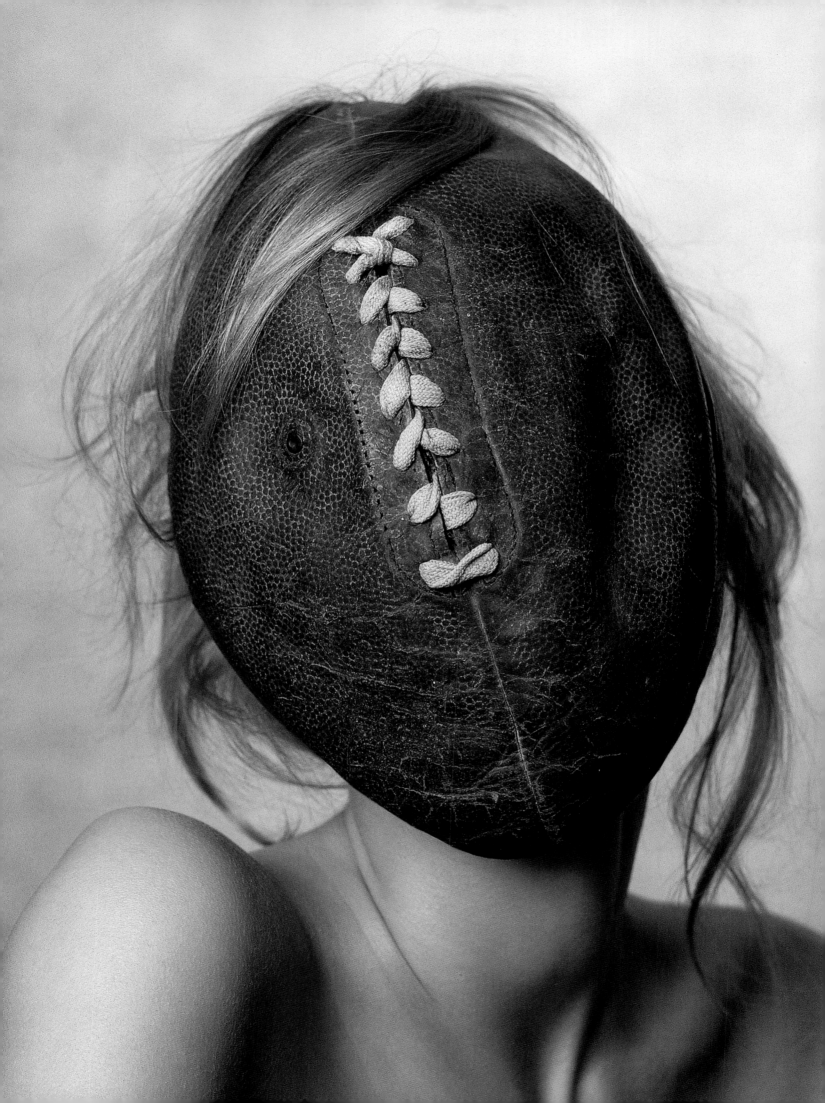

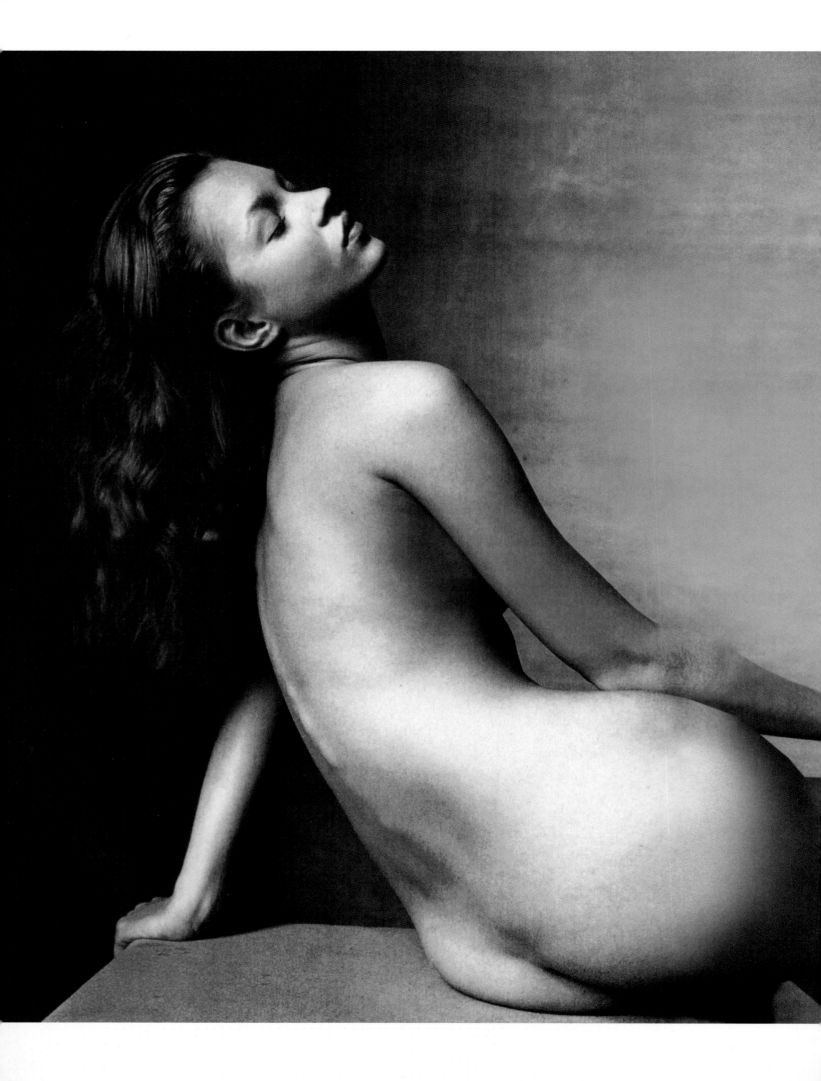

STRUCTURAL SUPPORT
Foods such as figs, tofu, and salmon help strengthen the bones—that is the message of this September 1998 picture by Irving Penn to illustrate a story about osteoporosis.

a piece of salmon, tofu, and a fig. Another visual challenge for the team was to illustrate an article on birth control. "We decided to illustrate it the old-fashioned way . . . with a chastity belt," said Posnick. The chastity belt in the picture is an antique and the real thing. Penn looked at the metal belt, did a drawing, and that was the picture.

Something similar occurred with an article about women who do not use makeup. The challenge here was that they would look too pale and thus deprive the photograph of much of its visual impact. "André Leon Talley came up with the idea of the 'Flemish face' based on Vermeer paintings and other artists of that era, who used to paint their subjects with a clean face," Posnick explains. Penn then proceeded to take a photograph that looked very much like a Vermeer painting. "Obviously, a lot of these images are not so much based on reality," comments Wintour. "They are about where Mr. Penn's imagination takes you."

THE BODY BEAUTIFUL
Kate Moss's natural grace is captured here by Irving Penn for the September 1996 issue.

THE TREATMENT OF TEXTS

COMPLETE MAKEOVER
In November 2003 *Vogue* ran a story, written by Julia Reed and photographed by Jonathan Becker, about the Kabul Beauty School in Afghanistan, during the Taliban regime.

In *Alex*, Dodie Kazanjian and Calvin Tomkins's biography of Alexander Liberman, the longtime editorial director of Condé Nast discussed the magazine's cultural and intellectual content: "I used to think we were communicating civilization, communicating culture, treating women in a serious way by offering them intelligent features. I even thought that by publishing all those essays and photographs on arts and artists—not frivolous artists . . . but the major School of Paris masters, and Rauschenberg and Johns, and Richard Serra, and de Kooning and Newman and Rothko—that we were performing a real service, because one of the magical things about exposing people to art is that art allows you to dare, and maybe, maybe, maybe some of that remains and the reader is subliminally altered."

Maintaining the spirit of Liberman's words, editor in chief Anna Wintour demands the same excellence and variety in *Vogue*'s texts as in the visuals. "The essence of *Vogue* is about being as smart, beautiful, healthy, and inspired as you can be," she says. The pieces must conform to *Vogue*'s journalistic gold standard of engaging in current cultural debate, from art and design to politics and science. *Vogue*'s reputation as a widely read, influential forum for intelligent writing frequently paves the way for exclusive access to extraordinary women at the forefront of every field, up to and including First Ladies.

Wintour's instinct for great journalism means she goes to great lengths to commission stories. "When we cover politics, no expense is spared: We

AIDS IN INDIA
Vogue's content includes reportage on current events explored in great depth and often specifically from a women's point of view. This December 2004 story (below) about AIDS in India, which mostly hits women and children, was written by Janine di Giovanni and photographed by Alex Majoli.

GONE BUT NOT FORGOTTEN
Darulaman Palace, which was once one of Kabul's grandest buildings, has been destroyed by years of war.

She gives off an
enormous, focused
energy and,
oddly enough, a kind
of radiant peace

send our reporters to Africa and South
America and the Middle East to meet
heads of state, terrorists, and humani-
tarians," she says. *Vogue*'s point of
view also includes moving reportage
of current events explored in depth,
and often from a specific woman's
point of view, such as the December
2004 piece by Janine di Giovanni
about the effect of AIDS on women
in India, or the November 2005 article
by Julia Reed on the devastation of
her hometown, New Orleans.

These probing pieces are comple-
mented by more inward-looking first-
person reflections in the Up Front
section. High-caliber specialist writing
runs from investigations of medical
and pharmaceutical developments
that will impact readers' health to
the entertaining erudition of Jeffrey
Steingarten on food. Every issue
is balanced to be enriching and sur-
prising—and to never lose sight of
Wintour's perception of the *Vogue*
reader as a woman who views life
with both intelligence and humor.

INTIMATE PORTRAIT
Laura Bush in the private quarters of the White House (below), on the eve of a second presidential term, was taken by Annie Leibovitz for the January 2005 issue. Mrs. Bush wears a silk dress by Oscar de la Renta.

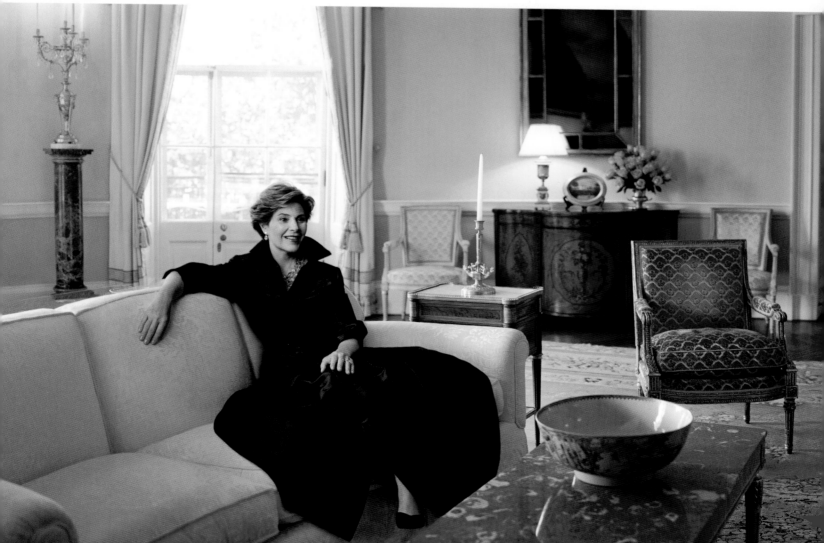

THE DESIGN COMMANDMENTS

Design director Charles Churchward is an important *Vogue* principal. Churchward's collaboration with the editorial team is a critical element in the *Vogue* creative process. His presence and opinions are crucial, to the point that he participates in editorial meetings and most cover shoots. Churchward is often consulted by Anna Wintour, whether about wardrobe and accessories, run-throughs, photo selection, or anything that may have to do with the look of the magazine.

After graduating from Pratt Institute and working as art director at *The Herald*, a local metropolitan newspaper, Churchward spent the next decade helping a number of modern-day glossy magazines evolve from the planning room to the newsstand. From *Ms.* to *Mademoiselle* to the *New York Times Magazine* to *House and Garden*, he worked closely with such top art directors as Bea Feitler, Ruth Ansel, and Alexander Liberman. "Around the mid-seventies I was lucky enough to be hired as a designer at *Mademoiselle*," says Churchward. "It was my first job at Condé Nast and a very exciting moment in my professional career, since right at that time Alex Liberman was using that magazine as a test lab for the changes he would later introduce in *Vogue*."

In 1984 he joined the staff of *Vanity Fair*, progressing from art director to design director, a position he held for the next eleven years. In 1995 he became design director at *Vogue*, the flagship of all the Condé Nast publications, where more recently he also helped launch *Teen Vogue*. In addition to receiving various prestigious awards from the industry, Churchward edited and designed the book *THEN: The Photographs of Alexander Liberman* and was a substantial contributor to Harold Evans's *The American Century*.

"My design philosophy at *Vogue* is based on a very simple set of rules," explains Churchward. "First of all, I don't want it to be pure design. Second, it should not be too trendy, because when you're working for the fashion world, where trends change all the time and are in constant movement, something has to stay stable in the packaging. And I'm basically a packager as much as a designer. I have to make a package that is familiar to everybody at all times. Therefore, there are a few chosen typefaces, there are a few chosen formats. My approach is to react to the photographs first. I would never do a design without looking first at the photos, one of the many useful things I learned from Alex Liberman."

When the pictures arrive, Churchward and Wintour exchange opinions about the ones they like. Churchward often designs layouts according to Liberman's collage style, albeit with contemporary touches. The mechanics consist of moving the prints within the box, experimenting with enlarging or reducing or overlapping them until the best size, position, and symmetry are achieved. Besides this, there are also a couple of design commandments at *Vogue*: "We have a few basic typefaces that I change over time," says Churchward. "But I do not want to experiment every month, because you would have chaos. Photography

NEW YEAR RESOLUTIONS
This picture, taken by Helmut Newton for the January 1997 issue, illustrates an article about new sports that get you out of the gym, such as fencing. The models are in Dolce & Gabbana dresses.

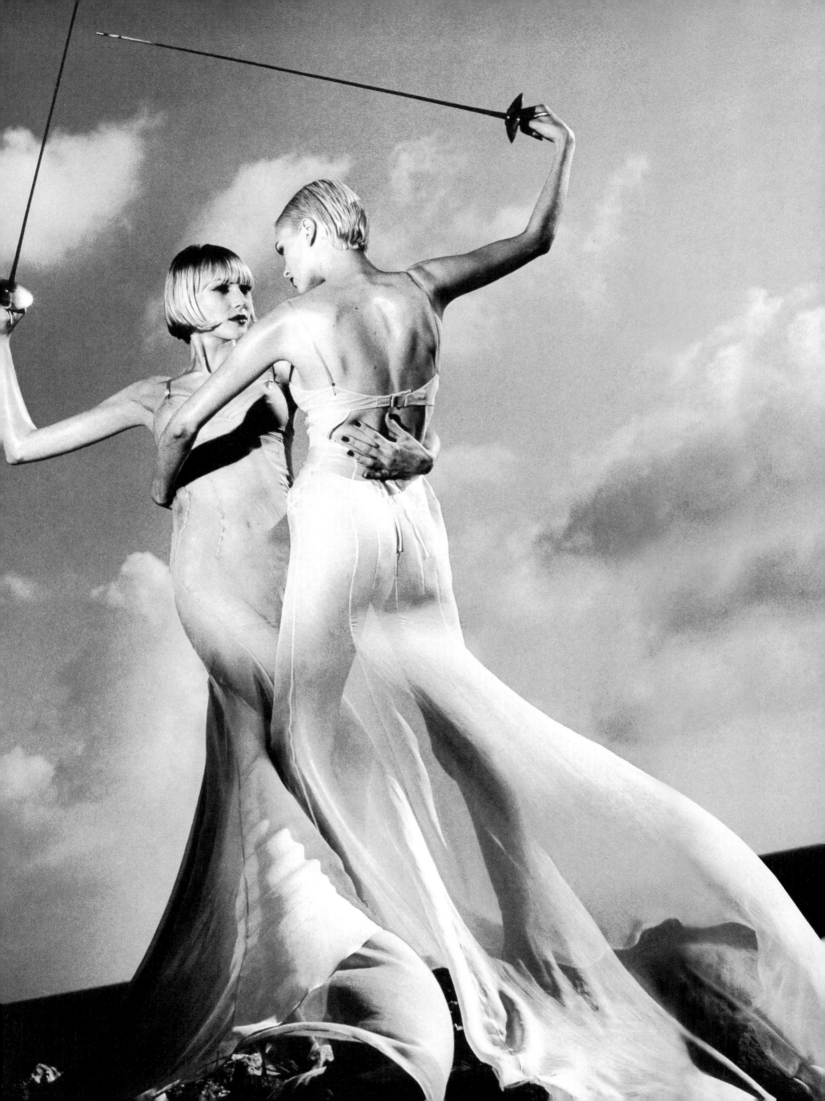

No one goes to more parties than *Vogue*. For more than a century, the magazine has documented soirees both refined and raucous. HAMISH BOWLES chronicles the best of the brightest.

A Thousand and One Nights Out

"Couples in the eighties were kept at arm's length from each other by the pouf of a Lacroix skirt"

"At Capote's Black and White ball the effect was like some blend of Hollywood, the Court of Louis XIV, a medieval durbar, and pure Manhattan"

Who said the eighties were dead? Benefits and perfume launches in the nineties reflect the ascendancy of the fashion world

A THOUSAND AND ONE NIGHTS OUT
Churchward applied Liberman's collage technique with contemporary touches to design this December 1997 piece about parties attended by *Vogue* for more than a century.

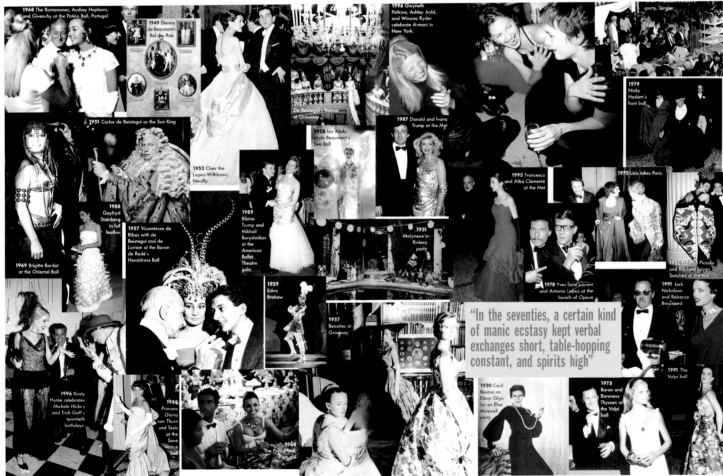

1968 The Romanones, Audrey Hepburn, and Givenchy at the Patiño Ball, Portugal

1949 Étienne de Beaumont's Bal des Rois

1996 Gwyneth Paltrow, Ashley Judd, and Winona Ryder celebrate Armani in New York.

party, Tangier

1951 Carlos de Beistegui as the Sun King

1957 De Beistegui's theater at Groussay

1928 Iya Abdy at de Beaumont's Sea Ball

1987 Donald and Ivana Trump at the Met

1979 Nicky Haslam's hunt ball

1952 Chez the Lopez-Willshaws, Neuilly

1988 Gayfryd Steinberg in full feather

1957 Vicomtesse de Ribes with de Beistegui and de Larrain at the Baron de Redé's Headdress Ball

1989 Blaine Trump and Mikhail Baryshnikov at the American Ballet Theatre gala

1931 Molyneux's Riviera party

1995 Francesco and Alba Clemente at the Met

1972 Liza takes Paris.

1969 Brigitte Bardot at the Oriental Ball

1929 Edna Brokaw

1957 Beauties at Groussay

1978 Yves Saint Laurent and Antonio Lopez at the launch of Opium

1980 Paloma Picasso and Raphael Lopez Sanchez at the Met

1991 Jack Nicholson and Rebecca Broussard

"In the seventies, a certain kind of manic ecstasy kept verbal exchanges short, table-hopping constant, and spirits high"

1996 Kirsty Hume celebrates Michele Hicks's and Trish Goff's twentieth birthdays

1988 Princess Gloria von Thurn und Taxis at the Save Venice ball

1968 The Patiño Ball, Portugal

1930 Cecil Beaton as Elinor Glyn for an Elsa Maxwell party

1973 Baron and Baroness Thyssen at the Volpi ball

1991 The Volpi ball

should be in color, and, if in black and white, it should not have too much pretension. There has to be an immediacy, a familiarity for people to see it and react to it. It shouldn't be too distant or too dark. It also shouldn't be too remote, removed from everyday life, unless it is a true fantasy. And one crucial thing," he adds. "Readers should identify with the clothes and the stories."

After the pages are designed, layouts are reduced to twenty-five percent of their size, and are placed on a magnetized board in the planning room to create miniboards of the layout, which can then be arranged and moved around. "It's like a puzzle or a game," explains Churchward. "We change and move pieces day and night. Sometimes we have to make them more journalistic, putting little flags on them or changing display type to achieve the desired unity and the right pacing of the editorial well and the whole book."

Churchward points out that he learned two major things from fashion magazines. "One is that you have to give some form of fantasy because you're selling clothes every season; you need it to make people believe in the fashion. The second is that you have to be able to show how to wear the clothes. We should be able to show an outfit from head to toe if possible, because the readers want to see what the hair looks like, and to know what shoes to wear with the clothes. You have to be very realistic about this. The design should be at the service of that need. In that way, the key factor in a *Vogue* design is a balance of fantasy and education. Deep down, at least one of these components should always be there. Everything else is extra."

Vogue has not had a complete redesign in many years. The format works successfully to answer the magazine's needs. "We added the

GOOD DESIGN
The opening pages to a story about facials at the Avon Centre, photographed by Raymond Meier for the March 1999 issue, illustrates how three of *Vogue*'s basic display typefaces are integrated.

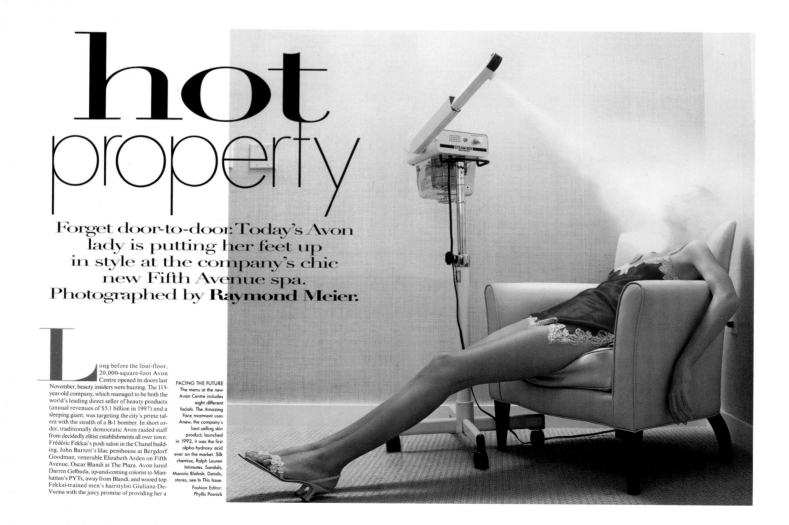

hot property

Forget door-to-door: Today's Avon lady is putting her feet up in style at the company's chic new Fifth Avenue spa. Photographed by **Raymond Meier.**

L ong before the four-floor, 20,000-square-foot Avon Centre opened its doors last November, beauty insiders were buzzing. The 113-year-old company, which managed to be both the world's leading direct seller of beauty products (annual revenues of $5.1 billion in 1997) and a sleeping giant, was targeting the city's prime talent with the stealth of a B-1 bomber. In short order, traditionally democratic Avon raided staff from decidedly elitist establishments all over town: Frédéric Fekkai's posh salon in the Chanel building, John Barrett's lilac penthouse at Bergdorf Goodman, venerable Elizabeth Arden on Fifth Avenue, Oscar Blandi at The Plaza. Avon lured Darren Gelbuda, up-and-coming colorist to Manhattan's PYTs, away from Blandi, and wooed top Fekkai-trained men's hairstylist Giuliana De-Vuona with the juicy promise of providing her a

FACING THE FUTURE
The menu at the new Avon Centre includes eight different facials. The Amazing Face treatment uses Anew, the company's best-selling skin product; launched in 1992, it was the first alpha-hydroxy acid ever on the market. Silk chemise, Ralph Lauren Intimates. Sandals, Manolo Blahnik. Details, stores, see In This Issue.
Fashion Editor: Phyllis Posnick

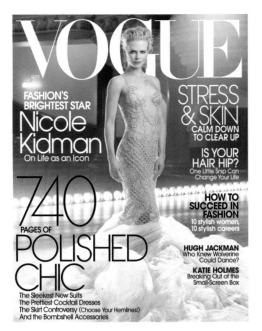

THE ELEMENT OF SURPRISE

According to Anna Wintour, the editorial and visual content of the magazine should be a mix of the expected and the surprising. This set of pictures of Nicole Kidman for the September 2003 issue is a perfect example of the latter.

Kidman appears romantic in a vintage dress and a Rochas jacket and dress as photographed by Irving Penn (top center and right, respectively); in menswear looks by Prada, Ann Demeulemeester, and Jean Paul Gaultier, photographed by Craig McDean (middle row), angelic in Annie Leibovitz's pictures wearing Atelier Versace (cover, top left; bottom left and center), and seductive in an Agent Provocateur slip and a Mr. Pearl custom-made black corset under Helmut Newton's lens (bottom right).

the company of men
The tomboy from Down Under, lanky and chic in fall 2003's menswear look. Photographed by Craig McDean.

grand illusion. The magnificent movie star, show stopping in couture. Photographed by Annie Leibovitz.

come what may

Four legendary photographers take on Hollywood's headiest fashion icon. Irving Penn, Craig McDean, Annie Leibovitz, and Helmut Newton map the compelling contradictions of Nicole Kidman.

master class

the method

"She has pulled off the miracle of being recognized in her art without unveiling herself," says Emanuel Ungaro. Vintage chiffon dress, with beaded slip from Southpaw Vintage Clothing and Textiles, NYC. Hair, Orlando Pita; makeup, Diane Kendal. Details, see In This Issue. Fashion Editor: Phyllis Posnick.

Photographed by Irving Penn

644

Nicole Kidman is a chameleon on the silver screen. But on the red carpet, she's steady as the North Star—serene, elegant, flawless.
By Sally Singer

i'm in love," swooned Nicole Kidman as she collapsed into the corner of the elevator. She had just finished her sitting with Irving Penn, and the experience—an intense and near-silent collaboration in which the protagonists sought to come to terms with a parasol and a Rochas gown—had left her drained and dreamy. "You enter a different realm," she said later about the encounter with the legendary portraitist. For the elevator journey back down to reality, Kidman wore a mocha suede jacket by Henry Duarte that, in its skinny, skinny fit, merged the Victorian and the rock 'n' roll. (Keith Richards would love it and indeed probably wore the East-West original back in the sixties.) She also wore Marc by Marc Jacobs trousers, a vintage scarf-top that flapped around to reveal her alabaster tummy, Prada Moroccan-leather sandals, and last year's Prada streamlined hobo bag.

The elevator stopped, and a tall, hijab-wearing African-American of exceedingly ambiguous gender stepped in. "You look just like Nicole Kidman," s/he remarked from behind her hood. Kidman smiled and, in a giveaway Australian accent, made a pleasant remark about the fine weather. Miraculously, the hijab-wearer still wasn't sure that this creature was the real thing—not even when, outside the building, Kidman waved goodbye to her/him as she sped away in her chauffeur-driven car.

Identifying Nicole Kidman is not, evidently, a straightforward business. It's not just that it's defamiliarizing to see the queen of the big night in hi-lo, boho Sunday-afternoon gear. It's that, in the words of Emanuel Ungaro, who recently dressed her for the BAFTAs, "Nobody seems to really know Nicole Kidman, because she has pulled off the

miracle of being recognized in her art without unveiling herself." It seems there may have been more than one person in that elevator wearing a veil.

"I don't think she likes looking natural," says Craig McDean, who photographed her for these pages wearing twenty separates. To consider the phenomenon of Nicole Kidman is, from one point of view, to consider the variety of masks and looks this extraordinary actress has worn with relish and that have transformed her into an icon of glamour and a certain fabulous appropriateness. It's not by chance that she has just been appointed the face of Chanel No. 5, the most classically chic perfume on the planet. As Tom Ford, who designed the dress Kidman wore to host the "Goddess" gala at the Met last spring, puts it, "She's developed a character for the red carpet, a public persona that is very groomed, very sleek, very controlled, very smooth, very much the star, very gracious, very elegant, very thoroughbred." As a result, Nicole Kidman is perhaps alone among actresses who regularly commit premeditated fashion not to have a criminal record.

Although stylish from the start, Kidman upped the stakes in 1997 when she wore a chartreuse Christian Dior sheath that was, observers felt on the night, the first time anybody had worn haute couture to the Oscars with real conviction. "If you look at designers as visionaries," says the actress, "and there are a select number who are visionaries, they can inspire, let you dream. That's a lovely thing to support and to act as a conduit for." Says John Galliano, the man responsible for the dress, "Nic is flawless—a true and believable beauty who completely resuscitated the red-carpet moment."

That Dior number is still her all-time favorite. "I love the simplicity of the design, the intricacy of the detail, the boldness of the color. It shouldn't have worked, you know." But it did, of course. Just as Christian Lacroix's lovely halter-neck for Bulgari and Pucci magically stole the show at this year's Cannes, and Gaultier's black toga frock looked very good with a gold statuette. A rumor circulated that Kidman had actually blocked any other borrowing from the haute-couture collection from which the Oscar gown came. (Cameron Diaz tried but failed.) Kidman demurs with a smile. "All I know," she says, "is that this was a dress that I loved."

Actually, Nicole Kidman knows a little bit more than she admires about red-carpet rules. Better than any of her contemporaries, she knows how to put them in a personal context. "Enjoy these moments. Appreciate them; embrace them for what they are. And know that they exist in a bubble"—and, more significant, in a professional context. She understands, says Baz Luhrmann, that "the red carpet is a job, and boy, is it a lot of work."

Nicole never allows her poise to falter in public—not even, reveals Luhrmann, in the "moments after her life fell apart" during the publicity tour for *Moulin Rouge!* At all times she's discretion personified.

There is no irony nor any detectable self-disclosure. This lofty bearing, coupled with her model's frame, is why designers love her so. "Valentino." "She has the most perfect figure." Ford. "She's amazing, she's

creature of the night
"Nicole is always Nicole, no matter who made the dress," says Rochas designer Olivier Theyskens. Rochas tiered brocade dress and bell-sleeved cropped jacket. Ford Leighton earrings. Hair, Luigi Murenu for Streeters; makeup, James Kaliardos. Details, stores, see In This Issue.

"She could kick back, use the body, use the red-carpet persona," says Baz Luhrmann, "but she has incredible balls"

dead calm
Kidman keeps her cool on the paparazzi path: "Embrace these moments for what they are. And know that they exist in a bubble" (on top). Prada short-sleeved shirt. Jean Paul Gaultier winking trousers with suspenders; concave vest. Viktor & Rolf blazer, cardigan, chevron shirt, eggplant blouse, and jeans. Hair, Orlando Pita; makeup, Lucia Pieroni for Clé de Peau Beauté. Details, stores, see In This Issue.

Nicole Kidman is perhaps alone among actresses who regularly commit premeditated fashion not to have a criminal record

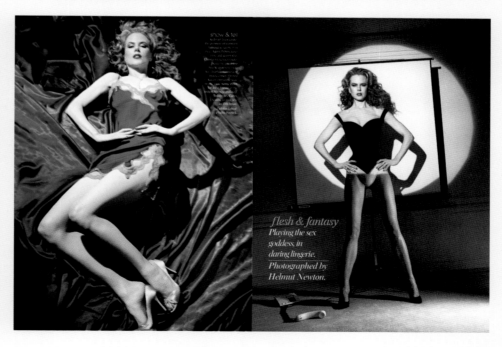

show & tell

flesh & fantasy
Playing the sex goddess, in daring lingerie. Photographed by Helmut Newton.

VOGUE

SEPT

FALL FASHION SPECTACULAR
OUR BIGGEST ISSUE EVER!
832 PAGES

IS THE NEXT
CANCER HOPE
ALREADY IN
YOUR MEDICINE
CABINET?

THE
GREATEST
LOVE STORY
EVER TOLD
NICOLE KIDMAN
MAKES HISTORY
IN A
TWO-MINUTE
MOVIE

The Most
Beautiful House
in Europe

PLUS STATEMENT JEWELS, MAGICAL MAKEUP, COUTURE CUISINE,
CELEBRITIES VS. SUPERMODELS & MUCH, MUCH MORE...

...INCLUDING THE K
DAZZLING DA

MODELS AND SUPERMODELS
Taking an old image of The Rolling Stones and
cutting and pasting multiple copies together
to the proportions of a three-page foldout
cover, Churchward came up with a design for
this September 2004 cover by Steven Meisel.
The photographer and editor could then plan
out the photo shoot and the number of models
needed. The models are (from left to right):
Daria Werbowy, Natalia Vodianova, Gisele
Bündchen, Isabeli Fontana, Karolina Kurkova,
Liya Kebede, Hana Soukupova, Gemma
Ward, and Karen Elson. The issue also holds
a record as the biggest in the history of the
American publishing industry: 832 pages.

MODELS OF THE MOMENT
From left to right:
Daria Werbowy, Natalia Vodianova, Gisele Bündchen,
Isabeli Fontana, Karolina Kurkova, Liya Kebede,
Hana Soukupova, Gemma Ward, Karen Elson.
Photographed by Steven Meisel
May 24, 2004

FASHION, DEMOCRATIC DAUGHTERS,
AMAZING EVENING DRESSES...

...DARIA, NATALIA, GISELE, ISABELI, KAROLINA, LIYA, HANA, GEMMA & KAREN
What Beautiful Girls Want to Wear Now

Nostalgia section and we introduced a few tweaks to Up Front. The Index section in the back went through more significant changes. Something similar happened to View at the front of the book: We shifted its position in the architecture and made it bigger. Regarding the logo, sometimes we condense it a bit owing to size changes in the March and September special editions. Sometimes we make it a little heavier. But the policy at Condé

Nast is not to play with the logo. Even size has remained pretty much the same. Sometimes we put a little shadow to it to make it read a little better. There have been only a few minor type changes and aesthetic tweaks over the years," says Churchward.

Special requirements apply for covers, Churchward notes: "Covers are posters. They should be attractive and have to have an immediacy to them.

The idea is to place both the logo and the head of the cover subject as high as possible, so that readers can recognize them immediately. The main cover line should be at the top left. That's where a person's eye goes first after looking at the image."

THE CHOSEN ONES
Angelina Jolie on the March 2004 cover, and Gwyneth Paltrow on the October 2005 cover, both photographed by Mario Testino. Paltrow has made the cover of *Vogue* five times.

Celebrities are never paid for a *Vogue* cover photograph. However, in a market of women's magazines avidly competing for celebrities and with readers who are insatiably curious about these stars' lives and preferences, the quest for the right cover celebrity is not an easy task. "Basically we need between ten and twelve each year, and the search is constant," explains entertainment editor Jillian Demling. She is in charge of negotiating with celebrities to pose for *Vogue* covers, and she coordinates the calendar and the logistics of the photo shoot. With the growing trend toward putting celebrities on the cover, *Vogue* has developed basic rules for working with them:

Each celebrity's appearance on the cover should have topical relevance— for instance, coinciding with the opening date of a movie or show. "*Vogue* is in weekly contact with all the studios, to keep abreast of the news regarding the making of the film and its opening," said Demling. "Sony, for example, gives us a list of openings scheduled for the next two years; other studios, for openings over shorter periods. Most celebrities are willing to pose for *Vogue* cover photos because it is a badge of distinction to be asked to do so, and because they are going to attain unique exposure. Others do it under obligation, because the studios demand of them by contract to be available to the press to promote a film. Many, however, participate happily and willingly because they love fashion, like Nicole Kidman or Sarah Jessica Parker."

The celebrity must be easily recognizable, must measure up to the *Vogue* image of a stylish, sophisticated, and elegant woman, and must be exclusive for the month in which she will appear on the magazine's cover.

"Jennifer Aniston sells well on the cover, as do Sarah Jessica Parker, Nicole Kidman, Sandra Bullock, Gwyneth Paltrow, and Renée Zellweger. Angelina Jolie was very successful as a cover, which is why she has appeared twice. Kate Hudson is a very strong presence, as is Reese Witherspoon," Demling continues. "*Vogue* knows which actresses are more popular than others for a cover through the sales figures it gets from the circulation department and through its own archival research. Also, when we conduct our cover testing, we test the popularity of the celebrity we plan to use, and this gives us an indication of how they'll sell the issue. If a celebrity appears more than once, we like to let at least eighteen months elapse between covers."

The celebrity must agree to the wardrobe and the cover look prescribed by the magazine's fashion team. "Once the concept is agreed upon, we try to have the celebrity come to our office and look over the clothes recommended for the shoot. We also try to make sure that the actress involved will be comfortable with the clothes and that they suit her style. The actress will try on the clothes and discuss possible variants to her attire," says Demling. "If the actress cannot be present, we'll discuss it by telephone, but to do so in person is far preferable."

Celebrities appear alone, with a few exceptions. According to Demling, "We prefer to have just one celebrity on a cover. Occasionally we will vary this rule, as when we featured three generations of Presley women on the cover of the 'Age' issue. Catherine Zeta-Jones appeared with Renée Zellweger when they were costars in the film *Chicago*." Other exceptions

FLYING HIGH

This December 2004 story on Cate Blanchett, photographed by Annie Leibovitz, shows her as an icon of style and a master at transformation. *Vogue* makes sure that the celebrity agrees on the wardrobe and the cover look with the magazine's fashion team. For her cover shoot Blanchett wears a Ralph Lauren ivory satin dress; below, left, a Burberry London leather trench and Hermès aviator hat and gloves; below, right, a Hermès suit; bottom, left, a Behnaz Sarafpour gown; bottom, middle, a Bill Blass black dress; and, bottom, right, a Proenza Schouler gold bustier bodysuit.

pale perfection

With 24 films behind her, this shape-shifting star is an icon of style and beauty, a mother of two, and a master of transformation on both stage and screen. Joan Juliet Buck tracked Cate Blanchett to Sydney to catch her run as Hedda Gabler and to talk about her role as Kate Hepburn in The Aviator. Photographed by Annie Leibovitz.

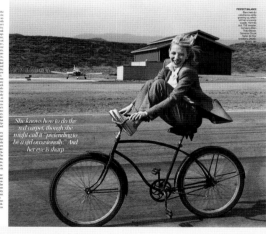

She knows how to do the red carpet, though she might call it "pretending to be a girl occasionally." And her eye is sharp.

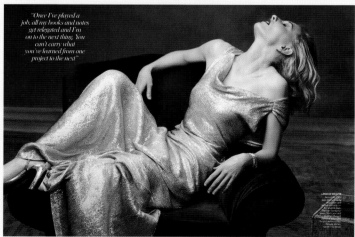

"Once I've played a job, all my books and notes get relegated and I'm on to the next thing. You can't carry what you've learned from one project to the next."

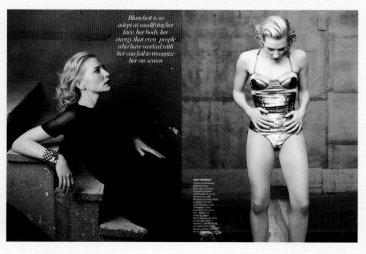

Blanchett is so adept at modifying her face, her body, her energy that even people who have worked with her can fail to recognize her on screen

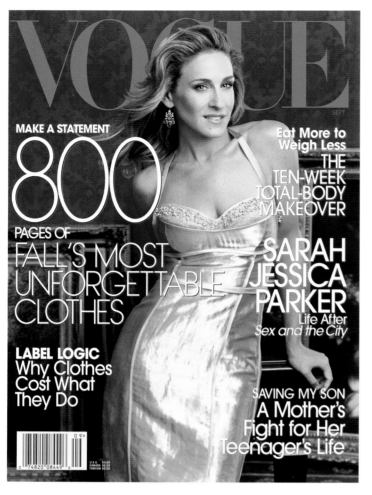

This September 2005 special edition with actress Sarah Jessica Parker on the cover, shot by Annie Leibovitz, shows her in the halls of the Plaza hotel before it closed for major renovation. It was one of the biggest monthly magazine issues in American publishing history, with an all-time record of 691 advertising pages. For her fashion shoot, Parker wears a Narciso Rodriguez silk halter dress (cover), a Yves Saint Laurent tuxedo (middle, left), a Carolina Herrera blouse and ball skirt (middle, right), an Oscar de la Renta corset dress with train (bottom, left), and, accompanied by Tony Bennett, a Louis Vuitton jacket and matching fitted skirt (bottom, right).

are when men have appeared on *Vogue* covers. "We shot George Clooney with the model Gisele, in his case because he was the star of the movie *The Perfect Storm*, was unmarried, very sexy, and adored by women, in her case to add fashion content. We also featured Richard Gere together with Cindy Crawford when the couple married. Those are the only two men ever to have appeared on the cover of American *Vogue*—besides Amber Valletta's eighteen-month-old baby son. She held him in her arms for the cover of an issue that featured model moms."

The celebrity must be willing to pose according to the magazine's demands and even, on occasion, to face physical challenges. "When we shot

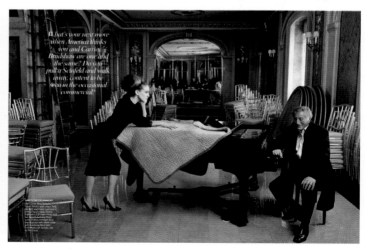

Cameron Diaz for the May 2003 issue, the concept was circus. We asked her to do the craziest things, as if she were being fired from a cannon, for example. She posed on a trapeze and hung by her legs without a safety net beneath her, ten meters above the ground. She did it without complaint." Another interesting case was Drew Barrymore, who posed with a live lion to illustrate a "Beauty and the Beast" concept. Photoshopping the lion into the picture was briefly considered, but to look convincing, a real beast was used, wearing a hidden collar that restricted its movement and reduced the potential danger.

BEAUTY AND THE BEAST
The lion at the side of actress Drew Barrymore on this April 2005 cover, photographed by Annie Leibovitz, is real. To avoid risks, the animal was wearing a hidden collar that restricted its movement. Barrymore is wearing Christian Lacroix Haute Couture dresses in both photographs.

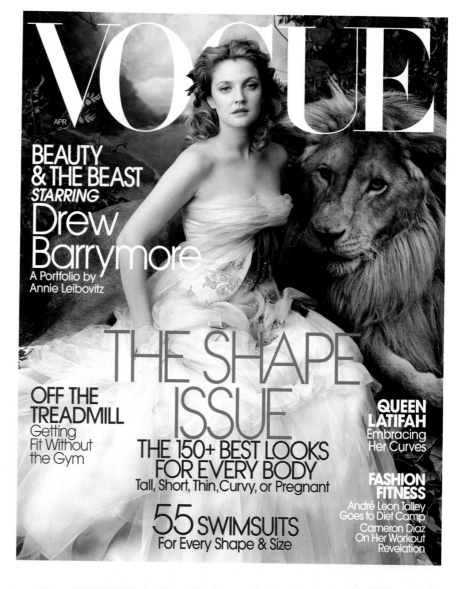

MEN ON BOARD
The only men ever to make the cover of *Vogue* were actors George Clooney (shown here with Gisele Bündchen, photographed by Herb Ritts for the June 2000 issue, to coincide with the release of the film *The Perfect Storm*, in which he starred), and Richard Gere when he married Cindy Crawford.

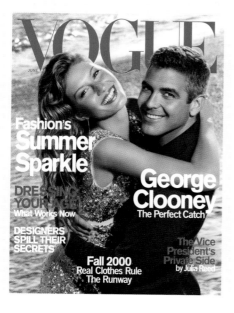

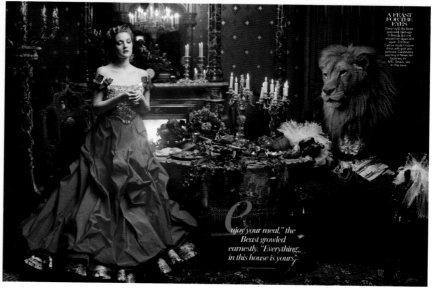

VOGUE

OCT

Sexy in the City
PLANNING THE PERFECT FALL WARDROBE

93
SENSATIONAL LOOKS

YOUR BEST SHAPE EVER
How Yoga Can Change Your Body (And Your Life)

RAGING HORMONES
The Battle Over HRT

ROCK-GODDESS HAIR
GETTING THE SEASON'S COOLEST CUT

THE NEW OLD THING
How to Rethink, Revamp, Recycle Your Clothes

THE WOMAN WHO BECAME A MAN
The Latest Novel from the Author of *The Virgin Suicides*

NO DOUBT ABOUT IT
The Girl's Got Style! Gwen Stefani Shines in Dior Couture

THE COVER SHOOT

The two fashion editors who normally supervise *Vogue*'s cover shoots are Tonne Goodman, who works with celebrities and handles about 80 percent of covers, and Grace Coddington. If the cover shoot is to be done by photographer Irving Penn the responsibility for the sitting will pass to Phyllis Posnick, who enjoys a long-standing professional relationship with the photographer.

The role of the fashion editor in a cover shoot is crucial. Goodman explains: "It is the fashion editor who represents *Vogue* on a cover shoot. She is the person who must know very clearly the image requirements for a *Vogue* cover, which are elegance, style, sophistication, personality, and intelligence. She must also take into account that both the cover image and the magazine itself are addressing an audience that can decode, understand, and appreciate all these elements not only from a fashion point of view but from a broader point of view as well."

Visual ideas for the covers generally come out of conversations between members of the fashion team, or between one of the fashion editors, the editor in chief, and design director Charles Churchward. Sometimes there is no specific theme, as was the case with Nicole Kidman in September 2003, when the subject was simply the couture. On other occasions, a reference comes into play. "In the case of Jennifer Lopez," says Goodman, "we tapped the image of the actress Ava Gardner because J.Lo is a fan of hers."

In general, the cover image is aspirational, Goodman continues. "But sometimes we plan to do the cover with one idea and eventually end up with a better one, as happened with Christy Turlington in the October 2002 cover shoot. At the beginning we did something very traditional, but later, when we started to take pictures of her with her yoga product line, Christy came up with a highly interesting yoga body posture, which was finally chosen as the cover by Anna Wintour. It was the right choice, as it fit in perfectly with our 'Shape' issue. A similar case came up when we were working on Gwyneth Paltrow's cover story for the October 2003 issue, shot on location in Oxford, England. After the traditional cover photo was taken, Paltrow sat down in a way that fascinated both the photographer and me. Another photo was taken which ultimately went on the cover instead of the one originally intended. The point is that no matter how many variations and options we may think of in advance, we should never discount the element of surprise, which plays a crucial role in the taking of cover shoots."

SPONTANEOUS COVER
At a time when yoga-obsessed Americans were enrolling in yoga classes en masse in an effort to improve their bodies, minds, and lives, model Christy Turlington led the way in promoting the benefits of yoga in this October 2002 cover story, photographed by Steven Klein. She's in Calvin Klein on the cover; at right the fashions include a black silk dress by Tom Ford for Yves Saint Laurent Rive Gauche and a Prada slip dress.

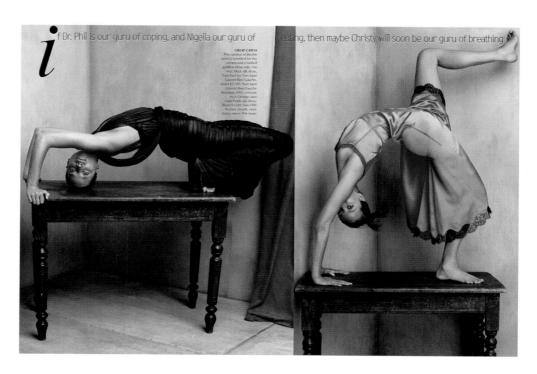

THE EXPANDING *VOGUE* WORLD

The *Vogue* brand has taken a number of confident new steps in the early years of this century, at home and abroad. In 2002 *Teen Vogue* was launched under editor Amy Astley, and its circulation quickly grew to some 850,000. *Men's Vogue*, launched in September 2005 under editor Jay Fielden, similarly attracted a popular response. "It had such an impact with its first issue," remarks Anna Wintour, "that in its second we were able to entice the elusive Tiger Woods to be photographed for the cover by Annie Leibovitz, impeccably dressed in a Prada suit and racing a jet ski." At the time of writing, plans are under way for a third offspring publication, *Vogue Living*.

But nothing is more important to Wintour than *Vogue* itself. "Everything has to stay true to the spirit of the parent magazine," she says. "*Vogue* represents the gold standard in cultural taste. We may be a superbrand, but, like all creative enterprises, we always retain a little mystery—even to ourselves."

LEAP TOWARD THE FUTURE
Actor Ben Stiller and model Stella Tennant with the Eiffel Tower as backdrop, taken by Annie Leibovitz for the October 2001 issue.

VOGUE'S MISSION

Each of the *Vogue* editors in chief over the years left her unique editorial or visual imprint on the magazine. The Wintour era, however, has extended the reach further to turn the magazine into a real protagonist of its time. One of the best examples occurred in September 2001, when Fashion Week came to a sudden stop after the terrorist attack on the World Trade Center in New York. Wintour remembers, "People in the office were paralyzed with shock. Designers were calling, saying they didn't know whether they should show or not. I said, 'Of course you must show.' I thought the only thing to do was to take action, get people moving and thinking about others. That was something I learned from my Dad. So the whole staff became involved in helping designers to style their shows." *Vogue* organized a group presentation at Carolina Herrera's showroom, where eleven designers "got their day in the sun after all," as Wintour wrote in her Letter from the Editor. The content of the issue was also transformed within the space of a week. An article was commissioned titled "Why Designers Love New York," and in the lead story models wearing white to signify peace waved the American flag from a New York rooftop.

Wintour has actively involved *Vogue* in fundraising since the early 1990s, playing a strategic role in developing the fashion industry's AIDS charity program, the CFDA/*Vogue* Initiative, through which she has helped raise

more than $11 million for AIDS research. "Everyone in the fashion industry was being affected by AIDS—and nobody wanted to talk about it," she says of her decision to join a collective effort to change this thinking and raise money. She cochaired the CFDA/*Vogue* event "Seventh on Sale"—the world's most desirable sample sale—in 1990 and 1995, once bringing Seventh Avenue to a standstill in the process: "I'll never forget the day Patrick Demarchelier took a *Vogue* group portrait of all the New York designers, from a crane high up outside 550 Seventh Avenue. As the designers walked out one by one, each wearing a 'Seventh on Sale' T-shirt, all the steamstresses of the garment district stood on the street, clapping them. It was really moving. It's at moments like that you feel really good about what you can do."

Vogue's involvement with AIDS activism has continued over the years. In 1999 Wintour cochaired "Unforgettable: Fashion of the Oscars," an auction of celebrity dresses that raised $1.4 million to benefit amfAR, and played a key role in Fashion for America, a charity backed by the CFDA and *Vogue* to bolster the retail industry and the economy and to raise money for the Twin Towers Fund.

However, few efforts have helped the fashion industry as much as the CFDA/ *Vogue* Fashion Fund. Established in 2003 and underwritten by Barneys

FASHION FUND FINALISTS
The CFDA/*Vogue* Fashion Awards celebrate and subsidize the industry's up-and-coming power players. The November 2005 picture (top), by Norman Jean Roy, presented the designers from the California firm Trovata, and the November 2004 photo (bottom), by Arthur Elgort, grouped the innovative designers that made the final cut that year.

and *Vogue*, it was set up to provide financial awards and business mentoring to emerging fashion designers. "While there were so many powerful players at the top of the fashion industry, it was becoming obvious to us how hard it is to survive as an emerging talent," explains Wintour. "When we looked around, Marc Jacobs and Michael Kors were our 'young designers'—and they were already in their forties. I decided we must go out and give the next generation support." The Fashion Fund grants a first prize of $200,000 and two runner-up prizes of $50,000, but Wintour was determined that the help offered should be more profound than just handing over money. "The application form involves pages and pages of information in which we find out what designers really need for structuring their businesses. The prize also involves a mentoring scheme with senior industry figures, and what we're finding now is that the winners all stress how invaluable that access and insight has been." The progress of the designers is monitored and reported. *Vogue* devoted fifteen pages to the finalists of the second Fashion Awards in its November 2005 issue, headlined "The Final Ten." The behind-the-scenes of the contest and the exciting and heartbreaking stories of the emerging fashion designers were later featured in *Seamless*, a documentary directed by Douglas Keeve that appeared in theaters and on the Sundance Channel.

Vogue is also a generous benefactor of the Metropolitan Museum of Art's Costume Institute. Wintour cochairs an annual benefit gala that has so far raised $25 million for the museum, turning the May event into a glamorous New York gala that threatens to outdo the lure of the Oscars. "In 2005, the numbers of people looking at the pictures from the Met on style.com outstripped those who watched the Academy Awards," says Wintour.

Vogue in general and Anna Wintour in particular support the past, present, and future of fashion beyond geographical, political, or religious borders. The magazine devoted eleven pages in its November 2005 issue, under the headline "Extreme Makeover," to the opening of a beauty school in Kabul. "This improbable and improbably wonderful event is *Vogue*'s contribution to the rebuilding of women's lives in Afghanistan," wrote the editor in chief in her Letter from the Editor. "The story meant much more than a simple donation for *Vogue* (which supported the foundation of the school from the very beginning), since to attend beauty school in Kabul is a political act, an assertion of the women's right to be economically active, socially engaged and physically autonomous." The Beauty Academy of Kabul became the subject of a well-received documentary feature by Liz Mermin, released in 2004.

FASHION AND AIDS
The CFDA and *Vogue* organized the charity event "Seventh on Sale" in 1990 and 1995 to take action against the disease that ravaged the industry. This picture, published in September 1990, was taken by Patrick Demarchelier.

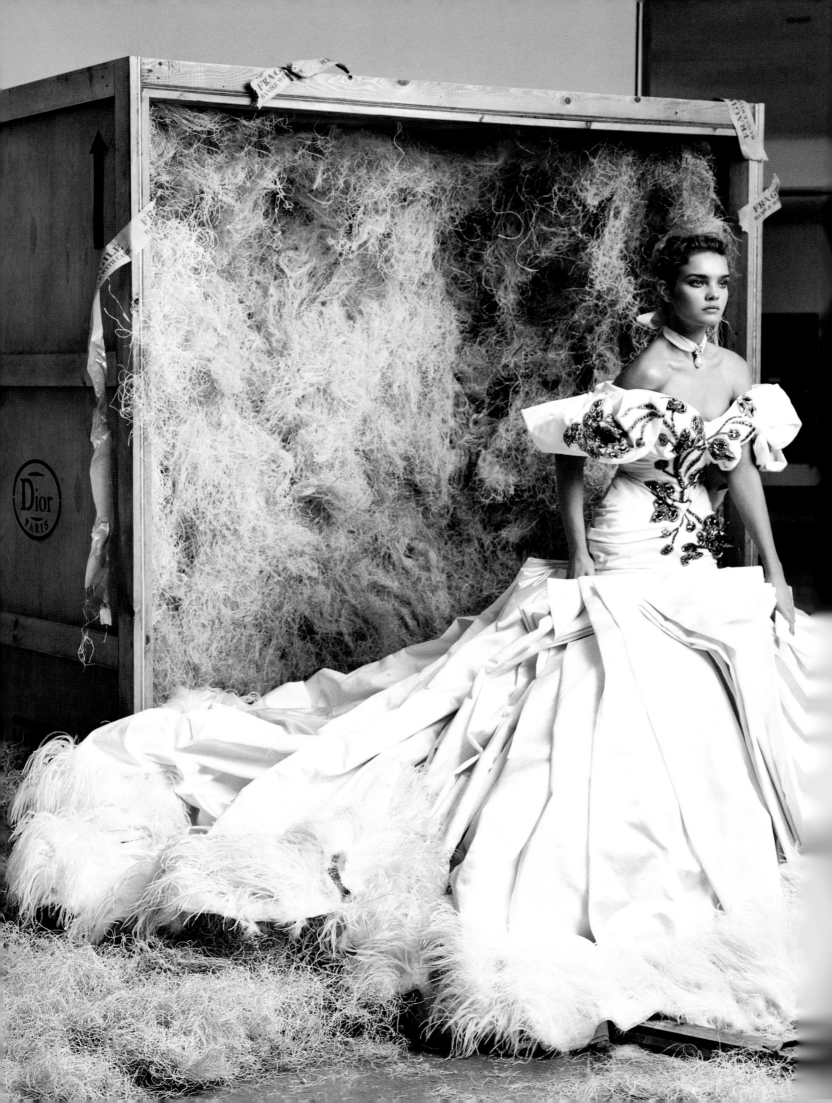

BIBLIOGRAPHY

Avedon, Richard. *Avedon: Photographs, 1947–1977*. New York: Farrar, Straus and Giroux, 1978.

Ballard, Bettina. *In My Fashion*. New York: David McKay, 1960.

Beaton, Cecil. *The Glass of Fashion*. Garden City, NY: Doubleday, 1954.

——. *Photobiography*. Garden City, NY: Doubleday, 1951.

Blumenfeld, Erwin. *See* Teicher, Hendel.

Brandau, Robert, ed. *De Meyer*. Biographical essay by Philippe Jullian. New York: Knopf, 1976.

Chase, Edna Woolman, and Ilka Chase. *Always in Vogue*. Garden City, NY: Doubleday, 1954.

Coddington, Grace, ed. *Grace: Thirty Years of Fashion at "Vogue."* Göttingen: Steidl, 2002.

Davis, George, ed. *Horst: Photographs of a Decade*. New York: J. J. Augustin, 1944.

Devlin, Polly. *Vogue Book of Fashion Photography, 1919–1979*. New York: Simon and Schuster, 1979.

Gabler, Neal. "x." *New York Times*,

Gray, Francine du Plessix. *Them: A Memoir of Parents*. New York: Penguin, 2005.

Greenough, Sarah. *Irving Penn: Platinum Prints*. Washington, D.C.: National Gallery of Art; New Haven, Yale University Press, 2005.

Gross, Michael. *Model: The Ugly Business of Beautiful Women*. New York: Morrow, 1995.

Hall-Duncan, Nancy. *The History of Fashion Photography*. New York: Alpine, 1979.

Heller, Steven, and Louise Fili. *Cover Story: The Art of American Magazine Covers, 1900–1950*. San Francisco: Chronicle, 1996.

Holme, Bryan, Katharine Tweed, Jessica Daves, and Alexander Liberman, eds. *The World in "Vogue."* New York: Viking, 1963.

Horst. *Salute to the Thirties*. New York: Viking, 1951.

——. *See also* Davis, George, ed.; Lawford, Valentine.

Janello, Amy, and Brennon Jones. *The American Magazine*. New York: Harry N. Abrams, 1991.

Jullian, Philippe. *See* Brandau, Robert, ed.

Kazanjian, Dodie, and Calvin Tomkins. *Alex: The Life of Alexander Liberman*. New York: Knopf, 1993.

Kery, Patricia Frantz. *Great Magazine Covers of the World*. New York: Abbeville, 1982.

Klein, William. *Close Up*. London: Thames and Hudson, 1990.

——. *In and Out of Fashion*. New York: Random House, 1994.

——. *William Klein: Photographs*. Profile by John Heilpern. New York: Aperture, 1981.

Koda, Harold, and Andrew Bolton, eds. *Chanel*. New York: Metropolitan Museum of Art, 2005.

Lawford, Valentine. *Horst: His Work and His World*. New York: Knopf, 1984.

——. *Vogue's Book of Houses, Gardens, People*. New York: Viking, 1968.

Leibovitz, Annie. *Photographs*. New York: Pantheon, Rolling Stone Press, 1983.

——. *Photographs—Annie Leibovitz, 1970–1990*. New York: HarperCollins, 1991.

——, ed. *Shooting Stars*. San Francisco: Straight Arrow, 1973.

Liberman, Alexander. *The Artist in His Studio*. Rev. ed. New York: Random House, 1988.

Lloyd, Valerie. *The Art of "Vogue" Photographic Covers: Fifty Years of Fashion and Design*. New York: Harmony, 1986.

Mirabella, Grace. *In and Out of Vogue*. With Judith Warner. New York: Doubleday, 1995.

Nast, Condé. "Class Publications." *Merchants' and Manufacturers' Journal*, June 1913.

Newton, Helmut. *Helmut Newton: Work*. Curated by June Newton. Edited by Manfred Heiting. Essay by Françoise Marquet. Köln: Taschen, 2000.

——. *Pages from the Glossies: Facsimiles 1956–1998*. Edited by June Newton and Walter Keller. Zurich: Scalo, 1998.

——. *Portraits*. New York: Pantheon, 1987.

On the Edge: Images from 100 Years of "Vogue." Introduction by Kennedy Fraser. New York: Random House, 1992.

Packer, William. *The Art of Vogue Covers 1909–1940*. New York: Harmony, 1980.

Penn, Irving. *Passage: A Work Record*. New York: Knopf, 1991.

——. *Worlds in a Small Room*. New York: Viking, 1974.

Postman, Neil.

Ritts, Herb, and Patrick Roegiers. *Herb Ritts: Work*. Boston: Bullfinch, 1996.

Rowlands, Penelope. *A Dash of Daring: Carmel Snow and Her Life in Fashion, Art, and Letters*. New York: Simon and Schuster, Atria Books, 2005.

Seebohm, Caroline. *The Man Who Was Vogue: The Life and Times of Condé Nast*. New York: Viking, 1982.

Snow, Carmel. *The World of Carmel Snow*. With Mary Louise Aswell. New York: McGraw-Hill, 1962.

Steichen, Edward. *A Life in Photography*. Garden City, NY: Doubleday, 1963.

Tebbel, John, and Mary Ellen Zuckerman. *The Magazine in America, 1741–1990*. New York: Oxford University Press, 1991.

Teicher, Hendel. *Blumenfeld: My One Hundred Best Photos*. Translated by Philippe Garner with Luna Carne-Ross. New York: Rizzoli, 1981.

Testino, Mario. *Front Row/Backstage*. Boston: Bullfinch, 1999.

——. *Mario Testino: Portraits*. Boston: Bullfinch, 2002.

Vreeland, Diana. *Allure*. With Christopher Hemphill. Garden City, NY: Doubleday, 1980.

——. *D.V.* Edited by George Plimpton and Christopher Hemphill. New York: Knopf, 1984.

Watson, Linda. *Vogue: 20th Century Fashion: 100 Years of Style by Decade and Designer*. London: Carlton, 1999.

Wood, Christopher. *The Pre-Raphaelites*. New York: Viking, 1981.

Yohannan, Kohle. *John Rawlings: 30 Years in Vogue*. Santa Fe, NM: Arena, 2001.

Zuckerman, Mary Ellen. *A History of Popular Women's Magazines in the United States, 1792–1995*. Westport, CT: Greenwood Press, 1998.

ACKNOWLEDGMENTS

We are deeply grateful to Anna Wintour for generously opening *Vogue*'s doors and allowing us access to interview the decision makers and the people who create the magazine every month, and for her unerring ideas, suggestions, and encouragement in helping to make this a great book.

We are especially indebted to Christiane Mack for her expert guidance through the complicated maze that is *Vogue*; to Patrick O'Connell, who has always been an outstanding troubleshooter as well as a source of inspiration and endless sense of humor; and to Charles Churchward, for his knowledgeable advice and philosophy to keep the pages of *Vogue* consistently fresh, and for illuminating our way through thousands of pictures.

Grace Coddington, Tonne Goodman, Phyllis Posnick, Sally Singer, Virgina Smith, Laurie Jones, Jillian Demling and Eve MacSweeney, Alexandra Mack, Barbara Kean, Sarah Mower and photographer Steven Klein, as well as Tom Florio, Deborah Cavanagh and Elissa Lumley could not have been more gracious and generous.

At the Condé Nast Library and Rights and Permissions department, special thanks go to Cynthia Cathcart, Stan Friedman, and Florence Palomo for their help in locating, sorting out, and classifying historical and contemporary issues of the magazine, as well as tons of pictures, biographies, and books on fashion, art, and photography; Linda Rice, Carol Plum, and Leigh Montville for their expert guidance; Gretchen Fenston, Shawn Waldron, Marianne Brown, Paul Hawryluk,

Dawn Lucas, Rachel Smalley, and Frank Wong for their scans of historical pages of *Vogue*; Maria Sacasa, Michal Saad, Brian Fee, Norman and Marian Brown, and Clarisa Moraña have been of great assistance during the editorial process. We also extend warm thanks to June Newton and Tiggy Maconochie.

To Charles Miers of Rizzoli International Publications, our publisher, thank you for believing in this book from the very beginning and for providing us with a great team to make it become a reality: Ellen Nidy, Ilaria Fusina, Maria Pia Gramaglia, Miko McGinty, Rita Jules, Tina Henderson, Julie Schumacher, Julie Di Filippo, and Kathleen Jayes.

Finally, we extend our warmest thanks to Ann Marlowe for copy editing of exceptional substance and detail.

INDEX

Boldface page references indicate photographs and illustrations.

PHOTOGRAPHY CREDITS

First published in the United States of America in 2006 by
Rizzoli International Publications, Inc.
300 Park Avenue South
New York, NY 10010
www.rizzoliusa.com

Executive Editor: Anthony Petrillose
Original Design and Layout: Javier Basile and Alejandro Romero
Jacket Design and Interior: Miko McGinty and Rita Jules
Typesetting: Tina Henderson

2009 2010 2011 2012 / 10 9 8 7 6 5
Distributed in the U.S. trade by Random House, New York

Printed in China

ISBN-13: 978-0-8478-2864-7

Library of Congress Catalog Control Number: 2006901749